REMBRANDT
CARAVAGGIO

Rembrandt

Waanders Publishers, Zwolle

Rijksmuseum, Amsterdam

Caravaggio

Duncan Bull

Taco Dibbits

Margriet van Eikema Hommes

Volker Manuth

Ernst van de Wetering

This catalogue is published in conjunction with the exhibition *Rembrandt–Caravaggio*, presented by the Rijksmuseum Amsterdam and the Van Gogh Museum in the Van Gogh Museum in Amsterdam, 24 February - 18 June 2006, celebrating the Rembrandt 400 Anniversary Year under the patronage of Her Majesty Queen Beatrix of the Netherlands.

The general concept of the exhibition originated with Ronald de Leeuw, Director General of the Rijksmuseum. The exhibition was supervised by Duncan Bull, senior curator of paintings.

Both the exhibition and catalogue throw light on the two great geniuses of baroque painting. They are famous throughout the world for their forceful expression of powerful emotions, dramatic use of light and disturbing realism. For the first time these two revolutionary artists are shown side by side. There are 38 paintings in the exhibition, most of them lent by leading museums in Europe, the United States and Australia. Rabobank is main sponsor of *Rembrandt–Caravaggio*.

Main sponsor

Rabobank

Insured by Aon Artscope, Amsterdam.

Contents

Foreword

Under the patronage of Her Majesty Queen Beatrix, the Netherlands celebrates this year the 400th anniversary of the birth of Rembrandt Harmensz van Rijn. The Rijksmuseum and the Van Gogh Museum are jointly contributing to the festivities by arranging a meeting between Rembrandt, the leading light of the northern Baroque, and his counterpart from southern Europe, Michelangelo Merisi, known as Caravaggio.

There has been no shortage of Rembrandt exhibitions in Amsterdam's Museumplein over the past century, and many opportunities have been seized to honour the master. The first of importance was mounted in the unlikely setting of the Stedelijk Museum, now best known for modern art, to mark the investiture of Queen Wilhelmina in 1898. Then, in 1932, there was the monographic exhibition in the Rijksmuseum on the occasion of the 300th anniversary of the founding of the University of Amsterdam. That was swiftly followed in 1935 by an exhibition celebrating the Rijksmuseum's golden jubilee. In 1956 came the 350th anniversary of Rembrandt's birth, and in 1969 the 300th of his death. Only the great retrospective of 1992 failed to fit this mould. The focus then was on the new insights that had been gained into the master and his workshop, partly due to the work of the Rembrandt Research Project.

Although these and many other exhibitions outside the Netherlands have demonstrated time and again that Rembrandt is an endlessly fascinating artist, we now feel that the time is ripe to bring him into the limelight in a very different way. The meeting with Caravaggio removes him from the national framework in which he has traditionally been placed. In institutions such as the Louvre, or the National Galleries in London and Washington, Rembrandt is always surrounded by his fellow countrymen, far removed from the Italian schools. Works by Caravaggio, who like Rembrandt is counted as one of the revolutionary innovators of the art of painting, were last seen in the Netherlands more than 50 years ago. And although he has long had the status of an international star, his name is surprisingly unfamiliar in this country.

The visual confrontation between Rembrandt and Caravaggio, the undisputed luminaries of the Baroque in northern and southern Europe, each of whom evolved his own original and dramatic visual idiom, nevertheless demonstrates that there are many parallels in their work. It reveals the pictorial challenges they set themselves and illuminates how they tackled them. The exhibition accordingly focuses on their dramatic use of painterly means. Both Caravaggio and Rembrandt played with contrasting colours, with light and shade, with unexpectedly realistic details. They used all of this in their painted narratives to express intense emotions in a new way. Caravaggio was the first to employ marked contrasts of light and shade to heighten the drama in his paintings. Rembrandt profited from Caravaggio's inventive example, but developed his own way of using light and shade to emphasise the inner emotions of his figures. The realism that shocked their contemporaries still has enormous power. Rembrandt and Caravaggio brought an intense scrutiny to their study of mankind – each in his own way. They imparted extra force and mystery to the great themes: love, religion, sex and violence. Rembrandt and Caravaggio changed not only the course of painting but also our view of the world.

Developing the concept of the exhibition and choosing the works to display was undertaken with great élan by a scholarly committee consisting of Duncan Bull, Taco Dibbits, Volker

Manuth and Carel van Tuyll van Serooskerken. We would like to express our gratitude to them, and in particular to Duncan Bull for the dedication and precision that he brought to the preparation of the catalogue. We are also indebted to Ernst van de Wetering, the director of the Rembrandt Research Project, who together with Margriet van Eikema Hommes very enthusiastically contributed to the publication. Charles Saumarez Smith and his curators at The National Gallery in London, were also extremely helpful during the initial preparations for the exhibition.

Works by Rembrandt and Caravaggio are star attractions in any museum lucky enough to have them. We are therefore most grateful to our sister institutions for their readiness to contribute to this show with highlights from their own collections. We are no less indebted to the private individuals who were prepared to be separated from works they own in order to celebrate this occasion.

Bringing so many unique masterpieces together is an expensive business, and the exhibition would not have been possible without the generosity of the Rabobank, the promoting partner of the Van Gogh Museum and the chief sponsor of the exhibition. We are also very grateful to R.H. Loudon, the former Dutch ambassador to Italy, his successor E.J. Jacobs, and M.B. Pensa, the Italian ambassador to the Netherlands, for their services in helping us to acquire many of the loans that were so important for the exhibition. We are indebted to the Stichting Rembrandt 400, co-ordinator of many activities in this anniversary year, and in particular for its support with the organisation of the exhibition.

The Netherlands Secretary of State for Culture exceptionally raised the ceiling of the government scheme for the indem-nification of objects on loan; this contributed to the realisation of *Rembrandt–Caravaggio* by diminishing the otherwise enormous insurance premiums.

Jean-Michel Wilmotte was invited to design the exhibition, and produced an extremely elegant plan that does full justice to the visual impact of the works by both artists. Victor Levie is responsible for the graphic design of both exhibition and catalogue.

In the period leading up to the opening of The *New* Rijksmuseum, the nearby Van Gogh Museum was the obvious partner to provide the venue for *Rembrandt–Caravaggio*. Both museums and their staffs took great pleasure in working intensively together on this prestigious exhibition.

Ronald de Leeuw
Director General Rijksmuseum

John Leighton
Director Van Gogh Museum

Acknowledgments

The realisation of this exhibition and catalogue has depended on the kind assistance of many people and institutions, most notably those who have generously allowed their paintings to travel to Amsterdam and have thus made the project possible. The exhibition was produced by the Exhibition Departments of the Rijksmuseum and the Van Gogh Museum, headed respectively by Jan Rudolph de Lorm and (until 1 July 2005) Andreas Blühm, supported by Wendela Brouwer, Roosmarijn Ubink and Aly Noordermeer. The catalogue was produced by Paulien Retèl. Much invaluable assistance was received from Geert-Jan Janse, who also compiled the Chronologies on p. 26 below.

In addition to the many people on the staffs of both museums who have helped in many ways, often well beyond the call of duty or of collegiality, we wish to thank the following:

Herbert Beck, Sergio Benedetti, Mària van Berge-Gerbaud, Piero Boccardo, Angela Carola, Dawson Carr, Stefano Casciù, Keith Christiansen, Anna Coliva, Marcus Dekiert, Prince Jonathan Doria Pamphilj Landi, Blaise Ducos, Jan Piet Filedt Kok, Gabriele Finaldi, Andrea Gattini, Jeroen Giltaij, Florian Haerb, Enriqueta Harris Frankfort, Carol Henry, Jeannie Hobhouse, David Jaffé, Guido Jansen, Jan Kelch, Arjan de Koomen, Matteo Lafranconi, Friso Lammertse, Helen Langdon, Katharine Lee Reid, Bernt Lindemann, Tomás Llorens, Stéphane Loire, Henri Loyrette, Michael Mack-Gérard, Andrea G. De Marchi, Harald Marx, Rick Mather, Bert W. Meijer, Uta Neidhardt, Mirjam Neumeister, Serena Padovani, Harry S. Parker, Anna Maria Petrioli Tofani, Carol Plazzotta, Vincent Pomarède, Wolfgang Prohaska, Konrad Renger, Martin Roth, Axel Rüger, Monique Ruhe, José Luis Sancho, David Scrase, Geert Jan van der Sman, Laurent Sozzani, Nicola Spinosa, Cathy Spurell, Carl Brandon Strehlke, Claudio Strinati, Luke Syson, Fatima Terza, Paul Thorel, Bert Treffers, Mariella Utili, Gerard Vaughan, Alejandro Vergara, Marieke de Winkel.

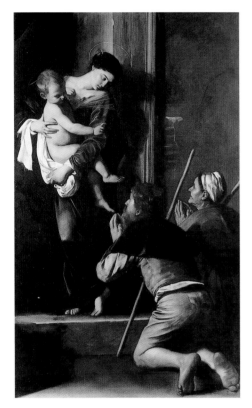

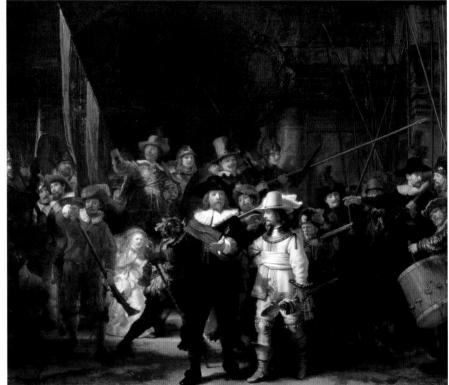

fig. 1 Caravaggio
Madonna of Loreto, 1603-1604 (260 x 150 cm)
Rome, San Agostino, Cavalletti Chapel

fig. 2 Rembrandt
The company of Captain Frans Banning Cocq and Lieutenant Willem van Ruytenburch, known as
'The Night Watch', 1642 (363 x 437 cm)
Amsterdam, Rijksmuseum (on loan from the city of Amsterdam since 1808)

Duncan Bull

Introduction: Rembrandt and Caravaggio

It was during the 18th century that the names of Rembrandt Harmensz van Rijn and Michelangelo Merisi da Caravaggio first came to be equated. In his widely read *Saggio sopra la pittura* of 1762, the much-travelled connoisseur and pan-European cultural publicist, Count Francesco Algarotti, pithily characterised Caravaggio as *il Rembrante dell'Italia*.[1] Twenty years later, in 1782, the more sober compiler of the first systematic history of Italian painting, Luigi Lanzi, re-ferred to the Dutch master as *Rembrant, detto da alcuni il Caravaggio degli Oltremontani*.[2] However superficial such slick phrases may be – and it is doubtful whether either author intended to be entirely complimentary to the 'Rembrandt of Italy' or to the 'Caravaggio of the peoples beyond the Alps' – they carry the implication not only that the works of the two painters are imbued with certain essential quali-ties that are directly comparable, but also that the men them-selves had come to be regarded as occupying equivalent positions within the artistic traditions of trans- and cisalpine Europe.

To allow an opportunity to examine those qualities is the principal aim of this exhibition celebrating the quater-centenary of Rembrandt's birth. And it takes place in an epoch when that implied equivalence is even more apparent than it was when Algarotti and Lanzi wrote. In the public consciousness of the early 21st century, the two painters now represent the respective pinnacles of artistic achievement in the divided Europe of the Baroque era. Rembrandt's popular reputation has long overtaken Rubens's as the star of the north, while Caravaggio's fame has almost entirely eclipsed that of Guido Reni, long considered the painter *sans pareil* of the Italian Seicento. Their critical fortunes, it is true, have by no means run parallel, Rembrandt having maintained his pre-eminence as the leading painter of the Dutch school throughout the 19th century,[3] whereas that of Caravaggio

among the post-Renaissance Italians was reached during the second half of the 20th century in a rise almost as meteoric as that of the turbulent years of his early Roman success. As the roll-call of publications, exhibitions and even films over the past 25 years attests,[4] there is now as insatiable an interest in the life and art of the creator of the *Madonna of Loreto* (fig. 1), still *in situ* on an altar in the church of S. Agostino in Rome, as in the painter of *The Night Watch* (fig. 2), enshrined in 1885 as the altarpiece of the cathedral-like Gallery of Honour in the Rijksmuseum Amsterdam.

At first blush, these two monuments of 17th-century painting might appear to have little in common beyond their status as monuments. One presents a group of patricians on parade, glorying in their largely ceremonial role as civic guards, ready to defend the Protestant civil liberties of which they are as proudly conscious as they are of their own social standing.[5] The other is a quintessential image of the Counter-Reformation, in which the Virgin Mary and the Christ Child appear in human form to two weary, travel-stained pilgrims who kneel barefoot before them in wonder at the miracle that affirms their Catholic faith and their per-sonal experience of the divinity.[6] The subjects and aims of the two pictures could not be more different, but their power and force are comparable. On the most basic level – and this was surely the prime quality in which Lanzi and Algarotti recognised the artists' kinship – both painters make their greatest impact through their manipulation of light and shade. Against sombre backgrounds the principal figures are picked out, their gestures emphasised, by a fall of light that appears natural and convincing but which is, in fact, highly contrived. This impression of relieved darkness is something that the works of both artists almost always give. However brilliant or subtle their colours may be, they delight in an overall dark tonality broken by areas of strong illumination

in which the patches of light are almost always locally placed, seldom if ever extending to the edges of the composition. The light defines the principal actions, and emphasises the salient elements. In Caravaggio's case it causes the figures to emerge towards the spectator from out of the picture plane; and in Rembrandt's it sweeps over and caresses the objects and characters within the pictorial space he has created.

Rembrandt and Caravaggio are not, of course, the only two artists to make use of light in this way, but their extraordinary control, their ability to gradate, modify and regulate the degree of illumination from spotlit areas to a gentle wash, employing light always at the service of the greater whole, the greater meaning, is unsurpassed, and sets them apart from almost all other painters who exploit effects of light. They are both justly considered the greatest masters of chiaroscuro, as the technique of creating strong contrasts of light and dark is known. But if this is the most obvious of the essential qualities that unite the two artists, we must be careful not to lose sight of the fact that they use chiaroscuro in very different ways. Caravaggio was the first great painter to develop chiaroscuro to the degree that his style can be said to be founded on it. As Ernst van de Wetering and Margriet van

Eikema Hommes show in their essay on p. 164 below, Caravaggio's contemporaries saw it as a means to give more body, more relief to his figures; but later generations have recognised it as a vehicle for strengthening the dramatic and emotional content of a given scene. Although Rembrandt is sometimes spoken of as Caravaggio's heir in this respect,[7] he was, from early in his career, far more concerned with the overall texture and sense of depth that light can create. In Caravaggio's great *Death of the Virgin* (fig. 3) the light rakes down from an invisible window at the left and picks out the apostles crowded around the Virgin's bed, falling most strongly on her corpse, while the surrounding darkness contributes to, but does not in itself create, the atmosphere of grief. On the other hand, in Rembrandt's equally sombre painting of an analogous scene, *The entombment of Christ* (fig. 4), it is the pool of light illuminating Christ's body and emanating from sources within the picture, combined with the lurid glow of the sky silhouetting the cross on the hill of Golgotha, that most forcefully sets the scene. If light and dark are used to organise the composition, they also contribute to the powerful sense of desolation in the face of death that modern viewers find so moving.

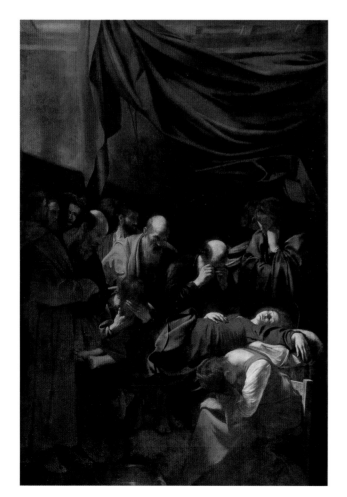

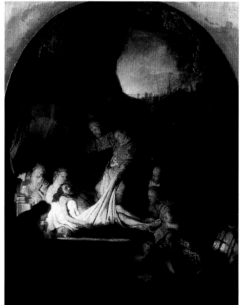

fig. 3 Caravaggio
The death of the Virgin, c. 1605 (369 x 245 cm)
Paris, musée du Louvre

fig. 4 Rembrandt
The entombment of Christ, c. 1639 (92.5 x 68.9 cm)
Munich, Bayerische Staatsgemäldesammlungen,
Alte Pinakothek

The extent to which Rembrandt can in fact be considered Caravaggio's heir is doubtful. His opportunities to see works by the Italian master, who had died when he was four years old, were limited, and Caravaggio's direct example can have exerted minimal influence on the development of his own use of chiaroscuro. We can, however, be sure that Rembrandt was aware of the works of Caravaggio's Dutch followers, several of whom were active in Utrecht when he was a young man (see Cat. nos. 2, 3 and 4). As so often happens when a great innovative artist has evolved a radically new style, Caravaggio's imitators seized upon and exaggerated its most obvious characteristics, and the works of the so-called Dutch Caravaggisti would have introduced Rembrandt only in general terms to the pictorial power of heavy contrasts of light and shade that Caravaggio had developed.[8] These artists, as Caravaggio himself seldom did, often made use of artificial light sources within the pictorial space itself. Rembrandt's device of illuminating the body of Christ in the *Entombment* by candles shielded in the hands of the bystanders (fig. 4) is undoubtedly derived from his knowledge of such works, but even in this relatively early work it is the overall dramatic potential of the shielded light, as much as its incidental effects, that comes to the fore. The device recurs with moving intensity in a poignant work of around 1660 (Cat. no. 16). What Rembrandt was doing was to take the principles of chiaroscuro as developed by Caravaggio and disseminated by his followers and to use them in new and powerful ways for his own aims. If his is a very different conception of chiaroscuro from Caravaggio's – grounded far more in the study of reflections and colour than Caravaggio's use of direct illumination – it also lies at the foundation of his style and is one of the vehicles through which he expresses his most profound thoughts.

That Caravaggio was aware of his achievements and purposes as a manipulator of pictorial light is suggested by his inclusion of a self-portrait in one of the most forcefully conceived biblical pictures of his early maturity, *The betrayal of Christ* (Cat. no. 17), in which he shows himself holding up a lantern and literally illuminating the nocturnal scene. This is a highly self-conscious, almost arrogant, statement. He, the painter, he seems to be saying, reveals the truth, the essence, of this most poignant moment of Christ's Passion by throwing light onto it through the medium of his art. When he painted the *Betrayal* in 1602, Caravaggio was 31 years old, and had been rocketed to fame by the success of his large-scale paintings of the calling and martyrdom of St Matthew (figs. 5 and 6), which he had executed some two years earlier for the Contarelli Chapel of the church of S. Luigi dei Francesi in Rome. These were his first truly public works, and it was not simply his tenebrism but the unexpected realism with which they are painted that provoked admiration and outrage in equal measure. Exploiting the dark spaces of the chapel and the fall of light from its high windows, Caravaggio darkened his backgrounds as never before, emphasising figures and gestures with a controlled directional light that pulls them forward so that they appear to be actually present in the viewer's space. In the *Calling of St Matthew* the saint and his fellow tax-gatherers are dressed in the fashionable clothes of Roman *bravi* gaming in a tavern – a subject that Caravaggio had treated in an earlier work (fig. 22), and an anachronism that may have appeared particularly daring at a time when idealised archaeological verisimilitude in scenes of early Christian history was being promoted by the Counter-Reformationists.[9] But it was in his presentation of Matthew's assassination that Caravaggio broke all the established rules, as Rembrandt was later to do in *The Night Watch*. Never before had the intrinsic violence of a martyrdom been so vividly conveyed, not only by the swirl of gestures around the fallen saint, but also in the relentless focus on the figure of his executioner, who dominates the composition both through his position and through the force of the light thrown onto his naked torso. It is an astonishing performance, not only in the innovation of making the executioner more prominent than the martyr but also in the pinpointing of the most blood-chilling moment in the action – or, one might say, in the performance of the drama. Its force lies, above all, in the illusion that we are spectators at the event.

There had been little in Caravaggio's earlier production to suggest that he was capable of such a sustained achievement on such a grand scale. On his arrival in Rome from north Italy in the mid-1590s, the young artist had struggled to prosper, as so often happens with provincials arriving in a capital, and had spent periods in the studios of older or more established artists, possibly adding the still-life and other details to their paintings in what might be termed 'production-line' work. At the same time, as one of his early biographers informs us, he painted independent small-scale works to be sold on the open market.[10] These appear to have been paintings of single figures, probably of a type similar to the *Boy bitten by a lizard* (Cat. no. 25) or the *Boy with a basket of fruit* (Cat. no. 27). Their extraordinary realism, tempered by a veiled eroticism and almost surreal juxtaposition of still-life and human elements, attracted the attention of a group of connoisseurs and patrons of avant-garde taste, supporters of Galileo and followers of the latest advances in science, optical instruments and above all music. It was for these men – among them some of the most influential collectors and prelates in Rome, such as Cardinal Francesco Maria del Monte and the marchese Vincenzo Giustiniani[11] – that Caravaggio painted his series of half-length figures of boys dressed as musicians (fig. 7) or as Bacchus, the god of wine (fig. 8), in which he increasingly developed the placement of strongly-lit figures against a dark background to give the illusion of a very present reality. There is, in addition, a preciosity to these works that undeniably reflects the taste of his patrons and the hothouse atmosphere of Del Monte's

refined salon, but which also testifies to his interest in the tensions between artificiality, realism and illusion that he was to exploit to enormous effect throughout his career. While the decadence of the *Bacchus*, with his basket of over-ripe fruit and his dirty bed-sheet with the mattress visible below it, has sinister sexual undertones that Caravaggio was fully to develop in the *Omnia vincit Amor* (Cat. no. 33), the description of these sordid quotidian details and of the flesh and musculature evokes a palpable presence that seems to insist that this is as much if not more the picture of a boy dressed up as Bacchus and posing for the painter as an image of a deity *tout court*.

Such brilliantly contrived effects of reality masquerading as art, and illusion as reality, were recognised by Caravaggio's early critics. His biographer Giovanni Pietro Bellori describes how he posed and dressed a girl, whom he had found in the street, in a seated position in his studio, and painted her just as she appeared to him. Then, simply by adding an ointment pot and jewels he transformed the painting into an image of the Magdalen (see Cat. no. 13). What is present in the paint is simultaneously both model and saint, a conscious combination of actuality and illusion of a complexity that none of Caravaggio's predecessors or contemporaries had dared to attempt. This ambiguity of presentation is perhaps even more striking in his images of the young St John the Baptist, where the conventions of depicting the saint as an idealised adolescent are overturned by the powerful representation of an actual adolescent playing at being a saint (fig. 59). It was Caravaggio's ability to transfer this illusionistic ambiguity

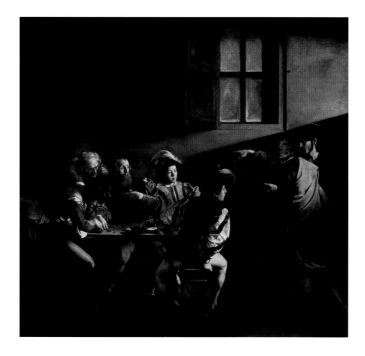

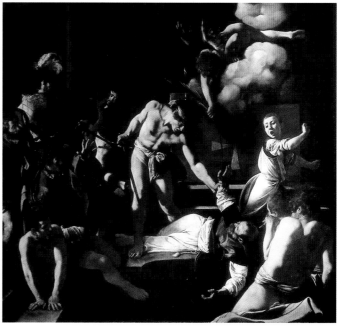

to large-scale, multi-figured paintings that accounts for much of the power of the St Matthew canvases, and also for the excitement they caused.[12] The *Madonna of Loreto* (fig. 1), too, partakes of this almost overemphasised insistence on the actuality of the figures, not only in the notoriously dirty feet of the pilgrims – a much discussed scandal, especially as they hover disgustingly near the altar above which the painting hangs – but also in the Madonna herself who, like the Magdalen, is almost recognisable as the woman of the street that she perhaps was. The culmination of such criticism came, most notoriously, in *The death of the Virgin* (fig. 3), which was refused by the church for which it was intended, most probably because of the lack of decorum with which the dead mother of Christ was portrayed. The swollen belly and the awkward body, deliberately arranged to suggest the recent agonies of death and with no concession to the dignified aspect deemed suitable for this holy figure, seem to have been too much for the authorities. This, it was said, was little more than a depiction of a drowned prostitute pulled from the Tiber, and thus an insult to the purity of the Virgin Mary. It was also rumoured, possibly with some truth, that the model was indeed a whore, and a mistress of Caravaggio's.[13]

The disturbing realism of these works derives much of its force from Caravaggio's reportedly firm adherence to the habit of painting only from models. This flew in the face of academic practice, by which figures were first carefully studied in drawings, the most appropriate poses chosen, the

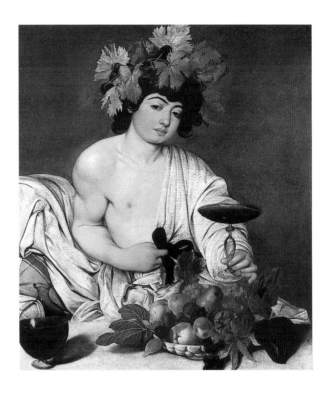

details of hands and gestures separately studied, and the painting then executed as an 'improvement' on nature, the most beautiful or most appropriate aspects having been selected. In the artistic theory of the time, it was largely in this process of selection that the 'art' of the artist was believed to reside, mere imitation of outward appearance being thought akin to mindless copying. Caravaggio, however, if we are to believe the accounts of his biographers, posed his models in darkened rooms or vaults with a high window, adjusting the light to the greatest effect and then transcribed what he saw

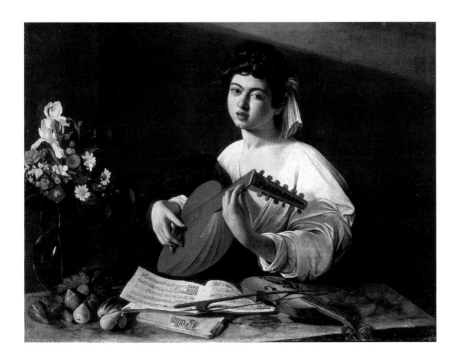

<< fig. 5 Caravaggio
The calling of St Matthew, 1599–1600 (322 x 340 cm)
Rome, San Luigi dei Francesi, Contarelli Chapel

< fig. 6 Caravaggio
The martyrdom of St Matthew, 1599–1600 (323 x 343 cm)
Rome, San Luigi dei Francesi, Contarelli Chapel

fig. 7 Caravaggio
Singing lute-player, c. 1596 (94 x 119 cm)
St Petersburg, The State Hermitage Museum

∧ fig. 8 Caravaggio
Bacchus, c. 1597–1598 (95 x 85 cm)
Florence, Galleria degli Uffizi

15

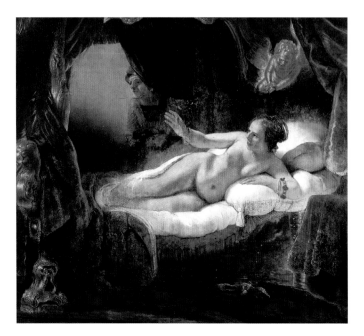

directly onto the canvas.[14] There is undoubtedly much that is mythic about this scenario, but his use of living models for even the most complex multi-figured compositions (see fig. 25), and the way in which they are posed and lit, does indeed account for much of what is most immediately striking in his works, and gives an edge to his intellectual interpretation and emotional exploration of the standard subjects of art.

This seems to have been recognised early on. Caravaggio's earliest biographer, the Dutch painter Karel van Mander, reported in 1604 that Caravaggio considered 'that all works […] are naught but […] child's play or trifles if they be not done and painted from life'.[15] As Volker Manuth discusses on p. 180 below, it is likely that Rembrandt would have known this passage. What influence, if any, that knowledge may have had is more difficult to assess, but it is surely telling that the observation is cited in full in the first extended biography of Rembrandt, published in 1718 by Arnold Houbraken, who immediately adds: 'Our great master Rembrandt was of the same opinion, taking it as his basic rule to follow nature alone, regarding everything else with suspicion'.[16]

Houbraken's direct opinion about Caravaggio is not entirely clear, but it emerges from the context that his remarks were intended as criticism of Rembrandt, not praise. In particular, he found Rembrandt's depiction of hands and of female nudes distasteful: the hands too often resembled 'those of wrinkled old women', while his nudes – according to Houbraken, 'the most lovely objects for a painter's brush' – were not only 'too dreary for words' (*te droevig om er van te zingen*) but even repulsive, it being 'a mystery why a man of such ingenuity and spirit should have been so perverse in his choices'. And although it is difficult today to reconcile these censures with such masterpieces as the *Bathsheba* (Cat. no. 36), the Edinburgh *Woman in bed* or the *Danaë* (fig. 9), it is nevertheless interesting that in this text in which the two artists' names are juxtaposed, Rembrandt should have been criticised for a perceived misuse of models in much the same way as Caravaggio had been during his own lifetime.[17]

The relation of Rembrandt's art to his use of models is as complicated and was as fruitful as that of Caravaggio to his, though in rather different ways. First, Rembrandt was a prolific draughtsman, an activity that Caravaggio appears to have eschewed.[18] He seized every opportunity to draw from the nude as well as setting down on paper, either from life or from other works of art, motifs, gestures and a whole range of poses and effects as he observed them.[19] This was a customary activity for a painter following the normal, Italian, convention of observation followed by selection, and the various records we have of his teaching activities show the standard academic practice of the life class. But although drawings after the model abound in Rembrandt's oeuvre

16

fig. 9 Rembrandt
Danaë, 1636 (185 x 203 cm)
St Petersburg, The State Hermitage Museum

fig. 10 Rembrandt
Female nude seated on a stool, (pen, bistre and wash, heightened, 29 x 17 cm)
Amsterdam, Rijksmuseum

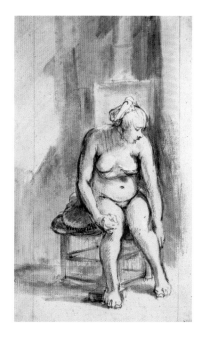

(fig. 10), it is striking how few of them are preparatory for, or even related to, his paintings. Such drawings show an intensity of observation of the model as model, an interest in the way light and contour define the human form, that is almost un-equalled before Degas. That Rembrandt himself considered them independent works of art, rather than the means to a painterly end, is supported by his extraordinary innovation of producing etchings, apparently intended for the market, which simply show posed models in studio settings, which have no pretence at a further subject (e.g. fig. 11). His obses-sion with the posed model undoubtedly lies behind such works as the great *Bathsheba* or *Danaë*, and is apparent even in the earlier *Sacrifice of Abraham* (Cat. no. 22). The honesty of his vision seems unrelenting: an earlier critic than Houbraken complained that 'He chose no Greek Venus as his model, but rather a washerwoman, or a peat-treader from a barn, calling this aberration the imitation of nature. [...] Flabby breasts, misshapen hands, aye the welts of the staylaces on the belly, of the garters on the legs, must be visible, otherwise nature was not satisfied'.[20] The resonances here with Caravaggio's perceived use of prostitutes are obvious, and as in Caravaggio's works, we find in many of Rembrandt's a tension between the realism with which the model is described and the role he or she is playing in the finished painting. It is unlikely that Rembrandt actually painted from the model, as Caravaggio is believed to have done, but that he posed models in the same way as Caravaggio is described as doing, in a dark room with light falling from above, is recorded in a drawing in which the model is shown sitting waiting for the painter to study her (fig. 13).

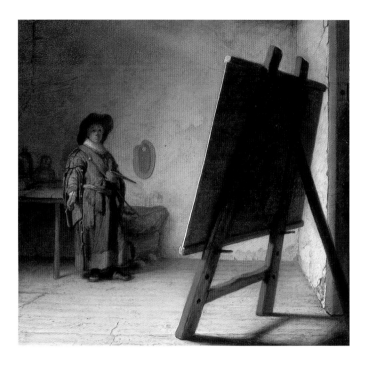

The model with whom Rembrandt had the closest relation-ship, throughout his career, was, of course, himself. Few other artists have produced so many self-portraits, or quasi self-portraits. While there is nothing among them directly com-parable to Caravaggio's metaphoric self-image as illuminator (Cat. no. 17), Rembrandt seems from his earliest days in Leiden to have been concerned with the image of himself as an artist. His early self-portrait in the studio (fig. 12) has come to epitomise the Romantic image of a penniless young painter, standing in a threadbare room dominated by the great fact of his easel while he decides where to place the next brushstroke. Some years later we find him in fancy

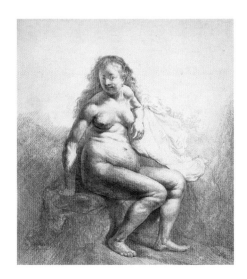

< fig. 11 Rembrandt
Nude woman seated on a mound, c. 1651
(etching, second state)
Amsterdam, Rijksmuseum

∧ fig. 12 Rembrandt
The artist in his studio, c. 1629 (panel,
24.7 x 31.7 cm)
Boston, Museum of Fine Arts (Zoe Oliver
Sherman Collection given in memory
of Lillie Oliver Poor)

> fig. 13 Rembrandt
Rembrandt's studio with a nude model,
c. 1655-1656 (pen, ink and wash,
20.5 x 19 cm)
Oxford, Ashmolean Museum

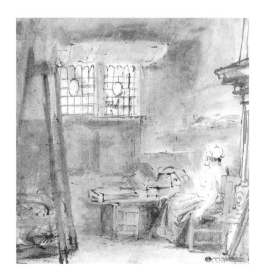

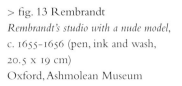

dress, playing at a generic oriental, complete with hunting-poodle (fig. 14), while in other works he can caricature his own features (fig. 47), or scrutinise his own countenance in various effects of light (Cat. no. 6). In them we see his fascination, which continued throughout his career, with the transformations that different clothing and different light effects could produce. Where Caravaggio metamorphosed a street-girl into a Magdalen (Cat. no. 13) or a martyr (Cat. no. 15), so Rembrandt transformed himself into an Old Testament patriarch, his young wife Saskia into Flora (Cat. nos. 14 and 28), his mother into a prophetess, or his son Titus into a monk (Cat. no. 26). We know, for example, that wings, armour and other objects were circulated among the painters' studios of Caravaggio's Rome, and were used by him to dress his models, including, presumably, the boy who posed for the *Amor* (Cat. no. 33);[21] Rembrandt himself collected rich garments, furs, fabrics and other items with which he ornamented both his figures and himself.[22] As in Caravaggio's single figures, the presence of the model seems to shine through in all these single-figure studies by Rembrandt, from the beginning of his career to the end (fig. 15). There is an uncertainty, or ambiguity again, as to the actual subjects that is not dissimilar to that surrounding Caravaggio's single figures. Should we interpret this picture of an old woman as a portrait, a prophetess, or merely a character study of old age? It is all three, and can be appreciated on each level. Nowhere is that openness to interpretation more apparent than in Rembrandt's painting of a woman dressed up as Flora, where technical evidence shows that she was begun as a Judith, holding the bloody head of

Holofernes, and only later converted to an image of floral fecundity (see Cat. no. 14). This semantic fluidity, this ability to suggest the significance of a figure to which we can respond on several planes, is common to both painters.

In a much earlier painting like *St Paul at his desk* of 1629–1630 (Cat. no. 8), where the iconography is similarly unspecific, the melancholy of the scholar's occupation is suggested as much through the lighting as through characterisation of the model, in a similar way to Caravaggio's *St Jerome* (Cat. no. 35). This extraordinary ability to evoke emotion and mood apparently through the simplest of means is something that surely accounts for the continuing appeal of both artists to the modern viewer. One of Rembrandt's most successful essays of his early years in this respect is the small *Supper at Emmaus* (fig. 17), in which his early experiments in chiaroscuro and his studies of models in different effects of light come together to stunning effect, allowing us to interpret the revelation of Christ's presence at the table as an epiphany of light. Although tiny, and painted on paper, it has an intensity that makes Caravaggio's larger interpretation of the same scene (Cat. no. 38) seem almost theatrical by comparison, and is the most striking early manifestation of the deeply felt subject-paintings Rembrandt was to go on to produce.

From his apprentice days, Rembrandt had set his sights on becoming a history painter in the great tradition, especially as illustrator and interpreter of the major biblical scenes. He was encouraged in this pursuit by the Dutch humanist Constantijn Huygens, who occupied a similar position in the intellectual and political life of Holland to Cardinal Del Monte or the marchese Giustiniani in Rome. As is well known, Huygens regretted that Rembrandt showed so little inclination to go to Italy as the most effective place to study. The young painter's arrogant answer was that he had too little time to do so, and could in any case see the best works of Italian artists in the collections and auctions of northern Europe.[23] It was, however, Rembrandt's more prosaic practice as a portraitist as much as his study of his Italian predecessors or Huygens's encouragement that helped him formulate his

fig. 14 Rembrandt
Self-portrait in oriental attire, 1631 (66.5 x 52 cm)
Paris, Musée du Petit-Palais

large-scale historical compositions from the mid-1630s onwards. After settling in Amsterdam in 1631, the young painter rapidly profited from the almost insatiable demand among the Dutch bourgeoisie for depictions of themselves (Cat. no. 20), and they recognised in Rembrandt a new and lively talent. If the income he received allowed him more leisure to pursue his history paintings, so the discipline of painting portraits at life size undoubtedly benefited his large-scale narratives. On occasion, when faced with the fashionable vacuity of a sitter, Rembrandt takes refuge in a virtuoso depiction of the clothing; but with a subject such as Johannes Wtenbogaert (Cat. no. 18), we can feel his penetrating sympathy for an aged and introspective preacher who must have seemed to him in many ways comparable to the biblical heroes such as St Paul, whom he had characterised so subtly (Cat. no. 8). Through his manipulation of light upon physiognomy, gradated shadings and broken brushstrokes, in which the very texture of the paint creates a kind of physical chiaroscuro, he appears to convey the thoughts behind the appearance and to reveal the spirit of his sitter (fig. 16).

The challenges of multi-figure portraits were perhaps even more influential on his development as a history painter. In the famous *Anatomy lesson of Dr Nicolaes Tulp* of 1632 in the Mauritshuis he recognised the efficacy of showing a variety of reactions to an event – a major consideration in a history painting – to animate a portrait convention that had hitherto consisted of little more than rows of impassive faces hierarchically arranged. But it was particularly the challenge set by double portraits that prompted Rembrandt to think

through the means of portraying not only the likenesses but, more importantly, the relationships of the personalities portrayed. In the superb portrait of *Jan Rijksen and his wife* of 1633 (fig. 19), he goes way beyond portrait conventions to capture a moment in daily life that expresses the mutual relation of husband and wife, relying on a sense of both action and time, so that the characters are defined as much by the domestic drama they enact as by the verisimilitude of the faces and clothing. Such innovations in bringing the concerns of history painting to portraiture fed back into his more ambitious works, such as the Munich *Holy Family* (Cat. no. 11), possibly his first large-scale history painting, in which the domestic relationship of Mary, Joseph and the infant Jesus is movingly explored on a heroic scale.

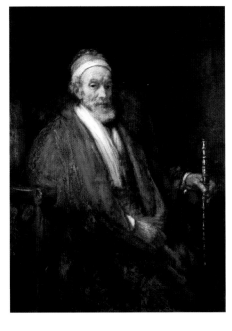

<< fig. 15 Rembrandt
An old woman reading, 1655 (80 x 66 cm)
United Kingdom, The Duke of Buccleuch and Queensberry's Collection

< fig. 16 Rembrandt
Portrait of Jacob Trip, 1661 (130 x 97 cm)
London, The National Gallery

∧ fig. 17 Rembrandt
The supper at Emmaus, c. 1628 (paper on panel, 37.4 x 42.3 cm)
Paris, Institut de France, Musée Jacquemart-André

19

Rembrandt's genius in conveying the emotional and psychological aspects of encounters between people developed rapidly, whether in the tender embrace of father and son in an Old Testament scene, or in the gesture of the dying Jacob blessing his grandsons (fig. 18). The latter is a distillation of the familial relationship of a patriarchal household quite independent of its biblical significance, in which Rembrandt, against tradition, also includes the boys' mother.[24]

His greatest achievements in evoking the complexities of human relations are undoubtedly the painting known as *The Jewish bride* of c. 1665 (see Cat. no. 29) and *Aristotle contemplating a bust of Homer* of 1653 (fig. 20). The latter was commissioned by a Sicilian patron, one who was, incidentally, well aware of Caravaggio, and who asked Rembrandt simply for a picture of a philosopher.[25] Rembrandt's choice was astonishing: he shows Aristotle as he had never been shown before, dressed up in the rich robes and pendant chain from Rembrandt's collection of studio props that had been used to adorn so many models, and to summon up in so many different pictures the world of the Old Testament or the generalised, romanticised oriental exoticism that Rembrandt delighted in. At the centre, all the light is absorbed by Aristotle's dark tunic so that his face, reminiscent of patriarchs and rabbis in other works, hovers above the lit sleeves as he gazes at the bust of Homer bathed in a roseate light that seems to come from the soul. With the lighting, the atmosphere, the reverent gesture of the hand upon Homer's brow, Rembrandt achieves the impossible: the pictorial expression of minds communing across the ages.[26]

This extraordinary depth of psychological penetration, this ability to use paint to figure forth the workings of the soul, is perhaps the characteristic in which, for the modern viewer, Rembrandt and Caravaggio show the greatest affinity. In his haunting canvas of Salome with the head of St John the Baptist (fig. 21), painted towards the end of his short life, Caravaggio explores the complex emotions of the woman whose beauty, sexuality and obedience to a cruel mother have led to the murder of the prophet. Against the darkest of backgrounds, the tightly-knit figure group is swept by raking light that emphasises the muscled arm of the executioner and the headdress of the hag, who serves as a foil for Salome's youthful beauty. Salome has just received the Baptist's head, which is impassively contemplated by her companions. Caravaggio shows her not on the point of bearing the gruesome trophy triumphantly to the banqueting table, but at the moment when the consequences of her deed begin to dawn upon her, her half-shaded face and her posture simultaneously conveying sensuality, cruelty, conscience and horror. As in Rembrandt's *Aristotle*, it is the close concentration on the lit figures in the dark room that heightens the atmosphere, the sense of the sinister here aided by Caravaggio's daringly unbalanced composition with the great void on the left into which Salome turns. Caravaggio's intense concentration on the essentials is even more pronounced in another meditative work of the later years, *The denial of St Peter* (fig. 23), where the moment of realisation of a misdeed is again the central subject (see also Cat. no. 16). The three half-length figures are crowded together, pushing out of the pictorial space to offer us the opportunity of contemplating the exchanges

20

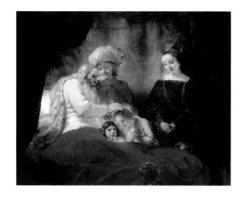 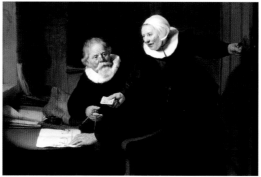

fig. 18 Rembrandt
Jacob blessing the children of Joseph, c. 1656
(175.5 x 120.5 cm)
Kassel, Staatliche Museen

fig. 19 Rembrandt
*The shipbuilder Jan Rijksen and his wife
Griet Jans*, 1633 (114.3 x 168.9 cm)
London, The Royal Collection (by gracious
permission of Her Majesty Queen Elizabeth II)

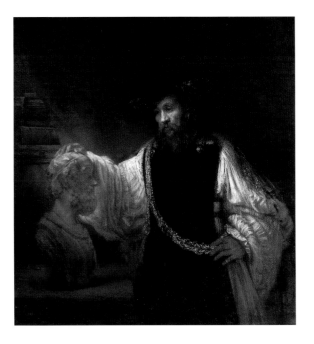

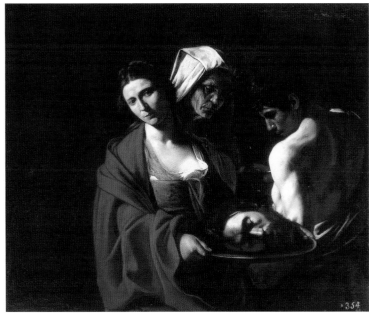

of glance and gesture that so eloquently spell out Peter's agony while the sparks of the fire rise up behind him.

Caravaggio arrived at the pictorial means for the expression of such deep and complex emotions by a different path from that followed by Rembrandt. Although he is known to have painted portraits, it was never an important part of his practice. He developed his interest in the psychology of human encounters in an innovative group of canvases, painted at much the same time as he was creating the ephebic and ambiguous single figures of gods and musicians. In *The cardsharps* of c. 1594 (fig. 22), Caravaggio updated a popular type of genre painting of low-life encounters, masterfully conveying the complicity of the two fashionable *bravi* about to trick a naive young man. More powerful, and more understated, is *The fortune-teller* in the Louvre, Paris, in which Caravaggio concentrates on the seductive arts through which the young man is duped, and choosing the moment when the drama is about to turn from gypsy flirtation to outright theft, something of which the young man is not, perhaps, entirely unaware. Already, in these works, as in the *Boy bitten by a lizard* (Cat. no. 25) Caravaggio not only captures the essence of a

story through gesture, but brilliantly chooses the most telling moment. If it was part of Rembrandt's genius to bring the lessons of history painting to portraiture, and of portraiture to history painting, so Caravaggio brought the fruits of these early genre paintings to his portrayal of the decisive moment of St Matthew's conversion (fig. 5) in the Contarelli Chapel, where the story of the tax-gatherer's summons takes place at a contemporary gaming table.

At the same time, the close-up focus on the half-length figures of his genre pieces could, Caravaggio innovatively discovered, also be adapted to more significant encounters such as that between Abraham, Isaac and the angel (Cat. no. 21), between Christ and Judas (Cat. no. 17)

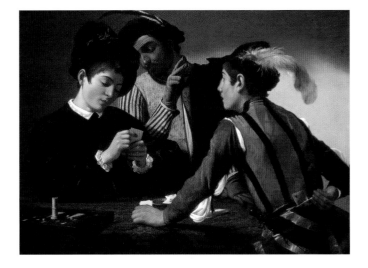

fig. 21 Caravaggio
Salome, c. 1608–1610
(116 x 140 cm)
Madrid, Patrimonio Nacional

fig. 2 Rembrandt
Aristotle contemplating a bust of Homer, 1653 (143.5 x 36.5 cm)
New York, The Metropolitan Museum of Art

> fig. 22 Caravaggio
The cardsharps, c. 1594
(94.2 x 131.2 cm)
Fort Worth, Kimbell Art Museum

21

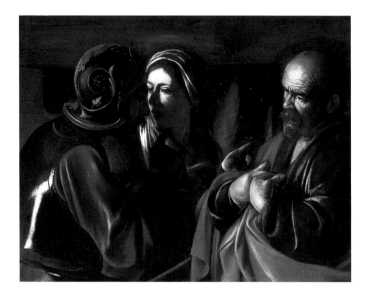

Rembrandt may well have derived his own concentrated half-length figure compositions of spiritual and psychological encounters, such as the *Aristotle* (fig. 20), the *Queen from antiquity* (Cat. no. 32) or the *Jewish bride* (Cat. no. 29) from the indirect example of Caravaggio, whose followers had spread throughout Europe this type of composition, often known as the *methodus manfredianus* after one of its chief proponents.[27] But the way in which his vision makes its greatest impact is something peculiar to himself. The power of his chiaroscuro, the appropriateness with which he uses light, invites an interpretation that sees a symbolic intention. In the *Blinding of Samson* (Cat. no. 9), for example, Kenneth Clark has drawn attention to the 'wave of light, which seems to have burst through a broken dam, overwhelms the miserable Samson and then is gone from him forever',[28] in a marvellous critical sentence that perfectly evokes the painting's effect upon today's viewer, who benefits from the cumulation of interpretations such masterpieces have accrued over time. In the slightly later *Wedding feast of Samson* (fig. 24), the lambent light that plays over the groups of figures and isolates the perfidious bride from the groups of baffled guests attempting to unravel Samson's riddle is as much, if not more, the source of the disturbing sense of impending catastrophe as is the controlled chaos of the divided composition. Here the light defines the

or, most poignantly, to the group of bewildered disciples examining Christ's wound in the *Doubting Thomas* of 1603 (fig. 28). In these close-up works, and especially in the frozen moment of concentrated horror of the *Judith and Holofernes* (Cat. no. 10), the chiaroscuro that defines the figures appears to take on a more symbolic role, creating what we might call a 'moral atmosphere' appropriate to the subject. Nowhere is this moral atmosphere more palpable, more pervasive, than in the late works such as *St Peter* and *Salome*.

fig. 23 Caravaggio
The denial of St Peter,
c. 1607-1610
(94 x 125.5 cm)
New York, The Metropolitan Museum of Art
(Lila Acheson Wallace Gift, 1997)

fig. 24 Rembrandt
The wedding feast of Samson, 1638
(126 x 175 cm)
Dresden, Staatliche Kunstsammlungen,
Gemäldegalerie Alte Meister

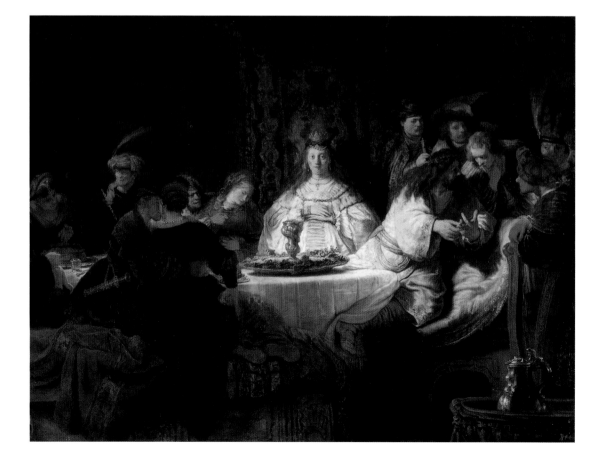

mood and thickens the moral atmosphere, as well as animating the story. It is a mark of Rembrandt's genius, just as it was of Caravaggio's, that he was able to apply these techniques to many different types of picture. If his work as a portraitist gave him new insights into the creation of narrative and history paintings, so the use of light which he developed for dramatic and emotional effect in his narrative paintings fed back into his portraiture. His triumph, in this respect, is of course *The Night Watch* (fig. 2), where the interwoven effects of light not only support the sense of action, but define the way the company looms out of the pictorial world into that of the viewer. There is an almost visionary quality in the way Rembrandt transforms the persons of Captain Banning Cocq and his companions, using light, gesture and atmosphere, into an heroic history painting that actively expresses the abstract quality of civic pride. Here all his advances in portraiture, in giving visual form to the psychology of people, of capturing, like Caravaggio, the most telling moment, come together. Both he and Caravaggio were, above all, able to make the imaginative leap between different types of painting, fecundating and renewing pictorial genres by intermingling them. Caravaggio's great canvas of *The seven acts of mercy* (fig. 25) similarly brings together his ability to use light both to define and to dramatise, with an astonishing economy of narrative clarity in which the abstract notion of Christian charity is personified through closely studied figures who are not types, but people who are at once real and symbolic. Both artists, and this is perhaps where they can most fruitfully be compared, revel in the transformative power of their art, and its quality to inform and illuminate.

What unites Rembrandt and Caravaggio then, in their very different worlds of Protestant Holland and Counter-Reformation Italy, is the success of their quests to find pictorial solutions to express the great themes of humanity. Both grounded their art on the study of people, on truth to the living model, and both developed, as no other artists, ways to take the reality they observed, through illumination and the manipulation of light, onto a higher, sometimes visionary,

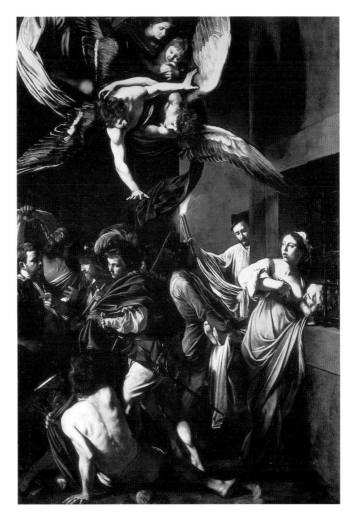

plane. Rembrandt's vast, late painting, the *Oath of Claudius Civilis* (fig. 26) and Caravaggio's huge altarpiece of the *Raising of Lazarus* (fig. 27) may serve to summarise their achievements.

The anecdotes that have accumulated around *The raising of Lazarus* are a testimony to its exceptional power. Painted in c. 1608-1609, in Sicily whence Caravaggio had fled from Malta, stripped of his knighthood and for the second time pursued by scandal, it was commissioned by a rich patron named Lazzari, who apparently allowed Caravaggio himself to choose the subject. The artist, according to the accounts, worked in secret, forcing the workmen he used as his models to hold up a decomposing corpse while he painted.[29]

fig. 25 Caravaggio
The seven acts of mercy, 1606-1607 (387 x 256 cm)
Naples, Pio Monte della Misericordia

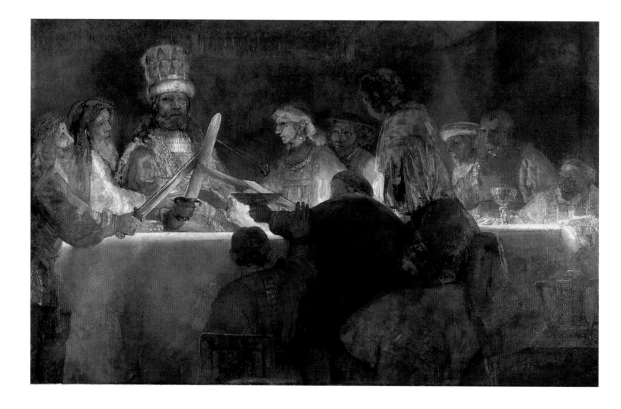

Whether or not this is true, the result is his most meditated masterpiece. Lazarus, whom Jesus raised from the dead, was seen as prefiguring of Christ's own resurrection, and Caravaggio has created, as had never before been done in portraying the miracle, compositional echoes of the canonical representations of Christ's burial and the removal of his body from the Cross. The emptiness of the composition, the gaping void of the upper half, only serves to heighten the concentration on the frieze of figures that extends in muted colours across the canvas. The light rakes down from the left, emphasising the pitiful emaciation of Lazarus's body and the tender detail of his sister's face close to his own. She is still grieving, and Caravaggio's genius in choosing the most dramatic moment again comes to the fore, for she seems as yet unaware of the miracle that is unfolding. The light emanates from behind Christ, silhouetting his arm and glancing off the top of his sleeve in a line that runs down to the finger that points to Lazarus in a gesture Caravaggio has developed from the much earlier *Calling of St Matthew*

(fig. 5). Christ, as much real as visionary, thus works the miracle through the light which falls directly on Lazarus, to whom life at that instant begins to return. He raises his hand, as if to shield himself from the unexpected illumination that calls him from the darkness of the tomb, in an ambiguous gesture that seems both to welcome the light of life, but suggests a reluctance to awaken from the sleep of death.

Rembrandt's *Oath of Claudius Civilis* is, alas, a fragment of a work the original size of which was over 6 metres in each dimension. As far as we can judge from Rembrandt's preliminary drawings, much of this consisted of empty space, so that the group of life-sized figures at the table would have formed an isolated patch of light in a vast and eerie vaulted space. As in *The entombment of Christ* (fig. 4) and *The denial of St Peter* (Cat. no. 16), Rembrandt has opted for concealed illumination, presumably from lamps upon the table, which gives an almost supernatural illumination from below as the light is reflected up from the cloth. Dominating the compo-

fig. 26 Rembrandt
The oath of Claudius Civilis, c. 1661-62
(196 x 309 cm)
Stockholm, Nationalmuseum

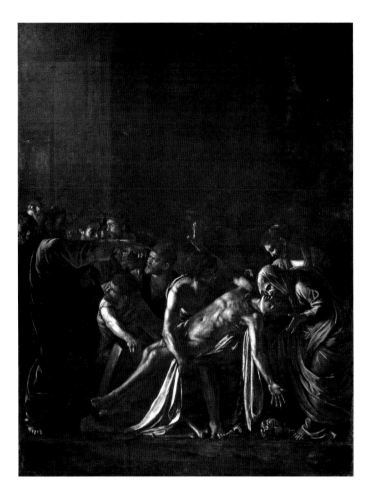

myths. It had been commissioned as a decoration for Amsterdam Town Hall, the first in a series of grandiose paintings of the ancient Batavian revolt which was considered the symbolic ancient prototype of the rebellion of the Netherlands against the domination of Catholic Spain, which had only shortly before been settled at the Peace of Münster that brought the Eighty Years' War to a close. It was rejected for reasons that are not entirely clear, and has come to be seen as a symbol of the decline of the aging and bankrupt artist in an Amsterdam that no longer understood his unique powers and genius.[30]

Be that as it may, this, the great masterpiece of Rembrandt's last decade, a metaphoric statement of the defiance of the rugged Protestant north against southern imperialism, eventually found its way from Amsterdam to Sweden, where it is now preserved in the National Gallery in Stockholm. Within Europe it is thus among the most northerly of Rembrandt's major paintings, just as the *Lazarus* in Messina is among the most southerly of Caravaggio's. Given the exigencies of 18th-century travel, it is uncertain that either Algarotti or Lanzi would have known these great paintings at first hand. But if, like the modern-day enthusiasts of whom they were the forerunners, they had had the opportunity of travelling from Sweden to Sicily in a day, they would surely have found that the sheer brilliance, expressive power and force of genius of the works more than justified their characterisation of the artists as the *Caravaggio degli Oltremontani* and the *Rembrante dell'Italia*.

sition is the one-eyed Batavian chieftain Claudius (*recte* Caius Julius) Civilis, a monumental figure whom Rembrandt with his usual bent towards realism has shown with a brutally empty eye-socket. Dressed in those real but generic robes by which Rembrandt characterises his patriarchs, Claudius holds out his sword as the Batavian chiefs swear to fight for their freedom from the tyranny of the Roman empire. The intensity of the reddish-brown glow almost gives the impression that the swords are being forged at the table, while the sheer physical presence of the thickly and freely applied paint adds to the excitement of the scene. The composition once again captures – perhaps most vividly of all Rembrandt's history paintings – the key, decisive moment of the drama. Like Caravaggio's *Lazarus, Claudius Civilis* has accreted

fig. 27 Caravaggio
The raising of Lazarus, c. 1608–1609 (380 x 275 cm)
Messina, Museo Regionale

25

Chronologies

Caravaggio

1571 Michelangelo Merisi da Caravaggio is born near Milan to Fermo Merisi and Lucia Aratori. His father is an architect and clerk of the works in the service of Francesco I Sforza, marchese di Caravaggio, whose wife Costanza came from the noble Roman house of Colonna, several of whose members later became Caravaggio's protectors. The precise date of his birth is not known, but was probably 29 September, the feast-day of the archangel Michael.

1584 On 6 April, Caravaggio is apprenticed for four years to the Milanese painter Simone Peterzano.

1592-1598 Caravaggio leaves for Rome after the settlement of his parents' estate (Fermo Merisi had died in 1577, Lucia in 1590). On his arrival he first paints copies of devotional works, decorations for church festivals, and genre scenes for the open market (the *Boy bitten by a lizard*, Cat. no. 25, is thought to be one of them).

Probably from around May 1593 Caravaggio is employed in the extensive studio of Giuseppe Cesari, the Cavalier d'Arpino, one of the favourite artists of the reigning pope, Clement VII. Caravaggio works there for around eight months; according to his biographer Bellori (1672) his main task is to paint 'flowers and fruit'.

1598-1600 Caravaggio is arrested on 4 May 1598 for wearing a sword in public, a privilege reserved for nobles and gentlemen. In his defence he says that he is painter to Cardinal Francesco Maria del Monte and a member of his household. Del Monte is a leading benefactor of artists, especially those from northern Italy, and his residence, the Palazzo Madama, is a key meeting-place in the avant-garde cultural life of the city. The cardinal not only becomes an important patron of Caravaggio, but is also instrumental in introducing him to other prominent art-lovers.

On 23 July 1599, Caravaggio is awarded an important commission to provide paintings for side walls (laterals) of the Contarelli Chapel in S. Luigi dei Francesi, the French church in Rome. He undertakes to complete the paintings, his first that are publicly accessible, within a year. He receives final payment for the work on 4 July 1600, by which time *The calling of St Matthew* and *The martyrdom of St Matthew* are installed in the chapel (figs. 5 and 6).

1600 On 24 September 1600, Tiberio Cerasi commissions Caravaggio to paint *The conversion of St Paul* and *The crucifixion of St Peter* (figs. 29 and 81) as the laterals for his newly acquired chapel in S. Maria del Popolo. They are to be finished before 24 May 1601, and the contract describes Caravaggio as 'a prominent painter in the city of Rome' (*egregius in Urbe pictor*). The altarpiece in the same chapel is commissioned from Annibale Carracci (fig. 69).

On 19 November 1600, Caravaggio is accused of assaulting one Girolamo Stampa (or Spampani). The painter is said to have struck Stampa with the hilt of his sword without provocation. Caravaggio promises not to harass Stampa again, and on 20 January 1601 Stampa withdraws his complaint.

1601 On 14 June 1601, the jurist Laerzio Cherubini commissions Caravaggio to paint an altarpiece with *The death of the Virgin* (fig. 3) for his chapel in S. Maria della Scala. According to the contract, Caravaggio is then living in the household of Cardinal Girolamo Mattei. The Mattei were one of the richest banking families in Rome, and their vast collection of paintings and antiquities was widely renowned. Cardinal Girolamo and his brother Ciriaco Mattei are major patrons of Caravaggio (Cat. nos. 17 and 38).

Caravaggio is arrested on 11 October again for wearing a sword without permission, and is again described as painter to Cardinal Del Monte. On 10 November he receives final payment for the Cerasi Chapel, though the paintings have not yet been installed.

1602 On 7 January, Ciriaco Mattei approves payment to Caravaggio for *The supper at Emmaus* (Cat. no. 38). A month later, Caravaggio is commissioned to provide the altarpiece for the Contarelli Chapel. On 22 September he receives the final payment for the altarpiece of *St Matthew and the angel* (fig. 44). An earlier version was apparently rejected, and was acquired by marchese Vincenzo Giustiniani. This wealthy collector and connoisseur was to acquire several major works by Caravaggio for his important collection.

1603 On 2 January, Ciriaco Mattei approves payment for *The betrayal of Christ* (Cat. no. 17).

At the end of August, the painter Giovanni Baglione brings an action for libel against Caravaggio and his colleagues Onorio Longhi, Orazio Gentileschi and Filippo Trisegni, who were allegedly circulating libellous poems about Baglione's character and artistic talents. Caravaggio is arrested on this charge on 11 September, and his deposition is taken down two days later. He is conditionally released after the intervention of the French ambassador, Philippe de Béthune.

1604 Pietro da Fusaccia, a waiter, lodges a complaint against Caravaggio for throwing a plate of artichokes in his face and threatening him with his sword. Caravaggio is found guilty of the charge on 4 June, but is not ordered to pay the fine demanded.

In October and November Caravaggio is twice imprisoned for insulting the police.

1605 At the end of July, Caravaggio is imprisoned for damaging the door and shutters of the house of Laura Vecchia and her daughter Isabella. In the same period, charges are brought against him by the notary Mariano Pasqualone, who accuses the artist of wounding him during an argument about Lena, Caravaggio's *donna* (lady or mistress). On 26 August, Caravaggio asks Pasqualone's forgiveness, and the charge is dropped. Less than a week later a new complaint is lodged against Caravaggio, this time by Prudenzia Bruni, who accuses him of throwing stones at her window.

At the end of October, Caravaggio is wounded in the throat and left ear by an unknown assailant. The painter says that he had fallen on his own sword. He is unable to work for some time, and goes to the house of a lawyer friend to recuperate.

On 1 December, Caravaggio receives the first payment for his *Madonna dei Palafrenieri*, an altarpiece for the basilica of St Peter, and thus one of his most important Roman commissions.

1606 On 8 April, Caravaggio confirms receipt of the final payment for *The Madonna dei Palafrenieri*. However, it is removed a few days after its installation on the altar, and in June Cardinal Scipio Borghese buys it for his own collection.
On 28 May, Caravaggio kills Ranuccio Tomassoni in a sword fight, which appears to have arisen from an argument about a tennis match. He flees Rome, seriously wounded, and possibly takes refuge on an estate of the Colonna family, just outside Rome, where he is said to have made several paintings. He leaves for Naples, probably in late September.

1607 In Naples, Caravaggio is soon receiving several important commissions from private individuals and religious bodies. They include his imposing masterpiece, *The seven acts of mercy*, the altarpiece for the confraternity of the Pio Monte della Misericordia, for which he receives the final payment on 9 January (fig. 25).

Caravaggio leaves for Malta at the beginning of July, probably under the protection of a member of the Colonna family.

1608-1609 On 14 July 1608, Caravaggio is admitted to the Order of the Knights Hospitaller of St John (the Knights of Malta). The order's rules prohibit a murderer becoming a member, but the Grand Master, Alof de Wignacourt, seeks and receives dispensation from the pope. While on Malta, Caravaggio paints portraits of De Wignacourt (fig. 42) and Fra Antonio Martelli (Cat. no. 19). He also paints a huge canvas of *The beheading of John the Baptist* for the order's oratory in the co-cathedral.

In October of the same year, Caravaggio is imprisoned for unknown reasons in the Castel Sant'Angelo on Malta. He makes a spectacular escape and flees to Sicily. He is expelled from the order *in absentia* on 1 December.

In June of the following year Caravaggio completes his large *Raising of Lazarus* for Giovanni Battista de' Lazzari's chapel in the Chiesa dei Crociferi, Messina (fig. 27). He paints other altarpieces in various Sicilian cities (fig. 70), as well as works for private patrons. He returns to Naples, probably in the autumn of 1609.

1610 On 11 May, Lanfranco Massa writes to Marcantonio Doria in Genoa, saying that the shipment of Caravaggio's *Martyrdom of St Ursula* (Cat. no. 31) has had to be postponed.

In mid-July Caravaggio leaves for Rome, possibly to seek pardon for Ranuccio Tomassoni's death. On 18 July, he dies of a fever in Porto Ercole, while still on his journey.

Rembrandt

1606-1620 Rembrandt van Rijn is born in Leiden on 15 July 1606 as the ninth child of Harmen Gerritsz van Rijn, a miller, and Neeltgen Willemsdr van Zuytbrouck.

Rembrandt attends the Latin School in Leiden between c. 1613 and 1615. He enrols as a student at Leiden University on 20 May 1620. His registration states that he is still living with his parents in the Weddesteeg. He seems never to have actually studied at the university.

1621-1627 Rembrandt is apprenticed for three years to the Leiden painter Jacob Isaacsz van Swanenburg.

Around 1624/1625 he spends six months in the studio of the Amsterdam history painter Pieter Lastman after which, from around 1626, he works as an independent master in Leiden.

1628-1630 After visiting Leiden on 10 January 1628, the Utrecht jurist Arnold van Buchel notes in his diary that Rembrandt is making a great name for himself in the town, but considers the praise premature.

On 14 February 1628, the 14-year-old Gerrit Dou becomes Rembrandt's first pupil.

Constantijn Huygens, the secretary of Stadholder Frederik Hendrik and a prominent art-lover and humanist, calls on Rembrandt and Jan Lievens at their shared studio in Leiden around 1629. It is through Huygens that Rembrandt is later awarded important commissions from the court in The Hague, among them a series of Passion scenes painted for the stadholder in the 1630s (fig. 4).

Harmen van Rijn, Rembrandt's father, dies in 1630.

1631-1634 At the end of 1631, Rembrandt settles in Amsterdam in the house of the art dealer Hendrick van Uylenburgh. In his early years in the city he mainly receives portrait commissions from local dignitaries. It is in this period that he paints those of Johannes Wtenbogaert and Joris de Caullery (Cat. nos. 18 and 20).

In 1632 Rembrandt completes *The anatomy lesson of Dr Nicolaes Tulp* (The Hague, Mauritshuis), his first group portrait. That same year the young artist paints the portrait of Amalia van Solms (Paris, Musée Jacquemart-André), the wife of Stadholder Frederik Hendrik.

In 1633, Rembrandt becomes engaged to Saskia van Uylenburgh, the daughter of a burgomaster of Leeuwarden and a cousin of Hendrick van Uylenburgh. From around this time, Rembrandt begins to acquire an increasing number of pupils, many of whom go on to become famous painters, among them Ferdinand Bol, Gerbrand van den Eeckhout and Govert Flinck.

1634-1638 Rembrandt marries Saskia on 22 June 1634 in Sint Annaparochie (Friesland). In the same year he becomes a burgess of Amsterdam and a member of the local painters' guild. The *Queen from antiquity* (Cat. no. 32) dates from 1634.

In 1635, Rembrandt and Saskia move into a house of their own, which they rent in fashionable Nieuwe Doelenstraat. Rembrandt has now set up on his own, and is working independently of Hendrick van Uylenburgh.

Rembrandt probably paints his *Prodigal Son in the inn* (Dresden, Gemäldegalerie) in 1635. It is usually regarded as a double portrait of the artist and his young wife.

Rumbartus, Rembrandt and Saskia's first child, is born on 15 December 1635. He lives only two months.

From the middle of the decade Rembrandt produces an increasing number of large history paintings, among them *The sacrifice of Abraham, Belshazzar's feast* and *The rape of Ganymede* (Cat. nos. 22, 37 and 34), as well as the Passion series for Stadholder Frederik Hendrik.

1638-1641 Cornelia, Rembrandt and Saskia's second child, is baptised on 22 July 1638, but survives only three weeks.

On 5 January 1639, Rembrandt buys an imposing house (now the Rembrandt House Museum) in Sint Anthonisbreestraat (now Jodenbreestraat) for 13,000 guilders. The large loan to finance the purchase is a major cause of his later financial difficulties.

A second daughter called Cornelia is buried in the Zuiderkerk on 12 August 1640, having lived only a few weeks.

Titus, Rembrandt and Saskia's fourth child, is baptised in the Zuiderkerk on 22 September 1641. He is the only one of their children to reach adulthood.

The first printed biography of Rembrandt, by Jan Jansz Orlers, is published in 1641. In it, Rembrandt is described as 'one of the most celebrated painters of our age'.

1642-1650 Saskia dies on 14 June 1642, the year in which Rembrandt paints *The Night Watch* (fig. 2). She is buried in the Oude Kerk. Some time later, Geertje Dircx, a widow, is engaged as Titus's nurse. The relationship that develops between her and Rembrandt will later lead to difficulties.

In 1647, Rembrandt's house and chattels are retrospectively valued at 40,750 guilders as at the time of Saskia's death.

In or around 1647, Hendrickje Stoffels is employed by Rembrandt as his housekeeper. Some two years later, in 1649, Geertje Dircx files a suit against Rembrandt for breaking his promise of marriage, and wins. Rembrandt is ordered to pay her alimony of 200 guilders a year.

1653-1660 In 1653, Rembrandt paints *Aristotle with a bust of Homer* (fig. 20) for the Sicilian nobleman Don Antonio Ruffo.

Cornelia, the illegitimate daughter of Rembrandt and Hendrickje Stoffels, is baptised in the Oude Kerk in Amsterdam on 30 October 1654.

Rembrandt's increasing financial difficulties force him on 14 July 1656 to request the High Court of Holland to make an assignment of his property. His possessions, including his large art collection, are sold at a series of public auctions. Over the years he had amassed a vast array of objects, not just exotic trappings and costly fabrics, which he used as props in his paintings, but also work by well-known colleagues and old masters. He also had a large collection of prints and drawings. The sale results are disappointing, and the house is transferred to Titus's name the same year. One of the causes of Rembrandt's bankruptcy seems to have been the costly purchases he made for his collection, in addition to the unpaid debt for his house.

Around 1658, Rembrandt, Titus, Hendrickje and Cornelia move to a smaller house on Rozengracht. The house in Sint Anthonisbreestraat is then auctioned, but the buyer fails to pay up. This happens again in 1659, and it is not until 1660 that it is finally sold for 11,218 guilders. Because of his bankruptcy, Hendrickje and Titus become Rembrandt's employers, and are also responsible for selling his work.

Titus in a monk's habit (Cat. no. 26) is painted in 1660. Arent de Gelder, Rembrandt's last pupil, is probably apprenticed to him in this period.

1661-1669 Around 1661, Amsterdam City Council commissions Rembrandt to paint the huge *Oath of Claudius Civilis* (fig. 26) for the new Town Hall. The finished painting was rejected and returned to the artist, who may himself have cut it down.

In 1662, Rembrandt paints *The syndics of the Amsterdam drapers' guild* (Amsterdam, Rijksmuseum), and *The Jewish bride* (Cat. no. 29) dates from this period or slightly later. He also receives several important commissions for portraits and other works.

Saskia's grave is sold in 1662; in 1663 Hendrickje Stoffels dies. She is buried in a rented grave in Amsterdam's Westerkerk on 24 July.

On 29 December 1667, the Florentine grand duke Cosimo de'Medici, calls on Rembrandt, who is referred to as a 'famous painter' (*pittore famoso*).

Titus van Rijn marries Magdalena van Loo on 28 February 1668. However, he dies the same year, and is buried in the Westerkerk on 7 September. Six months later, on 22 March 1669, his daughter Titia is baptised in the Nieuwezijdskapel in Amsterdam.

Rembrandt dies at the age of 63 on 4 October 1669. Like Hendrickje and Titus, he is buried in a rented grave in Amsterdam's Westerkerk.

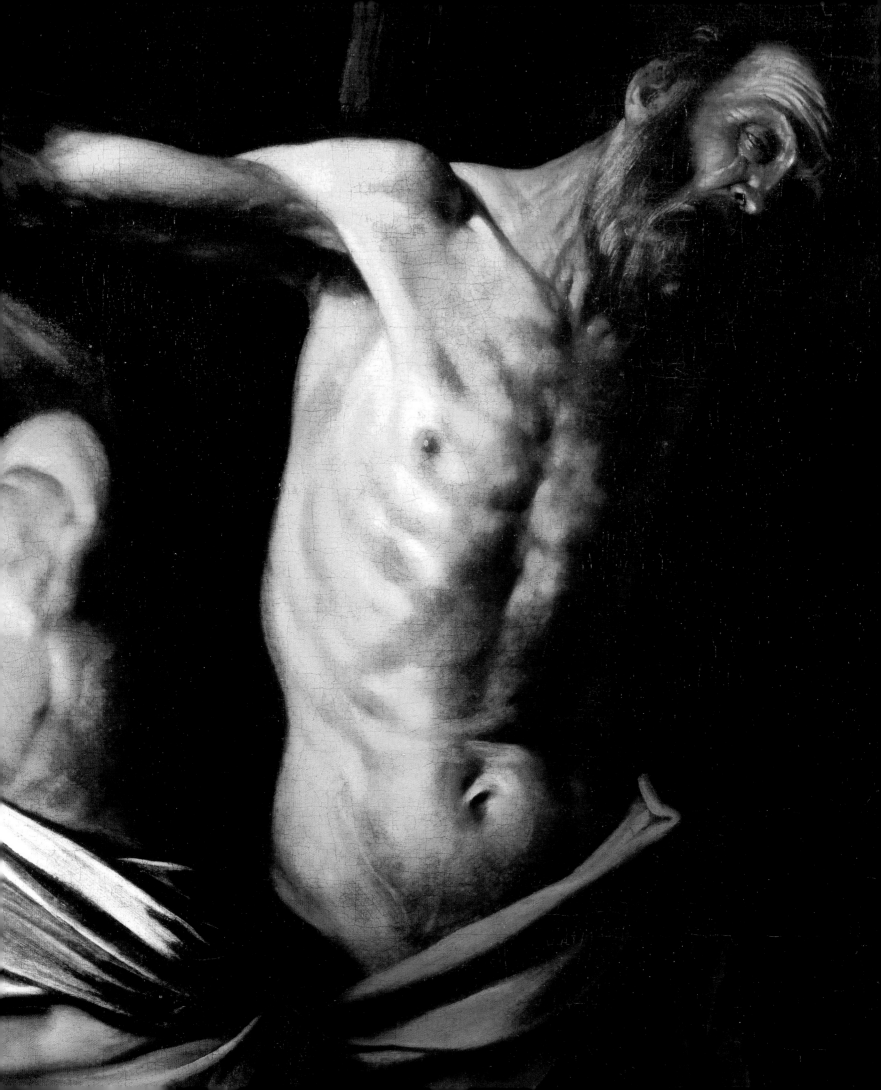

Taco Dibbits

*Prologue: Caravaggio, the Utrecht Caravaggisti and
the young Rembrandt*

Caravaggio

St Andrew on the cross

It is not so that Caravaggio invariably chose the most recognisable or spectacular event in a narrative. He often preferred the more inherently dramatic moment just before or after it. In his *St Andrew*, for example, he does not portray the actual crucifixion, as was customary, but another incident that took place during the saint's martyrdom as related in the *Legendario delle vite de'santi* of 1600.[1] It tells how the proconsul of Patras in Greece ordered that Andrew should not be nailed to the cross but tied to it. His suffering was to be prolonged because he had converted Maximilla, the proconsul's wife, to Christianity and had baptised her. However, the cruel punishment proved counterproductive, for the saint continued proclaiming his faith to his followers as they thronged around the cross. After two days the proconsul ordered that Andrew be taken down to avoid further disturbances. But while they were untying him he was surrounded by a blinding ray of light, angels appeared, and a supernatural force paralysed the executioners. When the light died, Andrew breathed his last. Thus God honoured his plea to be allowed to die on the cross.

Caravaggio depicts this frozen moment both literally and figuratively, for the executioner is shown paralysed on the ladder just after the light has died. Andrew's brittle body hangs exhausted, his head resting on his left shoulder, his eyes are turned upwards, as he breathes his last. It is a striking depiction of the moment of death as a release from the sufferings of life. The astonished onlookers, still baffled by the miracle, witness this tender moment with open mouths.

Caravaggio's fidelity to nature, without selecting its most beautiful elements, is abundantly clear here from the goitre in the neck of the woman on the left. Swellings of this kind often afflicted peasants in the mountains around Naples. By choosing to depict the goitre Caravaggio emphasised the reality of the woman's poverty.[2] He also made no concessions in his rendering of Andrew's body, with its old, white, wrinkled skin contrasting with the sunburned neck.

Now that the dazzling, divine flash of light is extinguished, the figures are illuminated by raking light from the left. The beam falling on the saint and his executioner contrasts with the otherwise dark space. The chiaroscuro not only imparts a sense of depth, but also contributes to the volumes of the individual figures. This is particularly apparent in the draperies with their dark shadows, and in Andrew's ribcage, where a play of shadows accentuates the emaciation of his body. The light is used to suggest *rilievo* (depth), but it also has a narrative function. The principal actors are of course in the 'spotlight', but the light picks out details that are essential for identifying the event. Andrew hangs not from his customary X-shaped cross, but from a traditional Latin cross[3], and is identifiable as Andrew because he is bound, not nailed to it. It is those very ropes that catch the light in Caravaggio's painting, while the saint's arms are largely in shadow. It may also be no coincidence that only the ear of one of the four figures at the foot of the cross is highlighted, given the story that 20,000 people listened to Andrew preaching as he hung dying.

Caravaggio painted this *St Andrew* in Naples, probably in early 1607.[4] It is unlikely, though, that any of the Utrecht Caravaggisti ever saw it. The Spanish viceroy of Naples, the conde de Benavente, removed it to Valladolid in 1610.[5] However, it is precisely this type of late work by Caravaggio that made such a deep impression on his Utrecht followers when they arrived in Italy. Though they would not have seen this particular picture, it is very possible that they, and even Rembrandt himself, may have known of it through a copy.[6]

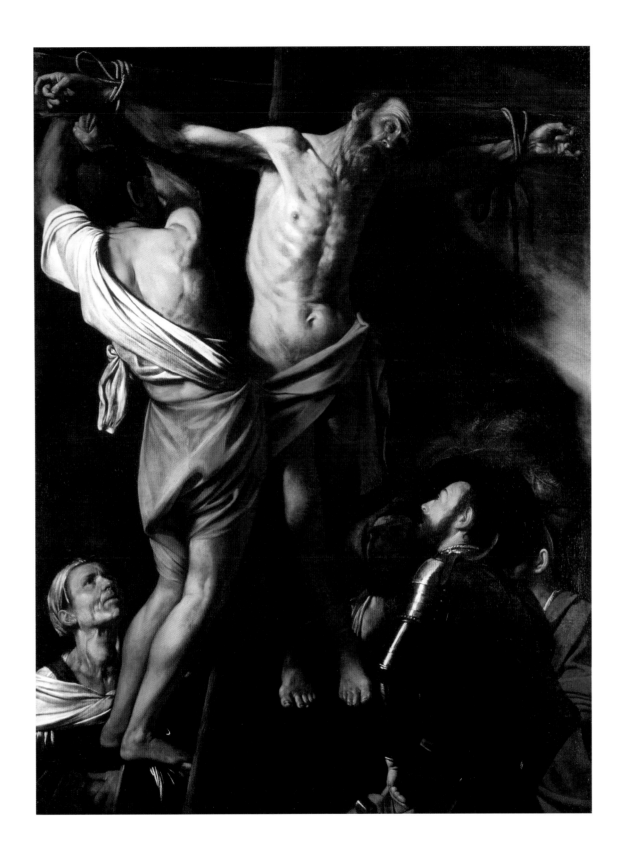

Cat. no. 1 Caravaggio
St Andrew on the cross, c. 1607
Oil on canvas, 202.5 x 152.7 cm
Cleveland, The Cleveland Museum of Art, Leonard C. Hanna Jr. Fund

The Utrecht Caravaggisti

Around 1629, Constantijn Huygens, the influential secretary of Stadholder Frederik Hendrik paid a visit to Rembrandt and Jan Lievens in Leiden. The intellectual, poet and great lover of the arts recalled the meeting in his memoirs, and wrote with rare enthusiasm about the work of these thrusting young talents. His only criticism was that they were a little too cocky, and that 'until now they have felt no need to devote a few months to an educational journey to Italy.'[1] The German painter and biographer Joachim von Sandrart, who himself went to Italy in 1628 and stayed there for seven years, also accused Rembrandt in his *Teutsche Akademie* of lacking the classical background required of an artist. A journey to Italy was widely regarded as an essential part of an artist's training, and Rembrandt had failed to undertake it.[2] Huygens, though, recorded the rejoinder made by Rembrandt and Lievens as to why they had little desire to travel. 'They are now, they say, in the full vigour of their years – both of them were only in their early 20s – and had to profit from that before all else; they have no time to waste on travel to far-off lands.' Huygens went on to say that the young artists had seen that Italian paintings were being collected in abundance north of the Alps, while in Italy one sometimes had to go to great lengths to track them down.

It is true that there were important collections containing paintings by Italian masters in the Netherlands in the first quarter of the 17th century, but as far as we know Rembrandt would not have found any Caravaggios in them (or at least none that are regarded as originals today).[3] Nor could the young painter have got to know the Italian's work through reproductive prints, because to the best of our knowledge there were none in the 1620s.[4] But the young Rembrandt, with his eagerness to learn, would certainly have acquainted himself with Caravaggio's style by studying the works of Dutch artists who had indeed gone to Italy and

had returned home around 1620. Several of them introduced Caravaggio's innovative manner in the north, where it soon became very popular. So although Caravaggio had no direct influence on Rembrandt, it is almost impossible to conceive of Rembrandt's obsession with light without the indirect influence of Caravaggio mediated by the work of those so-called Caravaggisti.[5]

The Dutch artist and biographer Karel van Mander was the first to write about Caravaggio. He devoted several lines to him in his *Schilder-boeck* of 1604, in the chapter on contemporary artists working in Rome, and concluded with the words: 'As regards his technique, it is such that it is very pleasing, and a wondrously beautiful manner, to be emulated by young painters'.[6] Caravaggio's innovative way of painting was imitated to such an extent that a genuine movement sprang up throughout Europe. And whether or not young Dutch artists heeded Van Mander's advice to imitate Caravaggio, his style certainly had a great influence on painting there in the second half of the 1610s and in the 1620s. The most important of the Dutch followers were Hendrick ter Brugghen (c. 1588-1629), Gerard van Honthorst (1590-1656) and Dirck van Baburen (c. 1594/95-1624). All three had spent time in Rome and were later active in Utrecht.

They, like Caravaggio, concentrated on history painting, and some of the features that they borrowed from him are also found in Rembrandt's work. These include the pursuit of naturalism by depicting people of flesh and blood, as well as concentrating in their compositions on the essence of a narrative, stripping out all embellishments. One of the striking aspects of the Caravaggisti is the expressive nature of the protagonists' gestures, and the use of light to accentuate the essence of the story. An important characteristic derived from Caravaggio, and one that influenced Rembrandt, was the use

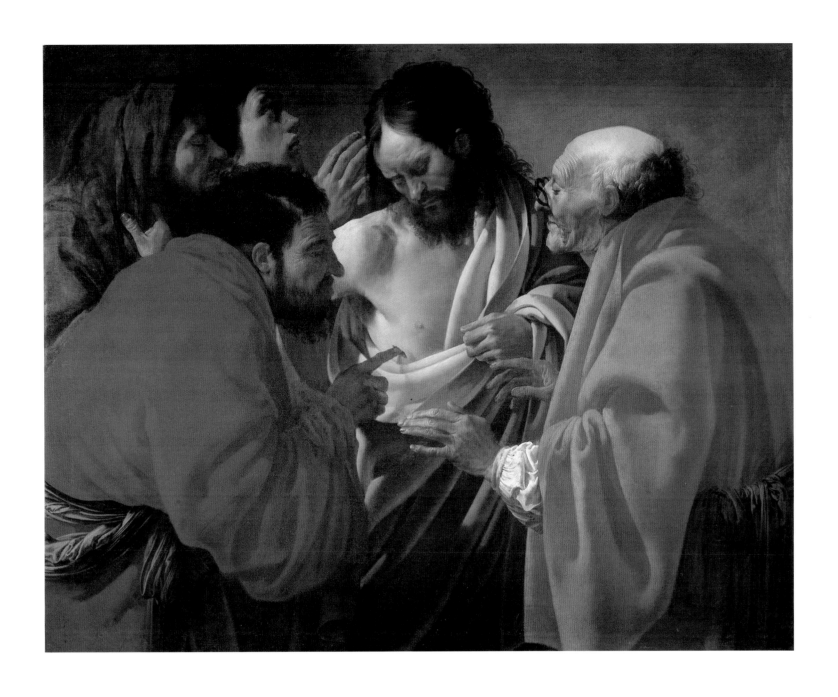

Cat. no. 2 Hendrick ter Brugghen
Doubting Thomas, c. 1622
Oil on canvas, 108.8 x 136.5 cm
Amsterdam, Rijksmuseum

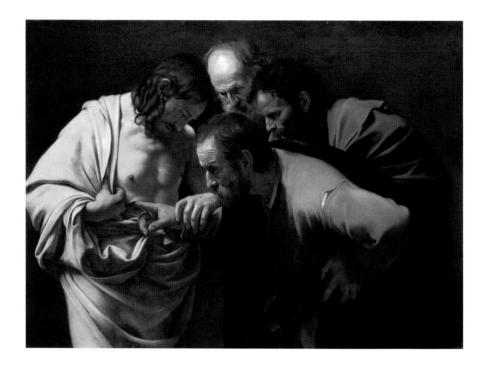

of a focused source of light in an otherwise predominantly dark painting, thus creating strong contrasts between and in the figures: *chiaroscuro*.

Hendrick ter Brugghen (Cat. no. 2), who was probably born in The Hague, trained with Utrecht's leading painter, Abraham Bloemaert (1564-1651). Ter Brugghen was the first of the three to go to Italy, perhaps as early as 1604. It is possible, then, that he was there before Caravaggio died in 1610, although there is no evidence to support this. Nor are there any paintings of his that were definitely made in Italy. All that we know about his stay there is that, according to him, it lasted for several years and that he returned to Utrecht in the autumn of 1614, where he worked until his death in 1629. According to the 17th-century art theorist and biographer Cornelis de Bie, Ter Brugghen was one of the best-known artists of his day.[7]

Honthorst (Cat. no. 3), was born in Utrecht and was also apprenticed to Abraham Bloemaert. He went to Italy later than Ter Brugghen, between 1610 and 1615, and thus never met Caravaggio. But as Mancini, the Italian biographer, wrote in 1621, he arrived in Rome 'in the days when Caravaggio's manner was being widely imitated.'[8] Far more is known about Honthorst's time in Rome than about Ter Brugghen's. He worked for important patrons, among them Cardinal Scipione Borghese, Pope Paul V's nephew and first minister, and lived in the house of another, the banker marchese Vincenzo Giustiniani, who reputedly had no fewer than 15 Caravaggios in his collection, among them *Omnia vincit Amor* and *Doubting Thomas* (Cat. no. 33; fig. 28).[9] Honthorst returned to Utrecht in 1620, six years after Ter Brugghen.

Dirck van Baburen (Cat. no. 4), who came from Wijk bij Duurstede (near Utrecht), studied under the well-known Utrecht painter Paulus Moreelse (1571-1638), who had himself been to Italy, unlike the teacher of the other two Caravaggisti. Van Baburen followed his example after his apprenticeship, and is recorded there in 1615.[10] Like Honthorst, Van Baburen was successful in Rome, and he too received commissions from Borghese and Giustiniani.[11] In common with his compatriots, he was influenced not only by Caravaggio's work but also by that of his immediate followers active in Rome. When Van Baburen returned to Utrecht in

fig. 28 Caravaggio
Doubting Thomas, 1603 (107 x 146 cm)
Potsdam, Stiftung Preußische Schlösser und Gärten Berlin-Brandenburg

1620 or 1621, he probably shared a studio with Ter Brugghen. His career, though, was short, for he died in 1624, three years after his return. Thus Honthorst was the only one of the three to survive the 1620s, but in the course of that decade he gradually abandoned the style inspired by Caravaggio and turned to a more classicist manner.

As Huygens observed when he called on Rembrandt in Leiden, the young artist was at the time painting small works in which, according to Huygens, he reached unparalleled heights. 'Rembrandt [...] likes to concentrate fully on a small painting, and achieves a result in small that one seeks in vain in the largest pieces by others.'[12] Seemingly, then, the contrast with the work of Caravaggio and the Caravaggisti could not have been greater. While Caravaggio and his Dutch followers were working mainly on commission, producing large history paintings on canvas, Rembrandt initially preferred small panels that were probably destined for the art market. But as with the Caravaggisti, Rembrandt's ambition was to work in the most highly rated genre of the day: history painting, that is, pictures of historical and mythological subjects.[13] So it is no coincidence that the three paintings by the Dutch followers of Caravaggio presented here are history paintings: *Doubting Thomas*, *Christ crowned with thorns* and *Prometheus chained by Vulcan* – stories taken from the Bible and classical antiquity (Cat. nos. 2, 3 and 4). Caravaggio and his Utrecht followers restricted themselves almost exclusively to such subjects, although they did also produce merry companies of, for example, people playing cards or reading each other's hands. They also developed a new type within that genre: compositions with just a single figure, a man or woman merrily playing music or drinking, shown half-length against an ochre or grey background (Cat. nos. 25, 27 and fig. 31). They painted few portraits or still lifes, and no landscapes at all.

Van Mander wrote that Caravaggio believed that 'all works, no matter of what nor by whom made, are naught but *bagatelles*, child's play or trifles if they be not done and painted from life, and that there is no good or better way of proceeding than by following nature. [...] This is no bad way of attaining a good end, for to paint from drawings (even if copied from life) is not as reliable as keeping reality in sight and following nature with all her different colours; but one must first have acquired sufficient insight to enable one to distinguish and select from the beauty of life that which is the most beautiful'.[14] Some people felt that Caravaggio and his Utrecht followers took this practice of working from nature to extremes, for they were soon being accused of failing to lay down any criteria for selection. Von Sandrart, for example, said of Ter Brugghen that he 'follows nature and its unfriendly shortcomings very well, but not disagreeably'.[15] Bellori had levelled the same accusation at Caravaggio in his biography four years previously.[16] He often 'merely' chose boys and girls from the streets as his models (Cat. nos. 13, 25 and 27). In the third decade of the century, Mancini was already describing the manner of Caravaggio and his followers as being 'very close to reality' (*molto osservante del vero*), and he noted that they always worked with it in front of them.[17] We do not know whether Caravaggio really did invariably paint from the live model, but he and his followers certainly did depict people of flesh and blood. The executioner tugging on the ropes in *St Andrew on the cross* (Cat. no. 1), for example, has sunburned legs, neck and arms. And there is a marked contrast in the saint's skin between the white of his torso and the tan on his neck, and furthermore we are not spared his dirty toenails. Even two beautiful youths like Prometheus and Mercury in Van Baburen's *Prometheus chained by Vulcan* (Cat. no. 4) are presented as people of flesh and blood who could not escape the ravages of the elements and time. Their hands, heads and necks are sunburned, and the skin of their joints is raw. Ter Brugghen, who had been singled out for criticism by Von Sandrart, shows in his *Doubting Thomas* (Cat. no. 2) that even Christ's face had been exposed to the sun. Like Caravaggio in his *St Andrew on the cross*, Ter Brugghen details the effects of old age, with its wrinkles and sunken mouth.

There is also one direct copy, a drawing, that Honthorst made in S. Maria del Popolo after *The crucifixion of St Peter*

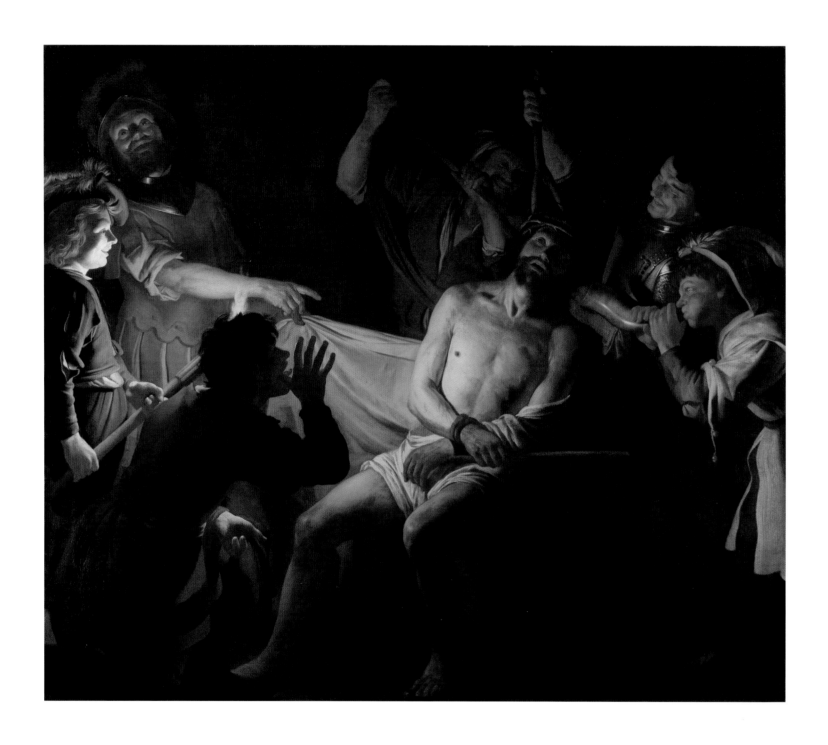

Cat. no. 3 Gerard van Honthorst
Christ crowned with thorns, c. 1622
Oil on canvas, 192.4 x 221.5 cm
Amsterdam, Rijksmuseum. Purchased with the support of the Vereniging
Rembrandt, the Jubileumfonds Rijksmuseum, the Rijksmuseum Stichting

and dated 1616 (figs. 81 and 82). This is also Honthorst's earliest known work.[18] However, the three Dutch artists did occasionally borrow whole or partial compositions from Caravaggio's paintings. Ter Brugghen's *Doubting Thomas*, which was painted more than seven years after his return from Italy, is quite clearly based on Caravaggio's treatment of the same subject (Cat. no. 2; fig. 28). Ter Brugghen's composition has all the features of Caravaggio's, albeit reversed left for right. He concentrates on the essence of the biblical event by showing the figures half-length against a plain, ochre-grey background. Eyes and hands play a key role. The disciple Thomas had doubted his companions' story about the Resurrection, and said that he could only believe it if he could see Christ for himself. Jesus then appeared in their midst and said to him: 'Reach hither thy finger, and behold my hands, and reach hither they hand, and thrust it into my side, and be not faithless, but believing. And Thomas answered and said unto him, My Lord and my God. Jesus saith unto him, Thomas, because thou hast seen me, thou hast believed; blessed are they that have not seen, and yet have believed' (John 20:27-29). Caravaggio and Ter Brugghen relate the story with emphatic gestures. Christ leads Thomas's hand to the wound in his side to present him with the tangible evidence of his resurrection.[19] The curious disciples lean forward, staring at Thomas's finger as he explores the wound. In order to lend added weight to the notion of 'seeing is believing', Ter Brugghen introduced the pince-nez through which the elderly disciple on the right is peering. Ter Brugghen continued the play of hands with a fourth disciple gazing up to heaven with his hands clasped in front of him, possibly representing those who had not seen but yet believed.[20] In Van Baburen's *Prometheus chained by Vulcan* (Cat. no. 4), the highly foreshortened body of the screaming Titan with his head thrown backwards recalls Caravaggio's *Conversion of St Paul* in S. Maria del Popolo (fig. 29).[21] There the apostle's foreshortening contributes so successfully to the illusion of depth that he appears to be falling out of the picture. The spread arms of Prometheus and Paul also heighten the drama of the event. This, though, is not more than a for-

mal similarity, for Prometheus's arms have a very different connotation from Paul's. They accentuate the violence of the scene, as the screaming Titan, his eyes bulging with fear, anticipates his punishment for the crime of stealing the fire of the gods. By chaining him to the rock with his arms spread, his belly is exposed for the eagle's daily meal of his liver, which will regenerate throughout eternity.[22] Paul's spread arms in Caravaggio's painting contribute to the high pathos of the scene: the persecutor of the Christians has fallen from his horse, and blinded by the divine light gropes alone in the dark.

Honthorst probably painted his *Christ crowned with thorns* (Cat. no. 3) soon after his return from Italy. Comparison with Caravaggio's *St Andrew on the cross* of 1606-1607 (Cat. no. 1) leaves little doubt about the influence of the Italian artist's late style, especially in the use of light.[23] It was with good reason that the Dutchman was nicknamed 'Gherardo delle Notti' in Italy. A group of soldiers have gathered around Christ in a dark room. 'And they stripped him, and put on him a scarlet robe. And when they had platted a crown of thorns, they put it upon his head, and a reed in his right hand: and they bowed the knee before him, saying, Hail, King of the Jews!' (Matthew 27:28-29). Only the light from the torch of one of the men illuminates this dramatic event. It emphasises the exhausted body of Christ, whose head is being pulled back by the staves of the soldiers forcing the crown of thorns on his head. Although this is an artificial light source within the composition, whereas Caravaggio's light comes from somewhere outside the painting, in both cases it imparts a strong *chiaroscuro*. The marked contrast between light and shade creates *rilievo*, or the illusion of depth, throughout the composition.[24] Honthorst introduced another 'trick' that is seldom found in Caravaggio, and that is the concealed light source. By placing the figure kneeling before Christ in front of the source of light, the side of him visible to the viewer is entirely in shadow, so that there is a high contrast between this figure and the glow from the light behind it, turning the man into a *repoussoir*. Rembrandt used a similar device in *The denial of St Peter*, where the maidservant

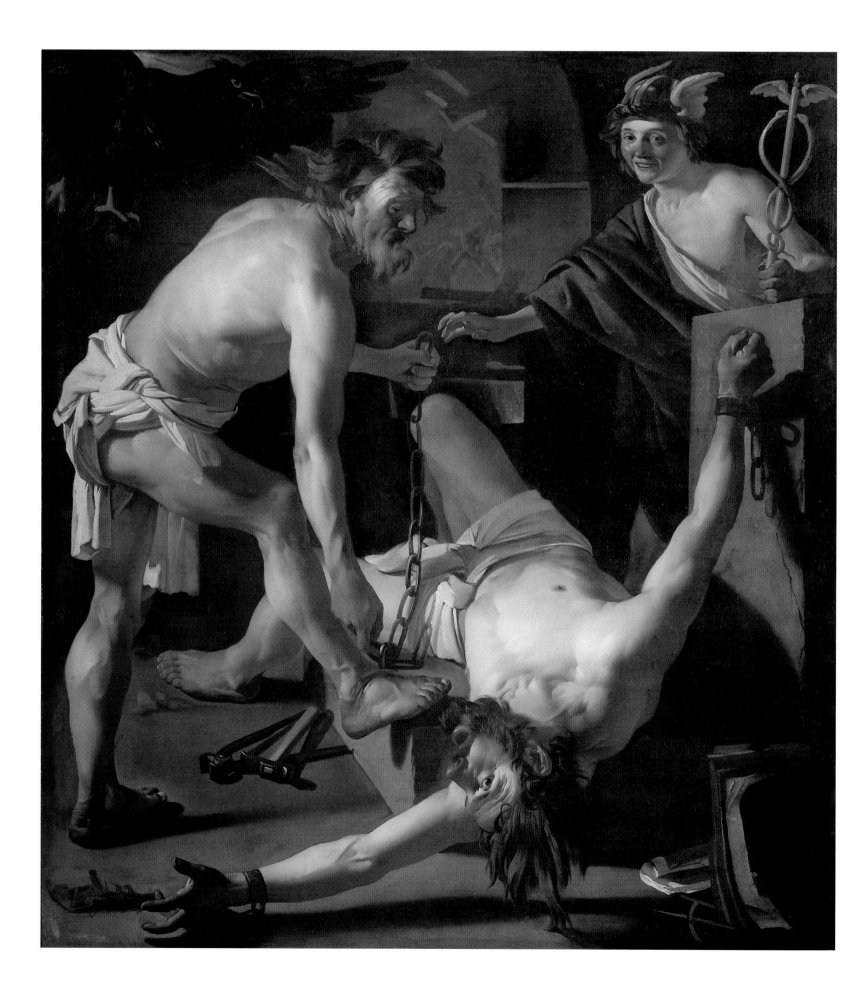

shields the flame of a candle with her hand (Cat. no. 16). Another advantage of the concealed light source was described later in the century by Rembrandt's pupil Samuel van Hoogstraeten. If the painter shows the source of light he has to make it the lightest tone of his composition. If, on the other hand, he conceals it, the lightest tone can be reserved for other parts: Christ's body and the mocking faces in Honthorst's case.[25] The masked source of light was a favourite motif of Honthorst's in the 1620s until, at the end of the decade, he switched to lighting that was not so full of contrasts.

The chiaroscuro in *Christ crowned with thorns* not only creates the illusion of depth between the figures but also within them. They are given volume by the use of highlights, a case in point being the gleaming armour of the soldier at the foot of the cross in Caravaggio's St Andrew which, like the armour and the gleaming horn in Honthorst's painting, has an elongated highlight. Then there are the plumes on the caps in both works, some feathers of which catch the light. It is striking how similarly both artists impart volume to the torsos of Christ and St Andrew, where the deep shadows are indicated by leaving the dark ground uncovered. By placing the flesh tones on top of it, sometimes with rough brushstrokes, the two artists also imitate the weathered skin of the two men.

As in the *Doubting Thomas* (fig. 28), where the light falls on the hands near the wound, the light in these paintings is also used in a narrative way. In *Christ crowned with thorns* (Cat. no. 3), it brings out man's cruelty. Looming up out of the darkness are the mocking faces of the guards, who continue taunting Christ even after he has been tortured and sentenced to death.

It is Caravaggesque paintings of this kind that the young Rembrandt would have seen without ever going to Italy. They represent the style of the Italian master whom he never tried to imitate but whom he absorbed and who was the source of the chiaroscuro that he himself used so distinctively, even in the small, early works of his Leiden period discussed below.

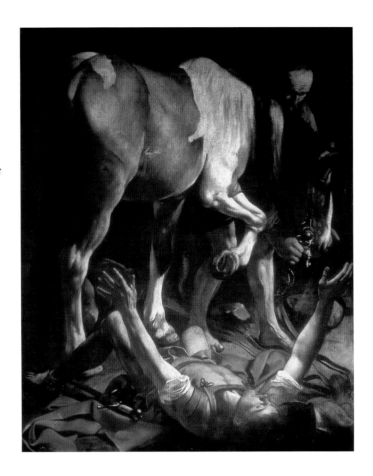

41

The young Rembrandt

A soldier in a gorget and plumed bonnet

This is probably Rembrandt's very first *tronie*.[1] The word, which comes from the French *troigne*, meaning head or face, was used in the 17th century to denote paintings of heads which, although painted from life, were not of a specific person but of a type of person. Popular types were an oriental man, an old woman, or a soldier.[2] In Caravaggio's case, the identity of the sitter was not the first priority in his paintings of boys with fruit or flowers (Cat. nos. 25 and 27), and Rembrandt, too, probably used people from his immediate circle as models. He often clad them in draperies and costumes and gave them attributes in order to characterise historical or exotic types. In the past, a desire to identify heads of this kind led some to suggest that this soldier was Rembrandt's brother Adriaen.[3] There is no foundation to that, but it is highly likely that it was painted from the live model, given the striking

way in which Rembrandt rendered the man's nonchalant and self-satisfied expression as he looks over his shoulder at the viewer with his upper lip curled slightly. Such heads were ideal opportunities to experiment with facial expressions, and Rembrandt's fascination with that aspect of painting may be why he continued to paint so many *tronies* throughout his career.

Here he has concentrated on the bust of a single figure shown in isolation against a grey wall on which raking light creates a clear demarcation between light and shade. This recalls the paintings of merry musicians and drinkers by the Utrecht Caravaggisti. One example is Dirck van Baburen's *Boy with a Jew's harp* (fig. 31), but there are also many others in the work of Gerard van Honthorst and Hendrick ter Brugghen. This genre derived from scenes by Caravaggio was introduced into the Netherlands by the Caravaggisti in the early 1620s, and it was still very popular when Rembrandt painted this soldier around 1626.[4] His use of colour – the salmon-pink cloak with the purple-blue lining, the ochre of the buff coat and the sash, the deep blue bonnet with the light blue and yellow feathers – is also similar to that of the Utrecht Caravaggisti. They, though, do not appear to have painted single soldiers, but only included them in multi-figured genre scenes.

These formal elements may be reminiscent of the work of the Caravaggisti, but Rembrandt's main concern appears to have been the way in which the light reflects off the different materials. He achieved his differentiation in the imitation of textures by a route other than that followed in Utrecht. There, and in Caravaggio, the paint surface is usually smooth and uniform, but from an early date Rembrandt used the properties of the paint to produce a striking rendering of textures. The leather buff coat, sash and cloak, for instance, were painted with long, flowing strokes that follow the folds

fig. 30 Hendrick Goltzius
Bust of a man, 1607 (pen and ink, 29.9 x 20.2 cm)
London art market, 1993

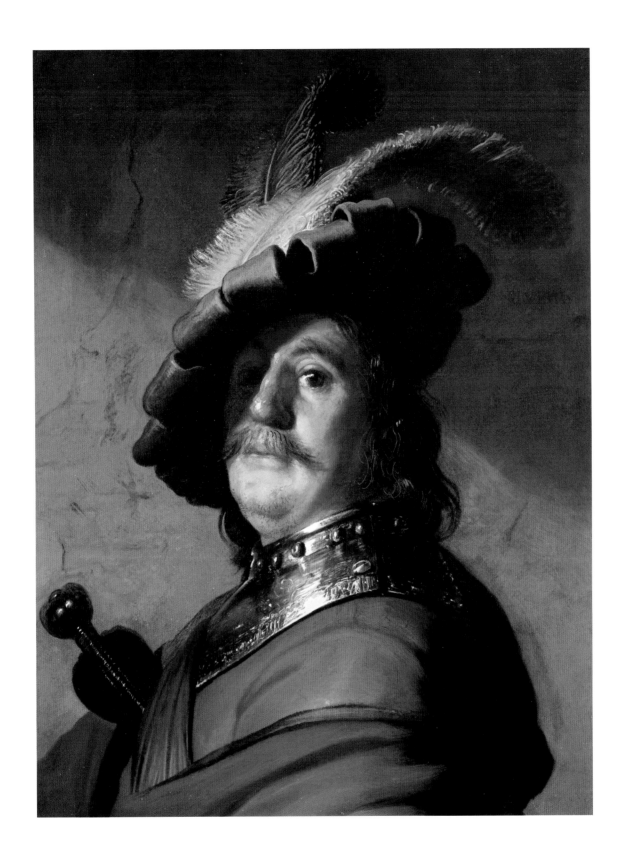

Cat. no. 5 Rembrandt
A soldier in a gorget and plumed bonnet, c. 1626–1627
Oil on panel, 39.8 x 29.4 cm
Private collection, United Kingdom.

in the materials, whereas the brushstrokes in the face are barely distinguishable. The soft, fluffy texture of the ostrich feathers is suggested with rather dry, thin, irregular strokes. The hair, by contrast was painted with long strokes, with the butt-end of the brush being used to make scratches in the paint right down to the light ground layer, making it appear that a few individual hairs catch the light. Rembrandt also took great pains with the reflections on the gleaming gorget, which are indicated with impasted, almost white highlights. The deep shadow falling over the man's right eye shows that Rembrandt was experimenting with light and shade. It strengthens the suggestion that the bonnet is jutting out of the picture. However, the climax of this use of light lies in the bonnet itself. Each of the flaps ascending like a staircase has a different reflection of the light, imparting a superb suggestion of volume to the headgear.

At first sight, this distinctive bonnet looks like those with slashed edges worn by soldiers in the paintings of Caravaggio and his followers, but closer inspection shows that it is of a different type. The brim was folded over and attached to the crown, with the edge then being cut to form loops. One finds this variant in 16th-century paintings from north of the Alps, but it then went out of fashion. The bonnet and the type of face bear such a strong resemblance to drawn heads by Goltzius as to raise the suspicion that Rembrandt had been looking at his work (fig. 30).[5] As a result, this soldier appears to have just stepped out of a history painting, such as the one of 1626 now in Leiden. A similar bonnet is worn by the boy playing the harp in the *Musical company* of the same year, and it appears to recur 10 years later in the *Self-portrait with Saskia*.[6] The bonnet's complexity, with all its slits, and the precision with which Rembrandt always depicted it, makes it likely that it was part of the stock of props in his workshop.[7]

Self-portrait as a young man

There are no known autonomous self-portraits by Caravaggio or his Utrecht followers. Rembrandt, on the other hand, depicted his own face more often than any other 17th-century artist: 40 times in paint, 31 times with the needle and etching plate, and many times in drawings. Although he had already featured as a protagonist in several history paintings, this is probably his first self-portrait in the strict sense of the word.

One can think of many reasons why he took himself as his model so often.[1] An important one is that his own face was always available and under his own control. He could study his grimaces in the mirror, particularly when he wanted

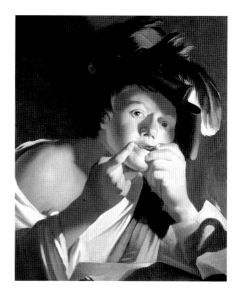

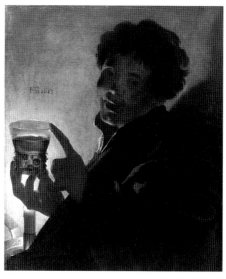

44

fig. 31 Dirck van Baburen
Boy with a Jew's harp, 1621 (65 x 52 cm)
Utrecht, Centraal Museum

fig. 32 Hendrick ter Brugghen
A boy with a wineglass by candlelight, 1623 (67.3 x 56.6 cm)
Raleigh, North Carolina Museum of Art (gift of David Koetser in honour of W.R. Valentiner)

> Cat. no. 6 Rembrandt
Self-portrait as a young man, c. 1628
Oil on panel, 22.5 x 18.6 cm
Amsterdam, Rijksmuseum. Purchased with aid from the Vereniging Rembrandt, the Fotocommissie, the Prins Bernhardfonds and the Ministerie van CRM

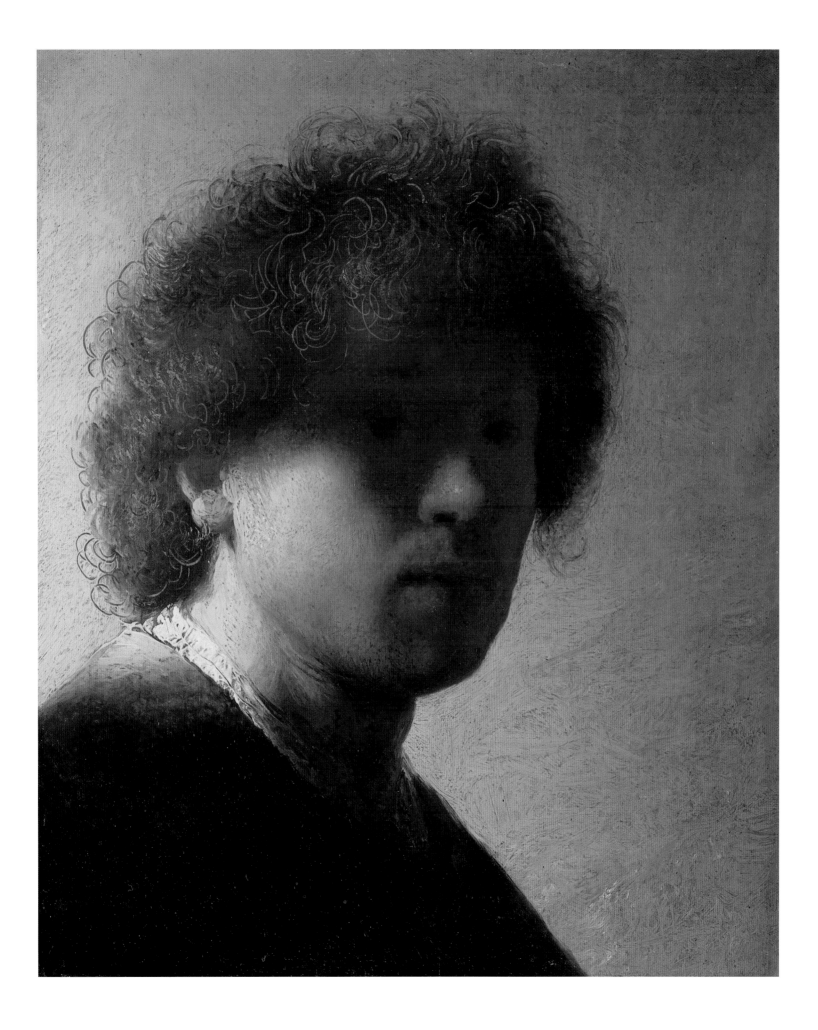

to capture difficult expressions. The small prints he made of himself around 1630 should be seen in the same light (fig. 33). This must also have played a role for Caravaggio when he painted the severed head of Goliath in the painting in the Villa Borghese. He used his own face in a masterly way to render the eyes still bulging with fear and the giant's dribbling mouth (fig. 34).

Rembrandt's small panel in the Rijksmuseum does not fit into the category of grimaces, but shows him in a relaxed mood. The young artist has concentrated entirely on the way in which the light falls on his clothing. The most important parts of the faces in his *tronies* and portraits are usually illuminated (such as the mouth, the nose, and at least one eye), but here he chose to shroud almost all of the peaceful face in shadow. Neither Caravaggio nor his Utrecht followers depicted the interplay of light and shade on a face in such an extreme form. Hendrick ter Brugghen seems to have been the only one to have experimented with this, for in his *Boy with a wineglass by candlelight* (fig. 32), the light barely touches the boy's face. He is not the subject. It is the complex play of light in the full rummer of wine in which the candlelight is reflected and through which it shines.

 Perhaps Rembrandt placed his eyes, the most important part of his face, in shadow because the true subject of this painting is light. Or to put it another way: the effect of light on different materials. He experimented with their depiction by playing with the structure of the paint itself. Coming from a source outside the painting on the left, the light streams across the shoulder and neck and along the cheek to touch just the tip of the nose. Thick, impasted paint marks the spot where the light first falls on him, with the gleam on his jacket being almost as white as the reflection on the white collar of his shirt. The neck and earlobe were also painted with impasto, but the paint surface becomes thinner the nearer it gets to the shadow, with the highlight on the nose, furthest from the light source, being least impasted. As he had done in his *Soldier* (Cat. no. 5), Rembrandt used the butt-end of his brush to indicate how the light plays over the hair and picks out a single hair here and there as if it were transparent. Unlike the Caravaggisti, who often set their figures against an undefined, dark backdrop, Rembrandt has paid close attention to the background, as he did in the *Soldier*. It was a fascination that remained with him all his life: with short, impasted strokes, through which the light-coloured ground layer is occasionally visible, the texture of the paint is used to suggest a plastered wall. The surface is like a map covered with a variety of paint textures with which Rembrandt approaches reality in an astonishing way.

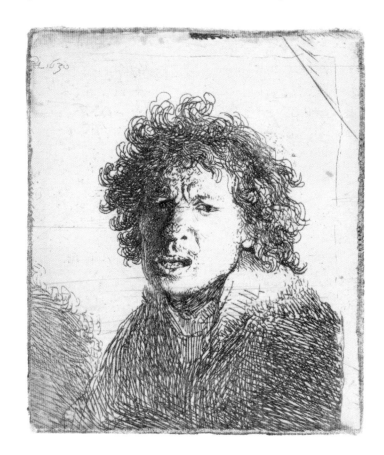

It would be wrong to regard this painting as a *tronie*, in which the sitter's identity is unimportant, for according to his contemporaries Rembrandt was already garnering fame.[2] It may have been an added attraction for the potential purchaser to buy a sample of craftsmanship in which the craftsman himself was the subject.[3]

Two old men disputing

This is perhaps the one painting by Rembrandt that is closest to Caravaggio's work in its handling of light, so it is not surprising that Bellori's 1672 description of Caravaggio's manner of painting seems equally applicable to this Rembrandt. 'He [Caravaggio] became more and more famous by the day for the colouring that he introduced, [...] everything was now depicted with pronounced shadows, using black abundantly to give his bodies *rilievo*. And he followed this practice to such an extent that he never brought his figures out into the daylight but placed them in the brown atmosphere of a closed room, having a light high up that fell down on the most important parts of the body, leaving the rest in the shadows in order to achieve a powerful force of light and shade.'[1]

Both Rembrandt and Caravaggio used light in their paintings to arrange the composition and create the illusion of depth. Having figures loom up out of a dark space, or conversely placing a dark figure in front of a light one, generates the illusion of three-dimensionality. Rembrandt made brilliant use of that principle in this painting. Sunlight streams into the dark study through a window on the left, where part of the window frame can be seen, and falls between the two wise men onto the book they are discussing.[2] The lost profile of the greybeard on the left is in the shadows and, reinforced by his brown coat, contrasts with the light-coloured cloak of the scholar on the right. The former's face is indirectly illuminated by the light reflecting off the open book on his lap. The contrast between his forehead and the dark background creates a sense of depth between him and the man bathed in sunlight. The light on his back and the balding back of his head also detaches him from the dark back-

ground. The eye-catching arm of the chair, of which the dowel at the end is right in the centre of the picture, stands out from the dark background. There are endless contrasts of light and shade from which the painting is constructed and which suggest depth, and they create such a convincing image that one quickly loses oneself in the picture, imagining oneself to be witnessing the discussion as an onlooker in the shadows of the study.

Rembrandt also used the light in the painting in a narrative way. It leads the eye, as it were, along the two disputing men to their hands and the white book, where it concentrates on the nail of the finger pointing to the line they are discussing. The scholar has turned away from his desk, beside which the candle has long since gone out, where his manuscripts await him in the semi-darkness. Here the 22-year-old Rembrandt shows himself to be a master of narrative, not just with the light but with the gestures and poses as well. The man seen from the back has adopted the pose of a listener, while the other man has turned towards him, his upper body leaning forwards slightly over the arm of his chair. He is pointing at the book almost imperatively, while his eyes are fastened on his companion's.

In addition to the use of light, the use of colour in *Two old men disputing* recalls that of the Utrecht Caravaggisti: the warm brown of the cloak and coat of the man on the left, the light grey-blue of the other's cloak, and the yellow tablecloth, which becomes greenish as it recedes into the shadows. It is also striking how often both the Caravaggisti and Rembrandt chose subjects featuring old people. There are so many of them that one suspects that they were a pretext for depicting old age.[3] In this painting, Rembrandt rendered the wrinkles on the face of the old scholar bathed in sunlight with streaks of impasted paint. This solution devised by the two young Leiden painters, Rembrandt and Lievens, of using the paint structure to depict the wrinkles in old skin, was not unique. Caravaggio was also a master at portraying old age, and he also used the texture of the paint to render folds in skin, albeit on a different scale and not so markedly. Excellent

47

fig. 33 Rembrandt
Self-portrait with open mouth, 1630 (etching, 7.3 x 6.2 cm)
Amsterdam, Rijksmuseum

fig. 34 Caravaggio
David and Goliath, c. 1609 (125 x 101 cm)
Rome, Museo e Galleria Borghese

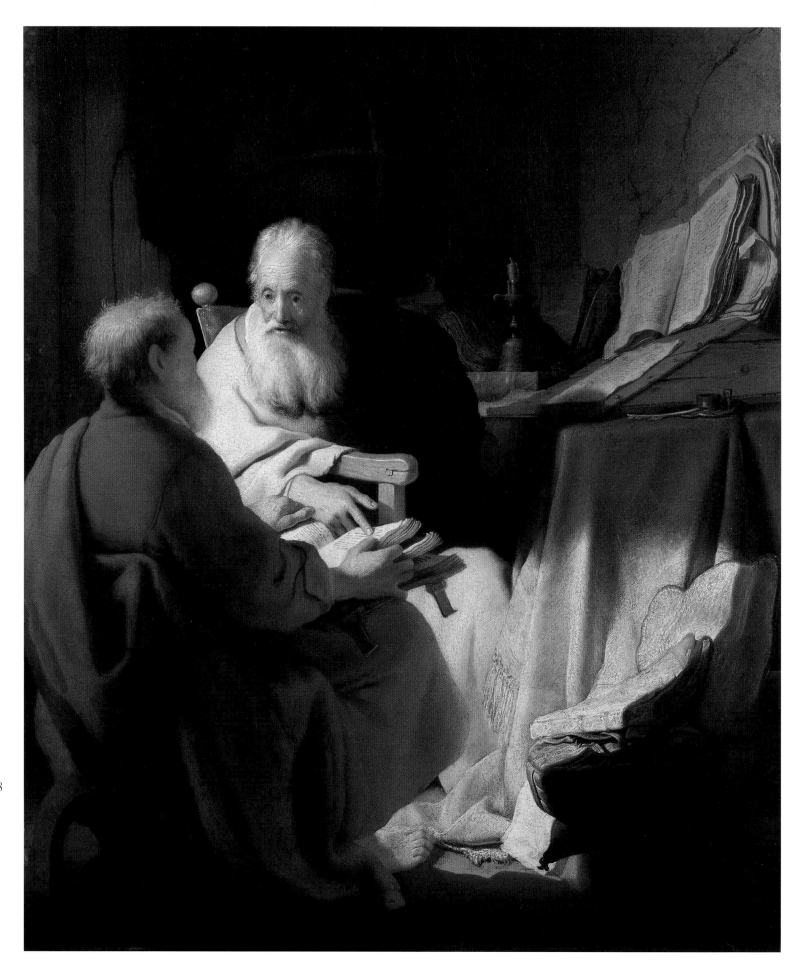

48

instances of this are the shrivelled skin of St Andrew, and that of the old, scholarly St Jerome (Cat. nos. 1 and 35). One of the many examples of Ter Brugghen's masterly way of visualising old age is his rendering of the old, slender fingers and wrinkled face of the bespectacled disciple in his *Doubting Thomas* (Cat. no. 2)

In his last will of 1641, the artist Jacques de Gheyn III (1596-1641), who originally came from Leiden, left several works of art to his brother. They included 'a painting by Rembrandt of two old men disputing. One has a large book on his lap on which sunlight falls'.[4] This is almost certainly the present painting, which was bought by the National Gallery of Victoria after its rediscovery in 1934 and has never left Australia since. De Gheyn must have been familiar with the precise subject, for in 1632 Rembrandt painted his portrait.[5] Brief descriptions of paintings were often included in inventories in order to make their identification easier.[6] However, the inventory listing of this Rembrandt wrongly gives the impression that it was a genre scene. The highly narrative nature of the work does indeed suggest that this was a specific dispute, but it is not certain who the two scholars are meant to represent. They are identified as Elijah and Elisha on an 18th-century reproductive print. In the 20th century it was suggested that they were Hippocrates and Democritus or Heraclitus and Democritus. Finally, Tümpel came up with the plausible suggestion that they are the apostles Peter and Paul.[7] The learned men are barefoot, which was traditionally associated with prophets, disciples and apostles. Peter and Paul are seen disputing about the Scriptures, as is the case, for example, in Lucas van Leyden's engraving of 1527.[8] Paul's doctrines were of particular importance for Protestants, so that identification would tie in neatly with De Gheyn's function as canon of the Mariakerk in Utrecht, which had gone over to the Protestant rite. Catholics had traditionally accorded a prominent place to Peter because he was the first pope. It was the convention to depict him balding and with a short fisherman's beard, like the man seen from the back in this painting. Paul, who was

usually portrayed with a long beard and luxuriant hair, would be the one turned towards the viewer. However, this identification is not entirely satisfactory. Peter is often clad in blue and ochre and Paul in red or reddish brown and green. Their inseparable attributes are also missing: Peter's keys to the kingdom of heaven and the executioner's sword with which Paul was beheaded. Whatever the subject may be, De Gheyn's description (or that of his notary) sums up the essence of the painting: old men, their interaction, books, sunlight.

St Paul at his desk

Only occasionally did Caravaggio depict a night-time scene. The best-known is perhaps *The betrayal of Christ* (Cat. no. 17). It is one of his two paintings with a visible light source,[1] and in that differed he from the Caravaggisti. Honthorst, who was nicknamed 'Gherardo delle Notti' during his sojourn in Italy, was famous for the candles, torches and lanterns in his nocturnal scenes. He often allows the viewer to look directly into the flame, but equally he can also conceal it with a hand or an object. This sets up a great contrast between the object in front of the light source and the glow from the candle or lamp behind it, creating the illusion of depth as in this picture (Cat. no. 8).

Rembrandt's early experiment with a concealed light source, his *Rich man from the parable* of 1627 (fig. 86) is very reminiscent of Honthorst's trick for suggesting depth. As with Caravaggio, the light in Rembrandt's early paintings generally comes from an invisible source outside the painting. The candle beside the desk in *Two old men disputing* (Cat. no. 7) is not lit. However, in *St Paul at his desk* Rembrandt had the brilliant idea of illuminating the scene from two sides, setting up a refined interplay of half-shadows on the face and *tabbaard* of St Paul, who is seated between the two sources of light. On the left, daylight floods across the whitewashed wall, and on the right is the glow of a candle or oil lamp standing on the desk but hidden by an open book. The white pages of the book in turn reflect all the light towards the wall, making the contrast with the totally shadowed back of the book serve as

49

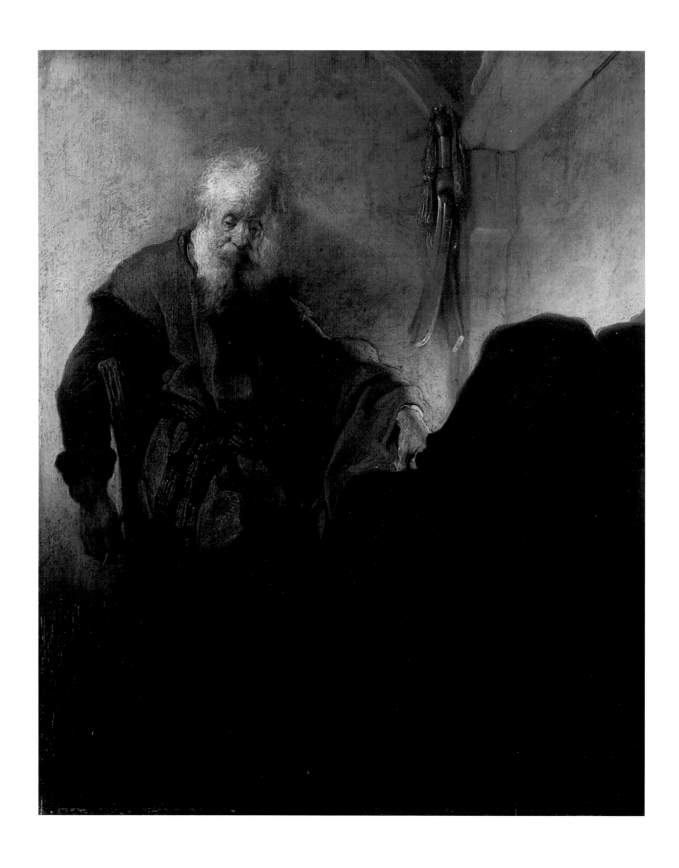

50

Cat. no. 8 Rembrandt
St Paul at his desk, c. 1629–1630
Oil on panel, 47.2 x 38.6 cm
Nuremberg, Germanisches Nationalmuseum

a pronounced repoussoir – the principle of the concealed light source.

Seated in this gently lit room, the old, tired apostle has turned away from his work, his left hand resting on the desk, and his right arm with the pen in his hand hanging over the arm of his chair. He stares at the floor, lost in thought. Like *Two old men disputing* (Cat. no. 7), this is a penetrating study of old age. Rembrandt drew and etched many old men in his Leiden period, and Jan Lievens, who shared his studio, even made a speciality of painting the heads of old men. The convincing depiction of books was also a challenge. They lie barely visible in the shadows in *St Paul*, whereas in the *Two old men disputing* and the *Rich man from the parable* (Cat. no. 7 and fig. 86) the piles of paper are brightly illuminated. Here, too, Rembrandt used the paint structure to suggest the rough surface of paper or parchment bound in worn leather. Books, of course, are a natural attribute of elderly scholars, but it seems that Rembrandt and Lievens saw a connection between the two, and in the way to depict them convincingly. Also, Caravaggio's *St Jerome* (Cat. no. 35), in addition to being the traditional image of the scholar in his study, is a remarkable still life of books flanked by a study of old age.

In his earliest painting of St Paul, *St Paul in prison* of 1627 in Stuttgart, Rembrandt followed the traditional image of a man with a long, pointed beard and with his attributes of the executioner's sword with which he was beheaded, and the books that allude to his conversion and his epistles.[2] This second depiction of the apostle was painted with a more assured and freer brush, and does not entirely follow the tradition. Paul has a short beard, and hanging behind him is a small oriental sword, a yataghan. It was a favourite prop in Rembrandt's workshop, and can also be seen in an early work by his pupil Gerrit Dou.[3] Although it is not an executioner's sword, its presence in the composition can be explained if it is interpreted as the weapon used by the saint in his persecution of Christians before his conversion: 'the sword represents the fury of Paul's persecution, the book his conversion' (*Mucro furor Pauli, liber est conversio Pauli*). It is probably no coincidence that Rembrandt painted and etched the apostle Paul on several occasions,[4] for he was an important figure for Protestants. Calvin wrote in his *Institutio*: '[...] we ought to pay more regard to the apostleship of Paul than to that of Peter, since the Holy Spirit, in allotting them different provinces, destined Peter for the Jews and Paul for us.'[5]

REMBRANDT
CARAVAGGIO

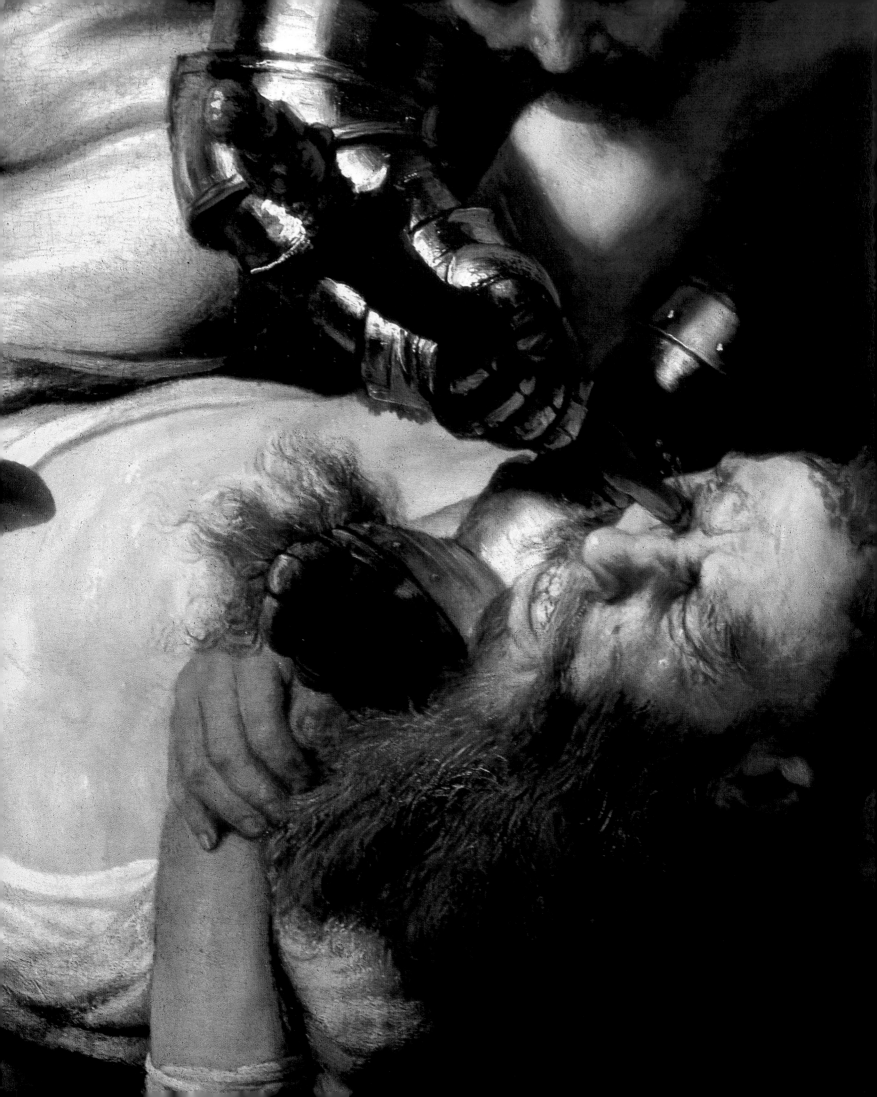

Rembrandt | Caravaggio
The Blinding of Samson | *Judith and Holofernes*

Depicting the psychology of violence

and the consequences of sexual lust

provided both Rembrandt and Caravaggio

with the opportunity to use their dramatic and

compositional skills to the utmost.

In *Judith and Holofernes* and *The blinding of Samson*

both artists pull no punches to portray in full gory detail

the bloody end of two biblical figures

who, after too great an indulgence in food and drink,

fell victim to the sexual allure and

seductive arts of powerful and beautiful women,

the one paying with his life, the other

with his eyesight.

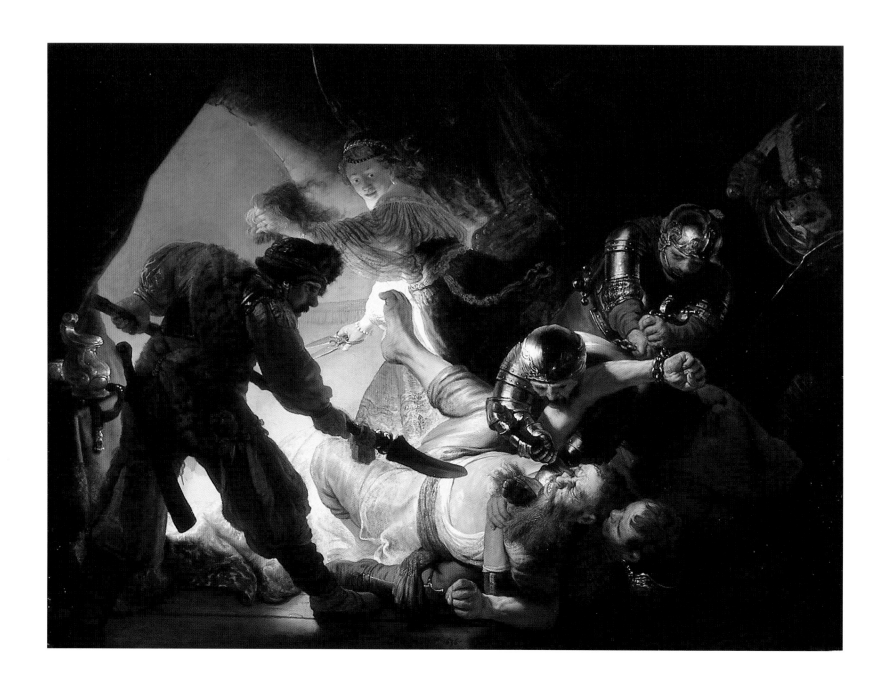

Cat. no. 9 Rembrandt
The blinding of Samson, c. 1635
Oil on canvas, 206 x 276 cm
Frankfurt am Main, Städelsches Kunstinstitut

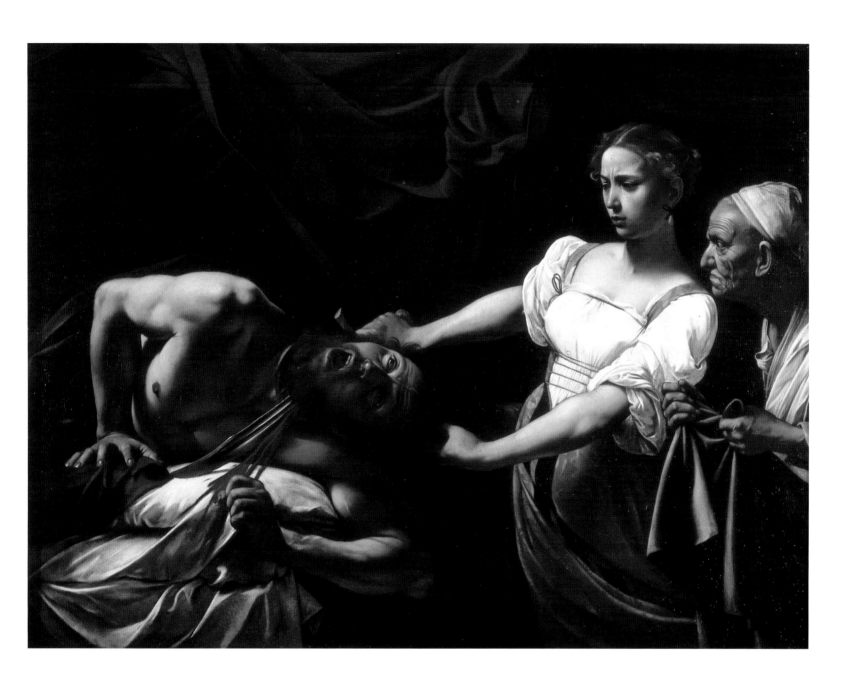

Cat. no. 10 Caravaggio
Judith and Holofernes, c. 1599–1600
Oil on canvas, 145 x 195 cm
Rome, Galleria Nazionale d'Arte Antica di Palazzo Barberini

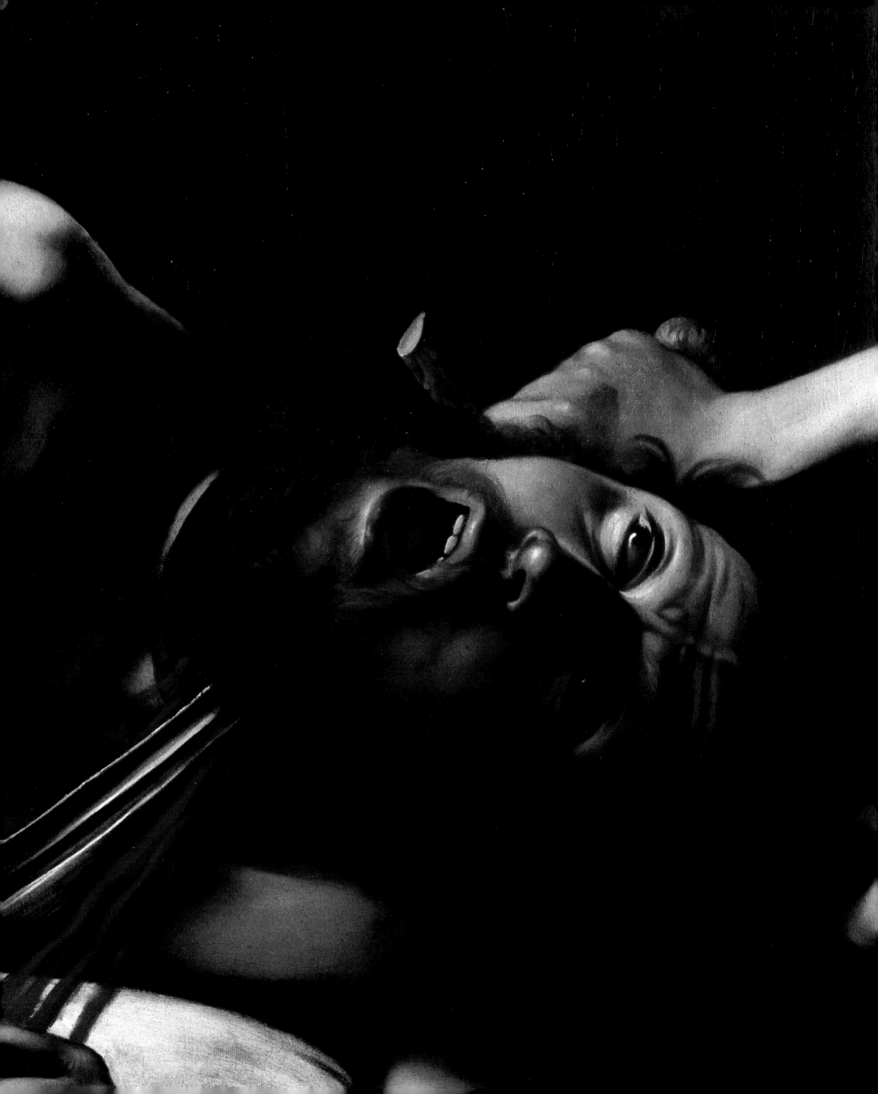

Caravaggio's picture – probably executed shortly before 1600 – was one of the first in which he took up the challenge of creating a full-blown narrative history painting. The subject of Judith had long been popular in Italian art, but Caravaggio unusually chose to depict the most horrific moment in the story of the beautiful Jewish widow, Judith who, together with her maid, stole into the camp of the Assyrian army that was besieging her home town of Bethulia. Using her charms, and dressed 'to allure the eyes of all men that should see her' (Judith 10:4), she won the trust of the commanding officer Holofernes, who invited her to dine in his tent with the purpose of seducing her. According to the Apocryphal Book of Judith, she 'was left alone in the tent, and Holofernes lying along upon his bed: for he was filled with wine. Now Judith had commanded her maid to stand without her bedchamber, and to wait for her [...]. So all went forth, and none was left in the bedchamber, neither little nor great. Then Judith, standing by his bed, said in her heart, O Lord God of all power, look at this present upon the works of mine hands for the exaltation of Jerusalem. For now is the time to help thine inheritance, and to execute mine enterprizes to the destruction of the enemies which are risen against us. Then she came to the pillar of the bed, which was at Holofernes' head, and took down his fauchion from thence, And approached to his bed, and took hold of the hair of his head, and said, Strengthen me, O Lord God of Israel, this day. And she smote twice upon his neck with all her might, and she took away his head from him' (Judith 13:2-8). She placed his head in a sack carried by her maid, and returned triumphantly with it to Bethulia. Faced with the mutilated body of their general and the sight of his head hanging from the battlements of the town, the Assyrians raised the siege and fled.

While Caravaggio's subject is the heroic deed of a woman for the salvation of her people, in Rembrandt's large and ambitious work from his most intensely experimental period of the mid-1630s,[1] it is the self-induced fall and the sexual frailty of a woman's victim that is central. The biblical hero

Samson was endowed by God with supernatural gifts and exceptional strength. His infatuation with the beautiful but vicious Delilah led him to stray further and further from the path of righteousness. When this cunning woman discovered the secret of Samson's invincibility lay in his uncut hair, 'she sent and called for the lords of the Philistines, saying, Come up this once, for he hath shewed me all his heart. Then the lords of the Philistines came up unto her, and brought money in their hand. And she made him sleep upon her knees; and she called for a man, and she caused him to shave off the seven locks of his head; and she began to afflict him, and his strength went from him. And she said: The Philistines be upon thee, Samson. And he awoke out of his sleep, and said, I will go out as at other times before, and shake myself. And he wist not that the LORD was departed from him. But the Philistines took him, and put out his eyes, and brought him down to Gaza, and bound him' (Judges 16:18-21).

The most immediately striking, indeed shocking, aspect of the two works is each painter's almost palpable enjoyment of their depiction of physical violence. Each emphasises the pain of the male protagonist, strengthening its intensity by the very different ways in which they set forth the reactions of the perpetrators and bystanders. Within the Italian artistic tradition, the expression of such emotions (known as *affetti*) was closely linked to the study of figures from life. Caravaggio's impressively staged depiction of the death-throes of Holofernes, who with staring eyes and open shrieking mouth howls against his fate, is quite clearly intended to disturb the spectator through its harsh actuality, the force of which is heightened by the static nature of the composition. Without precisely describing the dark space further than to suggest an air of close confinement, Caravaggio places his figures close to the picture plane, the horizontal format allowing him to follow the text describing Judith's approach to the bed. He then freezes the action, fixing the narrative at its most terrifying moment. It is with a mixture of disgust and reluctance that Judith calmly but firmly delivers the fatal stroke, her body bent slightly backwards as if she was literally

59

keeping her distance from her victim, while her pleated bodice, which emphasises her breasts, is given a corset-like stiffness. The impassive stare of the servant, whose wrinkled face and toothless mouth are counterpoised with the youthful beauty of her mistress, reinforces the powerful erotic charge that Caravaggio brings to the scene. The sharp contrast of facial features is one that Caravaggio exploited throughout his career, and may be connected to the writings of his Lombard contemporary and compatriot, Gregorio Comanini, who recommended painters to juxtapose sharply contrasting types in their paintings. But more than that, it is the servant's presence as voyeur that adds to the viewer's disquiet. She has seen it all before and her function, as Helen Langdon has cogently remarked, is reminiscent of the aged procuresses so frequently introduced as onlookers into erotic paintings of the 16th century.[2]

In Rembrandt's *Samson*, the chaotic turmoil of tumbling figures dominates the composition. In the foreground the Philistines overpower the hero, thrown to the ground and struggling like an animal at bay.[3] The pain caused by the piercing of his eye – shown with savage cruelty – is forcefully expressed by the exaggerated twist of his body, his upturned leg, and above all by the agonised curling of his toes. The pithy realism of this detail goes far beyond the

more measured gestures of Caravaggio's Holofernes. Within the swirling mass of his attackers, the prone body of Samson has clear affinities with an engraving by Cornelis Cort of 1566 after Titian's famous picture showing Tityus tormented in Hades for his unbridled lust (fig. 35). The parallels between this mythological figure – who symbolises the torment of carnal passion, for which he must bodily be punished on the order of the gods – and Samson – equally a victim of his unbridled lust – were undoubtedly known to Rembrandt and his contemporaries. In his *Wtlegghingh op den Metamorphosis,* published in Haarlem in 1604, Karel van Mander writes 'Others wish to proclaim with this great Tityus that no human power, however great, can prevail against divine justice without the transgressor being punished for the transgression.'[4] Rubens, too, had adapted Titian's figure of Tityus for his painting of the great transgressor Prometheus, now in Philadelphia, and it is clear that in borrowing the pose of the figure for his Samson, Rembrandt was also making use of its iconographical meanings and associations.[5] If Rembrandt indeed painted this picture as a gift for his protector, the great humanist and man of letters, Constantijn Huygens, as is usually believed,[6] it would be understandable that he should make, perhaps, a greater use of visual and literary associations than in other works.

In both pictures, the artists use light to emphasise the inherent drama of the atrocity. Thus Caravaggio sets his figures against a sombre background and lit by an invisible, artificial light which enters from outside the pictorial field. The strong contrasts of light and dark that define the musculature of Holofernes's torso and pick out the faces of Judith and her maid as they concentrate on their bloody deed, add to the atmosphere of desecration. Apart from the whites of the bed-linen and of Judith's blouse, the only strong colours are the brilliant dark red of the curtain and the similar hue of the blood streaming from Holofernes's neck. By confining the space and sharpening the light in this way, Caravaggio thickens the atmosphere to emphasise the horror. Rembrandt in his *Samson* goes one stage further, using the contrast between

fig. 35 Cornelis Cort, after Titian
Tityus, 1566 (engraving, 38.5 x 31.4 cm)
Amsterdam, Rijksmuseum

the light background at left and the dark foreground as a metaphor for Samson's fate. The hero both literally and figuratively falls from the light into the darkness in which, sightless, he must henceforth live. The organs of sight that had seduced him by allowing him to see Delilah have been taken from him forever.

Traditionally, both Judith and Delilah are considered to be exempla of female guile, symbolising the role of beautiful women in the downfall of powerful men through cunning and deceit. Unlike Delilah, however, Judith is also included in the pantheon of Old Testament heroes and heroines.[7] Her popularity was based on her example as a courageous, chaste and God-fearing woman, who although employing her charms to seduce Holofernes, did not in fact share his bed. Her energy and chastity (*pudicitia*) triumph over the stupidity and lust (*libido*) of Holofernes, something that Caravaggio subtly conveys through the distance Judith keeps from her victim, her arms unnaturally elongated as if to express her distaste at what she feels obliged to do. Rembrandt, on the other hand, leaves us in no doubt as to Delilah's baseness, showing her with the shears in her hand, holding Samson's shorn locks up to the light as she looks triumphantly at his degradation, both participant and observer.

Before Caravaggio, the actual bloody moment of the beheading of Holofernes was seldom depicted, in either the Italian or the Netherlandish artistic traditions.[8] It is the triumphant Judith with the severed head in her hand and often accompanied by her handmaiden, who was most frequently shown. Rembrandt, too, attempted such a depiction in a painting of 1635, but before he finished it he changed the figure of Judith by overpainting the severed head with a bouquet of flowers, transforming her into a figure of Flora (see Cat. no. 28).

Within their different contexts, Caravaggio's *Judith and Holofernes* and Rembrandt's *Blinding of Samson* are both works of extraordinary innovation, focusing unprecedentedly not only on the physical acts of violence but also implying their moral consequences. Although both subjects had a long pictorial tradition behind them, the portrayal of the most gruesome moment had almost always been avoided, and their head-on tackling of this aspect of the stories testifies to the daring and fertility of their imaginations. This is especially the case in the *Blinding of Samson*, where the actual gouging out of the hero's eyes had never previously been portrayed. Caravaggio's picture had an immediate effect, and enjoyed an enormous popularity, generating many copies, adaptations and versions among his followers. Rembrandt's choice of the moment of the blinding, on the other hand, remained almost unique. Through their unprecedented and incomparable power, both paintings belong to the undisputed high points of biblical history painting of the Baroque period. [DB]

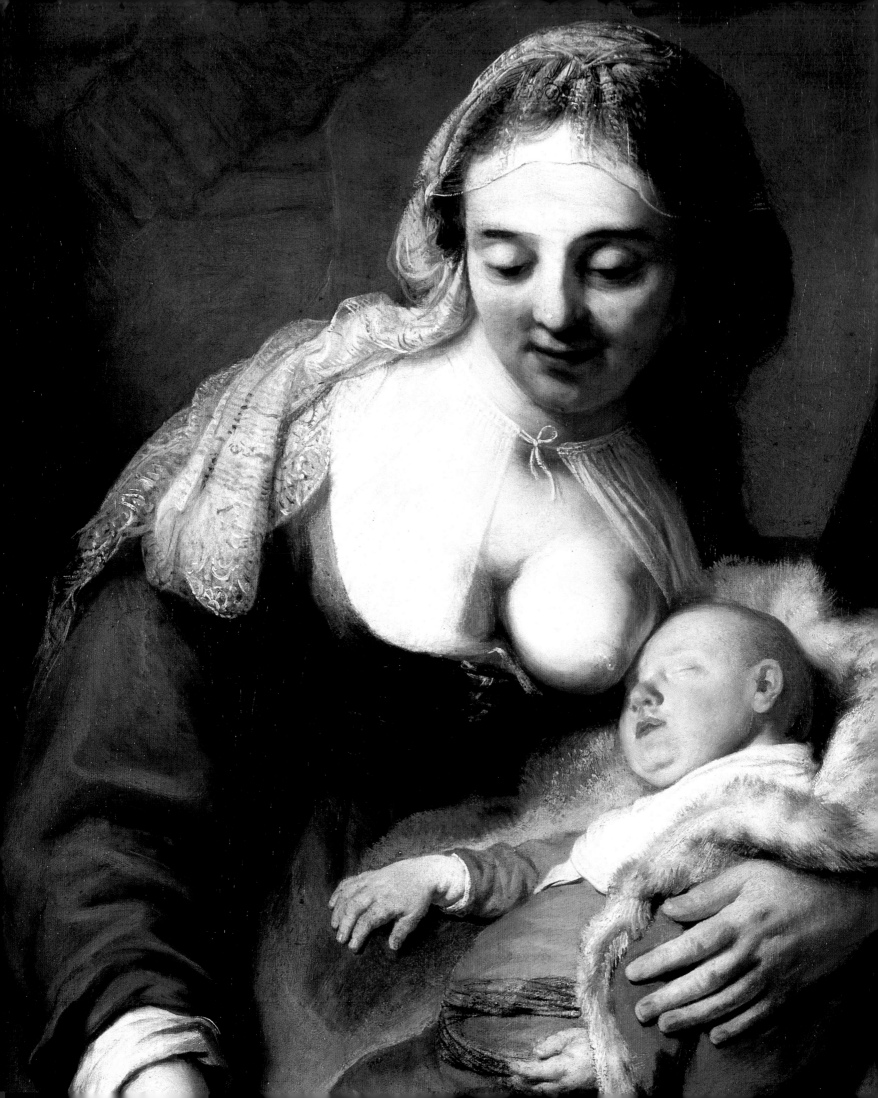

Rembrandt | Caravaggio
The Holy Family | *The Holy Family with*
in the carpenter's shop | *St John the Baptist*

The subject of the Holy Family,

showing the Christ Child, the Virgin Mary

and St Joseph, and often also including

the young St John the Baptist or Mary's mother St Anne,

has exercised artists throughout Christian Europe

since the early Renaissance.

From the 14th to the 19th century,

compositions with such groups were a mainstay

of artistic production, and in painting such works

artists were always, of necessity,

aware of the solutions reached by their predecessors

when formulating their own expressive

interpretations of the theme.

Cat. no. 11 Rembrandt
The Holy Family in the carpenter's shop, c. 1634
Oil on canvas, 183 x 123 cm
Munich, Bayerische Staatsgemäldesammlungen, Alte Pinakothek

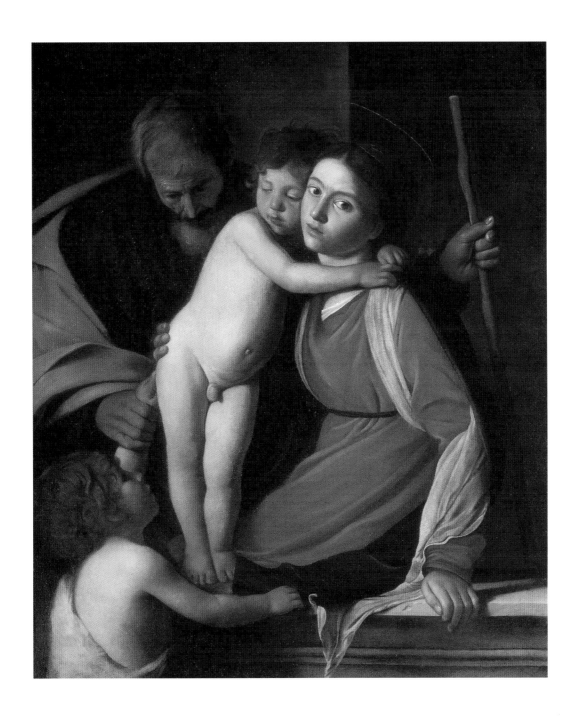

Cat. no. 12 Caravaggio
The Holy Family with St John the Baptist, c. 1603
Oil on canvas, 117.5 x 96 cm
New York, private collection, courtesy the Metropolitan Museum of Art, New York

Given the universal appeal and popularity of the subject, it is a little surprising that Caravaggio's *Holy Family with St John* and Rembrandt's *Holy Family in the Carpenter's shop* are exceptional within their respective oeuvres. Caravaggio's canvas is the only small-scale devotional Madonna he is known to have painted, and is conceived on quite a different scale and emotional pitch, for example, from his great altarpiece of the *Madonna of Loreto*, destined for the very public setting of the Church of S. Agostino in Rome (fig. 1). And although Rembrandt frequently explored the theme of the Holy Family in drawings and prints throughout his career, he only occasionally treated it in paint. Four paintings of the subject are known, the most notable being the present picture and the much smaller *Holy Family with angels* of about 20 years later (fig. 73), now in St Petersburg. The two artists' differing approaches to the subject tell us much about their artistic interests and personalities, and the way in which they made use of pictorial traditions.

What is striking about Rembrandt's *Holy Family in the carpenter's shop* is its sheer scale. Almost two metres high, it has the size and impact of a fully-fledged altarpiece destined for a Catholic church. This impression is partly due to its present exaggeratedly vertical format – it has been cut down at both left and right; but in its original state (which cannot be reconstructed precisely) its monumental character and ambition would have been equally evident. Although the signature and date are problematic and partial, the painting is generally agreed to date from 1634, and it therefore counts as one of the earliest, if not the very first, large-scale history paintings with figures almost at life size that Rembrandt attempted.[1]

The picture's provenance has not been established definitively, but it does not appear to have been painted either for a Catholic place of worship, as might be expected from its size, or for a Catholic patron as might be inferred from the subject. It seems that it was most probably acquired from the artist by an Amsterdam couple, members of the Reformed Church whose portraits Rembrandt painted in 1634. Although it is not known whether Marten Soolmans

and Oopjen Coppit actually commissioned the *Holy Family*, we know that other sitters who came to Rembrandt for portraits purchased subject pictures from him, and that is likely to have been the case here. The later evidence from an inventory of Oopjen Coppit and her second husband suggests that it hung in the main room of their Amsterdam house, and is thus unlikely to have had a devotional function.[2]

In both Italy and the Low Countries, images of the Holy Family in a domestic setting were generally painted on a relatively small scale, suitable to the intimacy of the subject, and were often intended for private devotion. Whether or not Rembrandt's picture was commissioned, it is surprising that he should have chosen this confined interior scene of Joseph, Mary and the infant Jesus as one of his first excursions into large-scale painting in the great tradition. From his earliest beginnings in Leiden he had had the burning ambition to be a history painter, tackling the great themes of the Bible and classical history. Until now, though, he had executed these in the diminutive formats used by his master Pieter Lastman, and in a relatively tight technique with contrasting colours and little variation in the forms. It may be that his experience as a portraitist in Amsterdam, filling a demand for full-length portraits at life size, and also confronted with the problems of constructing large-scale double portraits, gave him the impulse to expand his history paintings to a greater scale. Indeed, the pictorial and compositional challenges he tackles in the *Holy Family* are similar to those of a double portrait, in which the close bond between husband and wife has to be conveyed (fig. 19). Here the example of Rubens must have played a part, the painter *par excellence* on a grand scale, and also for Rembrandt's generation the foremost example of how the themes of Italian art could be combined with the northern painterly traditions.[3]

For all the full and heavy fleshiness of his Virgin – a far cry from the idealised Marys favoured by his Italian predecessors – it is clearly an Italian tradition that Rembrandt has here sought to assimilate and translate into his own language. Federico Barocci's small *Holy Family with a cat* in the National Gallery, London of c. 1575 is a typical example, itself derived

from that great painter of Madonnas and Holy Families, Raphael (fig. 36), with whose works Rembrandt would have been familiar through prints, copies, and original paintings that passed through Dutch collections and auctions.

Like his Italian predecessors, Rembrandt focuses on the maternal relationship of the mother and child. Before the canvas's format was altered, the Virgin with the Child on her lap would have occupied a more central place in the composition. It may be assumed that the missing portion to the left contained Rembrandt's depiction of the fire at which Mary is warming the infant, and which is evidently the source of the subtle light that falls across the Child and illuminates the cradle. The baby has fallen asleep after feeding, and the Virgin, her breast still hanging above the child's milky mouth, holds him tenderly, while Joseph, his work finished for the day and his tools hung up on the wall, leans across to contemplate the domestic scene.

Caravaggio was of course much closer to the pictorial world of Raphael and Barocci than was Rembrandt, both chronologically and as a product, albeit a critical one, of the Italian tradition. Like Rembrandt, he has chosen to show Joseph contemplating the Christ Child, who embraces his mother, evoking a moment of both awe and affection on the old man's part. It is worth emphasising that the theme of the Holy Family is above all a pictorial tradition, without biblical underpinning, one which from the 15th century onwards increasingly aimed to stress Christ's humanity. Caravaggio, more than Rembrandt, presents the Infant as an object of the spectator's devotion, bringing to his delineation of the child's flesh that careful, descriptive naturalism that he brought to his early genre pictures such as the *Boy with a basket of fruit* (Cat. no. 27). But at the same time, the interlinked figures, the pyramidal composition of the two holy figures, and the play of curves of St John's and the Virgin's arms and of St Joseph's cloak show him, perhaps more than in any of his other works, emulating the achievements of his great High Renaissance predecessors. The picture is also, perhaps, a response to the achievements of his older contemporary, the Bolognese painter Annibale Carracci, who consciously set out to revive the classical ideals of the High Renaissance masters. Caravaggio is known to have admired his rival, and his painting may have been directly inspired by a composition by Annibale, a version of which was owned by Caravaggio's admirers and patrons, the Giustiniani family (fig. 37).[4] Not only is the way in which Caravaggio shows the Virgin presenting the Christ Child to the viewer substantially similar to that of Annibale, but Caravaggio has also taken up the somewhat unusual motif of showing the Virgin looking out of the picture space toward the viewer. Indeed, it is the play

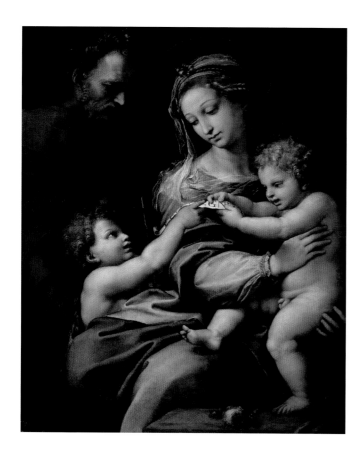

of glances that helps to make Caravaggio's picture so power-ful. While the infant St John looks up with reverence at his cousin, St Joseph carefully restrains him from touching the Christ Child, whose downward glance shows him aware of what is happening. This serves to stress the apartness of the divine Child, even within the tender environment of the family group. At the same time, Caravaggio underlines the physicality of the scene, not only through the Virgin's hand solidly supporting the infant's hip, but also through the careful description of her dress, cinched tight around the waist, and the beautifully delineated shawl that winds down her arm and rests on the parapet. It is typical of Caravaggio that he explores and sharpens the compositional and emotional inventions of his predecessors, taking their solutions one stage further.

It is not known when, or for whom, Caravaggio painted his Holy Family. Stylistically it can be dated to around 1603, when he was engaged with some of the most innovative works of his early maturity, such as the *Betrayal of Christ* (Cat. no. 17), *St Matthew and the angel* (fig. 44) and the *Madonna of Loreto* (fig. 1).[5] If it lacks the intense, almost harsh, realism of those works in which the presence of Caravaggio's posed models is almost palpably apparent, it is probably because the more conventional nature of the subject challenged him to temper his innate inclination to naturalism and to aim at a more universalised image. Nevertheless, the body of the Christ Child and the idealised face (by Caravaggio's standards) of the Virgin, swept by the subtle fall of light from the left, have a physicality and a presence that is entirely characteristic of the artist, sharpening the calm, almost meditative quality Caravaggio brings to this tightly knit scene. While adhering to the realistic presentation of the figures that he had used in such early works as the *Boy with a basket of fruit*, (Cat. no. 27) he here softens it to embrace the idealising tradition he had worked to subvert and to challenge in those works.

Surprisingly, Rembrandt's vision of the Holy Family, though equally contemplative, appears more idealised than Caravaggio's. The rather broad, scattered handling of the paint, especially in the faces of the Virgin and St Joseph, lacks the terse defining quality of his portraits of this period, such as that of Johannes Wtenbogaert (Cat. no. 18). It has sometimes been suggested that when painting this picture Rembrandt, like Caravaggio, may have been reacting to a north Italian precedent, and specifically one by Annibale Carracci.[6] But whether or not that is the case, it is surely true that Rembrandt was here striving for an image of the Holy Family and an evocation of domestic maternity that spring from the same Italian tradition used by Caravaggio. However much more substantially he portrays the protagonists, however careful he is to suggest the atmosphere of the carpenter's shop, this is in the end a triumphant attempt, as is Caravaggio's, at stamping his own artistic personality on one of the universal themes of the painter's art. [DB]

69

fig. 36 Raphael
La Madonna della rosa, c. 1518 (103 x 84 cm)
Madrid, Museo Nacional del Prado

fig. 37 Annibale Carracci, attributed
The Holy Family, c. 1599 (100 x 80 cm)
Staatliche Museen zu Berlin, Gemäldegalerie

Rembrandt | Caravaggio
Flora | *The penitent Mary Magdalen*
| *St Catherine of Alexandria*

Caravaggio and Rembrandt

were fascinated by the ability of art to transform,

by the way in which combinations of objects,

observed and depicted, can affect meanings and resonances.

The simple act of dressing up a model

does not change that person into the historical

or mythological figure he or she is playing,

but the act of painting the dressed model can do so.

In their presentations of the goddess Flora,

St Catherine of Alexandria and St Mary Magdalen,

Rembrandt and Caravaggio explore and exploit

the tensions between reality,

appearance and art to magnificent,

even disturbing, effect.

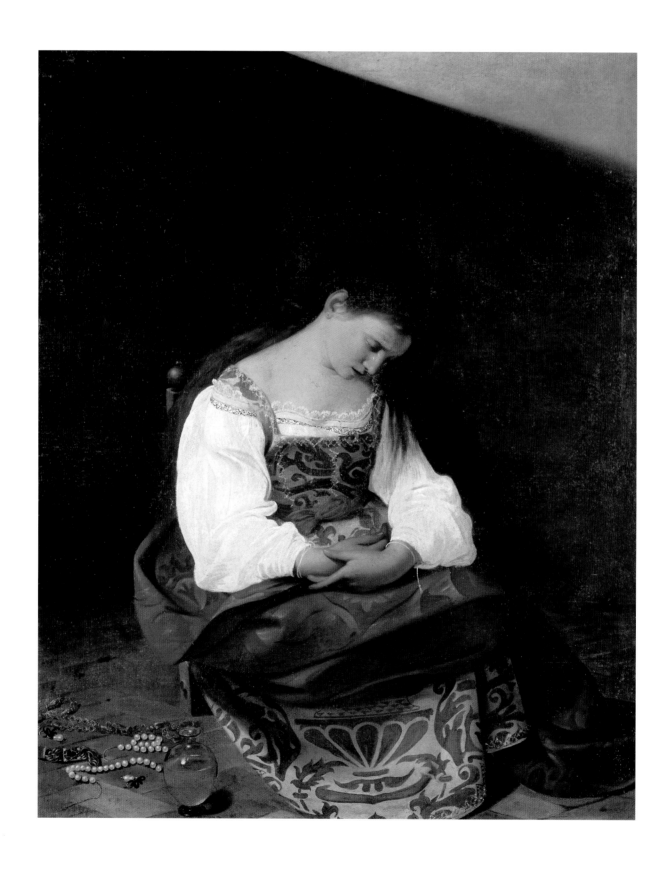

Cat. no. 13 Caravaggio
The penitent Mary Magdalen, c. 1598
Oil on canvas, 122.5 x 98.5 cm
Rome, Galleria Doria Pamphilj

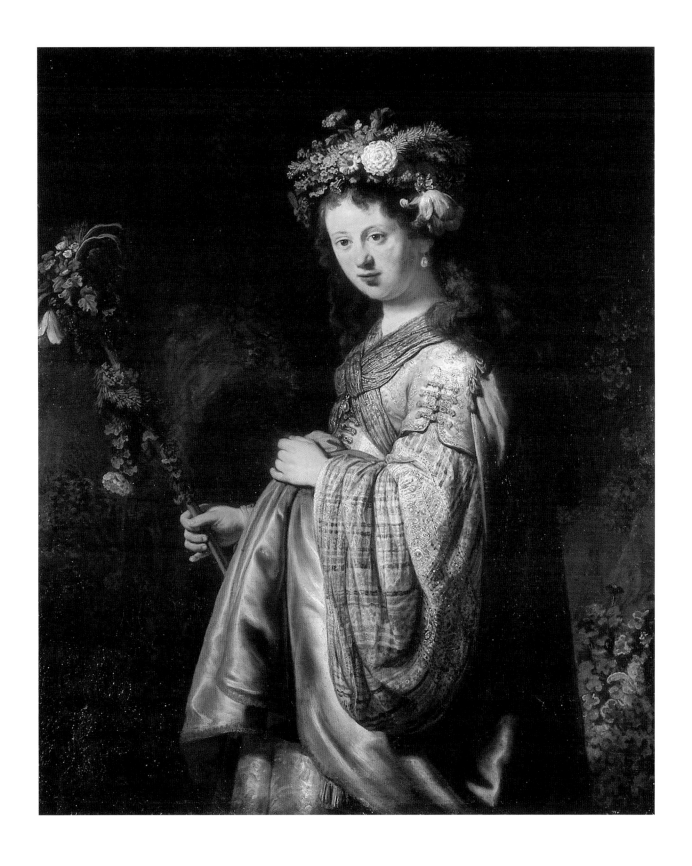

Cat. no. 14 Rembrandt
Flora, 1634
Oil on canvas, 124.7 x 100.4 cm
St Petersburg, The State Hermitage Museum

Caravaggio's *St Catherine* and *Penitent Mary Magdalen* are among his most stagy paintings, not so much because they are overtly theatrical in their presentation of the beautiful young martyr and the sorrowing saint, but because they seem to retain a sense of an almost too careful arrangement of stage props around the slightly uneasily posed figures. In the *St Catherine*, the wheel at left on which the saint was tortured, the sword she holds with which she was beheaded, and the palm of martyrdom so casually placed in the foreground, are all delineated with a sharpness of focus bordering on hyper-realism. These are symbols that characterise the saint and help the viewer identify who the woman is, but Caravaggio presents them as objects present and palpable to an extent seldom found in the works of his predecessors. This insistent realism is equally present in the ointment pot and jewellery on the floor to the left of the figure in the *Penitent Mary Magdalen*, where they form what approaches an incidental still life in its own right.

This tension between mimesis and symbolism in such objects is something that Caravaggio well knew how to exploit, and it was – at least implicitly – recognised in the 17th century by the leading critic and theorist Giovanni Pietro Bellori. Writing in the 1670s, Bellori criticised the young Caravaggio for copying nature too closely, stating that when posing and painting a person whose appearance he liked, he did not bring his own ingenuity to bear but simply followed 'nature's invention' – that is to say their outward appearance. He recounts as an example of this tendency, in what is possibly a factitious anecdote, how Caravaggio painted his *Magdalen*. 'When he came upon someone in the town who pleased him, he made no attempt to improve upon the creations of nature. He painted a girl drying her hair, seated on a little chair with her hands in her lap. He portrayed her in a room, adding a small ointment jar, jewels and gems on the floor, and so turned her into [literally: counterfeited her as] Mary Magdalen.'[1]

It is, Bellori implies, the attributes, the incidental parerga of the jewels and glass jar, that convert this picture from a straightforward study of a young woman to an image of a saint, and the same could be said of the sword, palm and wheel in

St Catherine. From Bellori's standpoint, Caravaggio ought to have idealised his models, softened and improved their appearance, giving them the elevated decorum of saints rather than describing them with the same realism as he does the studio props that serve to identify them. In both pictures it is perhaps this realism that accounts for the apparent staginess. Both figures retain the faint uneasiness of a living model holding a pose. Indeed, the girl playing St Catherine seems to be leaning for support against the swathe of drapery thrown somewhat incongruously over the axle of her wheel in order to maintain her balance as she patiently sits for the painter, while the clasped arms and angled head of the Magdalen retain the whiff of a studio arrangement.

Rembrandt's *Flora* from St Petersburg seems similarly to hold a pose. She is the earlier of the two three-quarter-length female figures adorned with flowers that Rembrandt painted in the mid-1630s, and she is both simpler and more artful than the slightly later version in London (Cat. no. 28). Like Caravaggio's two saints, she seems primarily to be a study of a richly dressed young woman – and Rembrandt has devoted particular attention to the textures, stripes and trimmings of her sumptuous but chromatically muted garments – to whom he has given a floral crown and flower-entwined staff. As in the case of the London *Flora*, the flowers are identifiable as marigolds, a columbine, anemones, forget-me-nots and a tulip,[2] but, unlike that picture, the figure seems to have been conceived in the form she now has, and was not adapted from another type. Rembrandt's precise intentions as to her identity cannot be established with certainty, and critical opinion has been divided as to whether she is meant as a pastoral figure (possibly based on a character from a stage play), as a representation of the ancient goddess Flora, or as a *portrait historié*, possibly representing the artist's young wife Saskia playing one of these roles.[3] This uncertainty stems largely from the fact that the wreathed staff – reminiscent of the thyrsus carried by the followers of Bacchus – does not have the semantic strength of the specific and established attributes Caravaggio has supplied to his two saints. On balance, however, it seems most

75

likely that, as in the London picture, she represents Flora, goddess of spring and fertility. Although this does not exclude the possibility that Saskia may have posed for the figure, the painting conforms to a number of images of idealised mythological or historical female figures that Rembrandt was painting around this time, including a picture of Bellona, the goddess of war (New York, Metropolitan Museum of Art), and the so-called *Queen from antiquity* (Cat. no. 32), whose identity as Sophonisba or Artemisia has also not been established definitively.

What seems clear, however, is that Rembrandt was playing with ideas of female beauty, sensuousness and purity in this poetic evocation of a single figure shown in uncharacteristically full lighting against a darker, neutral backdrop. It seems more than possible that here, as in the London *Flora* as well, he was reacting to the magnificent sensuality of a painting by Titian which is known to have been in Amsterdam in this period (fig. 50). That Rembrandt knew this picture can be deduced from the rather more literal use he made of it in a conventional portrait of Saskia in Dresden, in which she is shown holding a flower.[4] But in his St Petersburg picture it is Titian's voluptuous combination of female beauty, costume and floral abundance that has most interested him, and which he has adapted to produce his haunting image, which seems to hover between a depiction of a real woman and an evocation of the goddess of spring. This ambiguity, or openness to interpretation, may also stem from Titian's example, where the woman's characterisation as Flora is even less explicit, and which belongs as much to the Venetian tradition of paintings of beautiful women – often portraits of, or based on, courtesans – as to the established tradition of mythological paintings.

Caravaggio would have been equally, if not more, aware of such paintings by Titian. Although he is perhaps unlikely to have known the painting once in Amsterdam, he would certainly have seen similar works by Titian and his Venetian contemporaries, of which the *Flora* is but one, outstanding, example. That such works rely as much on the sexual attractiveness of the woman as on the iconography of the image adds a frisson to Caravaggio's characterisation of the two saints. As in Rembrandt's *Flora*, in these two paintings it is the combination of sumptuous drapery and female beauty that was Caravaggio's starting point, and he was indeed one of the first artists to exploit the sexual overtones inherent in the legends of so many saints. St Catherine – an immensely popular Counter-Reformation saint, whose legend is not supported by ascertainable fact – was believed to be a princess of royal descent and great erudition who refuted the arguments of 50 pagan philosophers, refused to deny her faith, and was beheaded after being tortured on a spiked wheel. It is perhaps her royalty that Caravaggio emphasises through his inclusion of rich draperies and the scarlet cushion on which she kneels, just as the expensive brocaded dress and drapery of the Magdalen emphasise that saint's status as a prostitute or courtesan, whose life of pleasure and vanity she is shown repenting after her conversion (see Cat. no. 30).

The very fact that we can recognise the features of St Catherine as those of Mary Magdalen in the *Conversion of the Magdalen* (Cat. no. 30), as well as in other works, speaks of his strong adherence to the physical characteristics of his models, as Bellori remarked. This sort of specificity draws further strength, as does Rembrandt's image of Flora, from the way in which the artists have combined various types and traditions of pictorial image. One of the few contemporary criticisms of Caravaggio's works that has come down to us, contained in a letter of 1603 written by the erudite Cardinal Parravicino, speaks of his works as falling between the sacred and the profane (*tra il devoto e il profano*).[5] Although Rembrandt's *Flora* is sacred only in a pagan sense, the ambiguity that Parravicino recognised is disturbingly present in all three pictures. [DB]

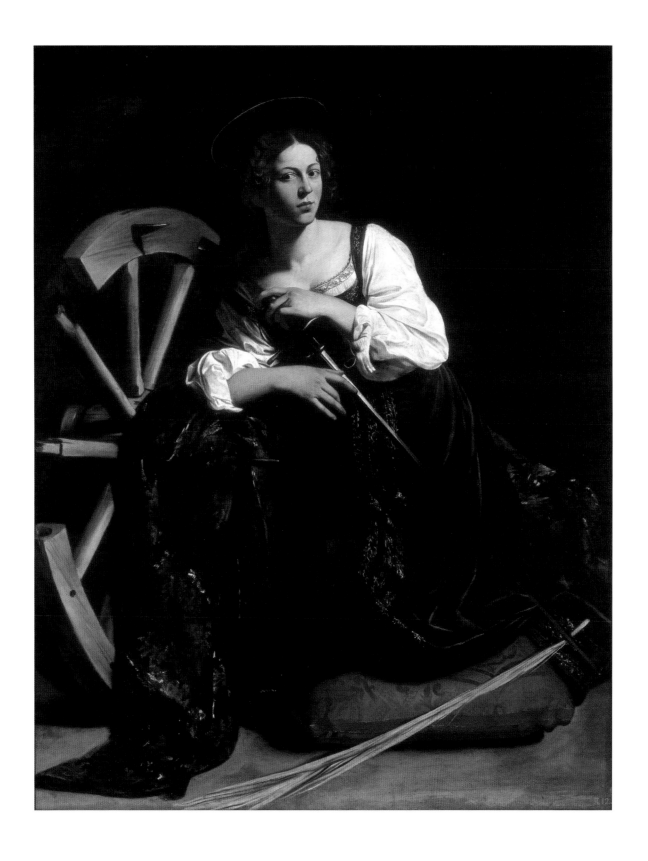

Cat. no. 15 Caravaggio
St Catherine of Alexandria, c. 1599
Oil on canvas, 173 x 133 cm
Madrid, Museo Thyssen–Bornemisza

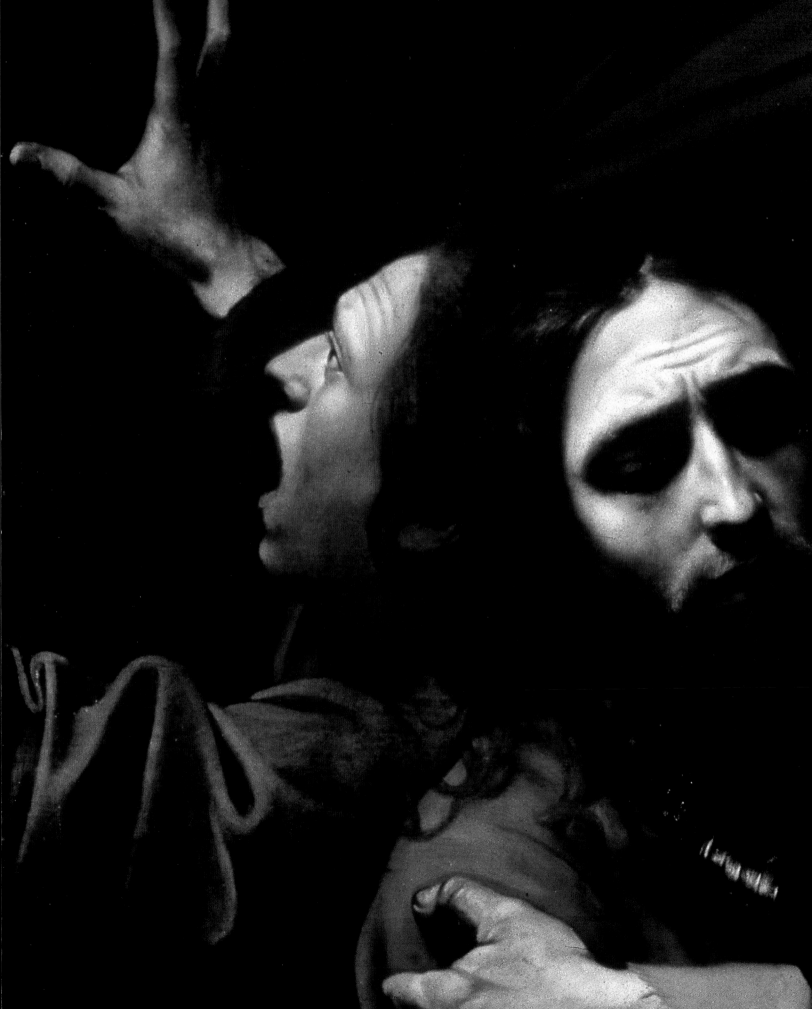

Rembrandt | Caravaggio
The denial of St Peter | The betrayal of Christ

One of the great advances that

the 17th century brought to religious narrative painting

was the exploration of the underlying emotions

of a particular biblical episode,

so that the finished work does not merely illustrate

the actions described in the scriptures

or other sources but examines

the human and theological associations

to which they give rise. In treating the great themes

of the Christian story, both Rembrandt and Caravaggio

trained themselves to isolate the most telling moments

of a particular episode with a clear simplicity,

while losing nothing of the complexity of the narrative

and its spiritual dimension as it unfolds in time.

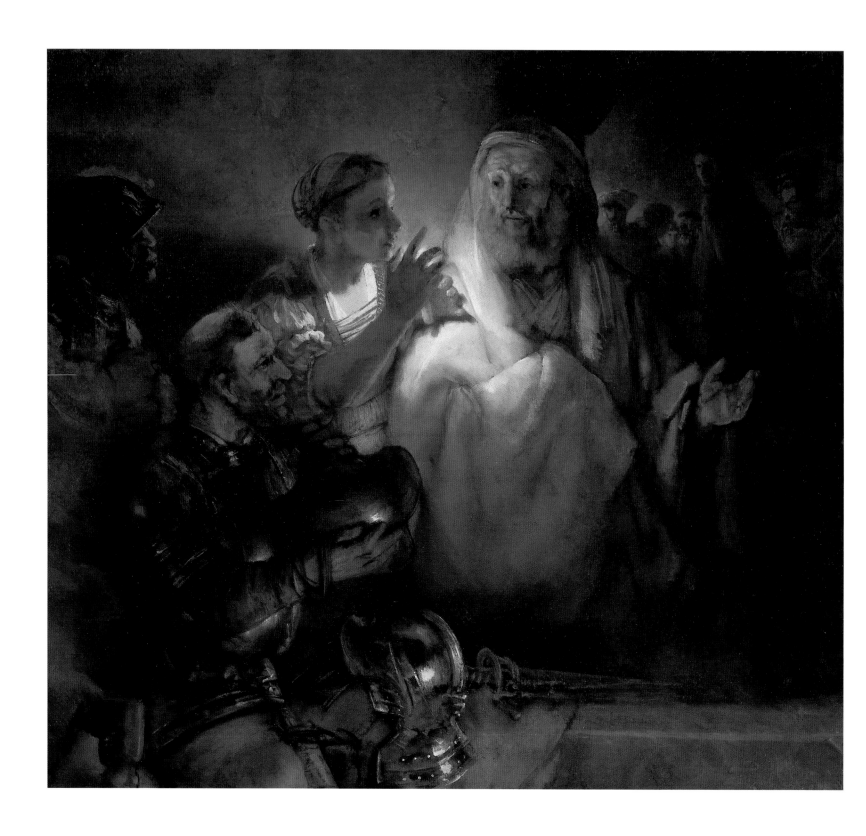

Cat. no. 16 Rembrandt
The denial of St Peter, c. 1660
Oil on canvas, 154 x 169 cm
Amsterdam, Rijksmuseum (purchased with aid from the Vereniging Rembrandt)

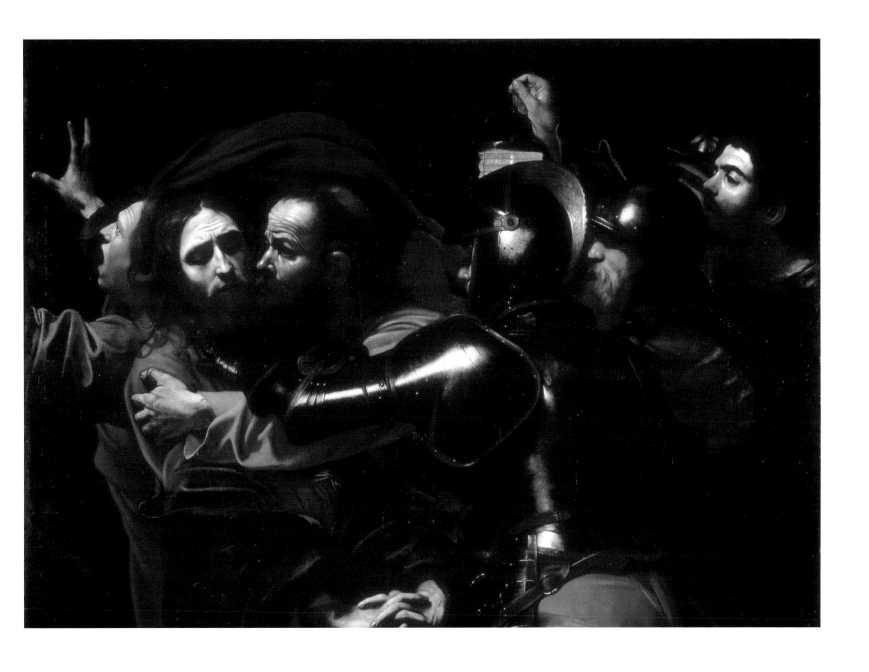

Cat. no. 17 Caravaggio
The betrayal of Christ, 1602
Oil on canvas, 133.5 x 169.5 cm
Dublin, the National Gallery of Ireland

In Caravaggio's painting of Christ's arrest in the garden of Gethsemane and in Rembrandt's depiction of St Peter denying knowledge of his master later the same night, each artist interprets and meditates on an act of betrayal. Each goes to the heart of the biblical texts, choosing what is most relevant for what he wishes to convey, and each brings his skills in the manipulation of light to bear with the greatest effect to highlight his interpretation. Judas's betrayal of Christ to the arresting soldiers by a kiss and St Peter's denial mark the beginning of Christ's Passion and desolation. In formulating their compositions and in shaping their responses to the written sources, both Rembrandt and Caravaggio bring their humanity of outlook to moments of extreme despair.

Caravaggio painted the *Betrayal of Christ* in 1602 for the prominent nobleman marchese Ciriaco Mattei, for whom he had executed the *Supper at Emmaus* (Cat. no. 38) approximately a year earlier.[1] The painter was then 31 years old, and was enjoying his first great Roman success. He was living under the protection of Mattei's brother, the devout Franciscan cardinal Girolamo Mattei, who may well have advised him on theological aspects in both paintings.[2]

In Caravaggio's composition, which is loosely based on a well-known print by Dürer (fig. 39),[3] Judas's act of betrayal takes place, curiously, to one side, while the pictorial field is dominated by the armour of the soldier in the foreground, who reaches forward past Judas to seize Christ by the throat. Above this figure, and almost hidden by his helmet, is a lantern held by the man reaching forward from the right, while on the left a young man flees with his cloak streaming behind him in a curve that contains and isolates the heads of Christ and his betrayer.

The moment Caravaggio has chosen to portray – that of Judas pulling Jesus towards him in an embrace, rather than the actual kiss itself – is unusual. Of the four gospel accounts St Mark's tells us that Judas went 'straightway to him, and saith, Master, master; and kissed him. And they laid their hands on him, and took him' (Mark 14:45-46). Caravaggio

shows Christ's lips parted as if in speech, and it may be that he is following St Matthew's account, in which Jesus speaks to Judas after the kiss and before being seized by the soldiers (Matthew 26:47-50). Given the implied movement of the embrace, which suggests that the kiss has not yet taken place, it seems more likely that Caravaggio has taken his cue from St Luke, who does not describe the kiss itself: 'he that was called Judas, one of the twelve, went before [the multitude of soldiers], and drew near unto Jesus to kiss him. But Jesus said unto him, Judas, betrayest thou the Son of man with a kiss?' (Luke 22:47-48). If that is indeed the case, Caravaggio's focus is on Christ's bitter question. In any case, it is clear that he has taken different elements from the differing accounts: St John is the only evangelist to mention the lantern and torches (John 18:3), while the fleeing figure to the left is mentioned only by St Mark (14:51-52). This is a distillation of the sources, in which the artist has selected what is necessary for his expressive purposes, whose force and focus are far sharper than the conventional multi-figured compositions of this subject by his predecessors and contemporaries.

Still intently experimenting in this early phase with the expressive potential of light, Caravaggio makes the dark but shining armour and brilliant red breeches of the central soldier epitomise the physical violence that is about to overtake the resigned and agonised Jesus. The lantern behind his helmet can scarcely be the light source that creates the reflections on the inky metal. For Caravaggio's artistic purposes it is the spectral quality of the undefined illumination – perhaps moonlight – which enters from outside the pictorial space and bathes the faces of Judas and of Jesus that is of importance, not the verisimilitude of its origin. In the whirl of gestures, from the outstretched hand of the fleeing disciple, through the clutching grasp of Judas up to the hand holding the lantern, it is Christ's knotted fingers, accentuated in the void below the soldier's arm, that are most prominent and the most carefully lit. The crisply delineated forms of the armour contrast with the softer folds of the passive Christ's draperies, just as the coarse physiognomy of Judas is juxtaposed with the pallid features of Christ, whose eyes and

mouth melt into shadow. The brutal energy of the group of figures at the right serves only to emphasise Jesus's isolation even as he is embraced.

Rembrandt's canvas of more than 50 years later, executed around 1660 in the diffuse, richly painted style of his full maturity, could hardly be more different in composition and coloration from the sharp, concentrated image of Caravaggio's *Betrayal*. Yet Rembrandt makes use of a remarkably similar range of devices and ingredients in dramatising the moment and the consequences of St Peter's denial. Here too, unusual emphasis is given to the gleaming helmet and the armour of the seated soldier on the left, whose military presence provides the background to Peter's act of perfidy: this soldier, Rembrandt implies, has been in the garden of Gethsemane and has assisted in the arrest. Rembrandt, too, has made use of multiple light sources:[4] the helmet is lit from lower right, while the Caravaggist device of the shielded candle held by the maid casts an interrogative light on St Peter.

Like Caravaggio, Rembrandt has fused separate events in the scriptural accounts to fix a moment pregnant with psychological tension. At the Last Supper, Jesus had prophesied that Peter would deny him three times before the cock crew. After Christ's arrest, Peter followed him to the house of the High Priest, where, according to St Luke, 'when they had kindled a fire in the midst of the hall, and were set down together, Peter sat down among them. But a certain maid beheld him as he sat by the fire, and earnestly looked upon him, and said, This man was also with him. And he denied him, saying, Woman, I know him not. And after a little while another saw him, and said, Thou art also of them. And Peter said, Man, I am not. And about the space of one hour after another confidently affirmed, saying, Of a truth this fellow also was with him: for he is a Galilaean. And Peter said, Man, I know not what thou sayest. And immediately, while he yet spake, the cock crew. And the Lord turned, and looked upon Peter. And Peter remembered the word of the Lord, how he had said unto him, Before the cock crow, thou shalt deny me thrice' (Luke 22:55-61).

Again, the four Gospel accounts differ, with Matthew (29:69-75) and Mark (14:66-72) placing the second denial outside on the porch of the house, but it is clear that Rembrandt has here fused all three denials. The space in which the action is set is clearly that of the hall, dimly lit by the glowing fire at lower right that illuminates the helmet. The maid holding the candle represents the first denial. The presence of the soldiers alludes to the second, which according to St Matthew and St Mark was addressed to the bystanders, one of whom St John (18:26) explicitly mentions as having been in the garden at the time of the arrest. It was only after the third denial and the crowing of the cock that Jesus turned to look at Peter, and this Rembrandt shows in the glimpse through to a second interior space at the upper right where Christ, standing before the High Priest, pivots his head to gaze back at his disciple.

If Rembrandt has thus compressed the narrative, it is with the purpose of focusing on Peter's inner struggle as he realises the enormity of his betrayal. Like Caravaggio, he provides a close-up view of events, showing the three figures at three-quarter length filling the pictorial field with a power that a more generalised view, as seen in a drawing of some five years earlier (fig. 38), lacks. And as in Caravaggio's composition, it is principally the play of gesture that carries the message: Peter's outstretched hand, immediately below the figure of Christ, expresses both his denial and his dawning remembrance of Christ's prediction of his betrayal. It rhymes with the hand of the maid, which conceals the light in a gesture that implies both interrogation and judgement. This painting marks a renewed return on Rembrandt's part to a concealed light source, which he had made much use of in his early years when still under the direct influence of the Dutch Caravaggist painters, and it is interesting to note that at an early stage of painting, while struggling to work out the composition, he suppressed a torch on the wall above the maid's head,[5] preferring the more subtle compositional solution in which the light falls mainly upon Peter's cloak, leaving his face in shadow, as befits his state of doubt and misery.

Rembrandt painted his *Denial of Peter* at the beginning of his last, most introspective, period, with the limited tonality and broad expressive brushstrokes that serve to reduce the scene to its essentials. His scrutiny of the aged St Peter's mental conflict goes hand in hand with the self-scrutiny found in his powerful self-portraits in old age. Caravaggio's *Betrayal of Christ*, on the other hand, is in many ways a young man's picture, in which he is still keen to show off his skills: this comes through especially in the accurate rendering of the details of the armour, about which one of his early critics remarked that he went so far as to record the rust.[6] But for all the powerful realism of the soldiers, Caravaggio's achievement, like Rembrandt's, is to capture the full implications of the betrayal at the moment it takes place. Like Rembrandt, he has eliminated everything superfluous, and indicates the setting in the garden only by the indication of foliage behind Judas's head (which may also refer to the tree on which Judas later hanged himself). Both painters, too, use a similar device of showing the subsidiary characters in profile, concentrating the full force of their genius for facial characterisation on the frontal presentation of the protagonists.

It had long been noted – even before the rediscovery of Caravaggio's picture in Dublin, when the composition was known only through copies – that the man extending the lantern from the right is almost certainly intended as a portrait of Caravaggio himself. It does indeed conform to what we know of the painter's features, and although

it was not unusual for artists to introduce self-portraits into religious scenes at this period, Caravaggio here shows himself literally illuminating the scene, just as both he and Rembrandt metaphorically illuminate these central episodes of the Christian story.[7] [DB]

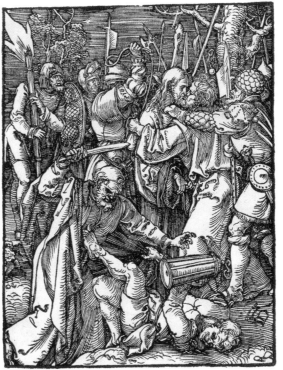

fig. 38 Rembrandt (?) *The denial of Peter* (pen and brown ink, 18 x 25.5 cm) Paris, École nationale supérieure des beaux-arts

fig. 39 Albrecht Dürer *The taking of Christ* from the *'Small' Passion*, c. 1509 (woodcut, 12.7 x 9.7 cm) Amsterdam, Rijksmuseum

Rembrandt | Caravaggio
Portrait of | *Portrait of Fra Antonio Martelli*
Johannes Wtenbogaert | *('The Knight of Malta')*

Rembrandt was a prolific portraitist;
indeed his reputation among his contemporaries
and much of his income largely depended
on his activities in this field.
By contrast, there are only four surviving portraits
that are generally accepted as being by Caravaggio,
and although he is known to have painted
at least twenty others now lost,[1]
portraiture seems never to have formed
a major part of his artistic activities or ambitions.
When he did turn his hand to portraiture,
however, he could prove just as capable as the more
practised Rembrandt in providing a penetrating study
of character combined with deep
psychological insight.

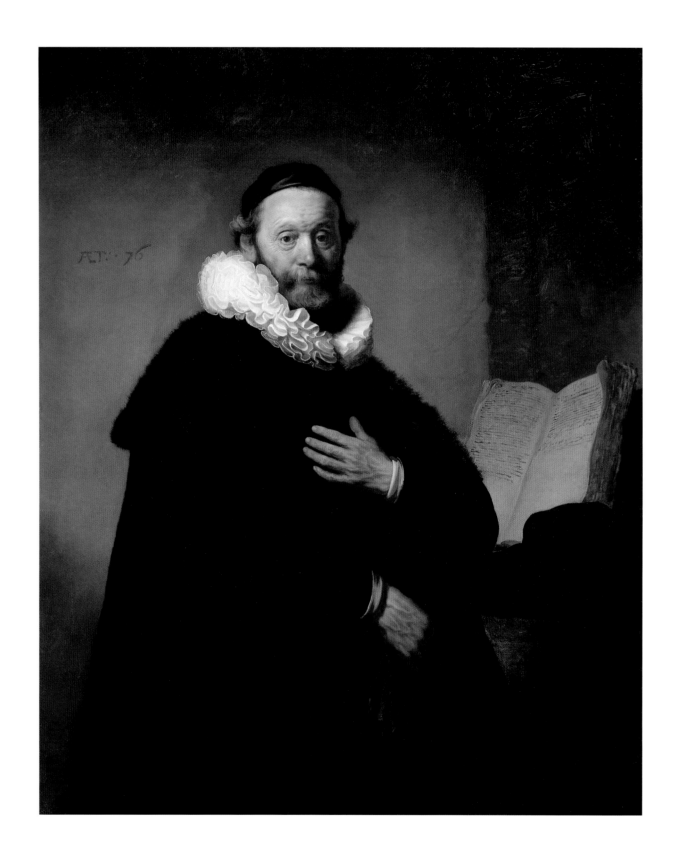

Cat. no. 18 Rembrandt
Portrait of Johannes Wtenbogaert, 1633
Oil on canvas, 130 x 103 cm
Amsterdam, Rijksmuseum. Purchased with aid from the Vereniging Rembrandt, co-facilitated by the Prins Bernhard
Cultuurfonds, the VSBfonds, the Rijksmuseum Stichting, the State, numerous private and corporate donors

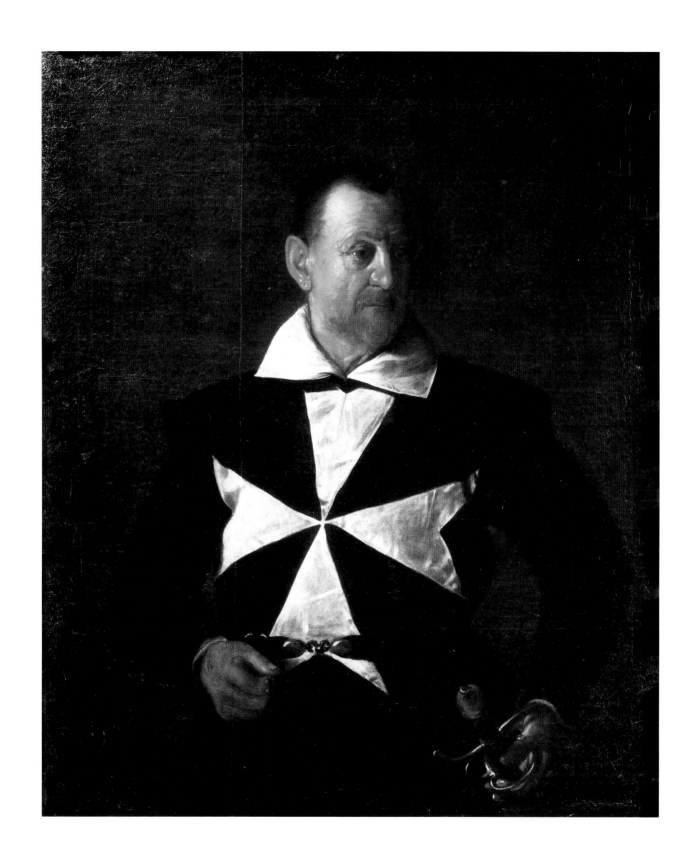

Cat. no. 19 Caravaggio
Portrait of Fra Antonio Martelli ('The Knight of Malta'), c. 1608
Oil on canvas, 118.5 x 95.5 cm
Florence, Galleria Palatina, Palazzo Pitti

Caravaggio's achievement as a portraitist can be judged from a comparison of his severe portrayal of the 74-year-old warrior Antonio Martelli wearing the insignium of a senior brother of the Catholic charitable and military Order of the Knights Hospitaller of St John, and Rembrandt's haunting study of the 76-year-old Remonstrant preacher Johannes Wtenbogaert – works in which both artists make use of and extend many of the standard conventions of portraiture to focus powerfully on the inner nature of their sitters.

What is immediately striking is the expression of spiritual power and sheer force of personality that emanates from these two canvases, both painted in the limited range of black and white dictated by the sitters' clothes, and both making use of a simple, minimally defined background which had been a convention of portraiture at half or three-quarter length since the late 15th century (fig. 40). Both are executed with a closely observed naturalism in which none of the features of old age is softened or smoothed away, with one half of the face brightly lit, the other in shadow. This scrutinising realism extends to the details of the costume – in the Rembrandt the sharply defined white cuffs and the tour-de-force painting of the fresh white ruffled collar, and in the Caravaggio the careful depiction of the play of scattered light on the fabric of the great white cross which follows the folds of the tunic to which it is sewn and animates this emblem of the sitter's professional identity with a sense of the tense activity of the man himself. Seldom has that standard device – almost cliché of 16th and 17th-century portraiture – the use of a white neckcloth to act as a foil to an austere physiognomy, been better employed than in these two pictures.

Although Wtenbogaert's and Martelli's careers and religious convictions could hardly have been more different, they possess a certain symmetry that may help to account for the comparable qualities of melancholic introspection that both artists have emphasised. Martelli, whose identity as Caravaggio's sitter has only recently been confirmed, was born to an aristocratic Florentine family, and rapidly distinguished himself as a soldier in the service of both the Grand Duke of Tuscany and the

Order of St John (the Knights of Malta) which he had joined at an early age. Founded during the First Crusade as a lay order of charitable and chivalric hospitallers, the Knights of St John became primarily military in purpose, seeing their role as defenders of the Catholic faith, particularly after the Reformation when Catholicism was increasingly vulnerable to Protestant developments in the north and to Islamic invasions from the east. Not only a noble lineage but a total obedience to Catholic doctrine and a strictly religious lifestyle were demanded from its members. Martelli remained an active soldier throughout his life, taking part in many of the knights' battles against the Ottoman forces, and was also an able politician and administrator within the order, rising to become an admiral and prior of two of its chapters before returning to Tuscany, where he was appointed General of Artillery shortly before his death in 1618.[2]

Wtenbogaert, too, was a man of action, but on the other side of the religious divide that split the Protestant north from the Catholic south. The son of a schoolmaster in Utrecht, he initially trained in law and served as secretary to Count Jan of Nassau before turning to theology, which he studied at various Protestant centres. His successful career as a divine included his appointment as court preacher to Prince Maurits of Orange, and he became a leading proponent of religious tolerance in northern Europe, eventually founding the Remonstrant Brotherhood, which sought political unity through religious freedom within the Reformed church. Although not an active soldier, he was no stranger to battlefields, having followed Maurits's campaigns and preached to the troops. He also fought his own religious and political battles with great zeal, suffering a long exile from the United Provinces when the anti-Remonstrant party had the upper hand.[3]

Rembrandt received the commission to paint Wtenbogaert from one of the preacher's Amsterdam followers and admirers, the rich Remonstrant merchant Abraham Anthonisz Recht. In April 1633 the aged divine came to Amsterdam from The Hague and sat to the 27-year-old painter, who was already showing that interest in theology and scripture which colours

so many of his paintings. Rembrandt chose to portray Wtenbogaert in an established tradition for portraits of theologians, standing next to a table on which there is an open book. Although it is perhaps unlikely that Rembrandt would have received more than one sitting from Wtenbogaert (of whom he also made an etching), he would certainly have been aware of the preacher's standing as a living symbol of humanist, religious tolerance and of his struggles to implement freedom in the choice of doctrine. And he clearly responded to the sheer physical presence of the man. Against a background divided into a light area which sets off the black costume and a dark stripe at right which acts as a foil for the illuminated pages of the book, Rembrandt has set Wtenbogaert in a pose that is monumental yet reticent. Holding his gloves in his right hand, as if to indicate that his stay is of short duration, he lays his left hand over his heart in a gesture that universally signifies sincerity, and within the conventions of the time implies the swearing of a solemn oath or of asking God to witness the truth of the speaker's intentions.[4] This gesture is

at one with the way in which, by means of the dark shadow on the collar under Wtenbogaert's left cheek, Rembrandt brilliantly gives prominence to the aged physiognomy while at the same time suggesting the reticence of a personality that seems to be withdrawing into itself. This melancholic aspect is further reinforced by the way in which the eyes, though looking straight at the spectator, seem to be focused elsewhere, suggesting higher thoughts and a measure of self-scrutiny. Rembrandt's genius in conveying the inner man can perhaps best be gauged when this portrait is compared to one by Jacob Backer (fig. 41) of three years later, which goes little further than a likeness.

Caravaggio captures a similar sense of inner reticence and introspection, mingled with power and authority, in the countenance of the aged Catholic knight, whom he portrays against an unrelieved dark background, suggesting a similarly ambiguous other-worldly gaze out to the right from the sparkling if deep-set eye. Caravaggio came to know Martelli during his

92

fig. 40 Titian
Portrait of Ranuccio Farnese, 1542 (89.7 x 73.6 cm)
Washington, National Gallery of Art Samuel H. Kress Collection

fig. 41 Jacob Adriaensz Backer
Portrait of Johannes Wtenbogaert, 1638 (122.5 x 98 cm)
Amsterdam, Rijksmuseum (on loan from the
Remonstrants Gereformeerde Gemeente, Amsterdam)

stormy sojourn on the island of Malta, the headquarters of the knights, where his talents and potential usefulness as a spiritual painter were recognised by the Grand Master, Alof de Wignacourt (fig. 42), who bent the rules to have the artist admitted to the order.[5] The 37-year-old painter must have felt that his involvement with the knights was a chance to rehabilitate his reputation, but at the same time the knights must have seen in the painter someone who, although not strictly qualified for admission, responded to the austere Christian and military ideals of the order. It is this sympathy that gives his portrait of Martelli such telling power. Where Rembrandt uses Wtenbogaert's deceptively simple gesture to relieve the black of the preacher's tunic, Caravaggio blazons forth the Maltese cross, endowing it with a visual and symbolic power that goes far beyond earlier portraits of Maltese knights (fig. 40). Again the gestures are simple: the somewhat thick, ungainly fingers of Martelli's right hand hold the beads of his rosary, indicating constant devotion and prayer, while his left hand rests on his sword. The gleaming sword-hilt is itself remarkably suggestive. The careful painter of still lifes who, when required, could reproduce in detail the magnificent armour of De Wignacourt (fig. 42), here merely hints at the significance of this weapon with which the spiritual fight is physically pursued by picking out the metal bands in a gleam of falling light.

For all his vaunted realism, then, and his insistence on painting from life, Caravaggio's empathy with his sitter elevates this portrait from a mere descriptive likeness into a spiritual testament, conveying far more than the outward appearance of the man. Both he and Rembrandt in their portraits of Martelli and Wtenbogaert, have managed, through personal insight and perfect control of the light, colour, balance and gesture, to capture the piety of a man of God blended with the presence of a man of action. [DB]

fig. 42 Caravaggio
Portrait of Alof de Wignacourt with his page, 1607 (194 x 134 cm)
Paris, musée du Louvre

Rembrandt
Portrait of Joris de Caullery

Rembrandt shows Joris de Caullery as a man in the prime of life surveying the viewer with pride and self-assurance. His full-bottomed buff coat and the almost three-quarter-length format give the portrait a monumental appearance. In his portrait of Antonio Martelli (Cat. no. 19), by contrast, Caravaggio shows the 74-year-old Maltese knight of the faith in a more modest pose. The left halves of the two men's faces are shadowed, but the difference in their postures speaks volumes. De Caullery is looking out at us across his right shoulder, radiating energy and stilled movement. Martelli's torso is front-on, while his head is turned slightly to his left, so that he seems sunk in thought. Both are dressed as soldiers and wear their swords on their left hip. Martelli's catches the eye because he is grasping it loosely with his left hand. De Caullery's is in the shadows, but he is holding a second weapon in his right hand, a small musket called a firelock. Attention is drawn to it by the light falling on the gleaming barrel.

Very little is known about De Caullery, which is odd, given that the portraits that he handed over to his children in 1654 (including this one) were painted by famous artists like Jan Lievens and Anthony van Dyck. He was described at the time as a 'noble and valiant man [...], sea-captain in the service of these lands', and in 1658 he was hailed for his bravery as captain of the *Utrecht*.[1] It is also known that, three years after this portrait was painted, he is recorded as being a lieutenant in one of The Hague's six civic guard companies.

While Caravaggio is thought to have painted only a few portraits, in the first two years of his career in Amsterdam Rembrandt produced no fewer than six monumental ones of this size. The floor was often used in full-length portraits to give the impression of depth, but that aid is lacking in half-lengths. Caravaggio nevertheless succeeded in suggesting volume by having the sitter loom up out of the darkness.

Rembrandt, too, was ingenious in creating a sense of depth in *Joris de Caullery*. He did so in three ways. First, De Caullery is not shown frontally but twisted, with his right arm slightly out from his side and his left hand on his hip, with the elbow sticking out in a clear perspectival foreshortening. Secondly the soldier's outline contrasts with the partly lighter background, so that he appears to be detached from it. Thirdly, and this was Rembrandt's greatest find, only part of the figure is illuminated. As a result, there are transitions within the figure from a dark foreground, a lighter middleground and dark background (the left arm). A focused beam of light subtly grazes De Caullery's shoulder, glancing off the buff coat at breast height. Rembrandt almost seems to have had an obsession with painting light falling on shoulders, probably because it could suggest volume. Apart from this painting, the way in which he conjured up the illusion of depth by lighting only part of the figure is perhaps best illustrated by the *Man in oriental costume*, the so-called 'Noble Slav' in the Metropolitan Museum in New York of the same year.[2]

At the end of 1631, Rembrandt took up the lucrative position of portrait painter in the business run by the art dealer and painter Hendrick van Uylenburgh (1578-1661) in Amsterdam. However, he had not yet moved there permanently when he painted De Caullery.[3] At first he kept on his studio in Leiden and lodged with Van Uylenburgh when he was in Amsterdam. There was plenty of work for him there, and his output of portraits was prodigious in the four years he worked for him.[4] The city was enjoying a period of enormous prosperity, and the newly rich were keen to immortalise themselves for posterity. The 25-year-old Rembrandt's portraits must have made a great impression, for within a year he had already received a commission for a sizable group portrait.[5] He probably painted the portraits of his Hague patrons like De Caullery in his Leiden studio. A year later, in 1633, he left Leiden and settled in Amsterdam for good. [TD]

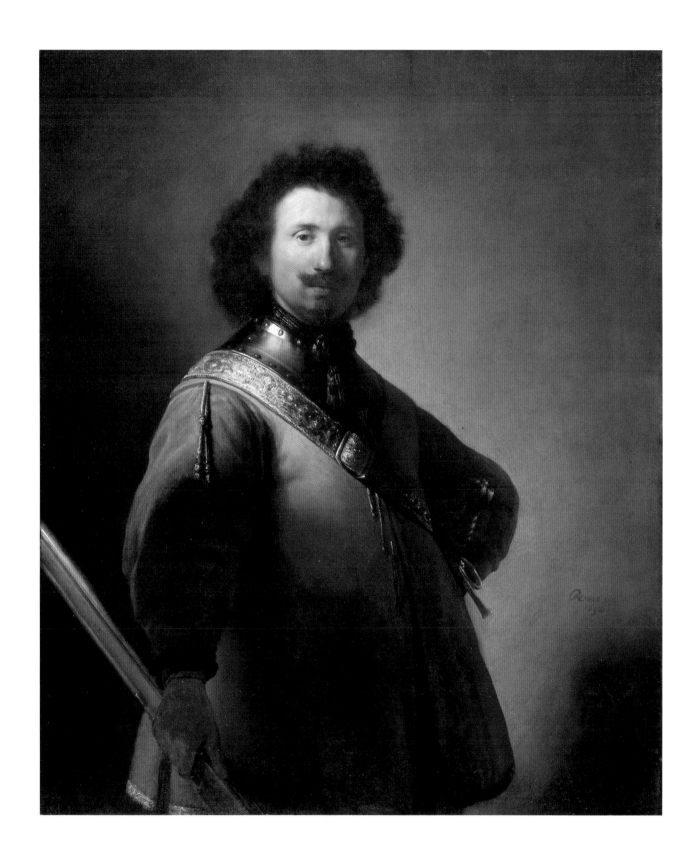

Cat. no. 20 Rembrandt
Portrait of Joris de Caullery, 1632
Oil on canvas on panel, 102.9 x 84.3 cm
San Francisco, Fine Arts Museums of San Francisco,
Roscoe and Margaret Oakes Collection

Caravaggio | Rembrandt
The sacrifice of Abraham | *The sacrifice of Abraham*

The Old Testament episode in which
God puts Abraham's faith to the test by commanding him
to kill his son Isaac as a sacrifice was regarded by Protestants
and Catholics alike as an important prefiguration of
Christ's sacrifice of himself for the salvation of humankind.
It thus formed a frequent subject for paintings, with artists interpreting
the biblical text in different ways to suit their purposes. It is one of the
few subjects that both Rembrandt and Caravaggio
painted at approximately similar moments
in their artistic developments, in large-scale pictures
which count among their masterpieces. Comparing their versions
illuminates their different ways of tackling the pictorial problems
of translating the words of the biblical text into paint,
and points both to some affinities but also to great differences
in their artistic temperaments and personalities.

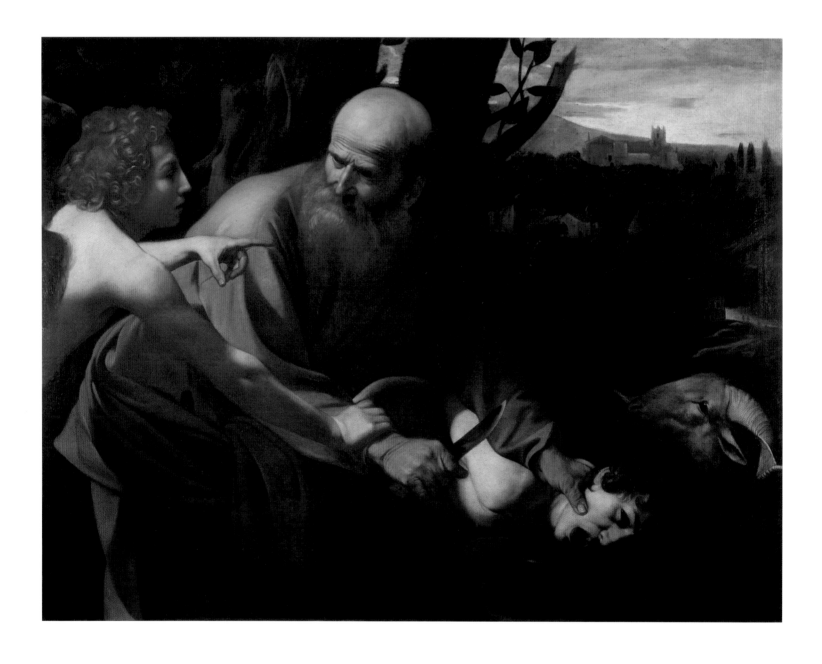

Cat. no. 21 Caravaggio
The sacrifice of Abraham, 1603
Oil on canvas, 104 x 135 cm
Florence, Galleria degli Uffizi

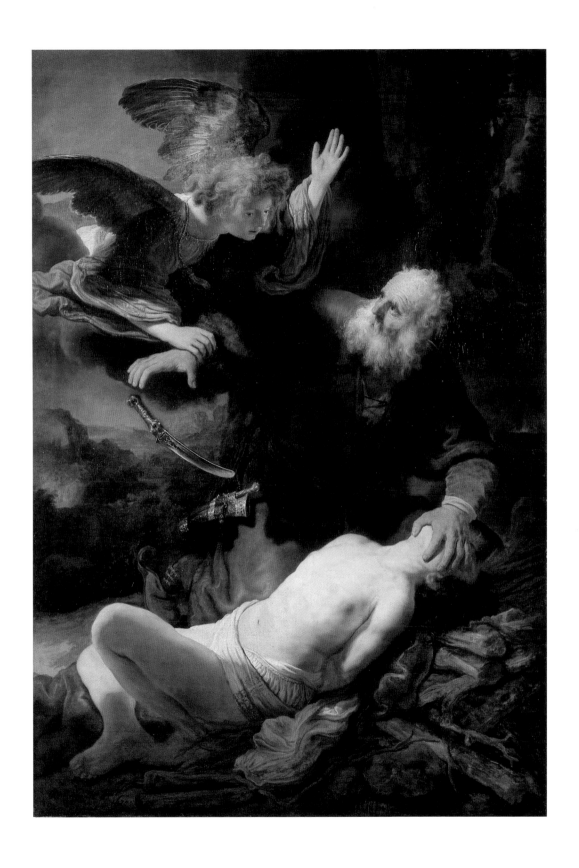

Cat. no. 22 Rembrandt
The sacrifice of Abraham, 1635
Oil on canvas, 193 x 133 cm
St Petersburg, The State Hermitage Museum

took the ram, and offered him up for a burnt offering in the stead of his son.'

Following established pictorial tradition (figs. 43 and 45), both artists have depicted the decisive moment in the story: the intervention of the angel as Abraham stretches forth his hand. And both, again following pictorial tradition, deviate from the text to show the angel physically restraining Abraham, holding back his arm rather than simply crying out from the skies. Both have also taken pains to set the scene, Rembrandt clearly indicating that the action takes place on a mountain-top by showing a distant valley, dreamily and

The episode of the sacrifice occurs in the book of Genesis (22:1-13) where it is recounted how 'God did tempt Abraham', appearing to the patriarch with the words: 'Take now thy son, thine only son Isaac, whom thou lovest, and get thee into the land of Moriah; and offer him there for a burnt offering upon one of the mountains which I will tell thee of. […] And Isaac spake unto Abraham his father, and said, My father: and he said, Here am I, my son. And he said, Behold the fire and the wood: but where is the lamb for a burnt offering? And Abraham said, My son, God will provide himself a lamb for a burnt offering: so they went both of them together. And they came to the place which God had told him of; and Abraham built an altar there, and laid the wood in order, and bound Isaac his son, and laid him on the altar upon the wood. And Abraham stretched forth his hand, and took the knife to slay his son. And the angel of the LORD called unto him out of heaven, and said, Abraham, Abraham: and he said, Here am I. And he said, Lay not thine hand upon the lad, neither do thou any thing unto him: for now I know that thou fearest God, seeing thou hast not withheld thy son, thine only son from me. And Abraham lifted up his eyes, and looked, and behold behind him a ram caught in a thicket by his horns: and Abraham went and

fig. 43 Pieter Lastman
The sacrifice of Abraham, 1616 (panel, 36 x 42 cm)
Paris, musée du Louvre

fig. 44 Caravaggio
St Matthew and the angel, c. 1602 (295 x 195 cm)
Rome, San Luigi dei Francesi, Contarelli Chapel

atmospherically painted, at the left. Caravaggio includes to the right, most unusually for an artist who seldom concerned himself with the depiction of landscape, a distant panorama of hills reminiscent of the countryside around Rome, with a richly coloured sky intimating that the action is taking place at sunset or at dawn. Rembrandt includes the split wood and the fire mentioned in the Bible, but omits the ram; Caravaggio includes the ram, but omits the other incidental details.

From the time of the *Judith and Holofernes* (Cat. no. 10), painted in 1599 or 1600, Caravaggio had shown an evident preference for horizontal canvases when conceiving his narrative and historical compositions. It was a format which allowed him to develop the northern Italian tradition of half or three-quarter-length figures in the foreground, close to the picture plane, and was particularly suited to the dramatic confrontation of the characters depicted. His decision to use this format for his *Sacrifice of Abraham*, which he painted in 1603 for the important Roman patron, Cardinal Maffeo Barberini, later Pope Urban VIII, was unusual. It precluded the dramatic descent of the angel from above which most artists incorporate to great pictorial effect, as does Rembrandt in his version. Indeed, the fact that only the previous year Caravaggio had painted just such an angelic descent in his large upright altarpiece of *St Matthew and the angel* (fig. 44) only reinforces the idea that he wished to show the angelic apparition on the same level and on the same scale as the principal figures in his *Sacrifice*. The most innovative aspect of the picture is the angel's interaction with Abraham on almost human terms. Only the bases of the wings and the soft idealised profile and blond curls of the figure at left announce that this is a different order of being from the terrified boy and the old patriarch who turns to encounter the angel's gaze.

As in so many other works, Caravaggio has focused on the most psychologically telling moment, and has frozen it in time. The angel has grasped Abraham's wrist at the instant of the knife's descent towards Isaac's throat, and neither father

nor son is yet aware that the horror is averted. This is particularly true of Isaac, in whose contorted face Caravaggio's early experiments with the expression of the passions, as in the *Boy bitten by a lizard* (Cat. no. 25), have now borne full fruit. The dominant thrust of the long diagonal that leads down the angels arm is towards the head of the boy, so that the picture has two equal points of focus, the ocular encounter of Abraham with the angel, and the head of Isaac juxtaposed with the ram that is there to replace him.

The almost painful naturalism with which Caravaggio describes Isaac's terror is all the more shocking within this static, ordered composition based on simple triangles, the lines of which are formed by the protagonists' arms and shoulders. As so often with Caravaggio, the physical presence of the model – in this case the same boy who played Cupid in the *Omnia vincit Amor* (Cat. no. 33) – remains almost tangible. As Abraham presses Isaac's head against the stone altarblock, his mouth opens to emit a scream. Caravaggio's ability here, as in the screaming head of Holofernes in his *Judith and Holofernes* (Cat. no. 10), to suggest the audible aspect of the story is remarkable, and the evocation of the sense of sound in painting may well have been a particular interest and goal for Caravaggio in his Roman years.[1] Here, it adds to the immediacy of a story that is just reaching its climax. Only the heaven-sent ram, introduced at the right as an almost parodic counterpart to the heaven-sent angel, hints at the resolution and the more conventional sacrifice to come.

In formulating his composition, based loosely on one by his former master, Lastman (fig. 43), Rembrandt was more concerned with the sweep of the narrative. Exploiting the vertical format of his canvas, he links the three figures from the angel at top left, through the curve of Abraham's arms, to the brilliantly lit young body of the victim. Only the angel's gestures and the falling knife break the arc, as Abraham glances upwards in the realisation that his son is saved. If Caravaggio sought out the crux on which the story turns, fixing the moment of greatest drama, Rembrandt follows the story through in a way that can only be described as theatrical,

with the exaggerated gestures of the angel announcing the suddenness of his appearance. Rembrandt's full-length figures move freely in the pictorial space, and it is significant that he shows his angel looking not at Abraham, as Caravaggio's does, but at Isaac, as if to ensure that his intervention is on time.

Rembrandt's use of light, too, is more flamboyant. Where Caravaggio picks out the limbs, shoulders and faces to highlight the salient points in the suspended action, Rembrandt uses the heavy contrast of the dark figure of Abraham and the lighter areas of flesh on the faces and on Isaac's body largely to strengthen the strong visual impact of the composition as a whole. It heightens the theatricality, but – ironically in a composition which is often referred to as Caravaggesque[2] – the heavy chiaroscuro seems more an end in itself than a vehicle for meaning.

There can be no doubt that Rembrandt took the opportunity in the figure of Isaac to create one of his most subtly painted early nudes, clearly enjoying his own particular skill in defining the texture of skin and flesh through the soft fall of light. In this concern with the beauty of Isaac's body, his picture conforms more than Caravaggio's to the standard Italian tradition of depicting the subject. This can be seen in Cigoli's painting of c.1607 (fig. 45), in which the nude was criticised shortly after it was painted for being too arousing or 'moving'.[3] Interestingly, Caravaggio, famous for his sensual paintings of adolescent boys, failed to exploit this opportunity in his own composition. What is equally strange is that Rembrandt, greatly concerned with physiognomic expression, should have chosen to suppress Isaac's face by placing Abraham's hand over it. Horace Walpole, the great connoisseur whose father owned Rembrandt's *Sacrifice* in the 18th century, concluded that Rembrandt had 'avoided much of the Horror of the Story by making Abraham cover the Boy's face, to hide the Horror from himself'.[4]

Rembrandt was 29 years old when he painted his *Sacrifice of Abraham*, at a period when he was conceiving ever more ambitious history paintings, and experimenting with more

and more turbulent compositions. It is an early statement of the full emotional force he could achieve in a composition teeming with movement and vitality. By contrast, the 31-year-old Caravaggio reveals himself to be a far more manipulative artist, paring down unnecessary details to capture the most poignant moment, and playing off ideas and evocations of violence against a harmonious and balanced whole. [DB]

103

fig. 45 Lodovico Cardi, called il Cigoli
The sacrifice of Abraham, c. 1607 (175.5 x 132.3 cm)
Florence, Galleria Palatina, Palazzo Pitti

Rembrandt
Jacob and the angel

The book of Genesis tells how Jacob returned to his native Canaan after many years spent working for his uncle Laban. At first he travelled with two women (Laban's daughters Leah and Rachel), two maidservants and his 11 children. On arriving at the ford of Jabbok he sent them on ahead while he remained behind to pray. An angel then appeared to him in human guise and wrestled with him until daybreak. Discovering that Jacob was not going to give up, the angel dislocated his hip and asked Jacob to let him go. 'And he [Jacob] said, I will not let thee go, except thou bless me. [...] And Jacob asked him, and said, Tell me, I pray thee thy name. And he said, Wherefore is it that thou dost ask after my name? And he blessed him there.' Jacob realised that 'I have seen God face to face, and my life is preserved. And as he passed over Penuel the sun rose upon him, and he halted upon his thigh' (Genesis 32:26-31).

In the few Dutch depictions of this subject prior to Rembrandt's, this Old Testament story was always set in a broad landscape with Jacob on the riverbank in the foreground and his family fording the river in the background. Rembrandt, though, has restricted himself to the essence of the story: the lonely struggle with the angel.[1] The focus is on the interaction between the two figures.[2] He cleverly portrays the outcome of their meeting through their poses and gazes. The wrestling bout that ends with Jacob's hip being dislocated is depicted with the angel bracing its leg against a rock in the left foreground and forcing Jacob backwards with one hand on his side and the other on his back. What is also shown, though, is the moment when Jacob grasps the angel to prevent him from leaving. For despite his exhaustion, he asks the angel to bless him. Both the angel's serene gaze and his spreading wings evoke this final moment when God's grace is bestowed on Jacob.[3]

By eliminating all the secondary details and focusing solely on the struggle, Rembrandt has not so much depicted the specific historical event as transformed it into a symbol of man's general struggle for God's grace. His constant testing of mankind is certainly a theme in the Catholic faith, but for Protestants it is of crucial importance. Jacob comes through the trial thanks to his perseverance in his faith.[4]

This concentration on the essence of a story, with the figures occupying much of the picture surface and all incidentals omitted, is also found in Caravaggio's work. One example is his *Doubting Thomas* (fig. 28), which also deals with an intimate physical contact between a person and God. The disciples' attention is fixed on Thomas's index finger, which Christ is guiding into the wound in his breast to demonstrate that his resurrection is real. Like Rembrandt in *Jacob and the angel*, Caravaggio shows his figures half-length in close-up, so that the viewer can study the facial expressions in detail while being confronted directly with the dramatic moment in the narrative. In this case, though, the doubter fails. Christ puts Thomas's faith to the test by appearing before him, but the latter needs tangible evidence that he has risen from the dead.

The lack of a pronounced chiaroscuro led to questions being posed about the autograph nature of *Jacob and the angel* during the 1956 exhibition in the Rijksmuseum marking the 350th anniversary of Rembrandt's birth.[5] However, a sharp contrast between light and shade would not have been in keeping with the story in the Bible, because dawn had already broken. Rembrandt handles the light as he had done in his early work (see Cats. nos. 7 and 32). A shaft of light enters from the left and falls between the figures, placing Jacob's back in the shadows, apart from his shoulders. The light has been used specifically to display the entanglement of the two figures. There is little contrast between the contours of the lower bodies (and thus little sense of depth), while the contrast between the dark outline of Jacob's visibly exhausted face and the angel's white shirt suggests the distance that opens up as the angel pulls himself free. [TD]

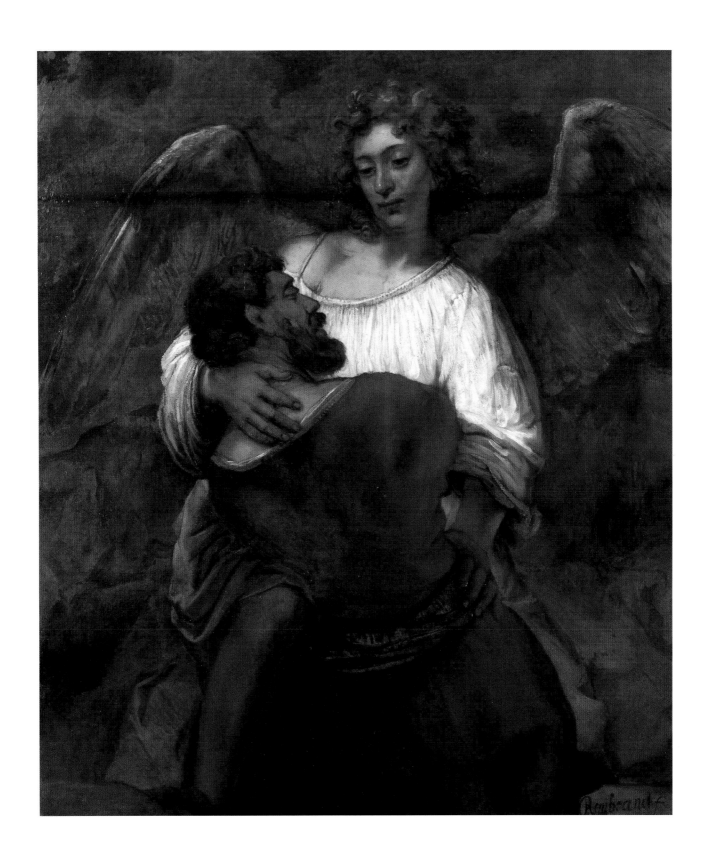

Cat. no. 23 Rembrandt
Jacob and the angel, c. 1659
Oil on canvas, 137 x 116 cm
Lent by the Staatliche Museen zu Berlin, Gemäldegalerie

Rembrandt and Caravaggio are two artists
in whose works it is possible to see the same persons and types,
based on living models, recurring again and again.
Rembrandt's features, as is well known, appear in his works
throughout his career, whether in formal self-portraits or
more imaginative compositions, while those of his wives
and mistresses, and of his beloved son Titus, are also found in a
variety of pictures with differing meanings and differing intentions.
Caravaggio's paintings, especially those done early in his career
in Rome, are also marked by the recurrence of a group of
recognisable models posed in different ways for different purposes,
whose features seem to colour the finished works.
In Rembrandt's painting of Titus as a young scholar at his desk,
and in Caravaggio's study of a boy bitten by a lizard,
the tension between the almost portrait-like
depiction of the youthful models and the more
generalised meaning of the works, contributes
to their power and mystery.

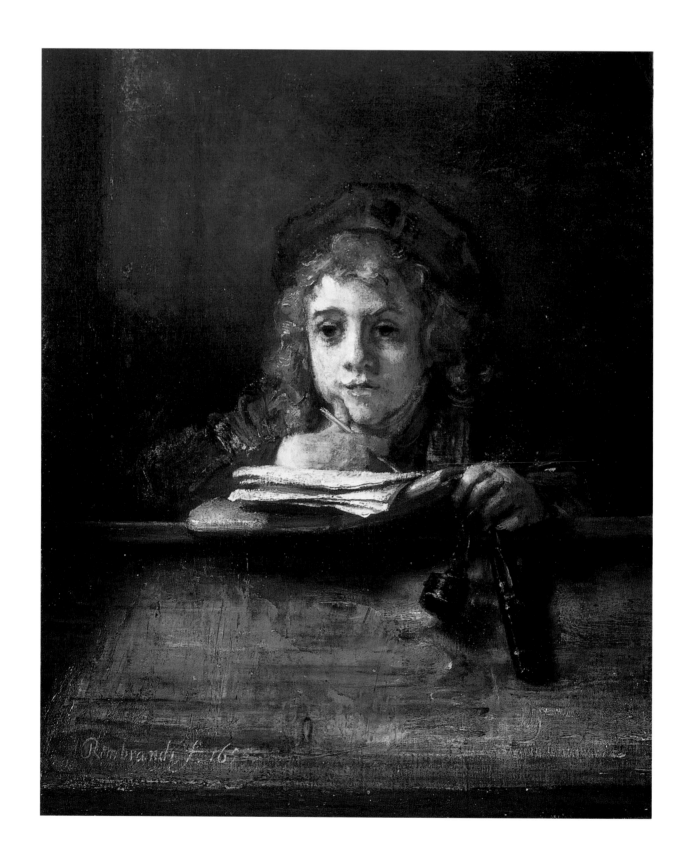

Cat. no. 24 Rembrandt
A schoolboy at his desk ('Titus as a scholar'), 1655
Oil on canvas, 77 x 63 cm
Rotterdam, Museum Boijmans Van Beuningen

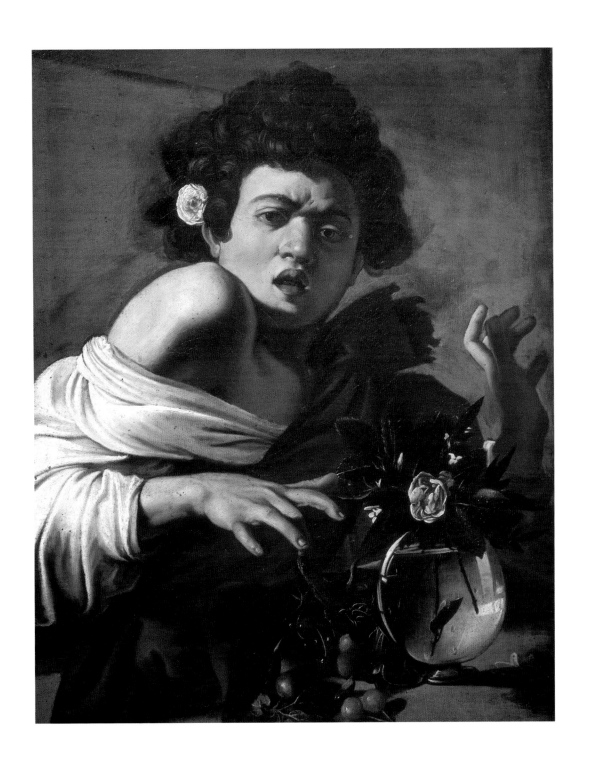

Cat. no. 25 Caravaggio
A boy bitten by a lizard, c. 1600
Oil on canvas, 65.8 x 52.3 cm
Florence, Fondazione di Studi di Storia dell'Arte Roberto Longhi

Rembrandt's young scholar and Caravaggio's bitten boy
are, in the simplest sense, character studies, and in them each
painter focuses with exceptional closeness on the figures de-
picted. Caravaggio's youth fills the picture field in a dramatic
close-up, while Rembrandt brings the viewer almost into
physical contact with the desk over which the schoolboy
leans. Above all, each provides intense, momentary glimpses
of a person whom the artist has caught unawares, and whose
emotions and state of mind the viewer is invited to contem-
plate, though not to interact with.

Caravaggio's *Boy bitten by a lizard,* which probably dates
from between 1595 and 1600, is one of the most powerful
early statements of his interest in human reactions to an
event, which he was to develop to such effect in his large-
scale narrative works. The young painter probably conceived
the composition (another version of which is in the National
Gallery, London) in the fervidly experimental years that fol-
lowed his arrival in Rome in 1592 aged 20 or 21. At this
period, while he was still struggling to establish himself,
he is known to have painted small-scale works for sale on
the open market.[1] These were principally designed to show
off his skills, both as a figure painter and as a painter of the

increasingly popular genre of still life. In one (fig. 46), he
shows the young god Bacchus sitting at a table on the edge
of which are fruits, sensuously holding a bunch of grapes
to his mouth. This type of picture, showing a single figure,
had been a popular genre in northern Italy in the mid-16th
century, but Caravaggio has brought a new power and force
to it, for the boy – an evident self-portrait – seems to be less
a personification of the god of grapes and wine than to be
offering his physical charms to the beholder with an almost
blatant erotic intent. The same is true of *A boy with a basket
of fruit* (Cat. no. 27), and even of the more classically con-
ceived, pictorially refined and iconographically exact *Bacchus*
in the Uffizi (fig. 8) where the erotic undertone is if anything
even more apparent. In *A boy bitten by a lizard* he takes the
combination of the elements of a half-length figure and a
still life found in these works a stage further. The boy himself
seems to have been one of Caravaggio's favourite models,
who also appears in several of his paintings of musicians
(fig. 7), but in this picture, although ornamented by his

111

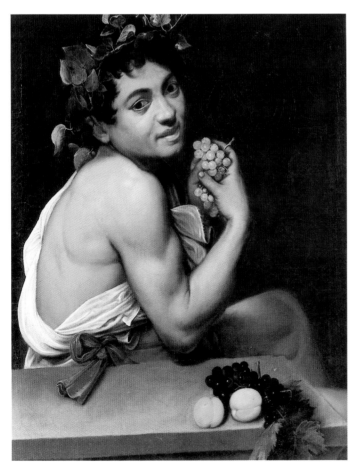

< fig. 46 Caravaggio
Self-portrait as Bacchus, c. 1593 (66 x 52 cm)
Rome, Museo e Galleria Borghese

∧ fig. 47 Rembrandt
Self-portrait in a cap, open-mouthed, 1630 (etching, 5.1 x 4.6 cm)
Amsterdam, Rijksmuseum

similar louche clothing from those other works, it is his shock and surprise at being bitten by the lizard – unsuspectedly lurking in the fruit he is about to enjoy – that Caravaggio has sought to capture. The image is all the more arresting for the air of decadence that Caravaggio brings to the effeminate youth with a flower in his hair and his affected pose and gestures.

For all his later reputation as a rebel, Caravaggio was intensely aware of the history and traditions of his art, and his early training in Lombardy would have alerted him to the importance that Leonardo da Vinci and other theorists placed on the accurate evocation of emotions through the manipulation of facial features and physical gestures. He would also have known Vasari's account of a drawing, admired by Michelangelo, made in the 1540s or 50s by the celebrated Lombard artist Sofonisba Anguissola, of a boy bitten by a crayfish in which, as Vasari tells us, both laughter and tears are portrayed.[2] Michelangelo had reputedly seen a drawing by Sofonisba of a laughing child, and had remarked that it was much more difficult to depict a child crying, thus provoking her to compose a drawing in which laughter and tears were contrasted. Although it is unlikely that Caravaggio knew the drawing itself, Vasari's description may well have inspired him to attempt an equivalent subject, with the added twist that the laughter at the boy's surprise is provoked in the painting's viewers, that is to say ourselves.

More than any other of his early works, Caravaggio's *Boy bitten by a lizard* gives a foretaste of the way he was to develop not only as a history painter, but one who also retained an interest in paintings of closely observed single figures (fig. 8 and Cat. no. 27). The ability, which he shares with Rembrandt, of isolating the most telling moment in a given scene, is here precociously evident, as is his gift of wringing the innate dramatic potential out of a simple scenario. Here, too, the sharply falling light – accentuating the frozen movement as it falls on the exaggeratedly hunched-up shoulder, and picking out not only the hand bitten by the reptile but the fluttering finger of the other hand thrown up in horror – announces his mastery of the manipulation of chiaroscuro. The immediacy of the action, the instantaneity of the emotions of shock and fear portrayed at the very moment they occur, is also counterbalanced by Caravaggio's careful description of the vase in which the light of a distant window can be seen, and of the carefully delineated fruits which harboured the lizard but which remain undisturbed by the commotion they have occasioned. Above all, it is the realistic presence of the boy, the sharp penetrating focus that comes from Caravaggio's reputed practice of painting only from life that elevates this picture from an exercise in expression into the pictorial crystallisation of a powerful reaction.

Rembrandt too was fascinated by the difficulty of recording transient emotions in paint. Early in his career he experimented with character-studies based on his own features, both in easel paintings (Cat. no. 6), and especially in etchings (figs. 33 and 47). These are essentially exercises, in which – almost caricaturally – he exaggerates grimaces and grins, building up the vocabulary of facial expressions which he was later to incorporate into the fuller language of his mature history paintings. Like Caravaggio, he also explored the emotive potential of single figures, often engaged in some absorbing task, as in the picture of a woman with a book (fig. 15), which hovers ambiguously between a representation of a biblical prophetess and a study of an old woman reading the Bible on a Protestant Sunday evening.

Rembrandt found the Dutch tradition of the *tronie* a useful starting point for achieving the kind of semantic fluidity found in such pictures, where mood and tone are more important than a specific description of the person or the action. Cognate with the northern Italian tradition of half-length figures or heads personifying beauty (fig. 50) or old age, a *tronie* is a portrait-like study of an individual head which, though often strongly individualised, is not intended as the likeness of an individual but rather as study of a character or type, intended to be admired for the beauty of its execution, its expressive content and the painter's ability to capture a psychological state. Rembrandt's paintings of exotic characters, such as the man with the turban (fig. 60) or the

soldier in a gorget and plumed hat (Cat. no. 5), are typical of this type of picture, which aims at a generalised impression of a type rather than the delineation of a particular individual.

It is in this tradition of the *tronie* that Rembrandt's image of the young Titus is perhaps best seen. For all its obvious evocation of the facial features of the artist's son, it is clearly not a portrait in the strict sense of the word, like the picture of the Titus at a more advanced age in the Wallace Collection, London (fig. 48). Nor is it strictly a *portrait historié*, that rather playful pictorial category in which a sitter is shown pretending to be a historical or biblical figure. Throughout his career, Rembrandt, just as much as Caravaggio, was fascinated by the transformations that fancy dress can bring – perhaps nowhere more so than in his self-portraits (fig. 14), in which he embellishes himself with as much an extravagant delight as Caravaggio does the ephebic youths of his early years.

In *'Titus as a scholar'*, the student's cap, the creamily painted sheets of paper and the insistently real, though broadly painted, hanging inkholder, transform the boy from a mere study of Titus as an individual into a meditation on learning, on youthful aspiration, on the melancholy of study. If the picture lacks the essentially playful element of the study of Titus in a monk's habit (Cat. no. 26), it takes on a profounder aspect.

Rather than concentrating on Titus's face and personality, Rembrandt's beautiful loose technique generalises the boy's features, picked out by a ray of sunshine to reveal the lad in a moment of intense concentration. The illumination acts as a metaphor for the internal illumination of the studies, and the boy becomes almost a paradigm of the process of thought that has been awakened. Nothing could be subtler than the dexterous way Rembrandt has shown the child's thumb pushing against his cheek, or captured the dreamy quality in his eyes. As in Caravaggio's more violent, cruder image of a startled boy, what we have here is not the image of an individual boy, but the portrait of a momentary state of mind.
[DB]

113

fig. 48 Rembrandt
Titus, the artist's son, c. 1657 (68 x 57 cm)
By kind permission of the Trustees of the
Wallace Collection, London

Rembrandt
Rembrandt's son Titus in a monk's habit

Caravaggio used models from his immediate circle for his frivolous, sensual *Boy with a basket of fruit* and *Boy bitten by a lizard* (Cat. nos. 25 and 27). The likely model for this contemplative, serene image of St Francis or a Franciscan friar was Rembrandt's son Titus.[1] It is not a portrait, though, and if the subject is not St Francis himself, the painting can be interpreted as a head in which Rembrandt focused on the essence of the Franciscan order as expressed in its Rule: '[to serve] the Lord in poverty and humility'. Light falling from outside the painting illuminates the young man, whose pale skin stands out against the dark hood. Rembrandt used clearly visible, broad brushstrokes to depict the meek face with its lowered, meditative gaze. The young man's meditation in Rembrandt's painting is given an introspective nature by showing the figure without any attributes and at less than half-length.[2]

Without distracting attention from that meditation, Rembrandt used a monochrome palette in a masterly way to emphasise two other aspects that were of crucial importance for St Francis and his followers: poverty and nature. The friar's worn brown habit is a patchwork of different pieces of material, the coarse, irregular texture of which is depicted with rough paint. The saint's poverty is not, as often in Italian images of him, emphasised by a tattered habit; here the light falls on a few coarse white stitches replacing the border along the edge of the hood. Nature, which the saint and his followers preferred in their withdrawn, contemplative life, surrounds the friar in the form of soft, greenish brown foliage.

It is not entirely certain whether Rembrandt depicted the saint himself or one of his followers. By placing him against an overgrown rock face he may have been alluding to the iconographic tradition of St Francis meditating in the forest near Assisi.[3] Although the saint is often depicted with a fluffy pointed beard and a sharp face there is no unequivocal tradition for St Francis's physiognomy.[4] The dark-brown habit of a coarse material with the distinctive hood symbolises the poverty in which the friars lived.[5] There are two other paintings by Rembrandt of friars in Franciscan habits, and it has been suggested that they and the Rijksmuseum work may once have been part of a series of evangelists and saints.[6] However, quite apart from the fact that those two friars are not set against a background of vegetation, which is customary in the iconography of St Francis in allusion to his woodland retreats, their grey hairs argue against the identification as St Francis, for he died at the early age of 44.[7]

The precise function of the Rijksmuseum painting and the other two friars is not known.[8] Although religious orders and monasteries were prohibited in the Dutch Republic, there was no lack of Franciscans.[9] It was not only Catholics who held St Francis in particular esteem. Protestants may not have believed in the miracles that gave saints their special standing, and they may have opposed the veneration of saints, but they did allow historical figures to serve as role models. St Francis held a special position here in view of the soberness of his lifestyle, his humility before God, and the obvious biblical foundations underpinning his order. [TD]

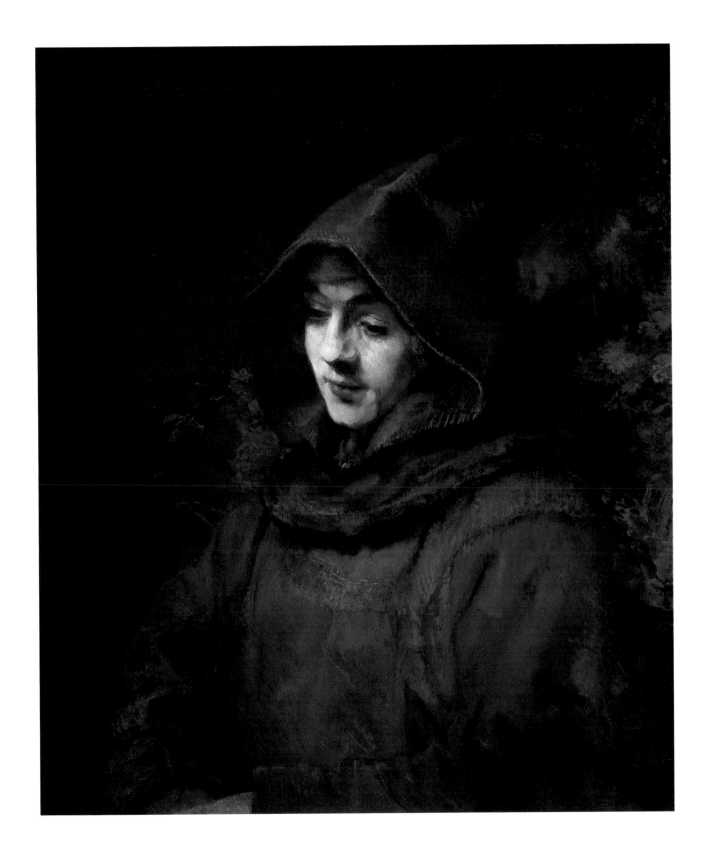

Cat. no. 26 Rembrandt
Rembrandt's son Titus in a monk's habit, 1660
Oil on canvas, 79.5 x 67.7 cm
Amsterdam, Rijksmuseum. Purchased with aid from the Vereniging Rembrandt

Rembrandt | Caravaggio
Flora (Saskia as Flora) | *Boy with a basket of fruit*

Caravaggio's terse depiction of a boy
clutching a basket filled with fruits and leaves and
Rembrandt's richly painted canvas of a woman holding a bouquet of freshly
picked flowers confront, on the most basic level, the same pictorial challenge:
that of presenting a single figure in its relation to the
cultivated produce of the natural world.
As in the *Boy bitten by a lizard* and the *'Titus as a scholar'* (Cat. nos. 24 and 25),
we can recognise models the artists used elsewhere in their works.
In the Rembrandt it is the generalised features of the artist's wife Saskia,
and in the Caravaggio the youth who recurs in several
paintings of his early Roman years. Neither is a portrait,
and both figures are shown in fancy dress, as it were, in which the still-life
element plays a prominent role.
Rembrandt invites, but does not compel, us to recognise
his dreamy-eyed woman as perhaps the goddess Flora,
perhaps a personification of spring;
Caravaggio leaves the question of the boy's identity more open.

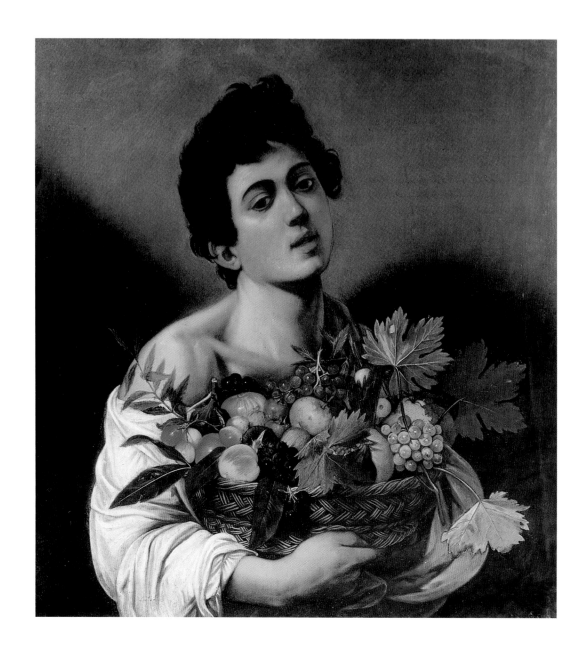

Cat. no. 27 Caravaggio
Boy with a basket of fruit, c. 1593
Oil on canvas, 70 x 67 cm
Rome, Museo e Galleria Borghese

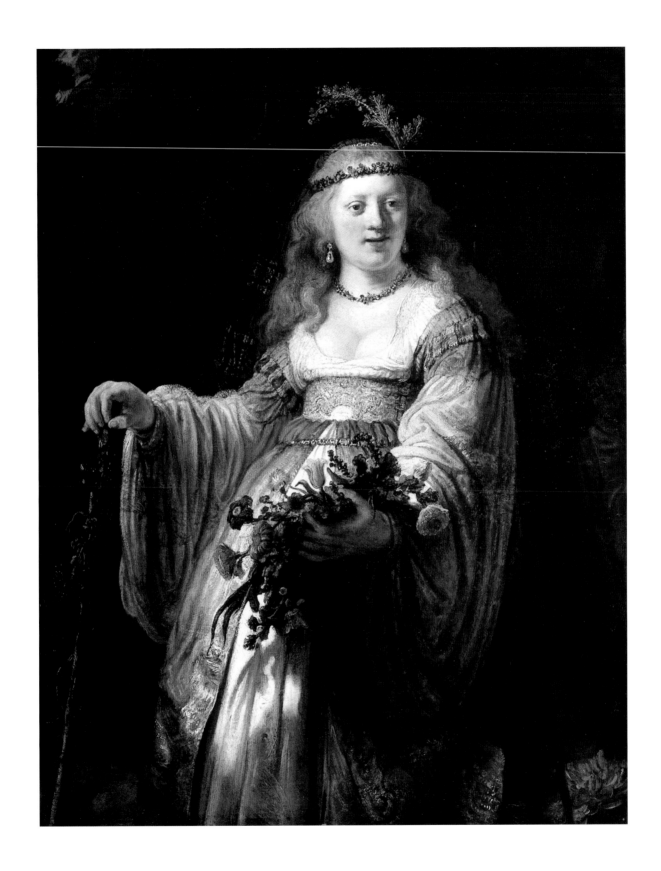

Cat. no. 28 Rembrandt
Flora (Saskia as Flora), 1635
Oil on canvas, 123.5 x 97.5 cm
London, The National Gallery. Bought with contributions from the National Arts
Collection Fund, 1938

It was Caravaggio's most prolific and constant Roman patron, the highly cultured marchese Vincenzo Giustiniani who reported the artist as saying that it required as much skill (*manifattura*) to paint a good picture of flowers as of figures. This is the basic premise behind both these works. Giustiniani – an avid collector and patron with a keen intellectual interest in the theory and processes of painting – includes Caravaggio's remark in a letter in which he lists and discusses the different types and styles of painting. Caravaggio is quoted in his fifth category (out of twelve), which is concerned with an artist's ability to portray 'flowers and other minute things', that is to say the type of painting known as still life. The painter, he says, must know how to control the colours, and to produce his effect by 'achieving a varied design of the small-scale objects in many different positions, and a variety of lighting upon them'. About figure painting, his fourth category, he states: 'the painter must know how to portray individual people, both faces and the body, the clothing and the hands, to capture a pose and give a sense of symmetry and design'.[1]

Caravaggio's painting has no readily recognisable subject. Whereas his *Boy bitten by a lizard* (Cat. no. 25) and his *Bacchus*

(fig. 8), in which a similar combination of single figure and still life occurs, are concerned with the drama of a given moment on the one hand, and the characterisation of the god of wine on the other, the artist here provides no easy indication of how we should interpret his painting. It is an apparently straightforward representation of a cheeky, attractive boy holding a basket full of luscious fruits, presenting both them and himself to the viewer.

Although the circumstances under which Caravaggio painted this work are uncertain, it seems possible that this is one of the paintings his early biographers say that he made for the open market – that is to say without taking into account the tastes or specifications of a particular patron.[2] If that is indeed the case, it may primarily have been intended an *exemplum* of his skills and talents, meant to appeal to a potential buyer for the brilliance of its execution following the general criteria that Giustiniani later enumerated. However insistently real the human and vegetable objects might appear – and Caravaggio has taken particular care in transcribing his observation of the fruits – it is also highly artificial in its presentation of the boy, who is set against a neutral backdrop with his hair carefully arranged and his tunic slipping seductively off his shoulder. There is no attempt to contextualise him,

121

fig. 49 Caravaggio
Still life of a basket of fruit,
c. 1596 (31 x 47 cm)
Milan, Bibliotheca
Ambrosiana

or to specify, for example, that we are to recognise him as a fruit-seller from a street market.[3] The apparent realism with which both the boy and the fruits are depicted have in fact more to do with artifice and illusion than with any attempt at narrative or anecdotal verisimilitude. Caravaggio may well have painted it with this intention, bearing in mind one of the classic texts about illusionism that was known to all connoisseurs and educated artists at this time.[4]

In a well-known passage, the ancient Roman author Pliny the Elder, whose writings are a major source of information about the art of classical antiquity, speaks of a painting of grapes by the Greek artist Zeuxis, which were rendered so realistically that they deceived birds, which tried to peck them. Elaborating, he describes another painting in which Zeuxis painted a boy carrying grapes. When the birds came to peck at these, Zeuxis chided himself for having painted the grapes better than he had painted the boy, for if he had succeeded, the birds would have been frightened away.[5]

It had become a common conceit in the 15th and 16th centuries for artists to attempt to recreate lost paintings described by ancient authors.[6] If it was, at least partly, Caravaggio's intention to emulate Zeuxis's lost work – and the celebrated still life in Milan (fig. 49) may well have the same idea behind it – this would explain the illusionistic qualities that come to the fore in this painting. It is one of the first in which Caravaggio uses the hard, slanting, ray of light that in later compositions, such as the *Supper at Emmaus* (Cat. no. 38) he was to employ to such expressive purpose. Here it picks out the boy's bare shoulder, giving a sense of heightened reality to the figure, and plays across the fruit allowing Caravaggio to show off his skills in defining the surfaces, contours and colours of the apples, cherries and grapes. For all the apparent naturalism with which the boy is presented – and that too is a product of the way he is illuminated against the neutral background – the picture remains a highly artificial conception that is more concerned with the power of illusion and with the artifice of art than with the straightforward delineation of a figure and a still life.

Although the thickly impasted flowers in Rembrandt's painting could not be more differently painted from Caravaggio's smoothly textured fruits, they are accurate portrayals of recognisable garden flowers: the bouquet contains marigolds, a tulip, a carnation, a buttercup and so on.[7] It is the surface of the paint, and the loose manner in which the seemingly haphazard but artfully arranged blooms and leaves have been suggested, that are as evident as their forms: we are invited to enjoy them as much for Rembrandt's technique, the way in which he has painted them, as for what they portray. Like Caravaggio, Rembrandt shows his figure strongly illuminated against a dark, amorphous background in which foliage and branches are only indistinctly suggested, providing no more than a hint that the figure is out of doors. Rembrandt provides as little indication as Caravaggio does in his picture why the figure should be holding the flowers. She gazes out of the pictorial space beyond the spectator, and is presented, like Caravaggio's boy, simply and straightforwardly, with a similar sense of heightened reality caused both by the strong illumination and the way in which her arms seem to thrust out towards the viewer.

It is interesting to note that the first known record of this painting, a description in a sale catalogue of 1756, describes it as a picture of a Jewish bride.[8] Given the fame of Rembrandt's

fig. 50 Titian
Flora, c. 1515 (panel, 79.7 x 63.5 cm)
Florence, Galleria degli Uffizi

so-called *Jewish bride* (Cat. no. 29), this is perhaps unsurprising, for the elaborate costume with its delicately falling veil, the flowers and the suggestion of withdrawn innocence do indeed lend an epithalamial quality to the young woman, whose evocation in paint we are invited to contemplate. The fact that her features resemble those of Saskia van Uylenburgh, whom Rembrandt had married in 1634, shortly before he painted this picture, adds an associative element to this quality. But the painting is clearly not a portrait of Saskia, and certainly not a portrait of Saskia as a bride, just as Caravaggio's fruit boy is no portrait of a specific fruit-seller. Quite what she represents seems up to the spectator to decide. The iconography is loosely that of Flora (see fig. 50), the Roman goddess of flowers, though slightly less specifically so than in Rembrandt's image of the goddess of about a year earlier (see Cat. no. 14), but it could equally well refer to the season of spring or even, as has been argued, be seen as a study in Arcadianism, showing an idealised shepherdess based on the pastoral poems of classical antiquity.[9]

All these interpretations are indeed possible, and it is perhaps a measure of the semantic fluidity of the picture, that Rembrandt's initial intention in this work, appears to have been very different from what we now see. Technical investigations and X-radiography have revealed that the artist initially conceived the figure as the biblical heroine Judith, placing the severed head of Holofernes into a sack held by her maidservant. Rembrandt evidently brought this subject to a fairly high state of completion before cutting down the canvas on the right to eliminate the maidservant and painting out the severed head by substituting the hanging sleeve and bouquet of flowers. The figure of Judith he left largely unchanged, adding perhaps the staff entwined with ivy which, like the flowers, raises associations with the pastoral.

Such a radical transformation, from a heroine renowned for a bloody and violent deed (see Cat. no. 10), into a figure redolent of the tranquility and enjoyment of the natural world, is evidence again that for Rembrandt, like Caravaggio, the ostensible subject of a picture was perhaps of less importance than a delight in exploring the artistic possibilities that a posed figure raised. The result is a masterpiece that can be enjoyed on many levels. The act of dressing up a model brings a level of make-believe, a free play of associations, created by the neutral presence of the figure and its potential to assume many identities. To this degree, for all its allusion to the natural world of flowers or spring, Rembrandt's picture is as artificial a confection as Caravaggio's. The power of the works lies in the way the two artists exploit the multiple layers of pictorial illusion and associative allusion, creating timeless images which raise more questions than they answer. [DB]

Rembrandt	Caravaggio
'The Jewish bride'	*The conversion of the Magdalen*
	The martyrdom of St Ursula

The ability to conjure up

the full subtleties of a human relationship

in purely visual terms

is something that only the greatest artists have achieved.

In these following works

Rembrandt and Caravaggio create,

through the gestures, postures and body-language of their

protagonists, an interaction of personalities

the purport of which is clearly recognisable even when

the actual subjects they are treating may not

immediately be apparent.

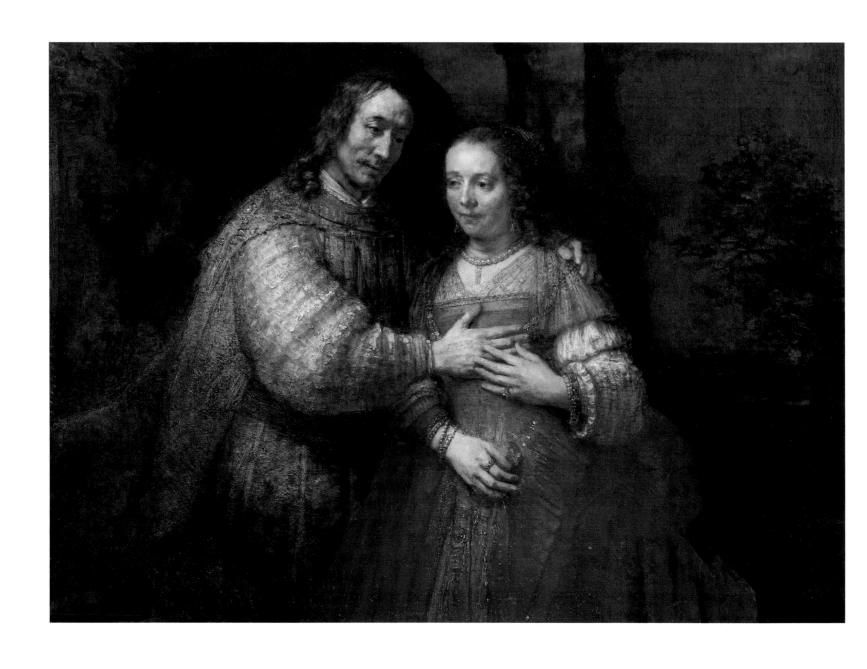

126

Cat. no. 29 Rembrandt
Portrait of a couple as figures from the Old Testament, known as 'The Jewish bride', c. 1665
Oil on canvas, 121.5 x 166.5 cm
Amsterdam, Rijksmuseum, on loan from the city of Amsterdam (A. van der Hoop bequest) since 1885

Cat. no. 30 Caravaggio
The conversion of the Magdalen, c. 1599
Oil on canvas, 97.8 x 132.7 cm
Detroit, The Detroit Institute of Arts. Gift of the Kresge Foundation and Mrs. Edsel B. Ford

128

Cat. no. 31 Caravaggio
The martyrdom of St Ursula, 1609-10
Oil on canvas, 143 x 180 cm
Naples, Banca Intesa Collection

One of the great innovations of Caravaggio's early years was his refinement of popular genre subjects. In such works of the 1590s as *The cardsharps* (fig. 22) or *The fortune-teller* in the Louvre, Paris, he examined the psychological tensions between two or three characters, showing them at half-length in a concentrated, close-up focus. His fertile genius led him to extend this powerful pictorial formula both to well-known biblical episodes – such as *Judith and Holofernes* (Cat. no. 10), where it emphasises the full force of the horror of Judith's action – and to more arcane subject matter, such as *The conversion of the Magdalen.*

At first blush the *Conversion* might easily be mistaken for a genre scene. A richly apparelled woman, the sumptuousness of her clothing emphasised by the complementary colours of the saturated red and green fabric she wears to left and right, is listening to a humbler figure, placed lower down, her face in shadow, who emphasises the points she is making by counting them off on her fingers. The comb, ointment pot and mirror signal that the principal figure is at her dressing table, interrupted at her toilet. She conforms to a long tradition of *vanitas* images and of pictures of courtesans by Giorgione, Titian and other Venetian artists (see fig. 50) that Caravaggio would have known. The juxtaposition of this figure and her prominent mirror with the more plainly attired woman – who is clearly not a serving-maid assisting her mistress – alerts us that we are witnessing a dialogue between two contrasting characters, the contrast of personalities underscored by the differing degrees to which their features are lit.

The dialogue is in fact that between the sisters Mary and Martha, one of whom, according to St Luke's gospel (Luke: 10:38-42), sat at Christ's feet listening to his teachings while the other busied herself with household chores. This pair, in a long tradition of biblical exegesis, hase been taken to represent the active and the contemplative aspects of religious life, and in legend, Mary came to be identified with Mary Magdalen, the reformed prostitute who anointed Christ's feet with oil. Tradition further embellished the legend by suggesting that it was the down-to-earth Martha who was responsible for the spiritual awakening in Mary that led to her conversion from her life of sin to one of repentance. This tradition, which has no scriptural foundation, was current in post-Tridentine Rome, and it undoubtedly provided the subject that Caravaggio here treats with consummate and innovative subtlety. The hardened soul of the Magdalen with the symbols of her sinful vanity around her – notably the ointment pot she used to anoint Christ's feet – is softened as she is illuminated by the words of her sister. It is Christ's miracles that Martha enumerates on the fingers of her strongly lit hands, while the source of that light, a high window at left, is reflected in the mirror on the table. Mary points to the reflection as if to allude to St Paul's metaphor that the divine is beheld 'as in a glass darkly' (II Corinthians 3:18).[1]

What is remarkable about this picture is that in it, despite the wealth of iconographical complexities, the young Caravaggio has so simply conveyed the essence of the story, that is to say the play of emotions between the two characters, enriching the dialogue by making allusive use of the pictorial conventions of *vanitas* and genre.

The radical process of simplification, by which he goes to the heart of a theme, is equally apparent in one of the most sombre masterpieces of his final year, the *Martyrdom of St Ursula*, which has strong claims to be considered his last finished painting. It was most probably commissioned after his return to Naples from his exile in Sicily and shortly before his final, fatal voyage to Rome, by the Genoese patron Marcantonio Doria, a step-daughter of whose had entered a convent under the name of 'Sister Ursula'. Here too, the spectator is confronted with a close-up, concentrated image of two figures at half-length, one brandishing a bow, the other in a posture of submission. It differs so greatly from the standard traditions of representing St Ursula – almost invariably shown with the 11,000 virgins who, according to the legend, shared the martyrdom of this obscure British-born saint at the hand of the Huns – that its subject remained unidentified until the recognition of the document

129

confirming its Doria provenance.[2] This describes it as 'St Ursula pierced by the tyrant' (*S. Orsola confitta dal tiranno*), and it is clear that in formulating his composition Caravaggio returned to the written sources – in this case most probably the popular compilation of saints' lives known as the *Legenda aurea* (*The golden legend*) – and rethought the subject afresh. It is recounted in *The golden legend* how, after Ursula's numerous followers had been beheaded, the prince of the Huns was so struck by the saint's beauty that he wished to marry her, but that when she refused he shot her dead with an arrow.[3]

Seldom in the history of painting have a martyr and her assassin been placed in such a pregnant confrontation, and never in representations of St Ursula had the crowded scene been so radically reduced to the two protagonists with a fringe of onlookers. If the space between Ursula and the Hun seems too close for the firing of an arrow, this only emphasises the psychological verisimilitude not only of the prince's ambiguous reaction as he realises what he has done, but also of Ursula's calm acceptance of her fate as, gazing downwards, she encircles with her hands the spot where the arrow has entered her breast. Only the seemingly disembodied hand thrust forward by one of the bystanders as if in an attempt to stop the arrow, separates the martyr from her killer, otherwise united by their red garments.

Whereas the realism of the mirror, the comb and the ointment pot in *The conversion of the Magdalen* are harnessed to their symbolic roles as the signifiers of the Magdalen's sinful life, Caravaggio's close attention to the armour and the costumes in *St Ursula* seems rather to act as a foil to the claustrophobic atmosphere of the scene, which is all the more concentrated through the lack of any definable setting. It is intriguing that Caravaggio has adapted from his much earlier representation of the *Betrayal of Christ* (Cat. no. 17) the device of including his own portrait among the onlookers, this time holding a spear. In the *Betrayal* he was assisting in the action he had portrayed: here he looks on, excluded, at the concentrated moment of martyrdom his art has created, and through which he has distilled the essence of an essentially violent action to

a meditation on the relation between killer and martyr. The chronological gap between the pictures also makes clear Caravaggio's stylistic progression from a tight manner of painting to the looser brushstrokes of his later years, a progression in the use of the texture of paint that would undoubtedly have continued further had he lived.

Even simpler in composition than Caravaggio's portrayal of the Magdalen's awakening conscience and of Ursula's acceptance of her fate is Rembrandt's glowing evocation of domestic love in the painting known since the mid-19th century as *The Jewish bride*. Rembrandt has pared away all context, all external paraphernalia of setting, to create what Christopher White has fittingly described as 'one of the greatest expressions of the tender fusion of spiritual and physical love in the history of painting'.[4] Placed slightly off-centre in the composition, the two figures seem to fuse together into whole, united by the tender gesture of the man who reaches across to place his hand on her breast, which she delicately touches in a reciprocal gesture of acceptance. The great red river of her dress is relieved only by her right hand, poised midway on it, while the figures themselves emerge from a soft golden-brown background tonality to engage our attention by their absorption in each other. The absence of all connotations, of everything superfluous to the central theme of a couple united in love, means that the subject that inspired Rembrandt to create this masterpiece is not readily identifiable. There has been much speculation that the couple are intended as representations of Old Testament characters, such as Abraham and Sarah, Boaz and Ruth, or Jephthah and his daughter, or as portraits of Rembrandt's son Titus with his bride, or of the Amsterdam Jewish poet Miguel de Barrios and his wife, or even as characters from a play. It seems most likely that they are Isaac with his bride Rebecca as described in Genesis 26:8, where Abimelech observes the couple sporting, and recognises that they were married. Isaac and Rebecca were long considered, and particularly in the 17th century, as an exemplary married couple, and the evidence of a drawing suggests that that at least was Rembrandt's most likely starting point.[5]

The problem will not be solved until documentary evidence comes to light, nor will the vexed question of the extent to which the canvas has been cut down. Although technical evidence strongly suggests that Rembrandt began the work with a much larger and more elaborate composition in mind, the presence of his authentic signature at lower left indicates that it cannot have differed significantly from its present dimensions when he finished it. In any case, it would appear that Rembrandt refined his original ideas to focus ever more closely on the figures themselves, transforming a narrative into a sharpened focus on its psychological implications, a process which has been dubbed *Herauslösung* by Christian Tümpel.[6] The results of this process in this painting, at any rate, produced one of Rembrandt's most moving and meditated masterpieces, one that takes Caravaggio's fertile experimentation in the expression of emotions through a close focus on half-length figures to a higher, more deeply felt plane, and one in which Rembrandt makes the most brilliant use of his richly impasted late painting style. [DB]

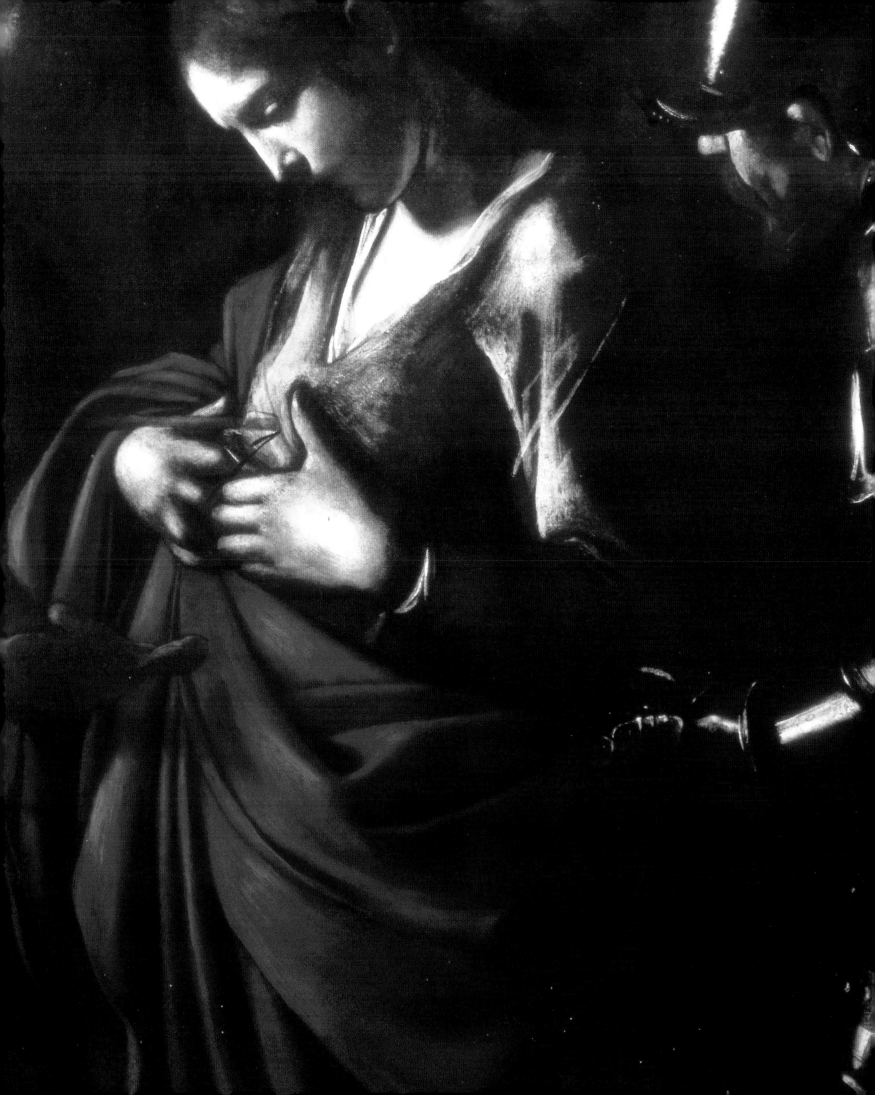

Rembrandt
A queen from antiquity, probably Sophonisba or Artemisia

Rembrandt has taken the contrast between light and shadow to extremes in this monumental *Queen from antiquity*. Seated against a dark background is a blonde woman clad in a brilliantly lit dress and gown with a splendid ermine collar. The strong *chiaroscuro* even extends to the details. The queen's three-dimensionality is enhanced by the deep shadows in her chubby face, in the fold of her gown and beneath both her hands. The Utrecht Caravaggisti were no longer employing such a pronounced *chiaroscuro* in the 1630s, for Van Baburen and Ter Brugghen had both died (in 1624 and 1629 respectively), and Honthorst was working in a very different style by then. Rembrandt, on the other hand, was to perfect the technique in the 1630s by which light was used to structure compositions and create the illusion of depth. A comparison with the *Two old men disputing* (Cat. no. 7) of roughly six years earlier shows that he had already laid the foundations for this approach in his Leiden period. A beam of light in both paintings falls from outside the scene onto the main character, who is wearing light-coloured clothing. A second parallel is the foreground figure, which is almost entirely shrouded in darkness and thus serves as a *repoussoir*. This figure's face is lit indirectly, in the *Two old men disputing* by a reflection from the book, while in the Madrid painting the light reflects off the queen's attire. Only the back of the head, neck and shoulders of both foreground figures are directly illuminated by an invisible light source outside the painting. The light is also used in both works to pick out the key objects in the story: the book and the nautilus cup respectively.

The use of such extreme contrasts in the details in the *Queen from antiquity*, and the structuring of the composition through light, recall the work of Caravaggio. For instance, Caravaggio's *Supper at Emmaus* (Cat. no. 38) also has the device of not entirely shading the *repoussoir* foreground figure, whose lost profile leads the viewer's eye into the scene, as it

were. There, too, the composition is lit from the left, and the light just grazes the shoulder of the disciple in the foreground. His profile is also illuminated indirectly, this time by the reflection from the white tablecloth.[1] Although the disciple is not holding the object that is crucial to the story, his gaze does lead the viewer's eyes to it: the bread on the table below Christ's hand. One major difference between Caravaggio and Rembrandt is the latter's use of the texture of the paint surface – a device he had already been experimenting with on a small scale in the 1620s (Cat. nos. 6 and 8). The smooth material of the queen's braided gown, the gossamer sleeves embroidered with gold thread, the gold chain and the sumptuous rug – the texture of the paint is everywhere different in the *Queen from antiquity*, whereas Caravaggio's paintings have a far smoother and more regular surface.

Standing in the shadows in the background of Rembrandt's scene is an old woman. X-radiographs show that Rembrandt made her much larger at first, and had her lean over the queen's shoulder on the left. Her wrinkled face below a headdress was right beside the smooth, fleshy face of the young queen. Stressing the differences between old and young by contrasting them was a popular theme in painting, and recommended in Italian and Dutch treatises on art.[2] Caravaggio exploited it in his *Judith and Holofernes* (Cat. no. 10), in which the old maidservant peers over Judith's shoulder with

134

fig. 51 Rembrandt
'The large Jewish bride', c. 1635 (etching, 21.9 x 16.8 cm)
Amsterdam, Rijksmuseum

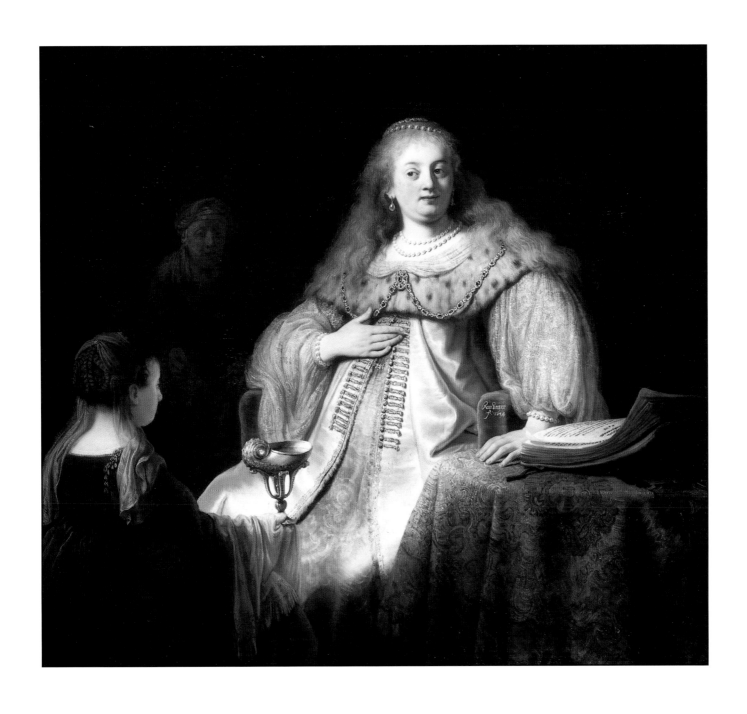

Cat. no. 32 Rembrandt
A queen from antiquity, probably Sophonisba or Artemisia, 1634
Oil on canvas, 142 x 153 cm
Madrid, Museo Nacional del Prado

a dour expression, and in *Salome with the head of John the Baptist*, in which her counterpart looks over Salome's shoulder at the Baptist's head on the platter (fig. 71).

Opinions differ on the true subject of this painting. The identification may have been complicated by the fact that Rembrandt appears to have changed horses in midstream, as he was to do the same year with his *Flora* (Cat. no. 14). The ugly old woman in *A queen from antiquity* was moved to the background. The X-radiographs also show that she was holding a gleaming circular object, which may very well have been a mirror that she was holding up before the queen.[3] That would have made the scene a woman at her toilet, the more so in that the girl with the nautilus cup was a late addition. Originally, then, the subject might have been the same as that in the *Woman at her toilet* in the National Gallery of Canada, in which the woman may be the biblical Queen Esther.[4]

When the painting was acquired for the Spanish royal collections in the 18th century, the woman was identified as Artemisia, the wife (and sister) of King Mausolos, whose death left her so prostrate with grief that she decided to turn herself into a 'living, breathing tomb' by mixing some of his ashes in her wine each day.[5] At the beginning of the 20th century, however, the queen was identified as Sophonisba, another figure from classical antiquity.[6] She preferred to give up her life by committing suicide for her beloved husband Masinissa, rather than fall into the hands of the Roman general, Scipio.[7] If that is the case, Rembrandt has captured the quiet moment before Sophonisba drinks the cup of poison sent to her by Masinissa.[8] Whatever the truth of the matter, both women are models of the feminine virtues of marital fidelity and self-sacrifice. Rembrandt depicted the crucial, dramatic moment at which a woman is on the point of deciding her own fate.

Finally, there is the striking resemblance to Rembrandt's so-called *Great Jewish bride* (fig. 51). Although there are also books lying on the table in that etching, attributes that were rarely depicted in association with women in this period, she too remains unidentified.[9] The woman in the *Queen from antiquity* may not be the same one as in the etching, and the two works are in totally different media, but Rembrandt nevertheless seems to have had the same end in view: to achieve a perfect imitation of the fabrics of the royal attire and of the hair hanging loosely around the women's shoulders. [TD]

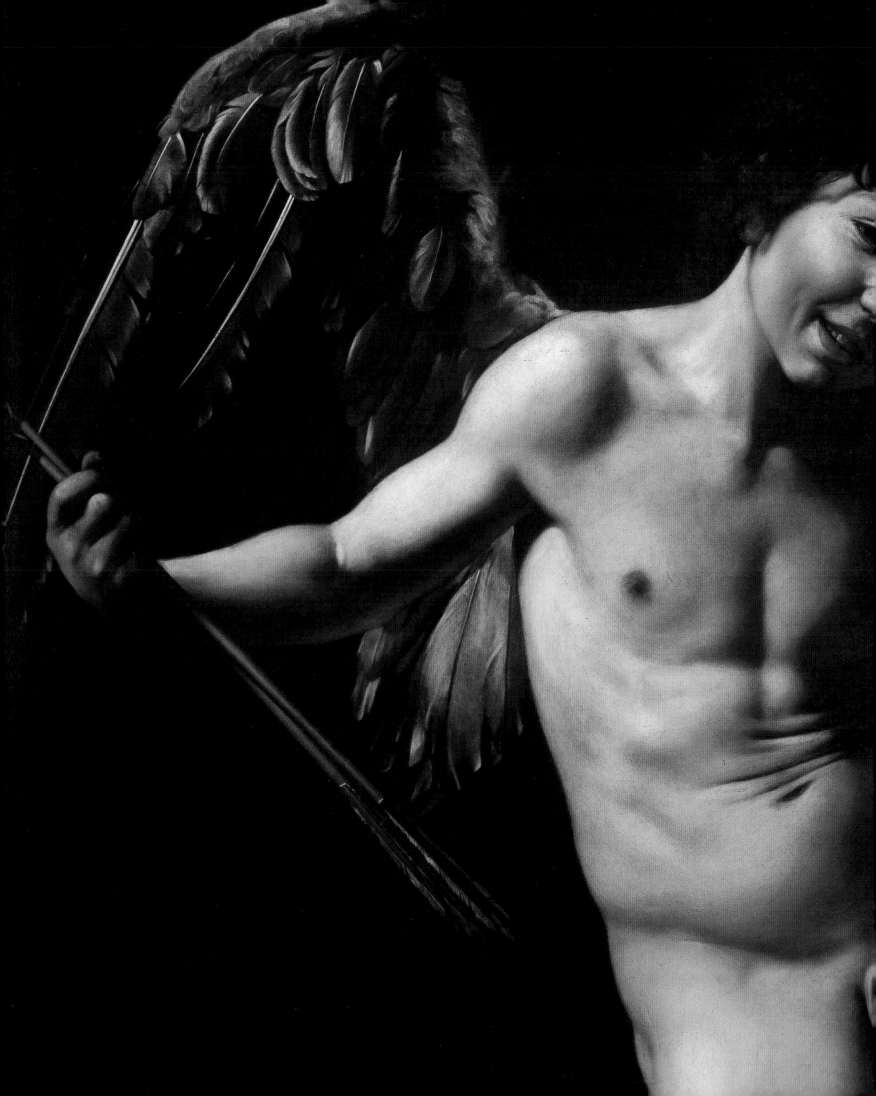

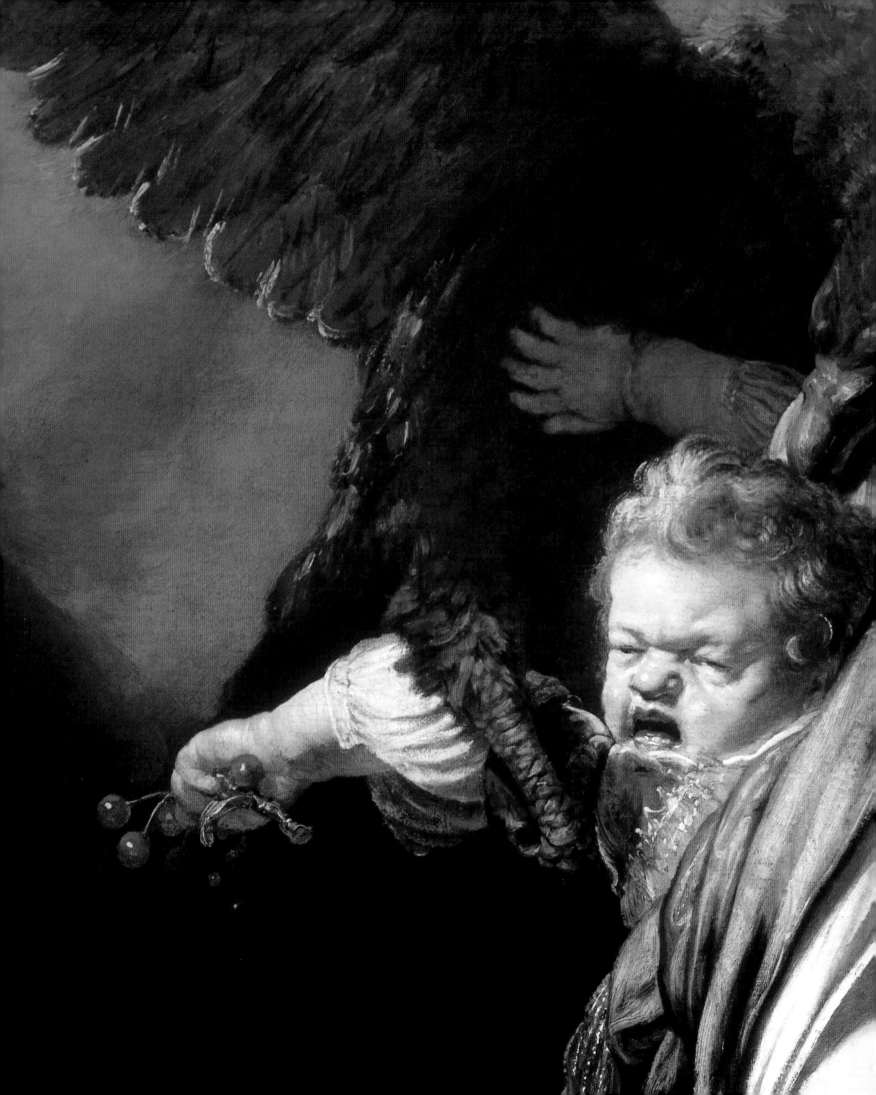

<table>
<tr><td>Caravaggio</td><td>Rembrandt</td></tr>
<tr><td>*Omnia vincit Amor*
(Love triumphant)</td><td>*The rape of Ganymede*</td></tr>
</table>

The myths and gods of classical antiquity

have provided painters with a fertile source for their imaginations,

and all ambitious artists of the 16th and 17th centuries

sought to bring their own interpretations to the universal themes

of antiquity that had become embedded in European culture.

In their treatments of the *Rape of Ganymede* and *Love triumphant* Rembrandt

and Caravaggio set out to shock, both bringing an idiosyncratic approach

to what had long been perceived as a problematic aspect of classical culture.

In formulating their compositions, both undermine

our expectations of the subjects through the pointed realism

of some, but not all, elements of the portrayal.

And both also radically subvert the received traditions of depicting

the subjects, doing so with a wit and an audacity that would certainly

have appealed to the intellectual tastes

of their audiences.

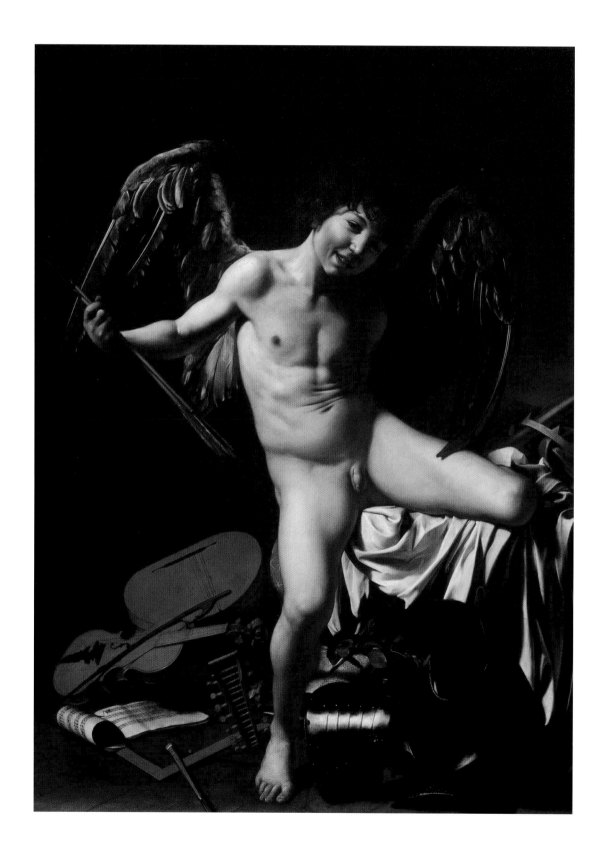

Cat. no. 33 Caravaggio
Omnia vincit Amor (Love triumphant), 1602
Oil on canvas, 156 x 113 cm
Berlin, Staatliche Museen zu Berlin, Gemäldegalerie

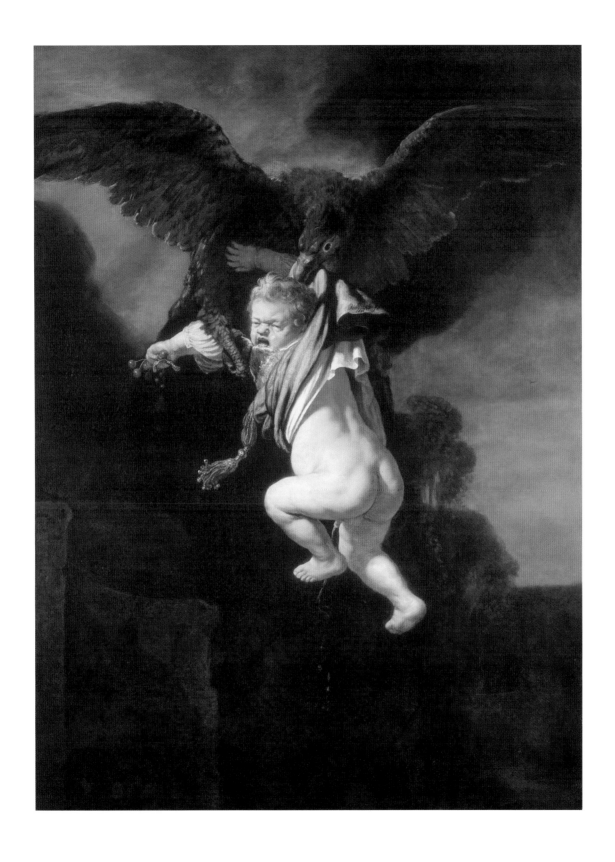

Cat. no. 34 Rembrandt
The rape of Ganymede, 1635
Oil on canvas, 171 x 130 cm
Dresden, Staatliche Kunstsammlungen Dresden, Gemäldegalerie Alte Meister

Cupid, or Amor, the son of Venus and playful boy-god of love, who is the subject of Caravaggio's painting, is instantly recognisable by his wings and by the two arrows he holds: one, with a golden tip, causes anyone pierced by it to fall in love, the other, leaden-tipped, puts love to flight.[1] Around him in a jumble lie musical instruments, military accoutrements, books and architects' drawing implements. On the most basic level the iconography is straightforward: *omnia vincit amor*, love triumphs over everything. The phrase, a classical maxim from Virgil's *Eclogues*,[2] was sufficiently well known to have become almost a cliché by the end of the 16th century. There can be little doubt that this

is the primary subject of the painting, and confirmation, if confirmation was needed, is provided by a poem written by the Roman poet Marzio Milesi shortly after Caravaggio painted it, which specifically applies the phrase to this picture.[3]

What is most startling in Caravaggio's conception is the immediacy of Cupid's presence, the way in which he is shown not as an idealised god, a being from the heavens who can control human emotions, but as a very real physical presence exposed to the searching light that Caravaggio throws upon him. There is a long tradition of images of Cupid stretching back to classical antiquity which was known not only to Caravaggio but to the man who commissioned this painting, marchese Vincenzo Giustiniani. Giustiniani, an avid collector of both ancient sculptures and modern paintings, was one of Caravaggio's most enthusiastic admirers. His wide-ranging interests embraced the visual arts, the sciences and the study of classical arts and letters; and there is some evidence that Caravaggio may have participated, along with poets such as Milesi, in the intellectual discussions held in Giustiniani's circle in which philosophical arguments concerning the nature of love, both physical and divine, would certainly have featured.

Caravaggio has indeed loosely based his Cupid on ancient Roman statues of the god, one example of which is known to have been owned by Giustiniani (fig. 52). While there can be no doubt as to the figure's classical origins, never before in the visual arts had the sensual qualities of the actual human flesh of the god been so relentlessly emphasised, and with such obvious physical delight as Caravaggio does here: from the way in which the wing caresses the boy's left thigh to the sinuous band of shadow that runs down his inner right leg or the rolls of skin where the torso meets the belly. This is both a god and a palpable living being.

Nor are the objects over which Cupid triumphs the normal obstacles that stand in the path of lovers, and over which love triumphs. They represent instead the classical social virtues – skill in music and the arts, and military prowess.

fig. 52 Cornelis Bloemaert
Cupid (engraving from *Galleria Giustiniani*, 51.5 x 35.5 cm)
Amsterdam, Rijksmuseum

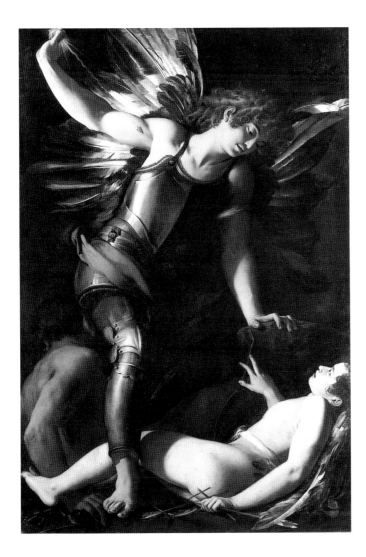

tered by the potency of a love that triumphs over human aspirations to keep things orderly and civilised.

In another of the few contemporary documents concerning the painting, the painter Orazio Gentileschi refers to the work as showing 'Earthly love', contrasting it to a 'Divine love' executed by a rival artist, Giovanni Baglione (fig. 53), which may itself reflect a lost picture by Caravaggio.[5] This description provides a clear hint that the strong sexual charge of Caravaggio's work was recognised by his contemporaries. Indeed, much of the power and complexity of the work arises from the fact that Caravaggio evokes so many of the various meanings and nuances of love, both human and divine, that were part of the intellectual currency in Giustiniani's humanist circle. Part of Caravaggio's strategy to shock is the cheeky come-hither smile on Cupid's all-too human face, his splayed legs, the position of his left arm, so that what is portrayed seems less an evocation of a divinity than a portrait of a street boy offering himself for the sexual gratification of the viewer. Caravaggio again exploits the tension between an almost too accurate description of a living model – a boy who has donned a pair of eagle's wings – and our expectations of what a god should look like. The strong homoerotic implications are further reinforced by the fact that Caravaggio derived the boy's pose from Michelangelo's famous image – well-known to Caravaggio's patrons – of the best-known paedophiliac story of antiquity: the rape of Ganymede by the god Jupiter (fig. 55).

Cupid is conquering exactly those civilised values that were most prized in the world-view of the patron, indeed he tramples on the whole fabric of civilised society itself. It is revealing that an early description of the painting in an inventory of Giustiniani's collection describes the work as 'A painting of a smiling Cupid in the act of disparaging the world'.[4] The dangerous side of love is present. It is also noteworthy how the almost brutal realism with which Caravaggio depicts the young flesh of the god is so pointedly contrasted with the more conventional precision he has brought to his description of the objects on the floor and table. Here the standard contents of a *vanitas* still life are scat-

If Caravaggio subverts the concept of an idealised love by suggesting that Love himself can be a sex object with the power to wreak havoc with men's lives and values, Rembrandt does just the opposite in an equal act of subversion in his extraordinary interpretation of the myth of Ganymede. This shepherd boy, as described in Ovid's *Metamorphoses*, was so beautiful, so sexually desirable, that Jupiter, taking the form of an eagle, swooped down and carried him off to Mount Olympus as his catamite.[6] Ovid's text, which Rembrandt would have known either in the original or in one of many translations, is explicit about

fig. 53 Giovanni Baglione
Divine love conquering the world, the flesh and the Devil, c. 1602-1603 (183.4 x 121.4 cm)
Berlin, Staatliche Museen zu Berlin, Gemäldegalerie

and theatricality that Rembrandt brings to this painting is, if anything, greater than that produced by Caravaggio's insistence on the fleshly qualities of his still classical Cupid. Against a background in which Rembrandt uses all the high Baroque devices of theatrical lighting and swirling motion to give this violent abduction its maximum impact, the helpless baby – its features contorted as it howls – pisses with fear, more like a rabbit snatched from a field than the comely shepherd of pastoral myth. In his initial thoughts for the composition, as recorded in a remarkably sketchy drawing (fig. 54), Rembrandt even considered including Ganymede's astounded parents in the composition as witness of the abduction. This idea may well have been based on Michelangelo's inclusion of the dog, which watches the eagle's sexually explicit snatching of the shepherd; and it may be that when executing the painting Rembrandt considered their presence as a step too far in the direction of a prosaic realism, preferring to concentrate on the irony of Jupiter's lust for a being whose emotional experience is limited to the basic level of fear. But even so, the heavy flesh of Rembrandt's baby, with its prominent buttocks, is as carefully and convincingly described as, say, the bosom of Geertje Dircx in the Edinburgh *Woman in bed* and the supple skin of his *Bathsheba* (Cat. no. 36), although it is clear that no erotic effect is intended as it so obviously is in Caravaggio's *Cupid*. Quite the contrary: Rembrandt undermines our preconceptions by his obvious determination to defuse the sexual charge inherent in the episode, just as Caravaggio undermines our preconceptions about the god of love by adding sinister, even brutal, sexual undertones.

Nothing, alas, is known of why, or for whom, Rembrandt painted his *Ganymede*. It has been suggested that it may have been commissioned by a Dutch humanist patron as a direct parody of the classical Ganymede myth.[8] That putative client might have enjoyed the tension between sublime myth and mundane reality as much as Giustiniani enjoyed the layers of meaning in Caravaggio's Cupid. The infant's act of micturation may well, as has been suggested, be an erudite reference to Ganymede's subsequent history, when he was transformed

the homoerotic intentions of the god. The visual tradition forportraying the myth, established largely in Italy during the 16th century, and undoubtedly also known to Rembrandt, was that of a beautiful youth clutched from behind in an often overtly sexual embrace by a giant eagle. The most famous and most frequently reproduced is the print after Michelangelo, which we have already seen Caravaggio exploiting when he posed his Cupid (fig. 55). Rembrandt certainly knew this canonical image, and it was clearly also the starting point for his radically different interpretation of the myth.[7]

Contrary to all literary and artistic tradition, Rembrandt almost perversely diminishes the famously handsome adolescent of Michelangelo's composition and Ovid's myth to a struggling bag of flesh, a squealing infant seized from its cradle by an eagle whose majesty of form and dramatic domination of the composition against clouds made visible by lightning in a night sky nevertheless announce that this is indeed the king of the gods. The tension between realism

fig. 54 Rembrandt
The rape of Ganymede, 1635 (pen, brown ink and wash, 18.3 x 16.0 cm)
Dresden, Staatliche Kunstsammlungen, Kupferstichkabinett

into the constellation Aquarius, the water-pourer.[9] But, like Caravaggio's picture, Rembrandt's is too serious, too strong and too disturbing an image to be dismissed as a mere parody, for it retains from the myth a sense of the power of the forces of nature and a reinterpretation from outside the standard tradition, of how those powers can be treated in art. This sort of radical rethinking of an established tradition suggests an artistic affinity between Rembrandt and Caravaggio that might not immediately be apparent, except to the extent that great artists of necessity question and refine the traditions that they draw from. Milesi's poem about Caravaggio's Cupid seems equally applicable to both paintings: the painter, he implies, by the act of painting conquers all, not only souls, but bodies. [DB]

Omnia vincit amor,
tu pictor, et omnia vincis,
Scilicet ille animos,
corpora tuque animos

(Love conquers all things
and you, painter, conquer all things;
He indeed conquers souls,
but you bodies and souls)[10]

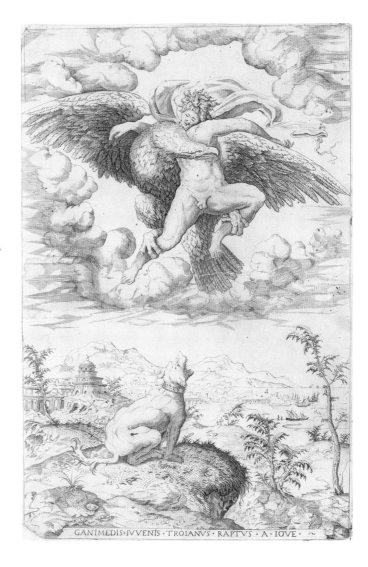

fig. 55 Anonymous artist after Michelangelo (Nicole Barbizet?)
Ganymede (engraving, 42.5 x 28 cm)
Amsterdam, Rijksmuseum

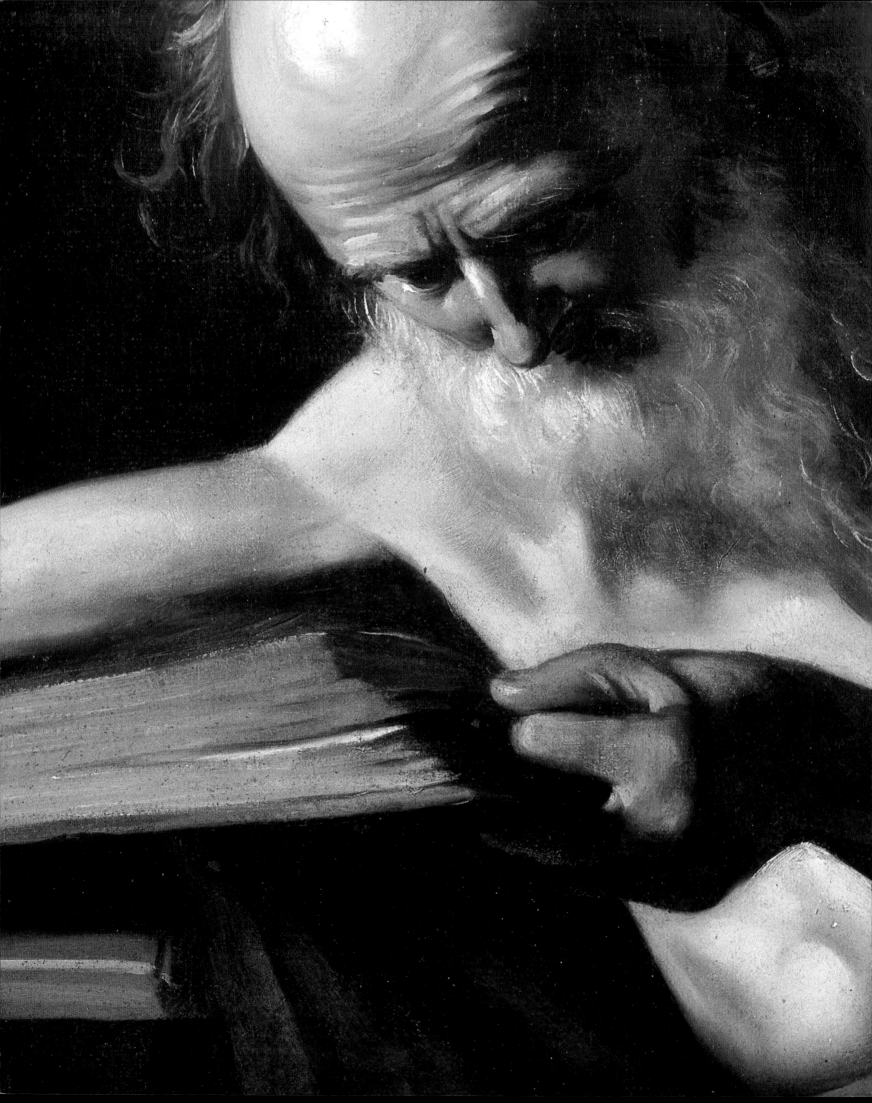

Caravaggio | Rembrandt
St Jerome writing | *Bathsheba bathing*

Both Rembrandt and Caravaggio

were able to pare down their representation

of historical or biblical figures to the essentials,

using their painterly skills

to suggest the complexities of the persons portrayed.

In the former's large painting of Bathsheba bathing

and the latter's depiction of the scholarly labours of St Jerome,

they focus on the physical qualities of the protagonists as a

starting point for their exploration of the characters' *personae*,

exaggerating and adjusting the environment

and lighting to heighten

their interpretations.

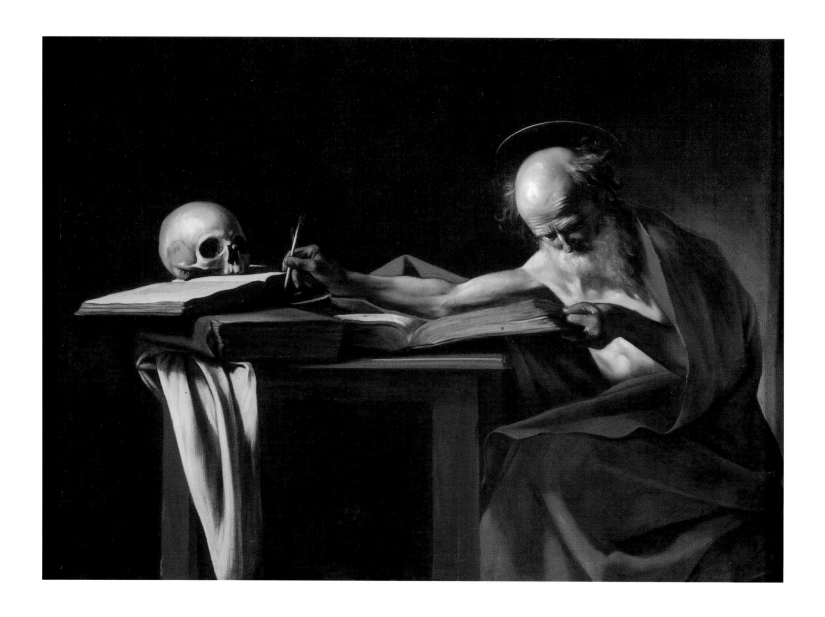

148

Cat. no. 35 Caravaggio
St Jerome writing, c. 1606
Oil on canvas, 112 x 157 cm
Rome, Museo e Galleria Borghese

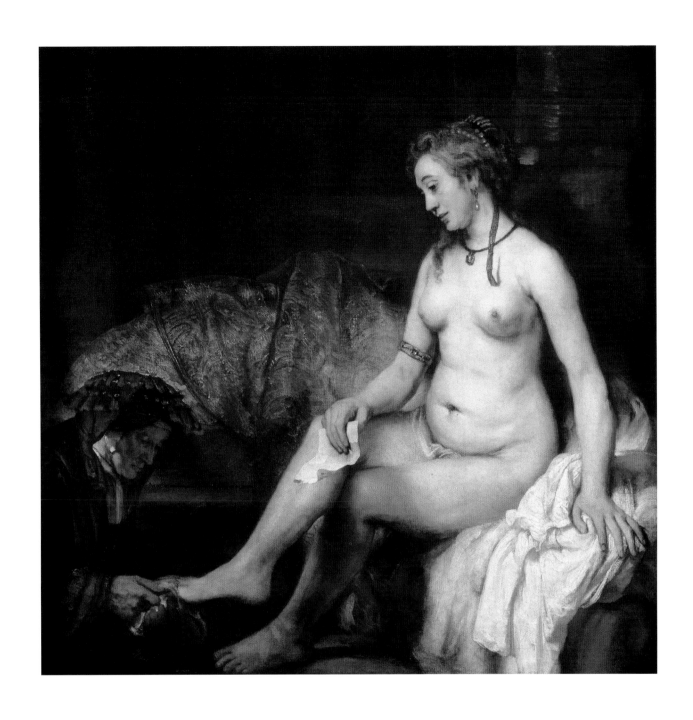

Cat. no. 36 Rembrandt
Bathsheba bathing, 1654
Oil on canvas, 142 x 142 cm
Paris, musée du Louvre. Bequeathed by Dr Louis La Cazes, 1869

From the Renaissance onwards, the Old Testament story of King David's sinful lust for the married woman Bathsheba was used by painters as a vehicle for an often erotic portrayal of the beauties of the nude female body. According to the Second Book of Samuel (11:2-4), King David, looking from the roof of his palace, 'saw a woman washing herself; and the woman was very beautiful to look upon. And David sent and enquired after the woman. And one said, Is this not Bathsheba, the daughter of Eliam, the wife of Uriah the Hittite? And David sent messengers, and took her; and she came in unto him, and he lay with her; for she was purified from her uncleanness: and she returned unto her house'. Later, when Bathsheba was pregnant with his child, David ensured that Uriah would be killed in a skirmish, and he married Bathsheba.

In his lyrical masterpiece of 1654, the 58-year-old Rembrandt chose to isolate the figure of Bathsheba, showing her seated at the bath with a single attendant drying her foot. He has eschewed the anecdotal elements of the story usually favoured by painters: neither David in his tower nor the messengers are depicted. The only indication that the figure is indeed Bathsheba is provided by the letter she holds. As so often with Rembrandt's major masterpieces, nothing is known of the circumstances under which he painted it,

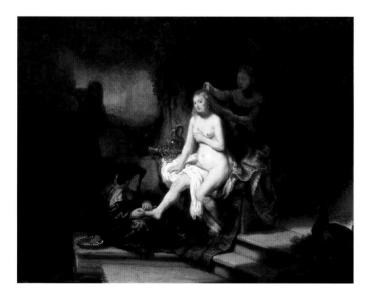

and whether or not it was commissioned or painted for his own pleasure.

Rembrandt's close-up concentration on Bathsheba is unusual, as is his monumental presentation of her. In the long pictorial tradition of the subject she is usually shown at an outdoor bathing location (to explain why she was visible to David), in luxurious enjoyment of her bath and attended by maidservants. This is indeed the composition of a small-scale painting, which also included David's palace in the background and bears Rembrandt's signature and the date 1643 (fig. 56).[1] There the erotic implications are clear, and the viewer is invited to share David's voyeuristic enjoyment of her naked body. In the Louvre picture, the space remains more ambiguous: the column behind Bathsheba's head suggests a grandiose structure, and the sumptuous draperies to the figure's right, painted with an astonishing network of freely applied brushstrokes of rich brown and ochres to suggest a golden sheen, seem to give a foretaste of the royal palace which Bathsheba is still to enter. Even more unusual is the sombre darkness of the upper half of the composition, suggesting that night has already fallen, and allowing Rembrandt to accentuate the woman's flesh against the background by means of the soft light that mysteriously enters from outside the pictorial space.

Although the female nude occurs much less frequently in Rembrandt's painted *oeuvre* than in his etchings and drawings, he had examined the theme of feminine luxury from early on, in a small painting of *Susanna and the elders* of c. 1634 through to the astonishingly intimate picture of a woman in bed of 1647, now in Edinburgh. At much the same time as the Louvre *Bathsheba* he also produced his extraordinary study of a woman entering a stream to bathe (fig. 57), a picture whose subject remains unfathomable apart from its giving a glimpse of an intimate moment, and painted with such an astonishing force and freedom that it has often been considered a sketch. Rembrandt's vision of Bathsheba in the Louvre may perhaps have started out as a study of this type, but on a much larger, more grandiose scale. The solid, carefully modelled flesh, creamily painted and with all the con-

151

fig. 56 Rembrandt (attributed to)
The toilet of Bathsheba, 1643 (panel, 57.2 x 76.2 cm)
New York, The Metropolitan Museum of Art

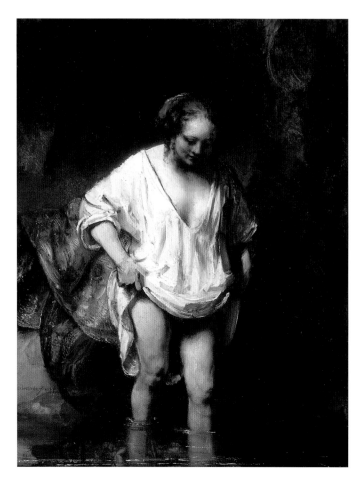

her.[2] His decision, at a late stage of the composition, to lower her head and show her gazing downwards – not at, or engaging with, the maidservant, but lost in thought – is yet further evidence of his very conscious determination to eliminate all anecdotal elements from the painting. Only the centrally placed letter in her right hand provides the reason for her withdrawn pensiveness. Brought by the unseen messengers, this is the summons from David that presents her with the moral choice between obedience to the king and faithfulness to her absent husband. Yet again, Rembrandt has picked out the key psychological moment. Indeed, he has extracted from the biblical text an element that it implies, but does not make explicit: the story itself is concerned entirely with David's sinfulness, of which Bathsheba is the incidental cause. Rembrandt's decision to focus on Bathsheba's moral dilemma was almost unparalleled in art, and the means

tours explored and described, counts among his most brilliantly subtle evocations of the human body. There is no hint of an idealised perfection; the attraction lies in the combination of plastic form and the softness of the application of the paint.

As in the *Woman bathing in a stream*, it is the withdrawn intimacy of the scene that is particularly remarkable in Rembrandt's *Bathsheba*, the way in which he allows the spectator an unembarrassed glimpse into a privacy that seems all the more personal given Bathsheba's complete lack of engagement with the sombre, aged serving maid who concentrates on her humble task. X-radiographs indicate that Rembrandt originally gave Bathsheba a more upward turn of the head, as if she was looking out of the pictorial space, perhaps gazing in the direction from which David had spied

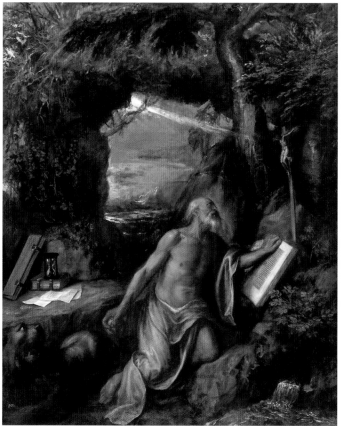

152

fig. 57 Rembrandt
A woman bathing in a stream, 1655 (panel, 61.8 x 47 cm)
London, The National Gallery

fig. 58 Titian
St Jerome in the wilderness, c. 1573 (216 x 175 cm)
El Escorial, Monasterio de San Lorenzo

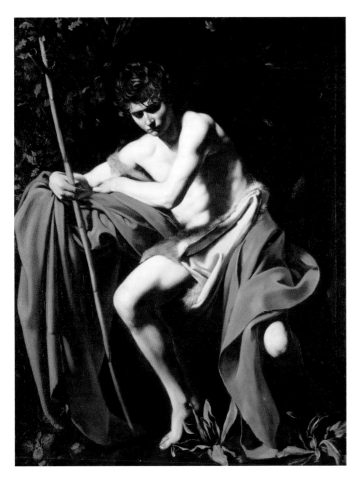

studying in Rome, he devoted himself to a life of scholarship, and he spent his last years in retirement in the Holy Land, working on his translations. Within the Christian church, and especially within the western European artistic tradition, he rapidly came to be seen as a prime symbol of scholarship and asceticism, and is frequently portrayed both as a scholar in a book-lined study, or, as in Titian's famous canvas (fig. 58) in solitary prayer in the desert, most usually accompanied by the anachronistic attributes of a cardinal.

The conception of Caravaggio's intense and deeply felt image of the saint may, perhaps, have been influenced by the tastes of the most important Roman cardinal of the early 17th century, Cardinal Scipione Borghese, who commissioned it from the artist, according to one of Caravaggio's early biographers.[3] The favourite nephew of Pope Paul V, Cardinal Borghese was effectively the head of the papal government, and one of the most powerful men in Rome. An avid connoisseur of art, he collected voraciously, acquiring paintings by established masters as well as works by avant-garde artists, among them Caravaggio, whose works he eagerly sought, owning, among others the *Boy with a basket of fruit* (Cat. no. 27) and the *Supper at Emmaus* (Cat. no. 38). Although reputedly one of the most hedonistic of the Roman cardinals, and with scant reputation as a scholar, Borghese would undoubtedly have responded to Caravaggio's stark image of this most austere of early Christians, whose status as cardinal Caravaggio hints at by the orange-red cloth draped around his body.

The painting probably dates from 1606, the year in which Caravaggio fled from Rome, and it is clear how far the artist has developed from his early interests in the closely focused study of a single figure found in *Boy with a basket of fruit* and *A boy bitten by a lizard* (Cat. nos. 27 and 25). Here the heightened realism of those two pictures is taken much further, the fierce slanting light now concentrating itself on the high dome of the saint's forehead to emphasise the power of his intellect. This diagonal shaft of illumination is similar to that used in *Boy with a basket of fruit*, but here it is extended to emphasise the salient points in the composition: the white

by which he provides us with an insight into Bathsheba's private world, both physical and mental, in the sombre but luxurious atmosphere of the bath, is one of the great achievements of western painting.

Like Rembrandt's Bathsheba, Caravaggio's St Jerome is shown at a moment of complete privacy, absorbed in his thoughts. And like Rembrandt, Caravaggio presents the essential character of the ascetic saint through a seemingly objective scrutiny of his aged face and body, and the way in which he is lit against a neutral dark background. St Jerome was one of the most important of the early Fathers of the Christian church, whose translation of the Bible from the original Hebrew and Greek into Latin was fundamental for the hegemony that the Catholic church was later to obtain in western Europe. After

153

fig. 59 Caravaggio
St John the Baptist, c. 1604 (172.7 x 132.1 cm)
Kansas City, The Nelson-Atkins Museum of Art

cloth hanging from the table's edge, and brilliant white of the hovering pen held in readiness. It equally illuminates the skull, which balances the saint's cranium as a reminder of his mortality.

Caravaggio was both famed and criticised in his own lifetime for his adherence to painting directly from the model. Some of his critics considered it an excess of naturalism, too near everyday reality to be suited to the higher ideals expected in a historical figure. Yet it is precisely the tension between the actuality of a body and the historical or religious associations it bears that Caravaggio was eager to exploit, and which makes, for example, the cupid in the *Omnia vincit Amor* (Cat. no. 33) so powerful and shocking an image. The same is true of his images of another ascetic saint, St John the Baptist, whom Caravaggio depicted on several occasions. In the *St John* of c. 1604 (fig. 59), Caravaggio softens his vision, to provide a more meditative and more introspective image of the saint who lived in the wilderness and foretold the coming of Christ. His painting of St Jerome takes this process one step further: just as Rembrandt moulded the heavy flesh of his Bathsheba into an image of sexual ripeness, so Caravaggio's description of the aged saint is adapted to his artistic aims. The model on whom the St Jerome is based is recognisable from other works painted in the first five years of the first decade of the 17th century. He appears as St Peter being crucified in the Cerasi Chapel (fig. 81), in the background of *The death of the Virgin* (fig. 3), and most recognisably at the top of the *Doubting Thomas* of 1603 (fig. 28). In the *St Jerome*, however, Caravaggio generalises his features more than in any of those works. He focuses less on the smaller details, indicating the wrinkles of the forehead with bold brushstrokes, and concentrating on where the cheeks and nose are struck by the light. The emaciated flesh of the torso is only summarily indicated, and the arm is impossibly elongated, its emaciated silhouette emphasised by the river of red where the cloak shows beneath it. This is no idealised image, however; the figure is abstracted, and nowhere is this more evident than in the dome of the forehead, which rhymes perfectly with the dome of the skull perched on the book to the left. Contained within the constricted space between the skull and the fall of red drapery at the right, the intellectual energy of the saint nevertheless bursts out in the only moment of spatial illusion Caravaggio allows himself in this pared-down composition: the thrust of the books over the table into the spectator's space. Caravaggio seems to be painting less a living model, though that model is nevertheless insistently present, than the very act of concentration and abstract thought that is taking place, just as Rembrandt's physical Bathsheba becomes a vehicle for her moral decision. [DB]

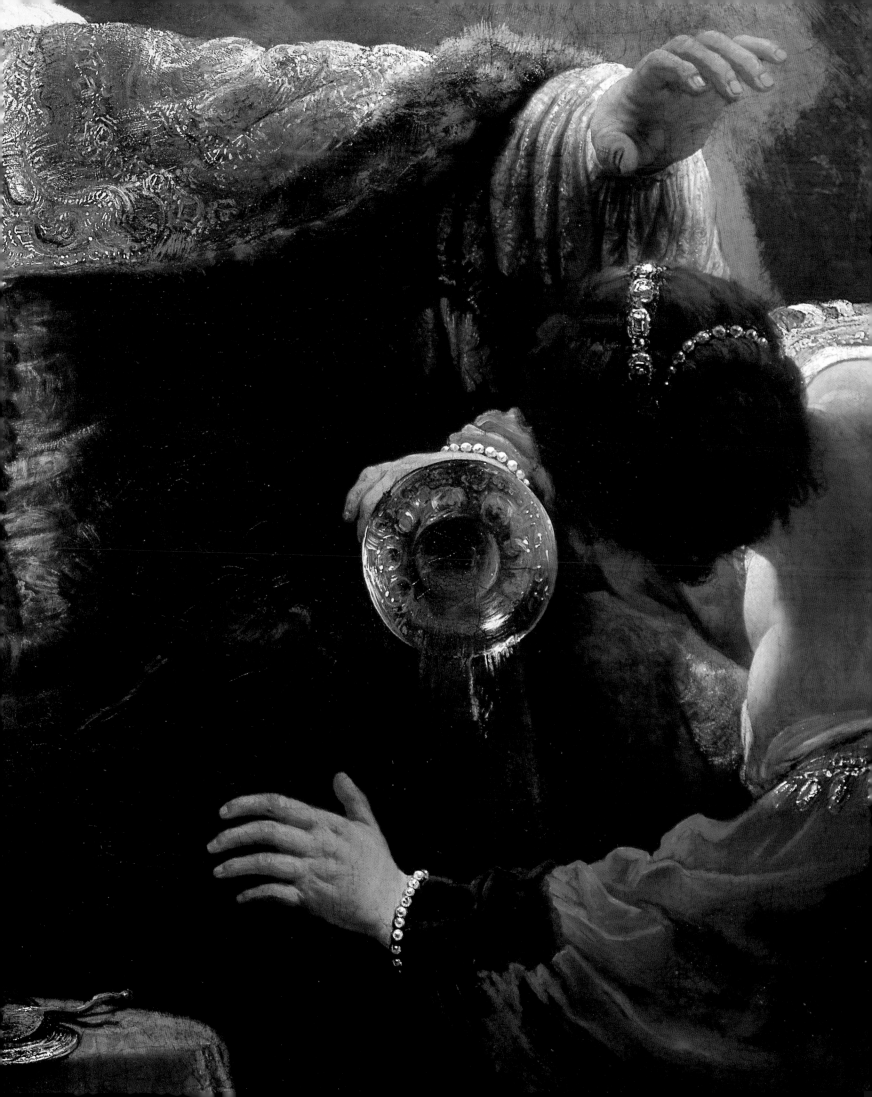

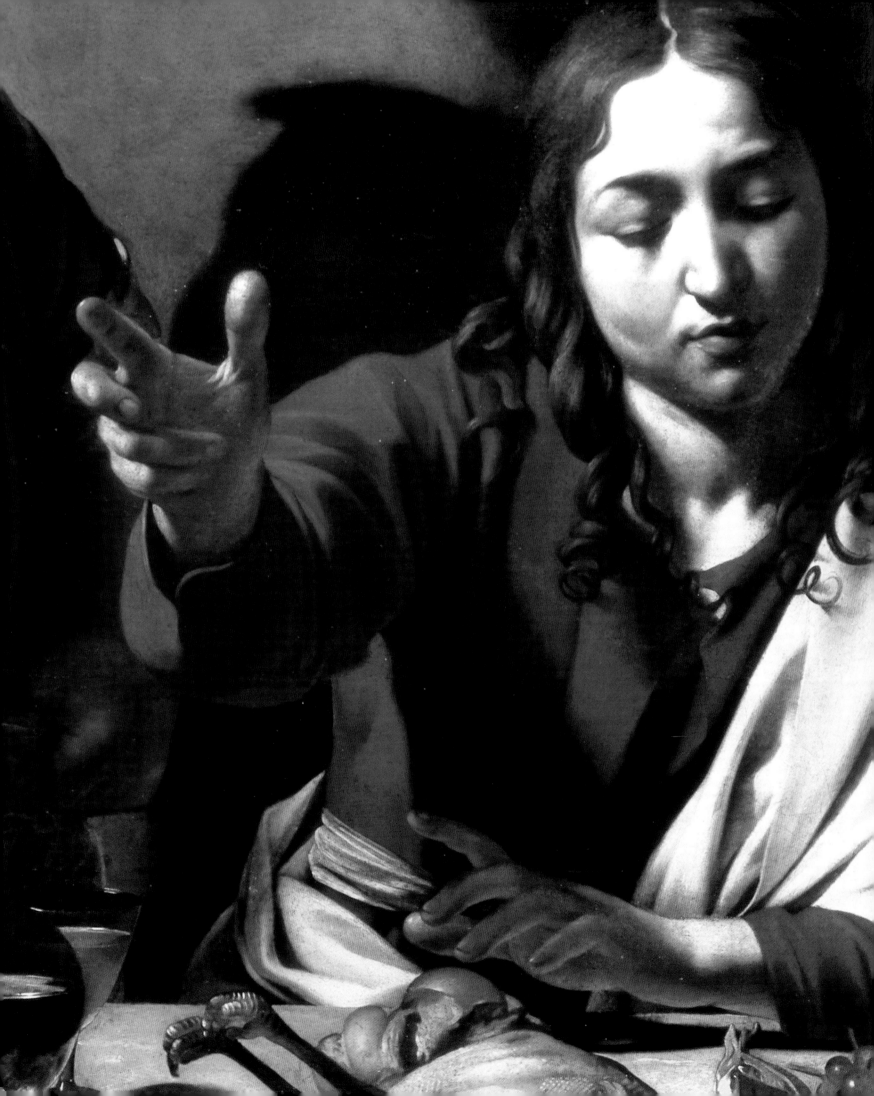

Rembrandt | Caravaggio
Belshazzar's feast | *The supper at Emmaus*

An enduring challenge that
painters face is that of making the supernatural
visible in a convincing way.
In the *Supper at Emmaus* and *Belshazzar's feast*,
Caravaggio and Rembrandt show
the interruption of a meal by divine intervention,
both choosing to highlight the unusualness of the event
by focusing on the reactions of the
dramatis personae.

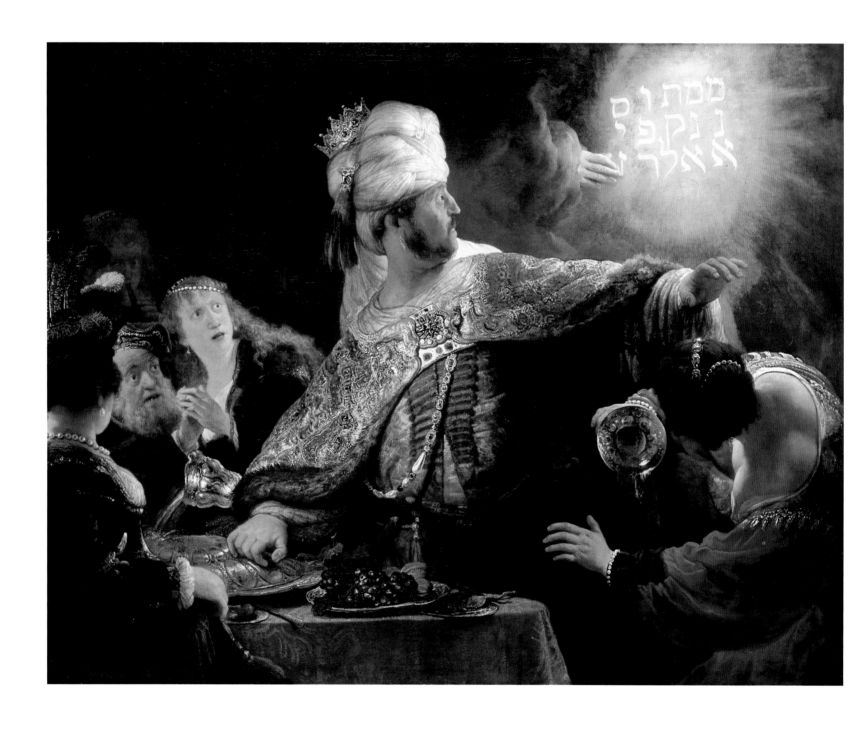

158

Cat. no. 37 Rembrandt
Belshazzar's feast, c. 1635
Oil on canvas, 167.6 x 209.2 cm
London, The National Gallery. Bought with a contribution from the National Art Collections Fund

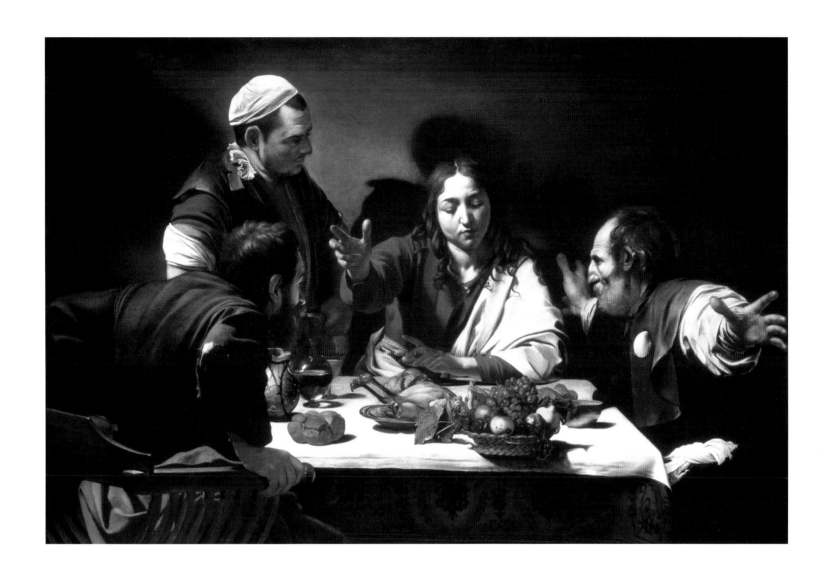

Cat. no. 38 Caravaggio
The supper at Emmaus, 1601
Oil on canvas, 141 x 196.2 cm
London, The National Gallery

Rembrandt painted his *Belshazzar's feast* around 1635, in the earliest phase of his youthful maturity, in a period when he was increasingly concerned with the problems of portraying the forceful expression of violent actions (see also Cat. nos. 22 and 10). It was also a period of intense fascination with the richness and variety of colour and texture to be found in exotic oriental costumes (fig. 60). These two interests come together with telling power in this Old Testament scene, in which the open gesture of the Babylonian king as he swings around to look at the writing hand provided Rembrandt with as great an opportunity for the depiction of sumptuous clothing as for the expression of a state of astonishment and fear.

The episode it illustrates, contained in Chapter 5 of the book of the prophet Daniel, is one of the most dramatic of the Old Testament set pieces, announcing as it does the destruction of Babylon, notorious for extravagant decadence, impious paganism and sacrilegious imperialism. Belshazzar, king of the Babylonians, gave a great feast to the lords of his land, and ordered the golden and silver vessels that his father Nebuchadnezzar had sacked from the temple of Jerusalem to be brought to the table so that 'his wives, and his concubines, might drink therein'. Not only was this a mockery of 'the temple of the house of God' from which the objects had been pillaged, but while drinking from them, the company further 'praised the gods of gold, and of silver, of brass, of iron, of wood, and of stone' thus further insulting the one God of the Jewish faith. They were interrupted, and that interruption is what Rembrandt's imagination has visualised. 'In the same hour came forth fingers of a man's hand, and wrote over against the candlestick upon the plaister of the wall of the king's palace: and the king saw the part of the hand that wrote. Then the king's countenance was changed, and his thoughts troubled him, so that the joints of his loins were loosed, and his knees smote one against another' (Daniel 5:5-6).

Implicit in the viewer's appreciation of the painting is a knowledge of the rest of the story, knowledge that would have been possessed by any educated Dutchman of the 17th century who had grown up in a culture that placed particular emphasis on the Old Testament.[1] Belshazzar's necromancers having failed to interpret the meaning of the apparition, it was only when the Jewish prophet Daniel – whom Nebuchadnezzar had also brought captive to Babylon – was sent for that the full import of the event became clear. Daniel berated the king for his blasphemy before translating the words 'Mene, Mene, Tekel, Upharsin' – here carefully rendered by Rembrandt in Hebraic script – as: 'God hath numbered thy kingdom and finished it'; 'thou art weighed in the balances, and art found wanting'; 'thy kingdom is divided and given to the Medes and Persians' (Daniel 5:25-28). The prophesy was fulfilled, for 'that night was Belshazzar the king of the Chaldeans slain. And Darius the Median took the kingdom' (Daniel 5:30; 6:1).

Rembrandt wrings every ounce of drama from the story: the fiery letters blaze in a circle of light of their own making, the richly dressed woman in red topples out of the pictorial space at right, spilling wine from her costly vessel, and two of the guests cower on the left with their mouths agape in astonishment and fear. All this serves to emphasise the psychological state of the central figure of Belshazzar himself, his arms wide open as if he himself was a weighing scale balancing the earthly forces of the banquet against the supernatural power of the writing hand towards which he is being irresistibly pulled. This poise, this suggestion of a swinging motion, would have been even more telling before the painting was cut down a little on all four sides and the canvas repositioned, with the composition turned slightly anticlockwise from its previous position.[2] Belshazzar, Rembrandt declares, is torn from his sensual life to the realisation of a higher power that awes him but which he does not yet understand.

Caravaggio's painting captures an equivalent moment of psychological realisation caused by a very different and benign apparition – one central to the doctrine of the Resurrection at the heart of the Christian story, and one that announces the continuation of life rather than an imminent death.

He illustrates and interprets the Gospel of St Luke, who describes how, after Christ's crucifixion and burial, two of his disciples went out of Jerusalem to the nearby town of Emmaus. On the way, they were joined by a stranger, who discussed the scriptures with them, and chided them for their slowness to believe. Only that evening, at supper in Emmaus, did they recognise the stranger's true identity, when he made the same gestures as Christ had during the Last Supper before his arrest and crucifixion: 'And it came to pass, as he sat at meat with them, he took bread, and blessed it, and brake, and gave it to them. And their eyes were opened, and they knew him; and he vanished out of their sight' (Luke 24:30-31).

It is this moment of revelation that Caravaggio has chosen to examine, showing Christ's action in blessing rather than breaking the bread, and capturing the astonishment of the disciples' recognition above all through their gestures. One throws his arms apart in astonishment, while the other is caught rising from his seat as the light, both literally and figuratively, begins to dawn upon him. Only the innkeeper – who knows nothing of the story and thus nothing of Christ's sacrifice – remains impassive though curious, with the supernatural illumination from the apparition also catching his face.

Like Rembrandt in his *Belshazzar*, Caravaggio is concerned to capture the drama in this turning-point of the story. Within a few minutes the risen Christ, having shown himself substantial, will vanish from the table: he is as much of an apparition as the writing hand in the story of Belshazzar. Each artist has recognised that the essential element in each story is concerned with gesture: the gesture of God's hand writing on the wall, and the gesture of Christ blessing the bread, and have emphasised this central theme through a whole play of subsidiary gestures. Rembrandt contrasts the clasped hands of the woman to Belshazzar's left with the impassive pose of the woman in the lower left corner, who has not yet noticed anything unusual happening, just as Caravaggio contrasts the exaggerated flinging out of the arms of the disciple on the right of his canvas with the static pose of the innkeeper diagonally opposite him.

And both strengthen the impact and the meaning of the play of gestures through the fall of light, Caravaggio bathing his figures with a strong illumination from a concealed light source that emphasises their frozen actions, while Rembrandt shows two contradictory light sources, which serves to heighten the supernatural atmosphere.

Caravaggio, too, was at the beginning of his early maturity when he painted the *Supper at Emmaus* in 1601 for his important patron Ciriaco Mattei, who commissioned several major works from him (see also Cat. no. 17). The work remains, to some extent, the production of a young painter who is showing off. Caravaggio's early skills as a specialist still-life painter are still to the fore in the virtuoso depiction of the bread, fruits and meats of the meal on the table, but he also plays daringly with spatial construction, pushing the disciple Cleophas's chair at left out of the picture space, and exaggerating the perspective and foreshortening of the other disciple's outflung arms. The painstaking realism with which the still life is painted, and the illusionism with which the basket juts out into the real world of the viewer, also act as a foil to the supernatural event, where the apparition of Christ is framed by the innkeeper's shadow, which forms a sort of halo around his head. And while following the biblical text of St Luke's gospel extremely closely, Caravaggio – perhaps at the suggestion of his patron, whose erudite brother Cardinal Girolamo Mattei may have assisted Caravaggio in formulating the iconography[3] – also takes a hint from St Mark's gospel, which tells us that Christ appeared to the disciples 'in another form' (Mark 16:12), by showing the Redeemer as a young, beardless man, and not with the established bearded features of the western artistic tradition.[4] This adds to the air of heightened reality, with the idealised face of Caravaggio's Christ contrasted with the carefully described wrinkles of the disciple and the lifelike description of the prosaic innkeeper, an everyday bystander in this supernatural scene. Whereas earlier artists had produced compositions that invite the spectator to meditate on the divine event, Caravaggio engages us in the drama.

The patron – if indeed there was one – of Rembrandt's picture is unknown, so it cannot be judged to what extent its content may have been influenced by his or her wishes. Rembrandt, too, appears to be showing off newly developed skills, and to be striving towards a more powerful overall effect than he had yet attempted. Like Caravaggio, he contrasts a substantially naturalistic rendering of the foodstuffs on the table with the supernatural occurrence, paying even more painterly attention to the rich chasing and reflections on the gold vessels that are such an important part of the story, and whose textures and reflections were of such pictorial interest to him in their own right. More significantly, he has taken particular pains to establish the correct orthography of the Hebrew inscription God's hand is engaged in writing. In doing so, he undoubtedly consulted his friend the Amsterdam rabbi and typographer, Menasseh Ben Israel, who reproduced the inscription in exactly this form in his treatise *De termino vitae*, published in Amsterdam in 1639.[5]

Both Rembrandt and Caravaggio go far beyond their predecessors in extracting the most dramatic potential from a well-known story. Both appeal to a recognition by the viewer of the accuracy of their depiction of things, while at the same time successfully suggesting the supernatural, which can, of itself, not be described. Their understanding of this tension, and how to make effective use of it, is one of the many traits that unite them as great artists. [DB]

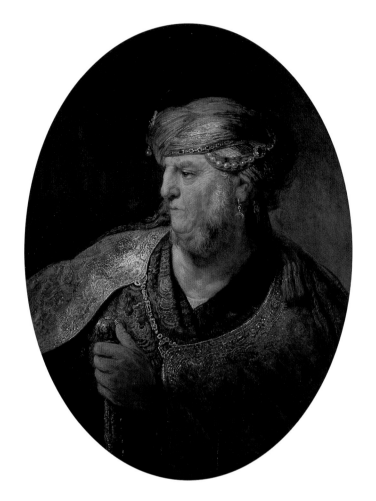

fig. 60 Rembrandt
Bust of a man in oriental dress, 1633 (panel, 85.8 x 63.8 cm)
Munich, Alte Pinakothek

Essays

Margriet van Eikema Hommes and Ernst van de Wetering
Light and colour in Caravaggio and Rembrandt, as seen through the eyes of their contemporaries

Few artists have suggested and used light in their paintings as convincingly as Caravaggio and Rembrandt. The similarities between them are striking. In many of their works, the bright light illuminates only a few parts of the scene, leaving large areas shrouded in darkness. The differences, though, are equally remarkable, and had repercussions for the use of colour, the suggestion of space, and for the very individual ways the two painters set about composing their works.

This essay opens with a comparison of two paintings that are brought together here: Caravaggio's *Judith and Holofernes* (fig. 62) and Rembrandt's equally gruesome *Blinding of Samson* (fig. 61). This comparative description will be kept as neutral as possible, and will not examine any painterly inten-tions on the part of the artists. Those intentions, insofar as they can be deter-mined, are the subject of the remainder of the essay.

Two paintings compared
Caravaggio's work shows the Jewish heroine Judith in the act of beheading Holofernes, the commander of the Assyrian army. She will hide his head in the sack held by the old woman. Rembrandt's painting is a scene from the Old Testament. Delilah, a Philistine woman, is the lover of Samson, an ene-my of the Philistines who is thought to be invincible. She, though, has managed to worm the secret of his strength out of him: his hair has never been cut since he was born. Delilah has his hair cut off while he sleeps, rendering him power-less. Rembrandt shows her running off holding his hair and the scissors as the Philistine soldiers overpower Samson and put out his eyes.

In Caravaggio's work, the light spears in as a dazzling beam from top left, creating bright effects where it hits the figures and the draperies. The paint-er was very careful in his placement of the lights and shadows. Every single form is modelled, described as it were, by the light, always with a clear contrast between light and shade. This gives each body the skin specific to that figure, and each drapery or other object a convinc-ing relief. One thing that stands out is that the contrast between light and shade is equally strong for the different forms. The lights on Judith's face and body are as bright as those on Holofernes's back

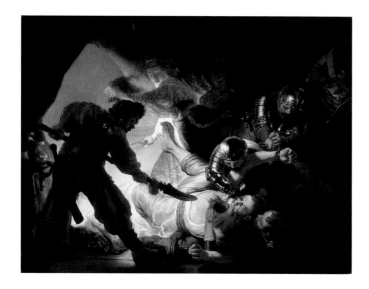

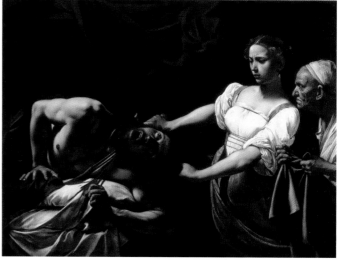

fig. 61 Rembrandt
The blinding of Samson, c. 1635 (Cat. no. 9)

fig. 62 Caravaggio
Judith and Holofernes, c. 1599-1600 (Cat. no. 10)

164

and on the old woman's face. The shadows, too, are equally dark on all three figures, as well as on the various objects, such as the red curtain at the top, although there is local reflected light in shaded areas of Holofernes's body. What does differ is the distribution of the light and the shadows depending on the location of the figures relative to the source of light, which is outside the scene on the left.

It is only when this picture is confronted with Rembrandt's does it become clear that there is no variation in the Caravaggio in the relationship between the background and the figures in front of it. Caravaggio kept the background very dark, so that the illuminated forms detach themselves from it, creating the effect that the figures stand out strongly in space. Rembrandt, on the other hand, organised his scene so as to set up an interplay between the different 'layers of depth' in the picture space. Caravaggio's choice of colour for the costumes and draperies appears arbitrary, but Rembrandt executed the clothing of Samson and the fleeing

Delilah, and the draperies in the background, in comparably light tones, with the result that these passages cohere within the scene. The intensity of that cluster of light tones, which stands out starkly against the dark surroundings, makes it seem that we are looking into a glowing oven. The silhouette of the soldier with the spear on the left stands out freely against this light background, thrusting him into the foreground.

Whereas Caravaggio 'described' each individual form equally carefully, creating a loose grouping of equivalent plastic forms, Rembrandt seems to do the opposite. He varies the modelling figure by figure depending on their positions within the space and the light, and he is generally sparing in his use of tonal contrasts within the separate forms.

The danger of anachronisms
Anyone analysing and interpreting the differences between the two paintings in greater depth is inclined to do so on the basis of personal impressions and associations. That, however, can eventually lead to serious misunderstandings. Kenneth Clark, for instance, said of the strong lighting effects in Rembrandt's *Samson* (fig. 61): '[...] a wave of light, which seems to have burst through a broken dam, overwhelms the miserable Samson and then is gone from him forever.'[1] However striking such an interpretation of Rembrandt's handling of light may appear to be, it differs radically from the artist's intentions. He used the same

lighting effect, for example, in *Two old men disputing* (Cat. no. 7), and in his *Christ in the storm* (fig. 74).

The actual reasoning behind this lighting effect that Rembrandt used so often is discussed below in connection with two passages written by contemporaries of his. In our analysis of the similarities and differences between Caravaggio and Rembrandt we will base ourselves as far as possible on writings from their own days, texts by painters and art-lovers who explicitly speak of Caravaggio and Rembrandt and their methods in treatises and manuals. In that way we hope to reconstruct the 'language' both artists could have used when speaking of the painterly procedures they followed, so that the reader can view their paintings through their own eyes, as it were.

The effect of time
Before discussing those texts, though, one must realise that, due to natural ageing and poor treatment, paintings by Caravaggio and Rembrandt no longer look exactly the same today as they did when they left the studio. We chose the above two works because they are relatively well preserved. Nevertheless, we know for certain that the effects of time have wrought changes in Rembrandt's *Blinding of Samson*, as they have in his other paintings. The main change here is the darkening of the paint, and of the dark paint in particular, which usually contains more oil

165

fig. 63 Unknown Rembrandt pupil
Drawing after *The blinding of Samson*
Size, medium and whereabouts unknown

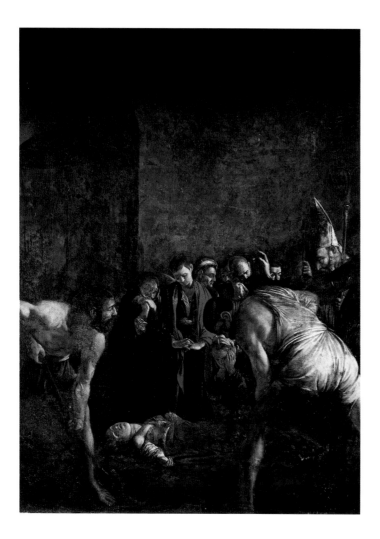

17th-century copy of it on copper (fig. 65).[2] As in the case of Rembrandt's *Samson*, there are more nuances in the shaded passages and the dark clothing in the copy, and the background is more clearly defined. In Caravaggio's original, by contrast, the illuminated forms and the red drapery loom up out of the darkness like 'islands'. However, there is a good chance that there was no great differentiation in the dark backgrounds of most of Caravaggio's other paintings. It emerges from the writings discussed below that shortly after his death, when his paintings were little affected by ageing, contemporaries were already speaking of a room with black walls in which Caravaggio was said to have placed his models.

Contemporaries on Caravaggio and Rembrandt

Light as a means of expression?
When one reads what the contemporaries of Caravaggio and Rembrandt had to say about their handling of light, one is immediately struck by a major difference from the modern interpretations. Nowadays, the pronounced chiaroscuro contrasts used by both artists are usually characterised as 'expressive', 'dramatic', 'mystical' or 'spiritual'. That has led to the view that they used light to give their scenes a special, often religiously charged meaning. For example, in the exhibition *La luce del vero* held in Bergamo in 2000, in which works by Caravaggio, Georges de la

than light colours do. The evidence that the *Samson* has darkened comes from a drawing that must have been made after it by one of Rembrandt's pupils (fig. 63). Drawings of this kind were exercises in making a reduced monochrome copy in order to learn how to reproduce the different tonal values in a painting in order to achieve a convincing spatial illusion (*houding* in the Dutch terminology of the day). The drawing shows that Rembrandt applied as much differentiation in the dark

passages as in the light ones. This was done using 'kindred colours' (*bevriende kleuren*), as they were called in the 17th century. We will return to these two crucial terms, *houding* and *bevriende kleuren* in the discussion of Rembrandt's painterly procedures below.

Copies by contemporaries also give an idea of the sometimes dramatic changes Caravaggio's works have undergone. It is a revelation to see how great the differences are between his *Burial of St Lucy* (fig. 64) and a well-preserved,

fig. 64 Caravaggio
The burial of St Lucy, 1608 (408 x 300 cm)
Syracuse, Museo Nazionale di Palazzo Bellomo

Tour, Zurbarán and Rembrandt were on display, it was assumed *a priori* that those artists' use of light had a religious significance.[3] In Caravaggio's case, in particular, the light is often linked to theological ideas about the mystical associations of light.[4]

Although religious writings of the day are sometimes invoked to support such modern interpretations, it is very much the question whether those texts are directly applicable to the artists' use of light. Not one contemporary of Caravaggio or Rembrandt who wrote about their paintings and artistic intentions ascribes any mystical or other profound significance to the light in their paintings. As will be shown in more detail below, they regarded it simply as a pictorial resource – in Caravaggio's case in order to give the individual figures a credible sense of volume, and in Rembrandt's to achieve a convincing suggestion of space and compositional concentration. Bert Treffers has demonstrated convincingly that most of Caravaggio's works contain no inducement for deeper reflection about his handling of light, because it turns out that there is no connection between the lighting of individual figures and the fact of whether they have or have not undergone a religious conversion or have some other involvement with the supposedly divine lights.[5] It is only in exceptional cases, when there is an explicit reference to divine light in the story depicted, biblical or otherwise, that a deeper meaning can be

attributed to the painted light.[6] The same applies to works by Rembrandt, such as *The Holy Family with angels* (fig. 73). It was only later in the 17th century, around 1670, during discussions within the Paris Académie Royale de Peinture et de Sculpture among artists from a totally different artistic milieu, that an expressive function was ascribed to the handling of light in a painting.[7]

Imitating nature

Caravaggio's biographers described him as someone who only painted directly from life, but it is debatable whether that should be taken absolutely literally, for both Caravaggio himself and Vincenzo Giustiniani, one of his most trusted admirers, moderated that view. The only record of a statement by Caravaggio about his ideas on painting was made in 1603 during a hearing connected with a complaint for defamation of character lodged by the painter Giovanni Baglione, one of Caravaggio's later biographers. When Caravaggio was asked to explain what he meant by the term *valenthuomini* that he applied to a number of painters whom he knew, he replied: 'The word *valenthuomo* as used by me means someone who knows how to practice his art properly. Thus a *valenthuomo* painter is someone who knows how to paint well and how he must imitate nature well (*imitar bene le cose naturali*)'.[8] Although several authors haveconstrued this as confirmation of Caravaggio's extreme faithfulness to life,

the choice of painters whom he cited as examples, among them Annibale Carracci, Federico Zuccaro and the Cavalier d'Arpino, shows that *imitar bene le cose naturali* does not mean working literally and consistently from nature, for it is known that those artists also worked 'from the imagination', sometimes predominantly so.[9]

Vincenzo Giustiniani, the eminent connoisseur and collector of Caravaggio's day, and one of his most important patrons in Rome, regarded the artist as anything but uncompromisingly naturalistic. In his famous letter of c. 1620 to Teodoro Amideni, he divided painting into 12 categories ranked by degree of difficulty, and it is explicit from the fact that he did not put Caravaggio in the eleventh category, 'painting with the natural object before one', that he did not regard him as an artist who worked purely from life.[10] Instead, he grouped him with the Carracci and Guido Reni in his twelfth and highest

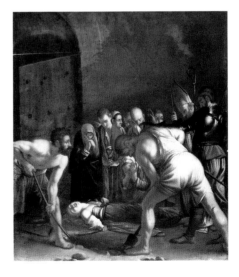

167

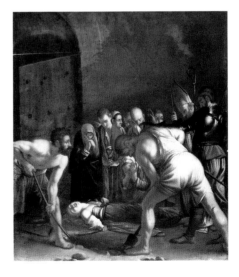

fig. 65 Copy after Caravaggio
The burial of St Lucy, (copper, 40.6 x 34 cm)
Rome, private collection

category, for masters who combined the skills of the eleventh category with those of the tenth – artists who created a painting *di maniera* – which according to Giustiniani meant that they worked from the imagination, in other words without any models at all.

Caravaggio's merits in the sphere of *di maniera* painting, however, were not noted by any of his 17th-century biographers, who all emphasise that he painted from life (*colorire dal naturale*). Characteristic of this view are the remarks of his first biographer, the Dutchman Karel van Mander, in his *Schilderboeck* of 1604. Van Mander could never have seen Caravaggio's work himself (he visited Italy from 1573 to 1577), but he undoubtedly had well-informed correspondents who kept him abreast of developments in Italy. What is particularly striking is that Van Mander says not a word about Caravaggio's use of light, the aspect that is of such interest today. Van Mander considered a very different feature of Caravaggio's work to be important, and that was his extreme faithfulness to reality. 'His dictum is that all works, no matter of what nor by whom made, are naught but *bagatelles*, child's play or trifles if they be not done and painted from life, and that there is no good or better way of proceeding than by following nature. Also that he does not make a single brushstroke unless he gathers close to life, and copies and paints it'.[11] The Roman art-lover Giulio Mancini was of a similar opinion, as emerges from his unpublished treatise for art lovers, *Considerazioni sulla pittura* (c. 1617-1621), in which he wrote 'In this method of working, this school [Caravaggio and his followers] is highly observant of the truth, and always keeps it before it while working'. Giovanni Bellori, in his 1672 biography of Caravaggio, stressed that the artist not only regarded nature 'as the subject of his brush' but could not even work without a model.[12]

Given the great emphasis that all his contemporaries put on this, it is certainly likely that Caravaggio had a model before him for shorter or longer periods as he painted.[13] But the assertion that he did not (or could not, according to Bellori) paint a single brushstroke without a model must be regarded as a gross exaggeration. It can be deduced implicitly from his own words cited above that working from nature should not be taken too literally. In his article 'Caravaggio and "L'esempio davanti del naturale"', Keith Christiansen pointed out that for his group compositions it would have been impossible for him to gather all his models together as a sort of *tableau vivant*, because the relative positions of the painted figures would often have been impossible in real life (fig. 66). The individual figures must have been fitted together like a collage. In other words, Caravaggio composed his group scenes 'from the imagination'. However, the conception that was his point of departure must often have been amazingly precise, given the very few *pentimenti* (changes made whilst painting) in many of his works. He must have had an unerring touch.[14] In addition, the fact that he worked from the model does not mean that he painted the light and the colours absolutely literally, photographically as it were. As will be seen below, he could not always have painted what he saw, but also chose his colours from what he *knew* and what he wanted to achieve in a painting, which would certainly have led him to manipulate the intensity of his lights and shadows.

The paradox stressed by many of Caravaggio's contemporaries, namely that he worked solely from nature but that that did not necessarily prevent him from working from the imagination as

fig. 66 Still from Derek Jarman's film *Caravaggio*, 1986
Caravaggio: 'You are paid to be still!'

well, also applies to Rembrandt. His contemporaries, too, made great play of the fact that he was uncompromising in following reality. What is surprising is that his biographer Arnold Houbraken first repeats Van Mander's words about Caravaggio's extremism on this point, which is a clear indication of the impression those remarks must have made at the time. Houbraken then continues: 'Our great master Rembrandt was of the same opinion, taking it as his basic rule to follow nature alone, regarding everything else with suspicion.'[15] Of course Rembrandt painted from the live model, and not just in his portraits. A drawing by one of his pupils shows that *tronies* (heads of different types of people) were also painted from life (fig. 67). However, there can be no doubt that he often worked from the imagination in his drawings and etchings, so why would he not have painted from it as well? His famous studio scene in Boston (fig. 12) is even interpreted as a statement that the best paintings are first painted in the 'idea, imagination or thought'.[16]

The German painter and art theorist Joachim von Sandrart, who wrote biographies of both Caravaggio and Rembrandt (the latter being his contemporary and fellow townsman in Amsterdam in the years 1638-1644) provides a solution to the dilemma of 'from nature' or 'from the imagination'. In his piece on Rembrandt he wrote: 'That [according to Rembrandt] one must follow nature solely and alone, and no other rules.'[17] By 'rules' Von Sandrart meant the standards of ideal beauty developed in classical antiquity and later refined by painters like Raphael. Rembrandt evidently believed that an artist should depict the same, unidealised reality – ugliness sometimes – as was found in reality. In 1681 the Amsterdam theorist Andries Pels published a poem on Rembrandt from which it is clear that 'nature' was identical to unidealised, everyday reality, in contrast to classical beauty, which Pels personified as a Greek Venus.

*'When he would paint a nude woman, as
 sometimes happened,
He chose no Greek Venus as his model,
 but rather
A washerwoman, or a peat-treader from
 a barn,
Calling this aberration the imitation
 of nature,
And all the rest vain adornment.
 Flabby breasts,
Misshapen hands, aye the welts of
 the staylaces
On the belly, of the garters on the legs,
Must be visible, otherwise nature was
 not satisfied.'*[18]

Caravaggio, too, sought out that kind of reality that borders on ugliness. Both he and Rembrandt will of course have made a close study of the skin, surfaces and colours of people and things – one only has to see how they emphasise wrinkles and other folds in the skin, swollen veins, the flexing of sinews and muscles – but that does not necessarily mean that they imitated those details literally, as it were, as their contemporaries suggested. It would have been more a case of assembling them 'programmatically' in the painting. The main contemporary criticism of the uncompromising realism of Caravaggio and Rembrandt was that it flouted the rules of decorum.[19]

Light and colour in Caravaggio

Modelling with light and colour

Caravaggio's biographers did not just believe that he neglected decorum. They also felt that by painting from nature he ignored many other aspects that they considered essential, among them *invenzione*, *disegno* (drawing) and perspective.[20] However, everyone agreed that Caravaggio's presumed method of working directly from reality had one major benefit, and that was that it enabled him to render flesh, draperies and other objects extremely convincingly. This view is already found in Van Mander: 'This is no bad way of attaining a good end, for to paint from drawings (even if they are done from life) is not as reliable as having life be-

fig. 67 Anonymous pupil of Rembrandt
An artist painting an old man, (pen, ink and brush, 9.1 x 13.9 cm)
Paris, Institut Néerlandais, Collection Frits Lugt

169

fore one and following nature with all her different colours'.[21] Caravaggio's colours had a 'truth, force and relief' not found in any other painter, in the opinion of the erudite art-lover Francesco Scannelli in his treatise *Il microcosmo della pittura* (1657).[22] The young painters in Rome accordingly praised Caravaggio as the 'only imitator of nature'.[23]

Contemporaries believed that that power of conviction lay not just in the lifelike details for which the artist had such a keen eye, although they did mention this. Giovanni Baglione, writing in 1642, praised the beautifully rendered dew-drops on the leaves of the flowers in the *Singing lute player* (fig. 7), and the vase in which a window is reflected.[24] Caravaggio's supreme verisimilitude lay above all in his use of colour, according to his biographers.[25] Bellori praised the 'truth of the colours', an aspect that Scannelli commented on several times: '[...] animating the colours with the greatest possible skill'.[26] That a painter was good at imitating the colours of nature may not appear par-

ticularly exceptional at first sight, but this was the aspect of Caravaggio's art that was regarded as innovative and as a true advance in painting. Bellori emphasised: 'There is no question that Caravaggio advanced the art of painting, because he came upon the scene at a time when realism was not much in fashion, and figures were made according to convention and manner, and satisfied more the taste for gracefulness than for truth. Thus by removing all prettiness and vanity in his colour, he strengthened his tones and gave them flesh and blood, while reminding the painter of [the importance of] imitation [of nature]'.[27] And it must have been this use of colour derived from nature and stripped of all frills that Mancini regarded as Caravaggio's greatest service: 'Our age owes much to Michelangelo da Caravaggio for his use of colour, which he introduced and which is now followed everywhere'.[28]

What was it that people found so lifelike in Caravaggio's colours, and how did they differ from those of his contemporaries? It must have been the way in which he modelled bodies, draperies and other objects. For centuries, methods had been handed down from studio to studio for suggesting plasticity in such things with *colours*, with the combination of pigments that had to be used for light tints, the mid-tones and the shadows being prescribed formulaically.[29] It now turns out, though, that when following these formulae the forms were generally *not*

modelled with colours in the way we observe them in nature. In reality, colours are at their most intense in the light (unless they are overexposed, as it were), with the intensity declining as the colour becomes shadowed. However, in many 15th, 16th and early 17th-century paintings one sees in draperies, for instance, that the strongest colour (for example, pure red or blue) is reserved for the shadows, and that the lighter tones are obtained with an admixture of white (fig. 68).[30] The problem here is that while white makes the colour lighter it reduces its intensity. There were also painters who deliberately chose to allow the intensity of their colours to decrease towards the shadows. In such cases, though, it turns out that they did not choose their colours properly, insofar as in the progression towards darkness the objects not only changed *tone* but also appeared to take on a different *colour*. In this altarpiece by Annibale Carracci (fig. 69) for a chapel where Caravaggio also supplied two paintings (figs. 29 and 81) it can be seen that the colour modelling in the draperies is inconsistent. In some the most intense colour is in the lit passages (the yellow cloth and the Virgin's blue cloak), while in others it is in the shaded areas (the Virgin's red gown), and in yet others it is in the mid-tones (the purples). Most fabrics seem to change both in tone and in colour from the lights to the darks, and some appear almost changeant. As Janis Bell has demonstrated so effectively, Caravaggio

170

fig. 68 Fra Angelico
Detail of *Christ glorified*, 1423-1424 (tempera on panel 31.7 x 73 cm)
London, The National Gallery

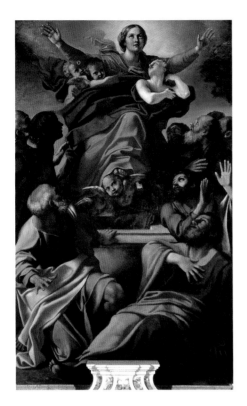

until the colour has virtually disappeared in the very darkest passages, as can be seen so well in *Judith and Holofernes* (Cat. no. 10; fig. 62). In the process, he provided painters with an alternative to unnatural modelling. With Caravaggio, bodies and draperies regain colours of 'flesh and blood', to quote Bellori. This undoubtedly necessitated the painter looking very closely at nature. But that does not necessarily mean that he observed each colour in reality afresh each time and then mixed each colour on his palette on the basis of his observations, as if he was an Impressionist. Caravaggio's 'discovery' appears to have been far more a matter of developing new recipes for pigment combinations for skin, draperies and all sorts of other objects – combinations with which he reproduced the illuminated tints, the mid-tones and the dark shadows better than his predecessors had managed to do. He could constantly re-use those paint recipes based on real-life observation, and it appears that he did just that, for one sees modelling with a particular colour in exactly the same way in different works.

The convincing and consistent modelling with colour in Caravaggio's Roman works is difficult to reconcile with some of his later canvases from Malta and Sicily, such as *The adoration of the shepherds* (fig. 70), in which apparently evenly filled draperies, like the Virgin's blue cloak and the red garment of the left-hand shepherd, alternate with very heavily contrasted, modelled skin

tints and draperies, such as the white cloth in which the Christ Child is wrapped. These phenomena are very reminiscent of what was seen in the case of *The burial of St Lucy* (fig. 64), a contemporary copy of which (fig. 65) shows that the original has aged badly.

Caravaggio restricted his use of strong colours because of their optical property of advancing prominently, ruining the suggestion of continuous modelling. There is often just a single deep red garment or drapery. Most of his figures are otherwise clad in white and grey, or in muted brown, yellow ochre or olive-green fabrics. It must have been this choice of colours that Bellori had in mind when he followed his praise of Caravaggio's colours cited above with the words: 'That is why he used no vermilion or azure blue in his figures, and the few times that he did so he weakened them, saying that they poison the tones'.[33]

Light and rilievo

There seems to have been little doubt in the 17th century why Caravaggio opted for harsh lighting. All of his biographers stress that it was prompted solely by a desire for sharp *rilievo*, that convincing effect of three-dimensionality on the flat picture surface. As Mancini summed it up: 'The characteristic of this school [Caravaggio's] is the use of a single light shining from above without reflections, as would occur in a room with one window and with walls painted black, so that, the lights [of the

was one of the first painters, if not the very first, who managed to combine both colour and *chiaroscuro* so convincingly that we invariably experience the colour of each individual body, drapery or object as constant, in both the illuminated and shadowed passages.[31] This is probably what Giustiniani meant when he observed in his letter mentioned above that while modelling, the artist 'painting with the natural object before one' had to ensure that in the transition from light to dark the viewer sees 'no change at all in the proper colour [of the object]'.[32] In Caravaggio's paintings, the brightest and most saturated colour is always in the illuminated passages, with its intensity decreasing in the correct proportion towards the shadows,

171

fig. 69 Annibale Carracci
The Assumption of the Virgin, 1600-1601 (245 x 155 cm)
Rome, Santa Maria del Popolo, Cerasi Chapel

forms] being very light and the shadows very dark, they give a strong *rilievo* to the picture, albeit in an unnatural manner that has been neither done nor devised in former ages or by painters in the past, such as Raphael, Titian, Correggio and others.'[34] Painters like Leonardo da Vinci, Fra Bartolommeo and Raphael had already understood that a high tonal contrast contributes to a strong *rilievo*. The difference was that Caravaggio heightened that contrast far more. Mancini's statement that Caravaggio depicted his darks without reflections is incorrect. It is true that they are almost entirely absent in his late works, but they are certainly present in his Roman canvases, as has been seen above with the shadowed body of Holofernes in *Judith and Holofernes* (Cat. no. 10; fig. 62).

Initially, Caravaggio did not make use of harsh contrasts of light and shade, as is well illustrated by *The penitent Magdalen* (Cat. no. 13). Bellori reports that the artist was still heavily influenced by the Venetian Giorgione (c. 1477-1510) at the time, and that when he began working from the model in Rome and started imitating the colours, he only used 'tempered shadows' and 'few differences in tone'.[35] It was only later, with his *St Catherine* (Cat. no. 15), that his palette was, as Bellori puts it, 'not gradual and with few differences in tone as at first, but everything was now depicted with pronounced shadows, using black abundantly to give his bodies *rilievo*'.[36]

Caravaggio's choice of increasingly harsh light would probably have been due to the extreme realism that he was after. In garish, angled lighting that has almost the effect of raking light at the transitions from light to shade, irregularities in the skin like wrinkles, veins and creases, stand out sharply.

Mancini writes that Caravaggio's garish handling of light *looks* like light in a room painted black with just one window, but he does not say that the painter actually placed his figures in such a room. He states elsewhere that in his group compositions it would have been utterly impossible for him to arrange all the figures with just a single window as the light source.[37] However, in the course of 17th century it seems that people began taking this description of Caravaggio's handling of light literally, because according to Von Sandrart (1675) the painter really did put his models in a dark room with a window set high up in one wall. According to Bellori (1672), Caravaggio painted his figures in a closed room with a single oil lamp hung high up, with the result that the light fell straight down, illuminating only the most important passages and leaving the rest in the shadows.[38] However, these remarks cannot be based on fact, and not just because, as explained, it would not have been possible for Caravaggio to have all the figures in his group compositions pose for him as a *tableau vivant*. Even when he painted an individual model, he could not have done so with the light described by Von Sandrart and Bellori, for with such a single focused beam he would not have had any light

172

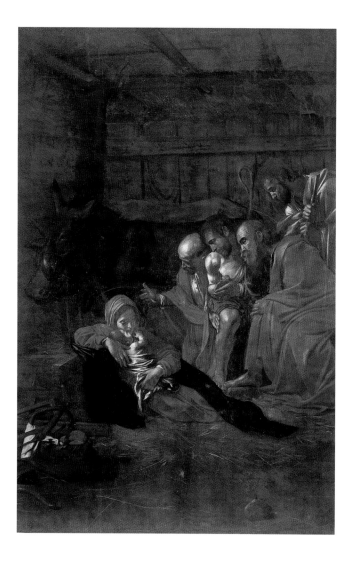

fig. 70 Caravaggio
The adoration of the shepherds, 1609 (314 x 211 cm)
Messina, Museo Regionale

on his canvas. And if he did, the model would have caught some of that light, and the interplay of light and shade would have been much more complicated than that seen in the painting.

This means that Caravaggio must have manipulated the intensity of the lights and darks while painting his models, However, he could very well have imitated lighting effects that he had observed earlier, for in some respects his light does make one think of that from an oil lamp, or from a small window in a dark room. So it is not surprising that his contemporaries remarked on that similarity. The properties of artificial light – from a fire, candle or oil lamp – were described by several Italian authors, among them Giovanni Battista Armenini (1587) and Giovan Paolo Lomazzo (1584).[39] One of the clearest descriptions was provided by Samuel van Hoogstraeten, a former pupil of Rembrandt's, in his book *Inleyding tot de hooge schoole der schilderkonst* of 1678. Van Hoogstraeten, who will be cited frequently below in connection with Rembrandt, has the following to say about the light from a candle, fire or oil lamp: 'All fire or candlelight is distinguished most from daylight by its abrupt shadows. Things illumined by fire, says Seneca, are different from those lit around by a broader light [where the transition between light and shadow is more gradual]. The abruptness of the shadows comes from the fact that the light from a small flame radiates as if from a single point, and

only strikes the objects it can reach in a straight line, and if it should miss the same [object] it only grazes it [the object] slightly and leaves the rest [of the object] unillumined. The lights of day, being greater than the separate parts that they illumine, to some extent light around the same, and envelop them with their broadness.'[40] This characteristic of artificial light recalls the relatively abrupt transitions from light to shade in Caravaggio's work. However, this kind of modelling is also reminiscent of the lighting in a room painted in a dark colour with one small window set high up in the wall. The daylight enters as a narrow beam, while the dark walls prevent it from being reflected, and as a result the illuminated forms stand out sharply against the dark shadows.

Caravaggio's contemporaries admired his sharp light with dark shadows. Scannelli, for example, praised his works as being 'in high *rilievo*, and lifelike'.[41] However, the garish light mainly gave rise to criticisms of varying kinds. Mancini, in the passage cited above, found the powerful, high-relief modelling, in which reflected light was absent, *unnatural*. He preferred a different kind of light which he described as *natural*, one that he saw in works by the Carracci and Raphael, among others. On the evidence of Mancini's text and descriptions by other contemporaries, that natural light was full daylight, with softer transitions and moderate shadows.[42] In works by Raphael, but especially those by Annibale

Carracci, one sees that the shadows often contain definite reflected lights. Compared to them, the reflected effects in Caravaggio are limited – undoubtedly too limited, in Mancini's eyes, so one should probably take his assertion that Caravaggio painted no reflected lights as an exaggeration. Bellori, too, says that the artist never depicted his figures as if they were in daylight, giving some painters the impression that Caravaggio 'did not know how to come out of the cellar'.[43] According to Bellori, Caravaggio's light was considered too simplistic. It served, for his followers anyway, as a quick remedy to get around difficult aspects of painting. They made complex passages so dark that there was simply nothing more to be seen.

Light and the suggestion of space
Bellori also singled out another problematical aspect of Caravaggio's handling of light: '[…] he painted all his figures with one single light and on one level, without toning [their tonal values and colours] down'.[44] What Bellori meant was that Caravaggio invariably modelled his figures in exactly the same way, as if they were all at the same depth in the pictorial space, without any aerial perspective. Such harsh criticism is understandable, for it is perfectly true that the way the light in Caravaggio's paintings is dispersed in the space is anything but logical, particularly in his multi-figured works. In those compositions, the figure close to the light source should be much more

173

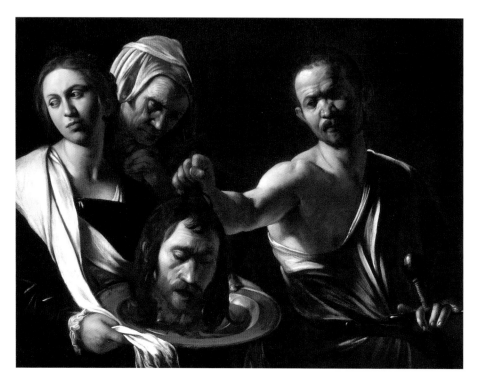

brightly lit than the figures further away from it. However, in *Salome receiving the head of St John the Baptist* (fig. 71), the figures look as if they are illuminated by a broad beam of parallel rays of light, with the result that they are all illuminated equally brightly.

Some of his followers seem to have been aware of the illogicality of the master's distribution of light in the picture space, and attempted to 'improve' it. Those painters, such as Georges de la Tour and Gerard van Honthorst, did imitate Caravaggio's dark shadows and bright lighting effects, but used artificial light and the lifelike projection of shadows, and they did this in large figure groups as well, as can be seen in Honthorst's *Christ before the high priest* of 1617 (fig. 72).

Light and colour, the suggestion of space, composition and paint surface in Rembrandt

Caravaggio's ideas and style spread throughout Europe. It was like an avant-garde movement, labelled Caravaggism at a much later date – a very early 'ism', in other words. As happens with such movements, support dropped off after a while. Guercino cast aside the dark shadows and returned to a state of decorum. Velázquez opted for a totally different way of handling the brush and light, and the Dutchman Gerard van Honthorst embraced a moderate Classicism after his return from Italy.

Rembrandt can also be regarded as a Caravaggist, albeit a rather late one. His choice of a radical realism, which

he pursued to the end of his life, would have been barely conceivable without the example of Caravaggio and his followers. The same applies to his handling of light, so one could say that he always remained a Caravaggist. At the same time, though, he tried to develop alternatives for precisely those facets of Caravaggio's style which, as shown above, many of his contemporaries found problematical, despite all their admiration for the artist. The quotations discussed below will show what those alternatives were.

The grouping of light and shade
Although a series of contemporaries wrote briefly or at length about Rembrandt, there are only two authors who took a structured approach to his way of dealing with the specific pictorial problems that are central to this essay. They were both painters themselves, so they were able to examine Rembrandt's art analytically. One of them was Samuel van Hoogstraeten, a pupil of Rembrandt's. The other, who has also been encountered above, was the German artist Joachim von Sandrart, who was living in Amsterdam at the same time as Rembrandt, from 1638 to 1644. On his return to Germany, Von Sandrart set to work on a very ambitious book that was published in 1675 under the title *Academie der Bau-, Bild- und Mahlerij-Künste*. Von Sandrart is very concise about the topics that interest us here – Rembrandt's handling of colour, light, shadows, reflections, and

174

fig. 71 Caravaggio
Salome receiving the head of St John the Baptist, 1607 (91.5 x 107 cm)
London, The National Gallery

the suggestion of space – but he does have the insight of an experienced painter. Van Hoogstraeten's more detailed texts sometimes provide a welcome elucidation of Von Sandrart's words.

Von Sandrart had the following to say about Rembrandt's use of light and shade, reflections and colour. 'In his works our artist introduced little light, except on the spot which he thought to be the most important; around this he kept light and shade together artfully. He also made well-considered use of reflections by which light penetrates shade very judiciously; his colour [it will become clear that Von Sandrart is here referring to the flesh tones] glowed powerfully, and in everything he showed perfect judgement.'[45] The fact that Rembrandt, like Caravaggio, used little light (and all the more effectively, for that) to pick out parts of a scene is readily apparent in all his works. He did so with 'perfect judgement', as Von Sandrart said, for with Rembrandt light was not just a simple cue for pointing at particular parts of a picture.

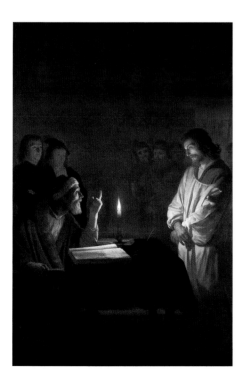

The full significance of Von Sandrart's cryptic words, 'he kept light and shade together artfully', cannot be understood by the modern reader. The key to the remark is provided by Van Hoogstraeten in his explanation of what he called 'kindred colours'. Van Hoogstraeten placed this phenomenon, which is really to do with light, in a broader historical context, one that implicitly involves perception psychology. His explanation gives Von Sandrart's keeping 'light and shade together artfully' an astonishingly rich meaning. Van Hoogstraeten's text gives an insight into the way in which Rembrandt and the painters in his circle thought of the relationship between light and shadow.

Van Hoogstraeten starts by referring to a passage in Franciscus Junius's *De schilder-konst der oude* (The painting of the ancients), which was first published in Latin in 1637.[46] Junius, using classical writings, points out that the Greeks and Romans were already aware that the effect of light in a painting depended on the way in which the dark passages were executed. Van Hoogstraeten goes on to say that in his comments on those classical texts Junius disapproved of harsh contrasts between light and shade, saying that such paintings 'look like chessboards', and 'in addition, he [Junius] wishes people to use the power of shadows in moderation'.[47] Whatever Junius may have meant by this (perhaps his remark is a criticism of the Caravaggists' use of very dark shadows), Van Hoogstraeten gave his own twist to the dis-

cussion. He was undoubtedly basing himself on what he had learned during his apprenticeship to Rembrandt for, as he admiringly relates, 'Rembrandt developed this virtue to a high degree'. And what was that virtue? 'The proper combination of kindred colours'. Van Hoogstraeten casts the explanation of what combining kindred colours meant in the following piece of advice. 'I therefore commend you not to mix up lights and shadows too much, but to unite the same fittingly in groups. Let your strongest lights be accompanied gently by lesser lights. I assure you that they will shine all the more beautifully. Let your deepest darks be surrounded by lighter darks, so that they will make the power of the light stand out even more powerfully.'[48]

Placing the highest lights in light surroundings, and flanking the deepest shadows with other, less deep tones, was a solution for the problem of chiaroscuro that was radically different from Caravaggio's. This completely new way of working does indeed reinforce the power of the light. At the same time, it enables the viewer to take in the composition at a glance, because the number of chessboard-like contrasts is sharply reduced. When 'reading' a painting with many contrasts, the viewer unconsciously feels forced to investigate all those forms, and that is the way we look at a Caravaggio. The painting is additive, it is an accretion of forms that are perused one at a time. Rembrandt's drastic limitation of the number of

175

fig. 72 Gerard van Honthorst
Christ before the high priest, c. 1617 (272 x 183 cm)
London, The National Gallery

sharp contrasts facilitates an initial, rapid synthesis of the image. Only then does the eye immerse itself in the details. That proves to be a way of composing that is typical of the Baroque.

The use of reflected light

Von Sandrart's statement that Rembrandt 'made well-considered use of reflections' is also of the greatest importance for our understanding of Rembrandt's ideas about painting, and here too we touch on a crucial difference between Caravaggio and Rembrandt. And once again, Von Sandrart's overly concise formulation is clarified by Van Hoogstraeten's patient explanation of the phenomenon of reflections.

He first gives a definition of the concept as it was interpreted in artists' studios. 'Reflection is really a casting back of the light of all illuminated things, but in art we only speak of reflection, the secondary illumination, which falls in the shadows'.[49] In other words, this is the light that is reflected back from one lit object onto another, falling on the shaded part of that latter object. That Rembrandt had a special interest in this phenomenon is clear not only from Von Sandrart but also from the following passage in Van Hoogstraeten: '[...] our Rembrandt acquitted himself wondrously well with reflections; aye it appeared that this preference for the casting back of a light was his true element'.[50]

Striking examples of this aspect of Rembrandt's mastery include his

Sacrifice of Abraham (Cat. no. 22), in which Isaac's illuminated upper arm lights up the side of his chest. The right side of the angel's face, which is turned away from the light, is illuminated by the light reflected from its own raised hand and from Abraham's face. But while Von Sandrart counted such efforts as one of the aspects of painting in which Rembrandt displayed 'perfect judgement', Van Hoogstraeten accused him of relying 'on his eyes and reputed observations', rather than 'on the fundamental rules of this art'.[51] If one tries to discover what Van Hoogstraeten meant by those fundamentals one gets no further than the rather pedantic (and moreover not always correct) rule that the tonal value of a reflection should be one quarter of that of the illuminated, reflecting surface.[52]

Leonardo da Vinci had written: 'This theory [of reflections] has been put into practice by many, but there are many others who avoid it, and each side laughs about the other'.[53] The views of Rembrandt and Caravaggio were certainly at odds here. As we have seen, Caravaggio made minimal use of it, while Rembrandt was already applying it early in his career, and relied on it increasingly as he developed as a painter, probably to escape the 'spotlight' effect that he employed a great deal up to and including *The Night Watch* (fig. 2). Van Hoogstraeten's lament that he wished that Rembrandt had 'lit more lights' in that painting is well known.[54]

Rembrandt's increasingly refined technique of allowing soft light to travel from surface to surface within the pictorial space is in sharp contrast to Caravaggio's harsh lighting. Rembrandt's *The Holy Family with angels* of 1645 (fig. 73), the painting in which he took the first steps towards what is now called his 'late style', shows how he tried to resolve the 'spotlight' problem. Not only did he introduce three light sources in the scene – the daylight that falls through an invisible window onto Joseph's workbench, the light from the fire in the hearth illuminating its immediate surroundings, and the heavenly light that bursts into the room with the angels and picks out the cradle and the Virgin with her book. Then, though, he lets the light falling on the book reflect back onto the Virgin's shadowed cheek, and has the heavenly light surrounding the angels reflect onto the Child's face under the hood of the cradle by way of the illuminated half of the Virgin's face and her white neckerchief. If one then explores the interplay of light within the group of angels one is dizzied by the complexity of the play of direct light, shadows and reflections. We are surrounded by such effects in our daily lives, but usually are not consciously aware of them. *The denial of St Peter* (Cat. no. 16) shows how this gliding light can fill the picture space in a way that is totally different from Caravaggio's severe handling of direct light entering the scene.

Light and the evocation of space

The differences in the two painters' evocation of the space in which they place their figures are as great as in their use of 'kindred colours' and reflections. Rembrandt's pictorial research into the realm of pictorial space ('research' may sound anachronistic, but it is most certainly applicable here) was directed primarily at colour in all its gradations. The above quotation from Von Sandrart contains the statement that Rembrandt's colouring 'glowed powerfully'. Here he was undoubtedly referring to the artist's skill in painting human flesh, which was much hailed in his own lifetime. In artists' studios from around 1600 onwards, the term 'glow', when applied to colour, was mainly used in this connection, because of new technical developments in the art of rendering flesh.[55]

It is striking that both Caravaggio and Rembrandt were praised by their contemporaries for their exceptional ability to capture the colour of human skin, which according to one writer was 'actually the main point of the whole work'.[56] This section will deal instead with a very different aspect of colour. In his book, Von Sandrart goes into great detail on the way in which Rembrandt 'broke' his colours, that is to say used an admixture to tone them down or make them lighter. Von Sandrart argues that this was necessary in order to arrive at a convincing suggestion of space. We would be tempted to think that the use of linear perspective constructions served that purpose, but according to Von Sandrart a proper interplay of tonal values and colours was far more important. This involves ideas on the depiction of space which are of the greatest significance for the development of painting. The Dutch word *houding* was used for this method of rendering space.[57] The concept that should be borne in mind here is relationship, in the sense of inter-relationships – in this particular case the inter-relationships of colours. For example, warm colours advance and cool colours recede. However, that recession only works if the colours are not bright, but broken. Another aspect of 'houding' was the sophisticated use of contrasts of light against dark and dark against light. However, all those steps in colour and tone are only effective for suggesting space if they are carefully balanced. Rembrandt was a master at this, as contemporaries like Joachim von Sandrart realised. An example of a painting in which Rembrandt appears to be giving a demonstration of what was meant by *houding*, and which is at the same time a superb example of his use of 'kindred colours', is *Christ in the storm* of 1633 (fig. 74).

177

The fact that Von Sandrart mentions both Rembrandt and Pieter van Laer in his passage devoted to *houding* could be an indication that Rembrandt was regarded as a pioneer in this area. Von Sandrart writes 'that all harsh, bright, strong and garish colours should be utterly avoided and rejected as something that brings about great discord within a painting'. He then mentions several 16th-century artists including Lucas van Leyden and Holbein as the forerunners in this new handling of colour, 'which those in the Low Countries, the Dutch in particular, inquisitively imitated, and who raised this art to the highest level, [namely] how one could mix, break all colours and rid them of all coarseness, so that everything in the[ir] paintings began to resemble nature. In a large altarpiece or another painting for which many colours are needed, care should be taken in the reduction of the colour, [that is to say] that one gradually loses oneself in the proper degree [in the space], with the colours succeeding each other freely in accordance with the rules of [aerial] perspective from one figure to the next, so that each finds its place. In Dutch we call that *Houding*. Von Sandrart then adds: 'This is an important rule which is little respected. And here we must learn from our wonderful Bamboccio [Pieter van Laer], as well as from others, in particular from the diligent and in this respect most ingenious Rembrandt, who, as can be read in the accounts of their lives [in Von Sandrart's book], have wrought true miracles, and have consistently achieved true harmony according to the rules of light, without one single colour being disturbing'.[58] And indeed, Rembrandt's evocation of space is governed more by light, colour and tone than is Caravaggio's, as was already seen with *The blinding of Samson* (Cat. no. 9, fig. 61). It will be clear that the darkening of the darker paint demonstrated by the drawn copy (fig. 63) has diminished the intended spatial effect of the original to some extent.

Paint relief and the suggestion of light

Only a few words written by Rembrandt himself have survived to give us some idea of his pictorial intentions. Only one sentence is devoted to light, and it comes in a letter to Constantijn Huygens concerning a painting that he had sent Huygens as a gift: 'My lord, hang this piece in a strong light and where one can stand at a distance, so it will sparkle at its best'.[59] With the word 'sparkle' (*voncken*) Rembrandt probably meant that the irregularities of the surface of the paint, which he applied mainly in the light passages, reflect real daylight. However one positions oneself in front of such a painting, there are always protrusions in the paint film that gleam in a way that cannot be controlled. This, as it were, results in true light being mixed by the light colour.[60] Impasted paint played no part in Caravaggio's light passages.[61] His followers like Honthorst did, when painting a candle or torch, put a local irregularity into the paint surface in order to make the glow of the flame more convincing as it reflected real daylight. Rembrandt, though, employed those means far more extensively and consistently. That can be seen, for example, in the sleeve of the man in *The Jewish bride* (fig. 75). It sparkles in an amazing way.

178

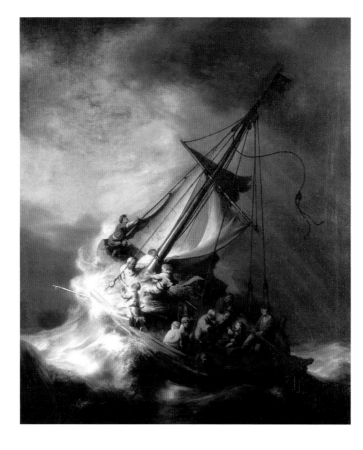

fig. 74 Rembrandt
Christ in the storm on the Sea of Galilee, 1633
(160 x 127 cm)
Boston, Isabella Stewart Gardner Museum

The sound historical view

The 17th-century writings quoted and analysed above reflect a way of looking at and thinking about art which will seem strange to many a viewer. Our modern ideas about art are more romantic: art for us is closely linked to freedom of expression. It is useful, though, to realise that 17th-century painting was first and foremost about an illusionistic representation of reality (or an imaginary reality), and that in order to achieve that end all sorts of 'tricks' and formulae had been developed which painters learned to apply in the course of their long training. Pioneers like Caravaggio and Rembrandt made changes to some of those formulae and added some new tricks of their own.

However, the confrontation of their works shows just how exciting the creative adventure must have been in their day as well. Despite all the similarities, the differences between their works are enormous. The opportunity that this exhibition and book provide to compare pairs of works, one by each artist, will challenge the reader to find words to describe and explain the obvious differences. He or she will also be stimulated to find words to describe the similarities between the works within the oeuvre of each painter. We hope we have been helpful in this comparative process by illuminating it with the language of the two painters and their contemporaries.

179

fig. 75 Detail of *'The Jewish bride'* (Cat. no. 29)

Volker Manuth

'Michelangelo of Caravaggio, who does wondrous things in Rome' On Rembrandt's knowledge of Caravaggio

Rembrandt and Caravaggio never met, and not just because of the generation gap separating the Lombard born in 1571 and the Dutchman 35 years his junior. The geographical distance between Italy and the Dutch Republic, where the two men lived and worked, played a part as well. As far as is known, neither ventured across the Alps to travel in the other's native country. Unlike the stay-at-home Rembrandt, who lived first in Leiden and then in Amsterdam, the restless Caravaggio roamed Italy from north to south, his peripatetic lifestyle taking him from his birthplace of Caravaggio, near Milan, by way of Rome and Paliano to Naples, Malta, Syracuse, Messina, Palermo, Naples again, and finally to Porto Ercole, close to the Holy City. When Rembrandt was born in 1606, Caravaggio was trying to keep out of the clutches of the Roman police. His fiery temperament repeatedly got him into serious trouble with the law, and this time he had mortally wounded an adversary in one of the many street brawls he got involved in. The eye-witness accounts contradict each other as to the cause of the quarrel and precisely what happened, but Caravaggio was wanted for manslaughter, and he took flight to avoid the police investigation, probably relying on the discreet assistance of one or more of his influential patrons.[1]

When Caravaggio died in Porto Ercole on his way back to Rome in 1610, the life of Rembrandt in Leiden would have been little different from that of any other four-year-old. At any rate, his career as an artist had yet to begin when Caravaggio's life ended. Despite significant differences between these two outstanding representatives of north and south European Baroque painting in the way they resolved artistic problems, there are several fascinating points of similarity. In order to understand the issues involved it is first necessary to discover how much Rembrandt and his Dutch contemporaries actually knew about the great Italian master. How could Rembrandt have familiarised himself with the latter's innovative compositions, handling of light and extreme chiaroscuro effects, his unconventional way with religious subjects, or his shockingly naturalistic protagonists and their emotionally charged actions? Which of Caravaggio's works were known in Amsterdam and other Dutch cities during Rembrandt's lifetime? These and related questions lie at the heart of this essay, which is an exploration of the various aspects of the critical reception of Caravaggio's art in the Dutch Republic, and its possible significance for Rembrandt.

'A wondrously beautiful manner, to be emulated by young painters'

Oddly enough, it was thanks to a Dutchman that Caravaggio's name became known north of the Alps during his lifetime. The biography written by Karel van Mander (1548-1606), a painter and artists' biographer from Meulebeke in Flanders who settled in Haarlem in 1583, was also the first published reference to the Italian artist. It is one in a series of biographies completed in 1603 that appeared as part of Van Mander's famous *Schilder-boeck* under the title *Het leven der moderne oft deestijtsche doorluchtige Italiaensche schilders* (The lives of the modern or contemporary eminent Italian painters).[2] Van Mander, who was widely travelled, was in Italy from 1573 to 1577, although that was long before Caravaggio began to cause a stir with his paintings. He obtained his information from artist friends in Rome, who reported in writing and in person.

Van Mander's passage on Caravaggio is short on biography, and in sketching the artist's social background he sought refuge in a well-worn *topos* from biographies of artist. He said that Caravaggio had worked himself up from poverty with diligence and courage, and had seized his chances, with the result that 'this Michelangelo has already garnered great repute, honour and name with his works'. Van Mander had never seen any of Caravaggio's paintings, and the information he got at second hand was often wrong.[3] Nevertheless, it appears that his informant had himself heard the Italian's pronouncement about the imitation of nature being the most important basic principle of his art. That, at least, is suggested by the wording with which the passage opens. 'His dictum is that all works, no matter of what nor by whom made, are naught but *bagatelles*, child's play or trifles if they be not done and painted from life, and that there is no good or better way of proceeding than by following nature. Also that he does not make a single brushstroke unless he gathers close to life, and copies and paints it'.[4]

Van Mander shared Caravaggio's views about the importance of painting from life, but with the proviso that the artist had to be capable of selecting the most beautiful of all the beautiful things on offer.[5] The remainder of the biography consists of comments on Caravaggio's conduct, in which, according to Van Mander, periods of intense work were followed by even more time spent roaming the streets of Rome, a rapier by his side, 'much given to fighting and quarrelling'. Van Mander, who demanded in his didactic poem *Den grondt der edel-vrij schilderkonst* that young painters lead virtuous lives in keeping with their profession, considered Caravaggio's behaviour reprehensible. For him, the virtues of Minerva, the patroness of the arts, were simply incompatible with the belligerence of Mars, the god of war. Despite this criticism, he praised Caravaggio's style of painting as 'a wondrously beautiful manner, to be emulated by young painters'.[6]

Rembrandt undoubtedly read Van Mander's account of Caravaggio's life. The innovative and most sensational aspect of his style was above all the uncompromising focus on nature, and it was a principle that Rembrandt, too, followed throughout his career. His figures do not correspond to the Classicist ideal of beauty, and he often ignored the rules of decorum current in his day. In the second place there was Caravaggio's spectacular handling of light and shade, which he used to give his lifelike figures a sculptural dimension and a remarkably powerful physical presence. That was the very aspect on which Van Mander was silent, probably because he had never seen a painting by Caravaggio. By what route could Rembrandt have learned about Caravaggio's contrasts of light and shadow, which are such a distinctive feature of his own work? What opportunities did he have to familiarise himself with those paintings, which had already become a topic of conversation in northern Europe before he took his own first steps as a painter?

Travelling painters and 'travelling' paintings

Rembrandt never visited Italy. The reason is known from the fragmentary autobiography of Constantijn Huygens (1596-1687), the influential, art-loving secretary to several stadholders. According to him, Rembrandt and his colleague Jan Lievens (1604-1674) felt that journeying to Italy was unnecessary because 'now, today, kings and princes on this side of the Alps collect paintings with such eagerness and partiality that one can see the best Italian pieces outside Italy, and that which one has to hunt down with great difficulty there can here be found heaped together in ample sufficiency'.[7] Here they were undoubtedly alluding to the rapidly growing trade in Italian paintings in the Republic. Amsterdam, in particular, was not only an important market for paintings from Venice and Rome, but from France and England as well.[8] Private collections were already being formed in the first half of the 17th century (and even more so in the second half), in which there were important examples of 16th- and early 17th-century Italian painting.[9] Many of the Italian works in the Netherlands had been bought either by Dutch painters, by the collectors themselves, or by local

181

agents. As will turn out in Caravaggio's case, not all that glistered was gold. Alongside high-quality masterpieces there were countless copies, not always of the highest calibre but evidently good enough to give an idea of recent, or relatively recent developments and innovations in Italian art and by individual artists. The young Rembrandt and Lievens, anyway, were convinced in the late 1620s that there was no need to make a special trip to Italy to acquire that knowledge.

It is impossible to say for certain when and on which occasion Rembrandt first encountered Caravaggio's art. However, it is very likely that he had already heard about the characteristics of the Italian's art before he could form his own impression of it. His first teacher in Leiden was Jacob Isaacsz van Swanenburg (1571-1638), a member of a prominent family of artists. Jacob, in his turn, had learned the basic principles of painting from his father, Isaac van Swanenburg (1537-1614), before setting off for Italy around 1591. He lived in Venice and Rome for some years before moving to Naples. He eventually returned to his home town of Leiden in 1617, a convert to Catholicism and accompanied by his Neapolitan wife Margaretha Cardone and their three children.[10] There can be no doubt that Van Swanenburg became very familiar with Caravaggio's work while he was in Rome, and later in Naples too, although the Italian had no influence on his own oeuvre. It is possible that

the two artists even met. The importance of Rembrandt's first teacher on the further development of his pupil, who must have studied under him between c. 1619/20 and 1622, is open to question. Van Swanenburg's oeuvre is still puzzling, and has barely been researched. For example, we have no idea what the paintings he made in Italy looked like. Most of the works attributed to him are pictures with small figures and glowing fires and scenes of hell, in which flames and clouds of smoke light up the often night-time sky.[11] It is not known whether Rembrandt simply learned the essential, basic skills of painting from him, or whether his master's seas of flames and infernal scenes heightened his awareness of the problems of depicting artificial light sources.[12] It is known that Van Swanenburg was living in Naples during Caravaggio's two brief stays there in 1606-1607 and 1609-1610. He probably knew many of his works, and undoubtedly told his young pupil about them back in Leiden. For lack of any more concrete examples, that word of mouth may have been the source of an initial acquaintance with the innovations of the exceptional artist.[13]

Rembrandt's second teacher, Pieter Lastman (1583-1633), had also visited Italy.[14] At the end of 1602 he travelled to Rome, possibly taking in Venice *en route*. Although no stay in Naples is documented, he probably was there, given the fact that after his return to Amsterdam he maintained a strikingly

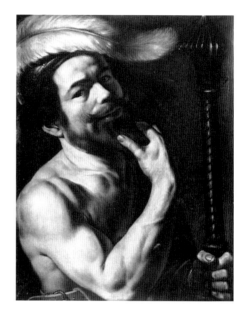

large number of contacts with Dutchmen who lived and worked in Naples as painters or art dealers between roughly 1595 and 1610.[15] Lastman was back in Amsterdam in 1607, where he, his mother and other members of his family bought a house in Sint Anthonisbreestraat, opposite the Zuiderkerk.[16] It was there, for six months in 1625, that he taught the young Rembrandt. Lastman was greatly respected, not just as a history painter but as a connoisseur of Italian art. He was frequently asked for his professional opinion about the authenticity of paintings, and some of them involved works by Caravaggio or copies after them. In 1619, for instance, a notary wanted to know whether a painting of the crucifixion of St Andrew that had been sold in Amsterdam was an original (*principael*) by Caravaggio.[17] The painting had belonged to the Flemish painter Louis Finson (fig. 76)

fig. 76 Louis Finson
Self-portrait as David, 1613 (81 x 62 cm)
Marseille, Musée des Beaux-Arts

until his death in 1617.[18] Finson, who was born before 1580, had been part of Caravaggio's innermost circle in Naples, and from an early date he had imitated his style in his own works, albeit with only moderate success. His numerous copies after Caravaggio's paintings were more accomplished. In 1613 he travelled through Rome on his way to the south of France. He was in Paris in 1615, and in Amsterdam a year later,[19] where he lived in the house of Abraham Vinck (c. 1580-1619), a colleague and acquaintance from his time in Naples who had arrived in Amsterdam with his Neapolitan wife and their children around 1610.[20] Vinck, too, evidently knew Caravaggio personally, for he is referred to as *amicissimo di Caravaggio* in a 17th-century source.[21] In his will of 19 September 1617, Finson left Vinck his share in two paintings, both by 'Michelangelo Caravaggio, the one being the Rosary, the other Judith and Holofernes', which they owned jointly.[22] The 'Rosary' was Caravaggio's famous *Madonna of the rosary*, which Finson and Vinck had acquired in Naples and brought back to Amsterdam (fig. 77). The painting was then bought by a group of painters and art-lovers in Antwerp, among them Rubens and Jan Brueghel the Elder, who donated it to the Dominican Church of St James, probably before 1651. It has been in Vienna since the end of the 18th century, where today it is one of the showpieces of the Kunsthistorisches Museum.[23] The *Judith and Holofernes*

mentioned in Finson's will was probably a work by Caravaggio that is now lost, a copy of which is preserved in Naples.[24] The authenticity of Finson's *Crucifixion of St Andrew*, which Lastman and his colleagues accepted as a Caravaggio in 1619, is now disputed. The original painted in Naples in 1606 has been in the Cleveland Museum of Art since 1976 (see Cat. no. 1). It was very probably taken from Naples in 1610 by the Spaniard, Don Juan Alonso Pimentel y Herrera, Conde de Benavente, who was in Naples from 1603 to 1610, to his family palace in Valladolid, where it was listed in two inventories in 1653.[25] There is little likelihood, then, that it was in Amsterdam in 1617 and 1619, partly because it was in Spain when it was rediscovered in 1974.

There are several copies of it – in a private Swiss collection, in the Museo Provincial de Santa Cruz in Toledo, and in the Musée des Beaux-Arts in Dijon,[26] and one wonders which copy was seen in Amsterdam in 1619 by Lastman and his colleagues Barent van Someren (1572-1632), Willem van den Bundel (1577/78-1655), Adriaen van Nieulandt (c. 1586-1658) and Louis du Pret (1589-1670). It is remarkable, anyway, that it was very probably a copy which the connoisseurs mistook for an original. Was it simply an error on their part, or was the positive attribution a concession to Finson's heirs, who had sold it as an original in 1617? Whatever the answer, Lastman was evidently regarded in Amsterdam as an expert on Caravaggio. That is

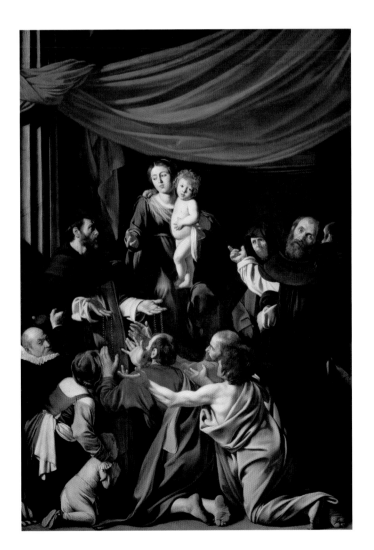

fig. 77 Caravaggio
Madonna of the Rosary, 1606-1607
(364.5 x 249.5 cm)
Vienna, Kunsthistorisches Museum

183

confirmed by a later notarised document of 27 February 1630. On this occasion, Lastman, his brother-in-law François Venant (1590/91-1636) and Adriaen van Nieulandt, once again, were asked for their opinion on a suspected copy by Finson after Caravaggio's *Madonna of the rosary*. The buyer merely wanted confirmation that the copy was indeed by Finson, in which case he was prepared to pay the considerable sum of 600 guilders for it.[27] As already noted, Finson and Vinck were joint owners of the original, which they had brought to Amsterdam before it went to Antwerp. In any event, this document shows that Finson was considered to be a very accomplished copyist of works by Caravaggio, which is also probably why not all of his copies have yet been identified. That, of course, applies especially to the unsigned ones, some of which may have been made with the intention of passing them off

as genuine Caravaggios. In other cases, though, Finson did sign his copies. They were more in the nature of variants, which differ from the originals in some details. Two cases in point are the copies Finson is known to have painted after the *Mary Magdalen*, which Caravaggio executed in 1606 on his way to Naples (fig. 78).[28] Both copies are signed, and the version in Saint-Rémy-de-Provence is also dated 1613 (fig. 79).[29] Finson added a skull under the Magdalen's left elbow in a departure from the original, to which he would have had access in Naples. The signature on the *cartellino* makes it clear that he wanted to make it look as if this was his own work, for he does not mention Caravaggio as the inventor of the composition. Caravaggio's *Mary Magdalen* was his most widely disseminated invention, going by the number of copies and variants by various artists, some 20 in all, many of them copies

after copies, and just one or two that are based on the original. It may have owed its attraction to the saint's popularity. It was certainly no coincidence that Finson painted his 1613 version while he was in Provence, because that was one of the centres of veneration of the Magdalen, who according to a western legend ended her days doing penance there. She was supposedly buried in the Church of St Maximin in Aix-en-Provence, the town where Finson was working until 1613.

Another version of the *Mary Magdalen* was made by the Frisian artist Wybrand de Geest (1592-c. 1661) – a relative by marriage of Rembrandt's wife Saskia – who was back by 1621 at the latest from a sojourn in Italy that began in 1614. The painting, which is now in a private collection in Barcelona, is signed on a letter at lower right and dated 1620 (fig. 80).[30] De Geest probably based it on one

184

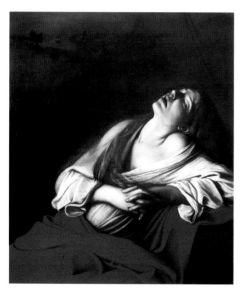

fig. 78 Caravaggio (?)
Mary Magdalen, c. 1610 (106.5 x 91 cm)
Private collection

fig. 79 Louis Finson, after Caravaggio
Mary Magdalen, 1613 (112 x 86.5 cm)
Saint-Rémy-de-Provence, collection Ravanas

fig. 80 Wybrand de Geest, after Caravaggio
Mary Magdalen, 1620 (110 x 87 cm)
Barcelona, collection Don Santiago Alorda

of the many copies of Caravaggio's original, possibly a version by Finson, whom he could have met in Provence on his way back from Rome, which would mean that he painted it there.[31] Unlike Finson, De Geest does state in his signature that this was a copy after an invention by Caravaggio,[32] and he too took some liberties, adding not only the skull but also a jar of ointment, the saint's stock attribute. There were also copies of Caravaggio's *Mary Magdalen* in Dutch collections. One was in the cabinet of the extremely wealthy Rotterdam brewer Reynier van der Wolf (c. 1610-1679), who had one of the finest groups of Italian paintings of its kind.[33] Part of his collection which he put up for auction in 1676, included works by Titian, Giorgione, Dosso Dossi, Annibale Carracci, Bassano and Claude Lorrain, sometimes several by the same artist. One of the 42 Italian paintings that came under the hammer was 'a dying Magdalen, lifelike, powerfully executed, and rare, by Michelangelo da Caravaggio' (see the Appendix, E). The 1,500 guilders that it fetched was one of the highest sums paid at the auction. The painting was probably identical with the one of the same subject that came up for auction in 1713, again in Rotterdam, from the estate of Adriaen Paets (1657-1712). Although the sale catalogue does give the dimensions, it is impossible to discover which of the many copies it was (see the Appendix, O). According to

his probate inventory, the Haarlem painter Cornelis Dusart (1660-1704) had 'a Mary Magdalen by Jacomo [sic] Vinsoni',[34] and this may have been yet another of Finson's copies after Caravaggio's original.

To return to Rembrandt's teacher, Pieter Lastman. He had had ample opportunity to study the works by Caravaggio in Rome. Their influence on his own style was only slight, however; he never became a Caravaggist. In contrast to the master's often monumental works, Lastman remained wedded to the small-scale cabinet painting. Caravaggio had specialised in the depiction of a limited number of almost life-sized figures, many of them close to the picture plane, set against a dark, neutral background. Lastman, though, retained his preference for Italianate landscapes with archaising architectural backgrounds for his often densely populated scenes. He also differed from Caravaggio in his polychrome palette. Here he was inspired by the works of Adam Elsheimer (1578-1610), who was originally from Frankfurt, and the Fleming Paulus Bril (1553/54-1626). Both painters arrived in Rome well ahead of Lastman, where their work proved very popular. All the same, Lastman must have been impressed by what he saw of Caravaggio's work in Rome, and occasionally one finds motifs in his paintings which can very probably be traced directly back to certain pieces by the Italian. For example, there is a young woman with out-

stretched arms fleeing and looking back over her shoulder in panic in Lastman's two versions of *Odysseus and Nausicaa* of 1609 and 1619 in Braunschweig and Munich. That figure bears a great resemblance to a boy in an identical pose in Caravaggio's *Martyrdom of St Matthew* in the Contarelli Chapel in S. Luigi dei Francesi in Rome (fig. 6). It is conceivable that Caravaggio's figure was the model, through the mediation of Lastman's works, for Rembrandt's fleeing Delilah in *The blinding of Samson* of 1636 (Cat. no. 9).[35] One of the soldiers in Lastman's *Resurrection* of 1612 in the Getty Museum, Los Angeles, is based on Caravaggio's recumbent figure in his *Conversion of St Paul* of 1601 in the Cerasi Chapel of S. Maria del Popolo in Rome (fig. 29).[36] The angel in Lastman's *Sacrifice of Abraham* in the Amsterdam Rembrandt House Museum displays striking similarities to the one in Caravaggio's second version of the altarpiece with St Matthew for the Contarelli Chapel.[37] Yet it was certainly not just specific motifs and details in Caravaggio's Roman works that made such an impression on Lastman. His style of painting can be described as an amalgam of different influences: first and foremost of Elsheimer, but also of Caravaggio's 'naturalistic' style and the late-Mannerist legacy of Lastman's teacher Gerrit Pietersz (1566-before 1645). It stands to reason that Lastman shared his knowledge of Caravaggio's art with his pupil Rembrandt.

Drawings and prints after Caravaggio
Anyone in the 17th and 18th centuries who wanted to get a good idea of Caravaggio's works either had to go to Italy to see the originals, or make do with copies. Only a handful of original paintings had left Italy or were on the art market within 150 years of being made. That was because most of Caravaggio's works were commissioned by religious institutions or private patrons, some of whom were passionate collectors and important benefactors of the artist. They cherished their costly possessions, although that did not mean that they refused to give access to interested art-lovers. This was particularly true of the aristocratic collectors in Rome. Many travelling artists, for example, visited the palaces of Cardinal Francesco Maria Del Monte (1549-1626) and the brothers Benedetto (1554-1621) and Vincenzo (1564-1637) Giustiniani,

who were among Caravaggio's main patrons. Given the popularity of his works and the great influence they had on his artist colleagues from an early date, the number of surviving 17th and 18th-century drawings and prints after Caravaggio's paintings is remarkably small. There are only around 35 known drawn copies, partial copies or variants.[38] Most are anonymous, and treat only 13 of Caravaggio's paintings, most of them in Roman churches.[39] This is not very surprising, since before he was forced to flee he had made more paintings in Rome than anywhere else.

Nevertheless, the number of copies is very unevenly divided, and evidently did not depend solely on the accessibility of the originals. It is interesting, for example, that there are more copies after *The calling of St Matthew* (fig. 5) than after *The martyrdom of St Matthew* (fig. 6) a work that was also on public

view in the same chapel.[40] The position is similar with *The crucifixion of St Peter* (fig. 81) and *The conversion of St Paul* (fig. 29), both in the Cerasi Chapel in S. Maria del Popolo.[41] The only drawn copy after *The crucifixion of St Peter* by a Dutch artist known to date was made in 1616 by Gerard van Honthorst (fig. 82).[42] On the other hand, there is a remarkably large number of painted copies (and variants) after Caravaggio's *Doubting Thomas* (fig. 28), a work that was in the marchese Vincenzo Giustiniani's collection of almost 600 paintings, and that served as the basis for a variant by Hendrick ter Brugghen, among others (Cat. no. 2).[43] Among the altarpieces by Caravaggio in Roman churches it was above all *The entombment* of c. 1603 in S. Maria in Vallicella, the so-called Chiesa Nuova, that spawned numerous copies (fig. 83). The best-known of them is the one by

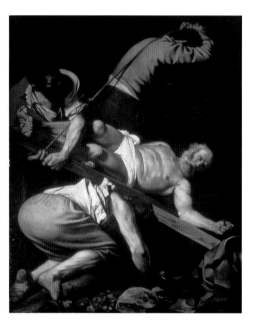

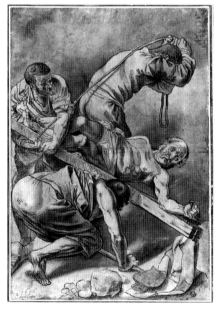

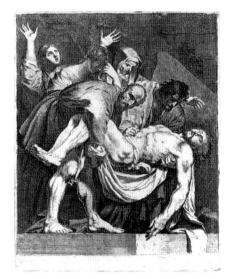

186

fig. 81 Caravaggio
The Crucifixion of St Peter, c. 1600-1601
(230 x 175 cm)
Rome, Santa Maria del Popolo, Cerasi Chapel

fig. 82 Gerard van Honthorst,
after Caravaggio
The Crucifixion of St Peter, 1616 (pen and brown ink with brown wash, 38 x 26.5 cm)
Oslo, The National Museum of Art,
Architecture and Design

fig. 83 Dirck van Baburen, after Caravaggio
The entombment of Christ,
(etching, 28.9 x 23 cm)
Boston, Museum of Fine Arts, George
Peabody Gardner Fund

Rubens, who also carried out commissions for the Chiesa Nuova while he was in Rome.[44] By contrast, there are very few if any copies or partial copies of other works by Caravaggio that were accessible to everyone. One example is the *The seven acts of mercy* (fig. 25), which Caravaggio painted in 1606-1607 for the high altar of S. Maria della Misericordia, a church that was part of a charitable institution in Naples.[45] Since Rome was the main focus of interest for travelling artists, it is logical that only a few copies were made of works that Caravaggio painted during his stays on Sicily and Malta. Not many artists from northern Europe ventured as far as those remote islands.

The number of reproductive prints and etchings is even smaller, with no more than six or seven being produced in the 17th century. As far as it is possible to tell, all of them were made by non-Italian artists. They, too, are mainly of paintings in Rome. The one exception is the engraving by Lucas Vorsterman (1595-1675) (fig. 84) after *The Madonna of the rosary*, which was painted in Naples and taken to Amsterdam by Finson.[46] Vorsterman made the engraving after the painting arrived in Antwerp. Most of the engraved copies are not very good. A typical example is the one by Pierre Fatoure (1584?-1629) after Caravaggio's *Supper at Emmaus* (fig. 85 and Cat. no. 38).[47] Various details, like the basket of fruit and the bread on the table, but also the locks of hair on Christ's right shoulder and the pattern in the tablecloth highlight the great divide in artistic quality. It is not clear whether Fatoure took Caravaggio's autograph original as his model, or a copy.

Whatever the answer, his print certainly gives no more than a rough idea of the composition, and the same applies to the vast majority of the other surviving drawings and engravings after Caravaggio. One striking fact is that these copies reproduce the distribution of light in Caravaggio's paintings extremely inadequately, and often in a simplified form. They give only an impression of the form and content of the composition, not of the handling of light that was such a distinctive and innovative feature of Caravaggio's art. That is why it has rightly been pointed out that the usefulness of the drawings and prints after Caravaggio's paintings 'would be limited only to those painters already in command of the equivalent of the whole style and would be impossible to those not familiar with Caravaggio's manner of painting'.[48] It can be concluded that in the 17th century the quantity and quality of the drawn or engraved copies after works

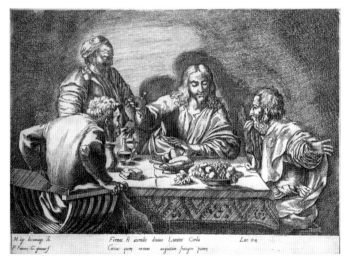

fig. 84 Lucas Vorsterman I, after Caravaggio
Madonna of the Rosary (engraving, 52.6 x 30.6 cm)
Amsterdam, Rijksmuseum

fig. 85 Pierre Fatoure, after Caravaggio
Supper at Emmaus, (engraving 30.1 x 20 cm)
Vienna, Albertina

by Caravaggio did little to advance knowledge of his style and compositions. Rembrandt, in any event, could not have gained a reliable idea from them of the painterly innovations of his Italian predecessor.

Caravaggio, Caravaggism and Rembrandt

If one looks at the paintings that are attributed to Caravaggio in 17th-century Dutch documents one soon realises that Rembrandt could only have seen a few of them with his own eyes. Most, however, were copies. It is doubtful whether he saw the *Madonna of the rosary*, which is recorded as being in Amsterdam in 1617 (Appendix, A; fig. 77), and was the only autograph work by Caravaggio known to have been in the Netherlands during Rembrandt's lifetime.[49] The painting had already been sold and was in Antwerp when he came to Amsterdam in 1625 to study with Pieter Lastman. Between 1625 and the end of 1631, his first years as an independent master in Leiden, it is absolutely certain that he never saw a work by Caravaggio, and it is doubtful whether he did later in Amsterdam. It should be borne in mind, though, that in addition to Caravaggio's own works it was the paintings of his Italian imitators that played an inestimable part in the dissemination of his style. Most of them lived and worked for a long time after the master's death, and their many paintings reflected his innovative man-

ner. One of the most influential of them was Bartolommeo Manfredi (1582-1622), who also came from Lombardy.[50] Joachim von Sandrart said of him in his *Teutsche Academie* of 1675 that he '[has] imitated and adopted [Caravaggio's manner] most assiduously, so that little difference can be discerned [between them]'.[51] What is interesting about this is that Von Sandrart first mentions an Amsterdam collection in which important paintings by Manfredi could be seen. It was that of the rich merchant Balthasar Coymans (1555-1634).[52] Von Sandrart knew what he was talking about, for he had himself lived in Amsterdam from 1637 to around 1642. It was not until 1709 that a grandson sold Coymans's collection, which in addition to three works attributed to Caravaggio (see the Appendix, N) contained several paintings by Manfredi. There can be no doubt that there were numerous paintings by Italian Caravaggisti in Amsterdam and other Dutch cities during Rembrandt's lifetime.

Rembrandt's first reaction to Caravaggesque painting can be seen in works from his Leiden period. He took his inspiration for them from paintings by a group of Utrecht artists who had been influenced in Rome by the works of Caravaggio and his Italian followers, and who brought those innovations back to the Dutch Republic (see also the prologue by Taco Dibbits above). Among those Utrecht Caravaggisti it was above all Hendrick ter Brugghen

(1588-1629), Gerard van Honthorst (1592-1656) and Dirck van Baburen (c. 1595-1624) who made the greatest impression on Rembrandt and his colleague Jan Lievens (Cat. nos. 2, 3 and 4). Both experimented almost simultaneously in Leiden with Caravaggesque compositions, naturalistic figures and the effects of artificial lighting. The results they achieved clearly differ, but do show unequivocally that their Caravaggesque nature can be attributed to the Utrecht painters and thus indirectly to Caravaggio's art. Attention has rightly been drawn to the 'great diversity between the works of the pioneer of the chiaroscuro art of painting, Caravaggio, and most of his Dutch followers'.[53] To this it can be added that those differences are also found among the Dutch Caravaggisti themselves.

Initially it was primarily the works of Honthorst, who had returned from Rome in 1620, that played a crucial role for Rembrandt and Lievens. Honthorst had studied Caravaggio's paintings exhaustively in Rome (figs. 82 and 87), and himself benefited in part from the support of Caravaggio's former patrons. Collectors valued his work highly, as is apparent from a letter of 20 July 1621 in which Thomas Howard, Earl of Arundel, thanked Sir Dudley Carleton for a Honthorst the latter had given him of Aeneas's flight from Troy. Arundel praised the artist 'for the postures & ye colouringe, I have seene fewe Duch men arrive unto it, for

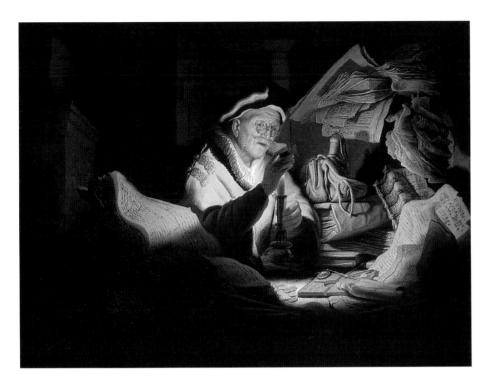

it hath more of ye Italian then the Flemish & much of ye manor of Caravagioes colouringe, wch is nowe soe much exteemed in Rome'.[54]

Honthorst made a speciality of something that is only found sporadically in Caravaggio's oeuvre, namely a nocturnal scene with an artificial source of light.[55] In his *The rich man from the parable* of 1627 (fig. 86), Rembrandt was clearly inspired by Honthorst, who painted many single or multi-figured compositions in which candles or oil lamps bathe nocturnal interiors in a warm glow (fig. 87).[56] A recurrent motif in them is a source of light that is screened off from the viewer. By contrast, in Rembrandt's 1628 painting in Melbourne of two old men disputing (see Cat. no. 7) there is

a very different problem associated with the Caravaggesque handling of light. It involves the contrast between the shadowed figure seen from the back in the foreground and the brightly lit figure facing him. Lievens, on the other hand, had already combined Lastman's polychrome palette (the master with whom he too had studied) with the heavily contrasted, illuminated

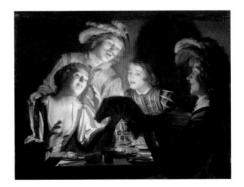

Caravaggesque type of scene with half-length figures in his *Feast of Esther* of 1625/26 (fig. 88).[57] That Rembrandt and Lievens had very different ideas about the Caravaggesque manner is clearly reflected in the works that they both made in their Leiden periods. In addition, Caravaggism for Lievens was only an episode, albeit an important one, in his early years as an independent master. Compared to Rembrandt, the influence of the Utrecht Caravaggisti on Lievens's work was stronger but brief. After 1631/32, those elements all but disappeared from his paintings. Rembrandt's interest in Caravaggism was more long-lasting and followed a more complex course. Even after he moved from Leiden to Amsterdam, Caravaggesque elements can be found in his dramatic compositions of the 1630s, such as *Belshazzar's feast* (Cat. no. 37), or the 1636 *Blinding of Samson* (Cat. no. 9). Even such late works as *The denial of St Peter* (Cat. no. 16) and *The oath of Claudius Civilis* (fig. 26) have unmistakable connections with Caravaggesque compositions. It is noteworthy that Rembrandt's orientation towards Caravaggesque painting as represented by the art of the Utrecht Caravaggisti, never restricted him to the borrowing and imitation of Caravaggesque elements and motifs. From the very start of his career it served him merely as a point of departure for the further development of his own goals and intentions as regards the effects of light

189

which, despite all the points of similarity, are ultimately very different from those of Caravaggio or the Utrecht Caravaggisti.

Rembrandt and Caravaggio never met. Rembrandt very probably never even saw an autograph work by Caravaggio, and the number of copies after the Italian master's work was very small indeed (see the Appendix). His knowledge of Caravaggio's art was based entirely on the stories and works of artists who had been to Italy, had seen originals by Caravaggio with their own eyes, but who interpreted what they saw in different ways in their own paintings. Most of those paintings confirmed, in any event, what Rembrandt had already been able to read in Karel van Mander, which was that the unidealised depiction of reality was the very cornerstone of the master's art. On this point Rembrandt undoubtedly agreed with Caravaggio. But that alone was evidently not enough for him. In his *Inleyding tot de hooge schoole der schilderkonst* of 1678, under the title *Voorbeelden van d'ouden* (Examples of the ancients), Rembrandt's pupil Samuel van Hoogstraeten posed the question of whether all great Italian and Dutch artists 'did not have something special as well as individual, either in the whole of their art or in some part of it?'. His answer as regards what was so special that distinguished the two great painters was unambiguous. Caravaggio set himself apart by virtue of his 'naturalness',

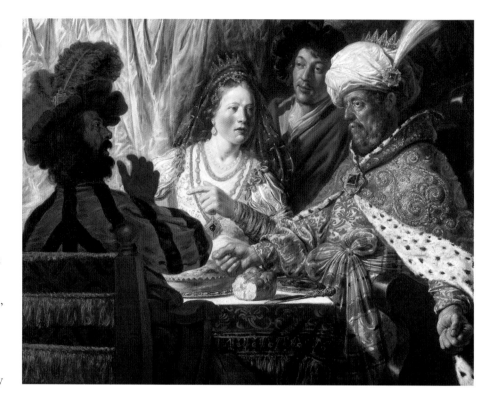

Rembrandt by his 'experiencing of the emotions'.[58] It was precisely those properties that distinguished the two painters and made them the greatest innovators in the art of the Baroque.

190

fig. 88 Jan Lievens
The feast of Esther, c. 1625-1626
(134.6 x 165.1 cm)
Raleigh, North Carolina Museum of Art

Appendix to the essay by Volker Manuth

The following chronological list shows the works by Caravaggio, copies after his paintings and works attributed to him documented in the Dutch Republic between 1617 and 1733. It has been compiled from announcements of forthcoming auctions, sale, collectors' and stock catalogues, and archival documents. Only rarely is it possible to determine the status of the work in question. The transcriptions are modernised in the English translation. Remarks and the author's amplifications and comments are set in square brackets. The publications listed under 'Literature' are only a selection.

	Date	Description	Translation	Source	Literature
A	19-9-1617	*Louys Finson, Schilder, Jacobssone, geboren van Brugge in Vlaenderen, Jonghman [...] Hij legateert [...] aan Mr. Abraham Vink [...] de helft competerende in 2 stucken schilderyen beyde van Michael Angel Crawats [i.e. Caravaggio] d'eene wesende den Rosarius, d'ander Judith ende Holopharnis, waarvan de wederhelfte den voorm. Mr. Abraham Vinck is toecomende.*	Louis Jacobsz Finson, born in Bruges in Flanders, bachelor. [...] He bequeaths [...] to Master Abraham Vinck [...] his half-share of two paintings, both by Michelangelo Caravaggio, the one being the Rosary, the other Judith and Holofernes, the other half of which belongs to the aforesaid Master Abraham Vinck.	The last will of the painter Louis Finson, dated 19 September 1617, in the presence of notary P. Ruttens (Amsterdam).	Bredius 1918, pp. 198-199; Bodart 1970, pp. 228-229
B	25-11-1619	*...dat het stuck schilderij, namentlijck een Crucificx van St. Andries [...] naer haer getuyges ooch en de beste wetenschap is een principael van Michael Angelo Caravagio.*	[...] that the painting, namely a *Crucifixion of St Andrew*, [...] is an original by Michelangelo Caravaggio, in the witnesses' eyes and to the best of their knowledge. [See C below]	Notarised statement by the painters Barent van Someren, Willem van den Bundel, Pieter Lastman, Adriaen van Nieulandt and Louis de Pret in the presence of notary W. Cluijt (Amsterdam) regarding the authenticity of a painting attributed to Caravaggio.	Bredius and De Roever 1886, pp. 7-8; Freise 1911, p. 10; Bodart 1970, pp. 234-235; Meijer 2000, p. 404, note 14
C	26-11-1619	*...verklaart Sr. Pieter de Wit, Coopman [...] dat omtrent twe jaeren geleden [...] hij getuyge in openbare opveylinge ten huyse van wijlen Abraham Vinck, schilder, van de erffgenamen van Louys Vinçon za:, schilder [...] gecocht heeft seecker stuck schilderie, wesende een St. Andries Crucinge, twelck bij den vercopers voor principael van Michael Angelo Caravagio.*	[...] Seigneur Pieter de Wit, merchant, declares [...] that some two years ago [...] he the witness bought from the heirs of the late Louis Finson, painter, [...] a particular painting at a public auction in the house of the late Abraham Vinck, painter, being a *Crucifixion of St Andrew*, which the sellers [asserted] was an original by Michelangelo Caravaggio. [See B above]	Notarised statement by Pieter de Wit, merchant, in the presence of notary W. Cluijt (Amsterdam) about the purchase of a painting attributed to Caravaggio.	Bredius and De Roever 1886, p. 8; Bodart 1970, pp. 235-236.

	Date	Description	Translation	Source	Literature
D	27-2-1630	*Charles de Coninck, Coopman tot Middelborch, vercocht aen Jacob van Nyeulant...een stuck schilderie, gedaen bij Mr. Louys Vinçon za: naer 't principael gedaen bij wijlen Michiel D'Angelo de Crawachy za: [i.e. Caravaggio] wesende een Uytdeelinge van de Paternoster aen de Preeckheeren. [Het schilderij] sal staen ter judicature van Pieter Lasman, Adriaen Nieulant ende Franchoys Veenant, alle schilders binnen deeser stede, enz.*	Charles de Coninck, merchant of Middelburg, sold to Jacob van Nieulandt [...] a painting by the late Master Louis Finson, done after the original by the late Michelangelo da Caravaggio of blessed memory, being a *Distribution of the rosary to the Dominicans*. [The painting] shall be adjudged by Pieter Lastman, Adriaen van Nieulandt and François Venant, all painters of this city etc.	Notarised statement about a copy after Caravaggio's *Madonna of the rosary*, said to have been made by Louis Finson. The buyer, Jacob van Nieulandt, asked for the expert opinion of Pieter Lastman, François Venant and Adriaen van Nieulandt.	Bredius and De Roever 1886, p. 9; Freise 1911, p. 17; Bodart 1970, p. 236.
E	15-5-1676	*Een stervende Magdalena, als 't leven, stark uytgevoert, en raar, door Michael Angelo da Caravagio*	A dying Magdalen, lifelike, powerfully executed, and rare, by Michelangelo da Caravaggio. [See O below]	Sale catalogue, Reynier van der Wolf, brewer, Rotterdam, 15 May 1676 (Lugt 5); fl. 1,500.	Hoet 1752, vol. 2, p. 342, no. 27; Bodart 1970, p. 99, no. 3.
F	15-5-1676	*Een Doot Kindeken door denzelve* [i.e. Caravaggio]	A dead child by the same [Caravaggio].	Sale catalogue, Reynier van der Wolf, brewer, Rotterdam, 15 May 1676 (Lugt 5); fl. 40.	Hoet 1752, vol. 2, p. 342, no. 28.
G	26-9-1684	*Michael Angelo Caravasi, Christus, Maria, Joseph, en andere Beelden, uytstekende gedaan*	Michelangelo Caravaggio, Christ, Mary, Joseph and other figures, excellently done.	Sale catalogue, Thomas Howard, Earl of Arundel, Amsterdam, 26 September 1684 (Lugt 7); fl. 92.	Hoet 1752, vol. 1, p. 1, no. 3.
H	23-8-1685	*Het zyn alle Principalen van de voornaemste en beroemste Italiaense Meesters, als Caravagio...*	They are all originals by the most prominent and famous Italian masters, like Caravaggio. [No further details]	Announcement of an auction in the *Amsterdamsche Courant*, of 23 August 1685: sale 'of the paintings from the cabinet of Mr du Fayn, during his lifetime Secretary of Briefs to Pope Paul V, brought from Rome in the year 1617', Amsterdam, 26 September 1685.	Bille 1961, p. 166; Dudok van Heel 1975a, p. 156, no. 12.
I	7-3-1687	*Sebastiaen van M. A. Carravaggio*	Sebastian by M.A. Caravaggio.	Probate inventory of Catharina Deyl, widow of the painter Nicolaes Rosendael, Amsterdam, 7 March 1687.	Bredius 1915-1922, vol. 2, p. 542.

	Date	Description	Translation	Source	Literature
J	19-4-1698	*Uytmuntende en voortreffelyke Schildereyen, waer onder zyn veele capitale stukken [van o.a.] Caravaggio*	Outstanding and excellent paintings, including many capital pieces by Caravaggio [among others]. [No further details]	Announcement of an auction in the *Amsterdamsche Courant*, 19 April 1698: sale, Guilelmo [Willem] Doedyns, painter, The Hague, 21 April 1698 (not in Lugt).	Dudok van Heel 1975a, p. 159, no. 50.
K	20-4-1700	*Een Stuk van Musikanten, na Michel Angelo Caravaggio*	A piece of musicians, after Michelangelo Caravaggio.	Sale Philips de Flines, Amsterdam, 20 April 1700, no. 59 (Lugt 174); fl. 32.10.	Hoet 1752, vol. 1, p. 57, no. 58.
L	2-9-1704	*Een Soldaat, van Michael Angelo de Carravaggio, uytmuntend konstig*	A soldier, by Michelangelo da Caravaggio, outstandingly artful.	Announcement of an auction in the *Amsterdamsche Courant*, 22 July 1704: sale, Pieter Six, Amsterdam, 2 September 1704 (Lugt 190); fl. 100.	Hoet 1752, vol. 1, p. 72, no. 11; Dudok van Heel 1975a, pp. 164, no. 80.
M	23-3-1707	*Konstige en playsante Schildereyen van [...], en M.A. de Caravacio*	Artful and pleasing paintings by [...] and M.A. da Caravaggio. [No further details]	Announcement of an auction in the *Amsterdamsche Courant*, 17 March 1707: anonymous sale 'of a notable estate', Oudezijds Herenlogement (not in Lugt).	Dudok van Heel 1975a, p. 167, no. 101
N	5-3-1709	*3 van M. Angelo de Caravaggio*	Three by Michelangelo da Caravaggio. [No further details]	Announcement of an auction in the *Amsterdamsche Courant*, 5 March 1709: sale, Jan Coymans, Amsterdam, 15 May 1709 (not in Lugt).	Dudok van Heel 1975a, p. 170, no. 125.
O	26-4-1713	*Een stervende Magdalena, door Michaël Angelo da Carravagio*	A dying Magdalen, by Michelangelo da Caravaggio (2 ft 2 in x 2 ft; c. 68 x 63 cm). [See E above]	Sale catalogue, Adriaen Paets, Director of the Dutch East India Company, Rotterdam, 26 April 1713 (Lugt 239); fl. 375.	Hoet 1752, vol. 1, p. 154, no. 2; Bodart 1970, p. 99, no. 3.
P	1714	*Michel Ange de Caravage. St. Thomas, touchent la Plaie du Sauveur, avec les Apôtres. Ce tableau est peint d'une Force extraordinaire, & si vrai, qu'on ne le peut voir sans Emotion.*	Michelangelo da Caravaggio, St Thomas touching the Saviour's wound, with the apostles. This painting is executed with extraordinary power, and so real it cannot be seen without emotion (4 ft 9 in x 6 ft; 149 x 213 cm).	Stock catalogue of the collection of Jaques Meyers, wine and art dealer: *Description du cabinet de Tableaux de Mr. Meyers, a Rotterdam*, Rotterdam (Fritsch & Bohm) 1714, p. 17.	Van Gelder 1974, p. 172; Meijer 2000, p. 405, note 20.

	Date	Description	Translation	Source	Literature
Q	1714	*Michel Ange de Caravage. Un jeune Homme ou Berger, avec un Bélier, peint du Gout des Caraches, & dessiné de la maniere de Jule Romain. Il vient du Cabinet du Duc de Gramont.*	Michelangelo da Caravaggio. A young man or shepherd with a ram, painted in the style of the Carracci and drawn in the manner of Giulio Romano. It comes from the cabinet of the Duc de Gramont (4 ft 3 in x 3 ft; 133.5 x 94 cm). [See also T below]	Stock catalogue of the collection of Jaques Meyers (c. 1660-1721), wine and art dealer: *Description du cabinet de Tableaux de Mr. Meyers, a Rotterdam,* Rotterdam (Fritsch & Bohm) 1714, p. 17.	Van Gelder 1974, p. 172; Meijer 2000, pp. 377, 405, note 20.
R	17-2-1714	*Konstige en plaisante Schilderyen van deze groote Meesters, als M. Angelo de Caravagio*	Artful and pleasing paintings by these great masters, like Michelangelo da Caravaggio. [No further details]	Announcement of an auction in the *Amsterdamsche Courant,* 17 February 1714: sale, Willem van Beest, broker, Amsterdam, 6 March 1714 (not in Lugt).	Dudok van Heel 1977, p. 110, no. 164.
S	4-11-1720	*Een groot Avontmael door Michielangelo de Carawagio*	A large Last Supper by Michelangelo da Caravaggio.	List of paintings transferred to Jan Osij by the art dealer Francisco-Jacomo van den Berghe, 4 November 1720; fl. 400.	Duverger 2004, p. 232, no. 51.
T	9-9-1722	*Een Jongman of Herder met een ram, in de manier van de Caraches, en geteekent in de manier van Julio Romano door Michiel Angelo de Caravagio.*	A young man or shepherd with a ram, painted in the manner of the Carracci and drawn in the manner of Giulio Romano, by Michelangelo da Caravaggio (4 ft 3 in x 3 ft; 133 x 94 cm). [See also Q above]	Sale catalogue, Jaques Meyers, Rotterdam, 9 September 1722 (Lugt 302); fl. 205.	Hoet 1752, vol. 1, p. 268, no. 21; Duverger 2004, p. 241, no. 21.
U	9-9-1722	*Een St. Jeronimus, stout geschildert, door dezelve* [i.e. Caravaggio]	A St Jerome, boldly painted, by the same [Caravaggio] (3 ft 2 in x 2 ft 3 in; 90 x 53 cm).	Sale catalogue, Jaques Meyers, Rotterdam, 9 September 1722 (Lugt 302); fl. 52.	Hoet 1752, vol. 1, p. 268, no. 22; Duverger 2004, p. 241, no. 22.
V	19-5-1723	*La Sainte Scéne par Michelangelo de Caravaggio, très bien peinte.*	The Last Supper by Michelangelo da Caravaggio, very well painted (5 ft x 7 ft; 162 x 227 cm).	List of paintings sold by the art dealer Francisco-Jacomo van den Berghe in The Hague, 11 August 1733; fl. 31.	Duverger 2004, p. 258, no. 73
W	11-8-1733	*Een schoon Stuk door Michel Angelo de la Caravagio, verbeeldende Petrus met de Dienstmaagd, het eenige hier bekend*	A fine piece by Michelangelo da Caravaggio of Peter with the maidservant, the only one known here (46 in x 66 in; 120 x 172 cm).	Sale catalogue, Adriaan Bout, The Hague, 11 August 1733 (Lugt 427); fl. 155.	

Notes

Introduction

1 Algarotti 1762, p. 44.
2 Lanzi 1782, p. 139. I am indebted to Bert Meijer for this reference.
3 See Boomgaard 1995 and Scallen 2004.
4 The veritable explosion of interest in Caravaggio since Roberto Longhi's ground-breaking exhibition in Milan of 1951 (*Mostra del Caravaggio e dei Caravaggeschi*, Palazzo Reale), can be gauged from the bibliography compiled by Massimo Moretti, appended to Macioce 2003.
5 See, most recently, Schwartz 2002.
6 For an extended discussion of the picture, see Treffers 1996.
7 See, among others, Spike 2001, p. 7; and the discussion by M. van Eikema Hommes and E. van de Wetering on p. 172 above.
8 For an overview of Caravaggism, see Nicolson 1979. For the Dutch Caravaggisti, see, most recently, exhib. cat. San Francisco etc. 1997.
9 See Hecht 1997.
10 G. Mancini, *Considerazioni sulla pittura*, 1619-1620, cited in Macioce 2003, p. 312. For an overview of Caravaggio's early years in Rome, see Langdon 1998, pp. 66-68.
11 There is now a huge literature about Caravaggio's early patrons. See Langdon 1998, *passim*; for these two in particular, see Gilbert 1995 and exhib. cat. Rome & Berlin 2001.
12 For the reaction to the Contarelli paintings, see Langdon 1998, pp. 252-57.
13 See Askew 1990.
14 Von Sandrart 1675-1680, vol. 2, bk. 2, ch. 19, p. 189: *Damit er aber auch die vollkommene Rondirung und natürliche Erhebung desto bässer herfür bringen möchte, bediente er sich fleissig dunkler Gewölber oder anderer finsterer Zimmer, die von oben her ein einiges kleines Liecht hatten, damit die Finsterniss dem auf das model fallenden Liecht durch starke Schatten seine Macht lassen und darmit eine hocherhobene Rundierung verursachen möchte.* See Christiansen 1986 for an extended discussion of Caravaggio's use of models.
15 Van Mander 1604, fol. 191r. For the text, see note 11 to the essay 'Light and colour', below.
16 Houbraken 1718-1721, vol. 1, p. 262. For the text, see note 15 to the essay 'Light and colour', below.
17 See Emmens 1979, pp. 101-111.
18 It is remarkable that Caravaggio is one of the few major Italian painters by whom no drawing is known; his predecessors, contemporaries and followers almost all practised drawing.
19 Bruyn 1983.
20 Pels 1681, p. 36. For the text, see note 18 to the essay 'Light and colour', below. See also the essays by V. Manuth, E.J. Sluijter and E. de Jongh in exhib. cat. Edinburgh & London 2001.
21 Langdon 1998, p. 271.
22 For Rembrandt's inventory, see exhib. cat. Amsterdam 1999.
23 Huygens 1987, p. 89. For the text, see note 7 to V. Manuth's essay below.
24 For the iconography see Haussherr 1976.
25 See Giltaij 1996.
26 For the iconography, see Emmens 1979, p. 250, and Held 1969.
27 See, most recently, Hartje 2004.
28 Clark 1966, p. 22.
29 Sussino 1960, pp. 113-114. See also exhib. cat. Naples & London 2004, cat. no. 9.
30 For a full account, see Nordenfalk 1982.

Prologue
Caravaggio, *St Andrew on the cross*

1 D. Mahon was the first to establish the connection between this painting and the description of St Andrew's martyrdom in the *Legendario delle vite de'santi*; see Tzeutschler Lurie and Mahon 1977, p. 13.
2 Merke 1971, pp. 321-322. This may also be an allusion to St Andrew, one of whose roles was as patron saint of those suffering from throat infections; see Kerler 1968, p. 159.
3 For the discussion about the shape of the cross that took place around 1600 see Tzeutschler Lurie and Mahon 1977, p. 5.
4 K. Christiansen in exhib. cat. Naples & London 2004, pp. 109-110, no. 5.
5 See Tzeutschler Lurie and Mahon 1977, p. 3.
6 On this, see the essay by Volker Manuth on p. 180 above, and Appendix B.

The Utrecht Caravaggisti

1 Huygens 1987, p. 89. For the text, see note 7 to V. Manuth's essay below.
2 Von Sandrart 1925, p. 202.
3 Although Pieter Lastman, with whom Rembrandt studied in Amsterdam in 1625, had been to Rome (1604-1609), and had appraised two works in Amsterdam that were held to be genuine Caravaggios, little direct influence of the Italian master can be detected in his own work. See the essay by V. Manuth on pp. 180-181, and especially his Appendix, nos. A and B; see also Judson 1986.
4 See the essay by Volker Manuth, pp. 185-186 above.
5 On this see the essay by Margriet van Eikema Hommes and Ernst van de Wetering. p. 172 above; and Van de Wetering 2004.
6 Van Mander 1604, fol. 191r: *Sooveel zijn handelinghe belangt, die is sulcx, dat se seer bevallijck is, en een wonder fraey maniere, om de Schilderjeught nae te volgen.*
7 De Bie 1661, p. 132.

8 G. Mancini, *Trattato della pittura* or *Considerazioni sulla pittura*, c. 1621, as transcribed in Judson and Ekkart 1999, p. 47: *[...] venne in Italia (Roma) [Mancini's correction] in quei tempi nequali la maniera del Caravaggio era communem.*
9 Exhib. cat. Rome & Berlin 2001, pp. 278-281, no. D2.
10 Van Baburen painted his earliest documented Italian work (now lost) in 1615 for the Servi church in Parma.
11 Vincenzo Giustiniani had a *Christ washing the disciples' feet* by Van Baburen; see exhib. cat. Rome & Berlin 2001, pp. 296-297, no. D6.
12 Huygens 1987, p. 86: *Rembrandt [...] concentreert zich graag vol overgave op een klein schilderij en bereikt in het kleine een resultaat, dat men in de grootste stukken van anderen tevergeefs zal zoeken.*
13 Huygens had already written that Rembrandt excelled in history painting; see ibid., p. 87.
14 Van Mander 1604, fol. 191r. For the text, see note 11 to the essay 'Light and colour', below.
15 Von Sandrart 1925, p. 178: *[...] die Natur und derselben unfreundliche Mängel sehr wol, aber unangenehm gefolgt.*
16 Bellori 1976, pp. 211-212: *[...] lo stesso abbiamo veduto in Michelangelo Merigi, il quale non riconobbe altro maestro che il modello, e senza elezzione delle megliori forme naturali, quello che a dire è stupendo, pare che senz'arte emulasse l'arte.*
17 Mancini 1956-1957, vol. 1, p. 108. Mancini noted that this produced good results in single-figure compositions. However, it was impossible, in his view, to have the many figures in a history painting pose simultaneously in a dark room, and to have them laugh, cry or walk. It is for that reason, he said, that the figures in Caravaggio's history paintings lacked movement and emotional expression (*affetti*).
18 Judson and Ekkart 1999, pp. 5-6, 331, no. D16.
19 It is worth noting, incidentally, that unlike Caravaggio, Ter Brugghen did not depict the wounds left by the nails in Christ's hands which, according to John, Thomas also wanted to see.
20 See Nicolson 1956, p. 104, about this interplay of hands.
21 First noted in Von Schneider 1933, p. 42.
22 See Bikker 2004-2005 for the most recent analysis of the subject.
23 That people were already aware of Caravaggio's influence on Honthorst at the time of the latter's painting is evident from a letter of 20 July 1621 in which Thomas Howard, Earl of Arundel, thanked Sir Dudley Carleton for a Honthorst the latter had given

him: *[…] it hath more of ye Italian then the Flemish & much of ye manor of Caravaggioes colouringe, wch is nowe soe much exteemed in Rome;* see Judson and Ekkart 1999, p. 106, no. 89.

24 On this, see the essay by Margriet van Eikema Hommes and Ernst van de Wetering, pp. 169-171 above.

25 Van Hoogstraeten 1678, p. 268; see also Blankert in exhib. cat. Utrecht & Braunschweig 1986, p. 32.

The young Rembrandt
Rembrandt, *A soldier in a gorget and plumed bonnet*

1 *Corpus*, vol. 1, no. A 8; exhib. cat. Melbourne & Canberra 1997, cat. no. 1; exhib. cat. Kassel & Amsterdam 2001, cat. no. 74; exhib. cat. Vienna 2004, cat. no. 18.

2 Van der Veen 1997.

3 Bauch 1966, no. 109.

4 See Dekiert 2003, pp. 16-45, for Caravaggio's scenes that served as models, and pp. 67-230 for works by the Dutch Caravaggisti.

5 The drawing was made into a woodcut by Christoffel van Sichem; see Reznicek 1993, pp. 256-258, no. K 345a, fig. 56. I am grateful to Huigen Leeflang for alerting me to the similarities to Goltzius's drawings. Dürer's 1522 woodcut of Ulrich Varnbüler may also have been a source of inspiration, or Lucas van Leyden's *Portrait*, newly republished by Hondius as a self-portrait by Lucas van Leyden, Hollstein 174. Rembrandt's *Soldier* has also been associated with the figure of *Il capitano* from the *commedia dell'arte* as depicted by Jacques Callot in an etching of c. 1618, but apart from the self-assured pose and the feathers in the bonnet there is no formal correspondence with that *Capitano*, who is shown full-length; see J. Lange in exhib. cat. Kassel & Amsterdam 2001, pp. 152-153, fig. 74a.

6 Bartsch 19.

7 *Corpus*, vol. 1, pp. 127f. See Gordenker 1995 for Rembrandt's collection of costumes. Marieke de Winkel, incidentally, believes that he never had a large collection of them. Many pieces of material are listed in his 1656 inventory, but there is little mention of costumes as such. His large collection of graphic art probably provided the inspiration for many of the costumes in his portraits and self-portraits; see De Winkel 1999, p. 68.

Rembrandt, *Self-portrait as a young man*

1 Van de Wetering 1999; Perry Chapman 1990. For this self-portrait, see see *Corpus*, vol. 1 (A 14), pp. 169-176; exhib. cat. London & The Hague 1999, cat. no. 5; exhib. cat. Vienna 2004, in the entry on cat. no. 1; and exhib. cat. Kassel & Amsterdam 2001, p. 69, fig. 17.

2 According to the jurist and art-lover Arnold

van Buchel in 1628; see Strauss and Van der Meulen 1979, no. 1628/1, p. 61.

3 This hypothesis was put forward in Van de Wetering 1999, p. 36.

Rembrandt, *Two old men disputing*

1 Bellori 1976, p. 217. For the text, see note 36 to the essay 'Light and colour' below, and also note 34 for Mancini's observation.

2 For this painting, see see *Corpus*, vol. 1 (A 13), pp. 159-168; exhib. cat. Melbourne & Canberra 1997, cat. no. 3.

3 Janssen 2005; exhib. cat. Braunschweig 1993.

4 *Corpus*, vol. 1, p. 167: *[…] schilderije van Rembrand gedaen, daer twee oude mannekens sitten ende disputeren, den enen heeft een groot bouck op sijn schoot, daer comt een sonnelicht in.*

5 *Corpus*, vol. 2 (A 56), pp. 219-224.

6 Van de Wetering 2000.

7 *Corpus*, vol. 1 (A 13), pp. 165-167; Tümpel 1969, pp. 181-187.

8 Hollstein 106.

Rembrandt, *St Paul at his desk*

1 The other is *The seven works of mercy* of 1606; see fig. 25 on p. 23 above.

2 *Corpus*, vol. 1 (A 11), p. 148. For this painting, see also exhib. cat. Kassel & Amsterdam 2001, cat. no. 32; Slatkes 1992, cat. no. 73; exhib. cat. Berlin, Amsterdam & London 1991, cat. no. 5; Van de Wetering 1997, pp. 177-178. fig. 232.

3 Exhib. cat. Kassel & Amsterdam 2001, p. 225.

4 Bartsch 149.

5 Quoted in Manuth 2005, p. 46.

REMBRANDT
CARAVAGGIO

Rembrandt, *The blinding of Samson*
Caravaggio, *Judith and Holofernes*

1 *Corpus*, vol. 3 (A 116), p. 190.

2 Langdon 1998, p. 168; G. Comanini, *Il Figino*, 1591, quoted by M. Gregori in exhib. cat. New York & Naples 1985, p. 257.

3 It has been suggested that Rembrandt drew inspiration from Rubens's hunting scenes in formulating this multi-figures scene of violence; see Manuth 1990, and Lenz 1985.

4 Van Mander 1604, *Wtlegghingh op den Metamorphosis Pub. Ouidij Nasonis*, fol. 33v: *Ander willen met desen grooten Tityus te kennen gheven, dat geen Menschelijcke macht, hoe groot, niet en vermagh tegen t'Godlijcke gherichte, oft de misdaedt en wort aen den misdader ghestraft.*

5 Manuth 1990, pp. 182-184.

6 *Corpus*, vol. 3 (A 116), p. 192f.

7 Bleyerveld 2000, *passim*.

8 Langdon 1998, p. 168, and Boonen 1991, p. 117.

Rembrandt, *The Holy Family in the carpenter's shop*
Caravaggio, *The Holy Family with St John the Baptist*

1 Van Thiel in exhib. cat. Berlin, Amsterdam & London 1991 vol. 1, cat. no. 14; *Corpus*, vol. 2 (A 88), p. 456.

2 *Corpus*, vol. 2, p. 458; For the Soolmans portraits, see *Corpus*, vol. 2, A 100 and A 101.

3 See ibid., vol. 2 (A 88), p. 456, for examples.

4 As first suggested by Roberto Longhi, with reference to Annibale's picture in the Louvre; see Christiansen 1999. For the Giustiniani version, reproduced here see Danesi Squarzina 2003, vol. 1, p. 186f.

5 See Christiansen 1999 for a full account of this picture, its dating, and a discussion of Caravaggio's Classicism.

6 Bruyn 1970, esp. pp. 35-38. Carracci is explicitly mentioned in *Corpus*, vol. 2, p. 456.

Rembrandt, *Flora*
Caravaggio, *The penitent Mary Magdalen*
Caravaggio, *St Catherine of Alexandria*

1 Bellori, 1672, as cited in Macioce 2003, pp. 324-325: *Onde nel trovare e nel disporre le figure, quando incontratasi a vederne per la città alcuna che gli fosse piaciuta, egli si fermava a quella invenzione di natura, senza altrimenti esercitare l'ingegno. Dipinse una fanciulla a sedere sopra una seggiola con le mani in seno in atto di asciugarsi i capelli, la ritrasse in una camera, ed aggiungendovi in terra un vasello d'unguenti con monili e gemme, la finse per Madalena.* Translation adapted from Hibbard 1983, p. 362.

2 Identified by Sam Segal; see *Corpus*, vol. 2, p. 496.

3 See ibid., pp. 500-501.

4 Ibid., p. 499. The exact date of the Titian's arrival in Amsterdam is uncertain, but it remained there in the collection of Alfonso López until 1641. For the portrait of Saskia, now in Dresden, see *Corpus* 3, p. 395.

5 See Macioce 2003, p. 117. It must be remarked that Parravicino's exact meaning is difficult to interpret.

Rembrandt, *The denial of St Peter*
Caravaggio, *The betrayal of Christ*

1 For a full account of this recently rediscovered picture, see Benedetti 1993.

2 See Gilbert 1995, pp. 135-141.

3 Herrmann Fiore 1995.

4 See E. van de Wetering in exhib. cat. Bergamo 2000, p. 158.

5 Kloek and Jansen 1993.

6 Bellori 1675, cited in Macioce 2003, p. 326: *Imitò l'armatura rugginosa di quel soldato.*

7 Longhi 1999-2000, vol. 2, p. 48, and Langdon 1998, p. 235. See also Herrmann Fiore 1995.

Rembrandt, *Portrait of Johannes Wtenbogaert*
Caravaggio, *Portrait of Fra Antonio Martelli ('The Knight of Malta')*

1 See Spike 2001, catalogue of 'Lost works by title'.
2 Gash 1997.
3 Molhuysen and Blok 1911-1937, vol. 2, cols. 1469-1472. See also additional literature cited in *Corpus*, vol. 2, p. 398.
4 *Corpus*, vol. 2 (A 80), p. 397.
5 See K. Sciberas and D. Stone in exhib. cat. Naples & London 2004, pp. 61-80.

Rembrandt, *Portrait of Joris de Caullery*

1 Bredius 1893.
2 Rembrandt had already experimented with this in his *Head of a man with a plumed bonnet* (*Corpus*, vol. 1, A 20). For that painting see exhib. cat. Boston & Chicago 2003, cat. no. 14.
3 Dudok van Heel 2004, p. 17.
4 At first he took along his pupil Isaac Jouderville as his assistant; see Van de Wetering 1983, and Van de Wetering 1986, pp. 45-90 and 60-76.
5 *The anatomy lesson of Dr Nicolaes Tulp*, 1632. See *Corpus*, vol. 1, A 51.

Caravaggio, *The sacrifice of Abraham*
Rembrandt, *The sacrifice of Abraham*

1 See Langdon 1998, p. 200. It is worth noting that Caravaggio's biographer, Bellori, singles out the fact that the boy is screaming (*che grida*), see Macioce 2003, p. 326.
2 For a discussion, see *Corpus*, vol. 3, p. 105.
3 Contini 1992, p. 88: *[…] pareva che movessi troppo.* There is an undoubted homoerotic undertone to this criticism, as the context makes clear.
4 Quoted in *Corpus*, vol. 3 (A 108), p. 112.

Rembrandt, *Jacob and the angel*

1 It is described as the 'wrestling of Jacob' (*worstelingh Jacobs*) in the inventory of the collection of Marten Davidsz van Ceulen, who owned it in 1687. It hung 'in the great chamber' (*op de saal*) in Van Ceulen's house at No. 246, Oudezijds Voorburgwal in Amsterdam, together with Rembrandt's *Denial of St Peter* (Cat. no. 16). See Bok 1990, with the inventory on p. 162.
2 J. Kelch, in exhib. cat. Berlin 1975, has pointed out that the structure of the painting, with its large planes and strong contours, means that it is best viewed from a distance, so Rembrandt probably made it for a specific location, which must have been a room of considerable size.
3 Tümpel 1993, no. 29 and p. 293.
4 Calvin stressed this interpretation of the story in his *commentarii* on Genesis 32:24.
5 M.M. van Dantzig in the newspaper *Het Vrije Volk*, 27 June 1956.

Rembrandt, *A schoolboy at his desk ('Titus as a scholar')*
Caravaggio, *A boy bitten by a lizard*

1 G. Mancini, *Considerazioni sulla pittura*, 1619-1620, quoted in Macioce 2003, p. 312: *[...] per vendere un putto che piange per esser stato morso da un racano ce tiene in mano.* See also Langdon 1988, p. 57.
2 Vasari 1878-1885, vol. 5, p. 81.

Rembrandt, *Rembrandt's son Titus in a monk's habit*

1 The identification is based on the close resemblance to the paintings in Vienna and Paris; see Bredius/Gerson, nos. 122 and 126. Valentiner 1908, p. 460, doubted the identification.
2 However, there was a tradition of depicting saints at half-length. Perhaps the best-known example in printmaking is Boëtius à Bolswert's series after Abraham Bloemaert, in which the compositions of Sts Theonas and Macharius display similarities to Rembrandt's painting. See Roethlisberger 1993, no. 182, figs. 283, 284.
3 Cort's print after Girolamo Muziano, Bartsch 129, is possibly the best-known example of this from the Dutch Republic. In 1657, three years before this painting, Rembrandt made an etching of the subject, Bartsch 107.
4 Savelsberg 1992.
5 Hedquist 1994, p. 24, identified the habit as that of the Franciscan Order of the Observants.
6 London, National Gallery, and Helsinki, Sinebrychoff Art Museum. See Valentiner 1920/1921, p. 221, and exhib. cat. Washington & Los Angeles 2005, no. 16 (by P.C. Sutton). Tümpel 1986, no. 92, p. 400, doubted the attribution of the Helsinki painting.
7 The first to comment on his age was Hofstede de Groot 1907-1928, vol. 6, no. 190, pp. 129-130.
8 See Wheelock 2005 and Manuth 2005.
9 Hedquist 1994, p. 24.

Rembrandt, *Flora (Saskia as Flora)*
Caravaggio, *Boy with a basket of fruit*

1 V. Giustiniani, *Lettera sulla pittura al Signor Teodoro Amideni'*, c.1620-1630, quoted in Macioce, *Fonti*, p. 314f: *[...]Quinto, il saper ritrarre fiori, ed altre cose minute, nel che due cose principalmente si richiedono: la prima che il pittore sappia di lunga mano maneggiare i colori, e ch'effetto fanno, per potere arrivare al disegno vario delle molte posizioni de'piccoli oggetti, ed alla varietà de'lumi; e riesce cosa assai difficile unire queste due circostanze e condizioni a chi non possiede bene questo modo di dipingere, e sopra a tutto vi si ricerca straordinaria pazienza; ed il Caravaggio disse, che tanta manifattura gli era a fare un quadro buono di fiori, come di figure.*
2 Mancini 1619-1620; quoted in Macioce 2003, p. 312. The painting may, however, have been executed in the studio of Caravaggio's

employer, the Cavalier d'Arpino, from where it was acquired by Cardinal Borghese.
3 It remains uncertain whether this is the picture that Mancini describes as a portrait of a peasant (*ritratto di un vilico*). See note 2 above.
4 Hibbard 1983, p. 17f., and Posèq 1990, esp. pp. 149-151.
5 Pliny, *Natural history*, XXXV, 65-66.
6 For a discussion of this, see Massing 1990.
7 Identified by Sam Segal, see *Corpus*, vol. 3 (A 112), p. 150.
8 Ibid., p. 160.
9 By A. McNeil Kettering, as cited in ibid.

Rembrandt, *'The Jewish bride'*
Caravaggio, *The conversion of the Magdalen*
Caravaggio, *The martyrdom of St Ursula*

1 For a full account of the rich iconography, see Cummings 1974, supplemented by the remarks of M. Gregori in exhib. cat. New York & Naples 1985, pp. 250-255.
2 The fullest recent account of this painting is exhib. cat. Rome etc. 2004. See also exhib. cat. New York & Naples 1985, p. 352, and F. Bologna in exhib. cat. Naples & London 2004, pp. 144-147.
3 Ellis 1900, vol. 6, p. 66: A*nd then all these virgins came with the bishops to Cologne, and found that it was besieged with the Huns. And when the Huns saw them they began to run upon them with a great cry, and araged like wolves on sheep, and slew all this great multitude. And when they were all beheaded, they came to the blessed Ursula, and the prince of them, seeing her beauty so marvellous, was abashed, and began to comfort her upon the death of the virgins, and promised to her to take her to his wife. And when she had refused him and despised him at all, he shot at her an arrow, and pierced her through the body, and so accomplished her martyrdom.*
4 White 1984, p. 202.
5 The relationship between the painting and the drawing, which shows Isaac and Rebecca observed by Abimelech, was first recognised by R.W. Valentiner in 1923. For a full discussion see Tümpel 1969.
6 Tümpel 1969, pp. 160-169. The results of the technical examination of the painting were unknown to Tümpel at the time of writing. For these see Kloek and Jansen 1993, figs. 13-16.

197

Rembrandt, *A queen from antiquity, probably Sophonisba or Artemisia*

1 See Bell 1995 for Caravaggio's revolutionary use of colour and chiaroscuro in this painting.
2 Summers 1981, pp. 339 and 347-355.
3 The object was formerly thought to be the dish belonging with the nautilus cup, or the urn from which the ashes were strewn. See *Corpus*, vol. 3, p. 776.

4 *Corpus*, vol. 2 (A 64), pp. 266-275.
5 See Aulus Gellius, *Noctes Atticae*, X, 18, 3.
The story was made famous by Valerius
Maximus in his *Memorabilia*, 4.4, Ext. 1. The
gesture that the queen is making with her
right hand has been interpreted as drawing at-
tention to her stomach, through which her
body has become a tomb for her husband. In
this reading, the pouch that the old woman
appears to be holding contains Mausolos's
ashes. There are also two prints by Georg
Pencz depicting both women which suppos-
edly support the identification of this one as
Artemisia, but their iconography is so far re-
moved from that of the painting that they are
of no help in resolving the issue. See Tümpel
1986, no. 97; exhib. cat. Edinburgh & London
2001, no. 31; and exhib. cat. Amsterdam 1999,
p. 77.
6 See Hofstede de Groot 1907-1928, vol. 6,
no. 223; *Corpus*, vol. 2 (A 94), pp. 504-510, esp.
p. 509; and *Corpus*, vol. 3, p. 776.
7 Livy, *Ab urbe condita*, XXX, 12, 15.
8 Another argument is based on the black
mourning garment worn by Artemisia in
Honthorst's scene of roughly a year later in
the stadholders' collection; Lunsingh
Scheurleer 1969, pp. 57-58, figs. 23 and 24. See
also De Winkel 2001, pp. 58-59, for the use of
this kind of garment in the 17th century. The
similar iconographies of the two queens has
often been a cause of confusion. There was
another painting of Artemisia in the stadhold-
ers' collection, by Rubens, but in an inventory
of 1632 it was described as a Sophonisba; see
Van Gelder 1951, pp. 113-114, fig. 4.
9 See Manuth and De Winkel n.d. Amy
Golahny's interpretation of the book beside
the woman, whom she identifies as Artemisia,
as the eulogy for her husband is not entirely
convincing; see Golahny 2003, pp. 132-133.

Caravaggio, *Omnia vincit Amor (Love triumphant)*
Rembrandt, *The rape of Ganymede*
1 Langdon 1998, p. 215, draws attention to
the binary function.
2 Virgil, *Eclogues*, X, 69.
3 See Macioce 2003, p. 264.
4 Inventory of 9 February 1638; quoted in
ibid., p. 353: *Un quadro con un Amore ridente, in
atto di dispregiar il mondo.*
5 Ibid., p. 130. The document concerns one
of the court cases in which Caravaggio was
involved.
6 Ovid, *Metamorphoses*, X, 152-161.
7 Clark 1966, pp. 13-18, offers an intriguing
proof of this.
8 See *Corpus*, vol. 3 (A 113), p. 166.
9 See ibid. (reporting the observations of
Margarita Russell).
10 Translation from Langdon 1998, p. 215.

Caravaggio, *St Jerome writing*
Rembrandt, *Bathsheba bathing*
1 The attribution has been doubted; see
exhib. cat. New York 1995, vol. 1, pp. 94-99.
2 Exhib. cat. Berlin, Amsterdam & London,
vol. 1, pp. 242-245.
3 G.P. Bellori, quoted in Macioce 2003,
p. 326. It should be noted, however, that
almost all of the many Caravaggios owned
by Scipione Borghese were acquired after
Caravaggio fled Rome in 1606.

Rembrandt, *Belshazzar's feast*
Caravaggio, *The supper at Emmaus*
1 See Schama 1987, *passim*.
2 *Corpus*, vol. 3 (A 110), p. 130, and p. 132,
fig. 6.
3 Gilbert 1995, pp. 141-152, esp. p. 152.
4 Scribner 1977.
5 See *Corpus*, vol. 3, p. 131. Discussion of this
source has been confined to its implications for
the dating of the picture. Menasseh Ben Israel
was engaged in writing the book while
Rembrandt was painting *Belshazzar's feast*, and
one wonders what more general influence the
Jewish divine's thesis on the Hebrew scriptures'
treatment of death may have had on his friend's
choice and interpretation of the subject.

Light and colour in Caravaggio and Rembrandt, as seen through the eyes of their contemporaries
1 Clark 1966, p. 22.
2 The copy is discussed in Marini 1987, p. 292.
3 See exhib. cat. Bergamo 2000.
4 For example in Calvesi 1971, Del Bravo
1983 and Rzepínska 1986. See Treffers 1991,
ch. 5, for a lucid survey of the literature in
which Caravaggio's use of light is associated
with theological ideas.
5 Treffers 1991, pp. 162-163. For example, in
the *Martyrdom of St Matthew* (fig. 6), it is not
just the martyr who is illuminated but the exe-
cutioner as well, and although the beam of
sunlight on the wall in *The calling of St Matthew*
(fig. 7) can perhaps be construed as a metaphor
for the divine light, it does not illumine the
apostle Peter, who had already converted, but
a greedy tax-gatherer counting money.
6 When there is explicit mention of the di-
vine light in a biblical story, such as *The conver-
sion of St Paul* in the Cerasi Chapel (fig. 29),
one sees that Caravaggio depicts it very tradi-
tionally, either in the form of clearly defined
rays of light, or by showing the effects of the
bright radiance on the onlookers, as in the
first version of the altarpiece.
7 For example by André Félibien in several of
his *Conférences*. See Félibien 1973.
8 Friedlaender 1955, p. 276: *Quella parola va-
lenthuomo appresso di me vuol dire che sappi far
bene dell'arte sua, così un pittore valenthuomo che
sappi depingere bene et imitar bene le cose naturali.*

9 On working from the imagination see
Miedema 1973, vol. 2, pp. 436-439.
10 Bottari 1822-1825, vol. 6, pp. 121-129, esp.
p. 126: *Undecimo modo, è di dipingere con avere gli
oggetti naturali d'avanti.*
11 Van Mander 1604, fol. 191r: *Dan zijn seg-
ghen is, dat alle dinghen niet dan Bagatelli, kinder-
werck, oft bueselinghen zijn, t'zy wat, oft van wien
gheschildert, soo sy niet nae t'leven ghedaen, en
gheschildert en zijn, en datter niet goet, oft beter
en can wesen, dan de Natuere te volghen. Also dat
hy niet eenen enckelen treck en doet, oft hy en sittet
vlack nae t'leven en copieert, end' en schildert. Dit
en is doch geenen quaden wegh, om tot goeden
eyndt te comen: want nae Teyckeninge (of sy schoon
nae t'leven comt) te schilderen, is so ghewis niet, als
t'leven voor hebben, en de Natuere met al haer ver-
scheyden verwen te volgen: doch behoefde men eerst
so verre gecomen te wesen in verstandt, dat men
t'schoonste leven uyt t'schoon onderscheyden en uyt
te kiesen wist.*
12 Mancini 1956-1957, vol. 1, p. 108: *Questa
schola in questo modo d'operare è molto osservante
del vero, che sempre lo tien davanti mentre ch'opera*;
Bellori 1976, p. 214: *[...] si propose la sola natura
per oggetto del suo pennello*, and p. 202. The
translation is from Kitson 1985, p. 11.
13 It is also noteworthy that there is not a
single drawn preliminary study by Caravaggio.
As Keith Christiansen has explained, there are
all sorts of indicators in Caravaggio's works
that could point to painting from the model.
See Christiansen 1986.
14 See Christiansen 1986, Keith 1998 and
Gregori 1992.
15 Houbraken 1718-1721, vol. 1, p. 262:
*Van deze meening was ook onze groote meester
Rembrant, stellende zig ten grondwet, enkele naar-
volging van de natuur, en alles wat daar buiten ge-
daan werd was by hem verdacht.*
16 Rembrandt, *The artist in his studio*, 1629,
oil on panel, 25.1 x 31.9 cm, Boston, Museum
of Fine Arts. This interpretation is given in Van
de Wetering 1997, ch. 4, esp. pp. 87-89. See al-
so Miedema 1973, vol. 1, p. 247 (Van Mander's
marginal note): *Idee, imaginaty, oft ghedacht.*
17 Von Sandrart 1675-1680, vol. 2, bk. 3,
ch. 22, p. 326: *[...] daß man sich einig und allein
an die Natur und keine andere Regeln binden
solle.*
18 Pels 1681, p. 36:
*Als hy een' naakte vrouw, gelyk 't somtyds
gebeurde,
Zou schild'ren tót modél geen Grieksche Venus
keurde;
Maar eer een' waschter, óf turftreedster uit een'
schuur,
Zyn' dwaaling noemende navólging van Natuur,
Al 't ander ydele verziering. Slappe borsten,
Verwrongen' handen, ja de neepen van de worsten
Des ryglyfs in de buik, des kousebands om
't been,
'Moest al gevólgd zyn, óf natuur was niet te vréén.*

19 For example, Bellori 1976, p. 218, asserts that Caravaggio painted *senza decoro*.

20 Characteristic of this is the criticism that Bellori attributes to Caravaggio's contemporaries; see Bellori 1976, pp. 217-218. See also Bellori 1976, p. 203, Scannelli 1657, p. 51, and Baglione 1935, p. 138.

21 Van Mander (1604), fol. 191r; for the text, see note 11 above.

22 Scannelli 1657, p. 51: *[..] verità, forza e rilievo.*

23 Bellori 1976, p. 217: *[...] e particolarmente li giovini concorrevano a lui e celebravano lui solo come unico imitatore della natura.*

24 Baglione 1935, p. 136.

25 As explained in Bell 1993.

26 Bellori 1976, p. 215: *Quella figura [Mary Magdalen] abbiamo descritta particolarmente per indicare li suoi modi naturali e l'imitazione in poche tinte sino alla verità del colore.* Scannelli 1657, p. 51: *[...] il quale mostra animare i colori con artificio più eccellente.* Giustiniani, in Bottari 1768, vol. 6, p. 127, also counted Caravaggio as one of the painters who painted objects in their true colours (*vero colorito*).

27 Bellori 1976, p. 212: *Giovò senza dubbio il Caravaggio alla pittura, venuto in tempo che, non essendo molto in uso il naturale, si fingevano le figure di pratica e di maniera, e sodisfacevasi più al senso della vaghezza che della verità. Laonde costui, togliendo ogni belletto e vanità al colore rinvigorì le tinte e restituí ad esse il sangue e l'incaranzione, ricordando a' pittori l'imitazione.* The word *tinte* means not only 'tone' in Italian, but 'colour'. However, elsewhere in his biography of Caravaggio (for example in the passages quoted in notes 35 and 36 below), Bellori consistently uses it in the sense of 'tone', and that has been adhered to here. The English translation is based on that in Kitson 1985, p. 11.

28 Mancini 1956-1957, vol. 1, p. 223: *Deve molto questa nostra età a Michelangelo da Caravaggio, per il colorir che ha introdotto seguito adesso assai communemente.*

29 Such formulae were already described around 1400 by Cennino Cennini in *Il libro dell'arte*, Florence, Bibliotheca Mediceo-Laurenziana, MS 23. See Thompson 1932-1933 for a transcription and an English translation.

30 On this problem, see, among others, Hall 1992 and Prater 1992.

31 Bell 1993 and Bell 1995.

32 Giustiniani, in Bottari 1822-1825, vol. 6, p. 126: *[...] che dipende dalla pratica di sapere maneggiare i colori, [...] e soprattutto con saper dare il lume conveniente al colore di ciascheduna parte, e che i sudici (i) non sieno crudi, ma farli con dolcezza ed unione; distinte però le parti oscure, e le illuminate, in modo che l`occhio resti sodisfatto dell' unione del chiaro e scuro senza alterazione del proprio colore.*

33 Bellori 1976, p. 212: *Non si trova però che egli usasse cinabri né azzurri nelle sue figure; e se pure*

tal volta li avesse adoperati, li ammorzava, dicendo ch'erano il veleno della tinte.

34 Mancini 1956-1957, vol. 1, p. 108: *Proprio di questa schola è di lumeggiar con lume unito che venghi d'alto senza reflessi, come sarebbe in una stanza da una fenestra con le pariete colorite di negro, che così havendo i chiari e l'ombre molto chiare e molto oscure, vengono a dar rilievo alla pittura, ma però con modo non naturale, nè fatto, nè pensato da altro secolo o pittori più antichi, come Raffaelo, Titiano, Coreggio et altri.*

35 Bellori 1976, p. 216: *Sono questi li primi tratti del pennello di Michele in quella schietta maniera di Giorgione, con oscuri temperati; [...].* On pp. 213, 215 and 217, Bellori states that such works were painted *con poche tinte*, as in the quotation in the following note.

36 Bellori 1976, p. 217: *Ma il Caravaggio [...]. facevasi ogni giorno piú noto per lo colorito ch'egli andava introducendo, non come prima dolce e con poche tinte, ma tutto risentito di oscuri gagliardi, servendosi assai del nero per dar rilievo alli corpi. E sínoltrò egli tanto in questo suo modo di operare, che non faceva mai uscire all'aperto del sole alcuna delle sue figure, ma trovò una maniera di campirle entro l'aria bruna d'una camera rinchiusa, pigliando un lume alto che scendeva a piombo sopra la parte principale del corpo, e lasciando il rimanente in ombra a fine di recar forza con veemenza di chiaro e di oscuro.*

37 Mancini 1956-1957, vol. 1, pp. 108-109.

38 Von Sandrart 1675-1680, vol. 2, bk. 2, ch. 19, p. 189, and Bellori 1976, pp. 204-205.

39 Armenini 1971, p. 81, and Lomazzo 1968. See Benedettti 2003 for a recent article on the influence of nocturnes on Caravaggio.

40 Van Hoogstraeten 1678, p. 259: *[...] alle vuur of kaerslicht wort meest door zijn kantige schaduwe van het dachlicht onderscheiden. De dingen door vuur verlicht, zegt Seneka, zijn anders, als die van een wijder licht omscheenen worden. De kanticheit der schaduwe komt, om dat het licht van een kleine vlamme, even als uit een punt, straelt: en alleenlijk treft op de dingen, die het rechtlijnich kan bereyken, en daer het zelve komt te missen, schampt het kort af, en laet de rest onverlicht: daer de dachlichten, grooter zijnde, dan de byzondere deelen, die zy beschijnen, de zelve eenichzins ook als omschijnen, en door haere grootheit omringen.*

41 Scannelli 1657, p. 199: *[...] molto rilevate, e simile al vivo.*

42 Mancini 1956-1957, vol. 1, p. 109: *[...] e con lume naturale gli dà il colore e l'ombra con le movenze e gratie.* On this, see also Bell 1993, pp. 106-110.

43 Bellori 1976, p. 218: *[...] divolgando ch'egli non sapeva uscir fuori dalle cantine.*

44 Ibid.: *[...] coloriva tutte le sue figure ad un lume e sopra un piano senza degradarle.*

45 Von Sandrart 1675-1680, vol. 2, bk. 3, ch. 22, p. 327: *In seinen Werken ließe unser Künstler wenig Liecht sehen, außer an dem für-*

nehmsten Ort seines Intents, um welches er Liecht und Schatten künstlich beysammen hielte, samt einer wolgemeßenen reflexion, also daß das Liecht in den Schatten mit großem Urtheil wieche, die Colorit ware ganz glüend, und in allem eine hohe Vernunft.

46 Junius 1641.

47 Van Hoogstraeten 1678, p. 305: *En Junius, van wien wy dit gemelde ontleenen, berispt de harde aeneenstooting van licht en bruin, en zegt, dat dergelijke Schilderyen wel schaekberden gelijken. Vorder wil hy, datmen de macht van schaduwen matich gebruike.*

48 Ibid., pp. 305-306: *Daerom beveele ik u niet te veel met lichten en schaduwen door een te haspelen, maer de zelve bequamelijk in groepen te vereenigen; laet uwe sterkste lichten met minder lichten minlijk verzelt zijn, ik verzeeker u, datze te heerlijker zullen uitblinken; laet uwe diepste donkerheden met klaere bruintens omringt zijn, op datze met te meerder gewelt de kracht van het licht mogen doen afsteeken. Rembrandt heeft deeze deugt hoog in top gevoert, en was volleert in 't wel byeenvoegen van bevriende verven.*

49 Ibid., p. 262: *Weerglans is wel eygentlijk een wederomkaetsing van het licht van alle verlichte dingen, maer in de konst noemen wy maer alleen reflectie of weerglans, de tweede verlichting, die in de schaduwe valt.*

50 Ibid., p. 273: *Wonderlijk heeft zich onzen Rembrandt in reflexeeringen gequeeten, jae het scheen of deze verkiezing van 't wederom kaetsen van eenich licht zijn rechte element was.*

51 Ibid.: *[...] had hy hem maer wat beter op de grondregels deezer konst verstaen: want die alleenlijk op zijn oog en gewaende ondervindinge steunt, begaet dikmaels feylen, die den spot van leerjongers, ik zwijge van meesters, verdienen: en zoo veel te meer, daer deeze zekere kennissen, voor die'er zich een weynig aen laet gelegen zijn, zoo gemakkelijk zijn te bekomen.*

52 Ibid., p. 268.

53 Codex Urbinas Latinus 1270, fol. 56: *[...] questa tale consideratione, è messa in hopera da molti, e molti altri sono ch'ela fugono, e questi si ridono l'uno de l'altro.* See McMahon 1956, vol. 1, p. 78 and vol. 2, fol. 56.

54 Van Hoogstraeten 1678, p. 176: *Schoon ik wel gewilt hadde, dat hy 'er meer lichts in ontsteeken had.*

55 Taylor 1998 and Sluijter 2005.

56 *De Mayerne manuscript* (London, British Museum, Sloane 2052); see Berger 1973, p. 289: *[...] reste maintenant a dire quelque chose des visages & nudites qu'a la verité est le plus principal poinct de cest œuvre.*

57 On 'houding' see Taylor 1992.

58 Von Sandrart 1675-1680, vol. 1, bk. 3, ch. 8, p. 85: *Im übrigen ist diß meine gründliche Meinung, wie sehr ihr auch mag widersprochen werden, daß alle harte, helle, starke und hohe Farben insgesamt zu meiden und zu verwerfen seyen, als eine Sache, worinn die ganze Discordanz eines Gemähls bestehet: wann nicht deren hartkrellige Art gebrochen, und gedämpfet, oder mit Vernunft durch andere annehmliche und verträgliche temperirt wird. Dann diese frische ganze*

Farben, wie von Kartenmahlern und Färbern, auch wol von andern, die in unserer Kunst etwas verstehen wollen, gebraucht werden, sind so wenig in einem vernünftigen Gemälde zu dulten, als wenig gesund und angenehm ist, das rohe Fleisch aus der Meßig ungekocht essen. Diesem werden beyfallen alle die Warheit lieben, und erkennen, daß etliche alte Teutsche, als Holbein, Amberger, Lucas von Leyden, Sotte, Cleef und andere, uns mit diesem Liecht wol vorgegangen: welchen die Niederländer, sonderlich zuleßt die Holländer, lehrhaft gefolget, und diese Kunst in den höchsten Grad erhoben, wie man alle Farben mischen, brechen, und von ihrer crudezza reduciren möge, bis daß in den Gemählen alles der Natur ähnlich kommen. In einem großen Altar, oder auf einem andern Blat, das vielerley Farben bedarf, ist zu beobachten die disminuirung: daß man nach und nach, in gerechter Maße, sich verliere, und die Colorit ungehintert, nach der Perspectiv Regeln, von einem Bild zum andern netto folge und ihr Ort bekomme: welches wir auf Niederländisch Hauding nennen. Diß ist eine sehr nötige Observanz, wird aber wenig erkennet. Und hierinn haben wir zu lernen, von unserm verwunderbaren Bambots, auch von andern, insonderheit von dem laboriosen und dißfalls hoch vernünftigen Rembrand: welche, wie in deren Leben zu ersehen, gleichsam Wunder gethan, und die wahre Harmonie, ohn Hinternis einiger, besondern Farbe, nach den Regeln des Liechts, durchgehends wol beobachtet.

59 Letter by Rembrandt, 27 January 1639 (Paris, Fondation Custodia, Frits Lugt Collection, A 179): *My heer hangt dit stuck op een starck licht en dat men daer wijt af ken staen soo salt best voncken.* For a transcription, see Strauss and van der Meulen 1979, p. 167 (document 1639/4).

60 Van de Wetering 1997, p. 175.

61 In Caravaggio's works, the paint is usually slightly rougher in texture in the illuminated passages than in the shaded ones, but that will be due to the fact that the light colours contain relatively large amounts of lead white, a pigment that when suspended in oil yields a paint in which the brushstroke is readily left visible. Caravaggio sometimes added some egg to his white paint for the very brightest lights in order to increase their intensity, as in *The supper at Emmaus* (Cat. no. 38). See Keith 1998.

'Michelangelo of Caravaggio, who does wondrous things in Rome'. On Rembrandt's knowledge of Caravaggio

1 See Langdon 1998, pp. 309-318, for a lively description of the events that led to Caravaggio's flight from Rome. The most complete publication of all the known documents relating to Caravaggio's life and work is Macioce 2003.

2 See Van Mander 1604, fol. 191r. Van Mander's report on Caravaggio is also published in Noë 1954, pp. 293-294, together with a commentary on pp. 152-155 and 295-297. See also Blankert in exhib. cat. Utrecht & Braunschweig 1986, especially pp. 17-18 for van Mander's comments on Caravaggio. An English translation of this article, under the title 'Hendrick ter Brugghen and Dutch Caravaggism', appeared in Blankert 2004, pp. 151-184.

3 For example, Van Mander wrote that Caravaggio and Giuseppe Cesari (also known as the Cavalier d'Arpino, 1568-1640) had made history paintings in S. Lorenzo in Damaso, Caravaggio supposedly included a dwarf in one of them who was sticking his tongue out in the direction of Cesari's work in ridicule. This was evidently based on incorrect information, for Van Mander included this passage in the corrigenda in his later edition of the *Schilder-boeck*.

4 Van Mander 1604, fol. 191r. For the text, see note 11 to the essay 'Light and colour', above.

5 Ibid. Translation based on that in Kitson 1985, p. 10.

6 Ibid.: *[...] een wonder fraey maniere, om de Schilder-jeught nae te volgen.*

7 See Huygens 1987, p. 89: *Zij beweren, dat zij in de bloei hunner jaren, waarmee zij in in de eerste plaats rekening moeten houden, geen tijd overhouden om die in den vreemde met reizen te vermorsen; en verder dat, nu tegenwoordig koningen en vorsten aan deze zijde der Alpen met zulk een gretigheid en voorliefde schilderijen verzamelen, men de beste Italiaansche stukken buiten Italië kan zien en dat wat men daar op allerlei plaatsen met groote moeite moet opsporen, hier opeengehoopt en meer dan genoeg te vinden is.*

8 See Van der Veen 1992, esp. pp. 120-124, for the various aspects of collecting paintings, drawings and prints. A detailed analysis of the development of the Dutch art market will be found in Bok 1994. See Vermeylen 2003 for the situation in the southern Netherlands (Antwerp in particular).

9 Probably the most important such collection was in the house called De Hoop (Hope) at Keizersgracht 209, which had belonged to the brothers Gerard (1599-1658) and Jan Reynst (1601-1646) since 1634. They owned paintings by Jacopo Bassano, Paris Bordone, Domenico Fetti, Giulio Romano, Lorenzo Lotto, Guercino and Titian, among others. They acquired the bulk of their collection in Venice in the 1620s, and many of the paintings came from the famous collection of Andrea Vendramin; see Logan 1979. See Lugt 1936, Van den Berghe 1992, and above all Meijer 2000, for other collections of Italian paintings in the northern and southern Netherlands.

10 For Swanenburg, see exhib. cat. Leiden 1976, pp. 49-50, and especially Ekkart 1998, pp. 126-128.

11 Such nocturnes with seas of flames in the background were popular in 16th-century Netherlandish painting as the settings for mythological or biblical subjects. On this, see the thorough research conducted by Neumeister 2003, especially the chapter 'Die Nächtliche Brandlandschaft als Kunstlichtszene', pp. 43-64.

12 It seems to be Jacob Isaacsz van Swanenburg's fate that his significance as a painter is inextricably bound up with his role as Rembrandt's first teacher. That role is quite often either understated or overstated in the art-historical literature. In the most recent discussion of the problem this is exemplified by Westermann 2000, pp. 28-30, and Van de Wetering 2000, pp. 32-39. See also Golahny 2003, pp. 59-64, for Rembrandt's apprenticeship to Van Swanenburg.

13 E. van de Wetering has stressed in a more general sense the importance of the oral tradition from which the young Rembrandt probably profited in Van Swanenburg's studio; see Van de Wetering 200, p. 39.

14 On Lastman see, for example, Bredius and De Roever 1886. The only monograph on Lastman is still Freise 1911. For his biography see above all Dudok van Heel 1991a. See also exhib. cat. Amsterdam 1991.

15 On this see Dudok van Heel 1991b, esp. pp. 8-10.

16 See Dudok van Heel 1975b.

17 See the Appendix, B. The full text of the document can be found in Bredius and De Roever 1886, pp. 7-8.

18 See the Appendix, C, and Bredius and De Roever 1886, p. 8.

19 On Finson see Bredius 1918, as well as Bodart 1970, and Briels 1997, p. 327.

20 For Vinck, see De Roever 1885, esp. pp. 182-187, and Briels 1997, p. 399.

21 See Prohaska 1980, p. 112, note 11. See also Meijer 2000, p. 377 and note 10. Vinck is called *amicissimo di Caravaggio* in a letter of 22 July 1673 from the painter and art dealer Giacomo de Castro to Don Antonio Ruffo in Messina.

22 See the Appendix, A; published in Bredius 1918, pp. 198-199; see also Bodart 1970, pp. 228-229.

23 On this see Prohaska 1980.

24 It is in the Museo Pignatelli. Some authors believe it is by Louis Finson himself, see F. Bologna in exhib. cat. Naples & London 2004, no. 26 (ill.), and Spike 2001, no. 89 (with a listing of the earlier literature on the painting).

25 See Tzeutschler Lurie and Mahon 1977. See also Spike 2001, no. 55 (with the earlier literature on the work).

26 For the copies, see Tzeutschler Lurie and Mahon 1977, figs. 2-4, and Spike 2001, nos. 55, C1-4.

27 See the Appendix, D; published in Bredius and De Roever 1886, p. 9.

28 See M. Gregori in exhib. cat. New York & Naples 1985, pp. 313-315, no. 89 for a discussion about which of the many surviving versions of Mary Magdalen in ecstasy may be the original. See also Bodart 1966, and Moir 1976, nos. 69a-69u. The most detailed discussion of the various versions is Pacelli 1994, esp. pp. 161-197.

29 One version (canvas, 126 x 100 cm; signed at lower right: *LUDOVICUS FINSONIUS FECI...*) is in Marseille, Musée des Beaux-Arts, inv. no. 90, on which see Bodart 1970, pp. 94-97, Slatkes in exhib. cat. Utrecht & Braunschweig 1986, p. 258, no. 55 (ill.), and Pacelli 1994, p. 164 and fig. 72. For the version dated 1613 (canvas, 112 x 86.5 cm) in Saint-Rémy-de-Provence, see Bodart 1970, p. 96 and fig. 11, and Pacelli 1994, p. 169 and fig. 73.

30 Canvas, 110 x 87 cm. Signed on the letter: *Imitando Michaelem/ Angelum Carrav..../ Mediolan./ Wymbrandus de Geest/ Friesus/ A. 1620.* See Pacelli 1994, p. 166 and fig. 74, pp. 169-170 and fig. 75 (detail of the signature), and recently A. Brejon de Lavergnée in exhib. cat. Naples & London 2004, pp. 164-165, no. 25b, with colour illustration.

31 Slatkes thought that De Geest made the painting only after his return to Friesland; see exhib. cat. Utrecht & Braunschweig 1986, pp. 258-259. However, the use of the word 'Friesus' in the signature (see note 30) makes this unlikely, for such a reference to his origins would have been superfluous in his home town, and no such designation is found on any of the paintings he made in Friesland.

32 See note 30.

33 On Van der Wolf as a collector see Delahay and Schadee 1994, esp. pp. 34-35, and Meijer 2000, pp. 390-392.

34 See Biesboer 2001, p. 302, 1.

35 See Blankert 1993. An English translation of this article is in Blankert 2004, pp. 261-266.

36 Walsh 1995.

37 Bruyn 1970, esp. p. 39.

38 For the copies after works by Caravaggio, see Moir 1972 and Moir 1976. Moir 1972, p. 123, mentions 33 or 34 drawn copies, including those known only from written reports.

39 On this, see Moir 1972, p. 124.

40 Moir 1976, p. 91, nos. 20 and 21.

41 Ibid., p. 92, nos. 23 and 24.

42 See Van Gelder 1946. For the drawn copies by Italian artists, see Moir 1976, pp. 92-93, nos. 24a-b and 24d-g.

43 For the many copies, see Moir 1976, pp. 88-89, nos. 18a-18z. See also the Appendix, P.

44 His reduced copy is in the National Gallery of Canada (inv. no. 6431), on which see Judson 2000, pp. 243-245, no. 75 and fig. 223.

45 See Moir 1976, p. 100, no. 37. M. Gregori in exhib. cat. London 1982, p. 127, mentions a partial copy of just the Madonna and Child which was probably made by Luca Giordano (Rome, art market).

46 See Hollstein, vol. 43, p. 53, no. 47 II, for Vorsterman's engraving. Vorsterman also made an engraving after Caravaggio's *Madonna di Loreto* (fig. 1); see ibid., p. 52, no. 46 (ill.). Since Caravaggio's painting has never left Rome and Vorsterman evidently never visited the city, Moir 1976, nos. 29a, 29r, and note 211, suspects that he modelled his engraving on a copy that he could have seen in Charles I's collection during his sojourn in England from 1624 to 1630.

47 On Fatoure and questions regarding his origins see M. Préaud in Saur, vol. 37, p. 194.

48 Moir 1976, p. 24.

49 This has already been called into question in Judson 1986, p. 57.

50 On Manfredi, see Hartje 2004 (with earlier literature).

51 Von Sandrart 1925, p. 277: *[...] sehr fleissig nachgefolgt und angenommen [...], so dass wenig Unterschied erschienen.*

52 See Bikker 2004.

53 According to Białostocki 1988, p. 9: *[...] tiefen Verschiedenheit, die zwischen den Werken des Altmeisters der Helldunkelmalerei, Caravaggio, und den meisten seiner niederländischen Nachfolger bestand.*

54 Quoted in Braun 1966, p. 347. My thanks to J. van der Veen for bringing this letter to my attention. It was also recently cited in Prohaska 2003, p. 60.

55 See the monograph Judson and Ekkart 1999 for Honthorst's life and work. A detailed discussion and analysis of his nocturnes with artificial lighting will be found in Müller Hofstede 1988. On this, see also Neumeister 2003, pp. 146-199.

56 See *Corpus*, vol. 1, (A 10), pp. 137-142, for the Rembrandt in Berlin, and more recently B. van den Boogert in exhib. cat. Kassel & Amsterdam 2001, p. 210, no. 29. For Honthorst's *Musical group by candlelight* of 1623 in Copenhagen, see Judson & Ekkart 1999, p. 225, no. 288, and pls. XXII and 173, and exhib. cat. San Francisco etc. 1997, pp. 236-238, no. 35, with colour illustration.

57 See *Corpus*, vol. 1, pp. 446-460, C2.

58 Van Hoogstraeten 1678, p. 75: *[...] of in 't geheel der konst, of in eenich deel, niet iets byzonders als eygen gehad heeft? [...] natuerlijkheyt, [...] lijdingen des gemoeds.*

Bibliography

Algarotti 1762
F. Algarotti, *Saggio sopra la pittura*, Bologna 1762

Armenini 1971
G.B. Armenini, *De' veri precetti della pittura*, Hildesheim & New York 1971 (facsimile reprint of ed. princ. Ravenna 1587)

Askew 1990
P. Askew, *Caravaggio's Death of the Virgin*, Princeton 1990

Baglione 1935
G. Baglione, *Le vite de' pittori, scultori, et architetti*, ed. V. Mariani, Rome 1935 (facsimile reprint of ed. princ Rome 1642)

Bauch 1966
K. Bauch, *Rembrandt: Gemälde*, Berlin 1966

Bell 1993
J.C. Bell, 'Some seventeenth-century appraisals of Caravaggio's coloring', *Artibus et Historiae* 14, no. 27 (1993), pp. 103-129

Bell 1995
J.C. Bell, 'Light and color in Caravaggio's *Supper at Emmaus*', *Artibus et Historiae* 16, no. 31 (1995), pp. 139-170

Bellori 1976
G.P. Bellori, *Le vite de' pittori, scultori e architetti moderni*, ed. E. Borea, Turin 1976 (ed. princ. Rome 1672)

Benedetti 1993
S. Benedetti, 'Caravaggio's "Taking of Christ", a masterpiece rediscovered', *The Burlington Magazine* 135 (1993), pp. 731-747

Benedetti 2003
S. Benedetti, 'Darkness and light', in exhib. cat. Sydney & Melbourne 2003, pp. 28-32

Berger 1973
E. Berger (ed.), *Quellen für Maltechnik während der Renaissance und deren Folgezeit, (XVL.-XVI-II. Jahrhundert) in Italien, Spanien, den Niederlanden, Deutschland, Frankreich und England nebst dem De Mayerne Manuskript*, Walluf bei Wiesbaden 1973 (reprint of ed. princ. Munich 1901)

Van den Berghe 1992
E.H. van den Berghe, 'Italiaanse schilderijen in Amsterdam in de zeventiende eeuw', *Jaarboek Amstelodamum* 84 (1992), pp. 21-40

Białostocki 1988
J. Białostocki, 'Der schwarze und der farbige Raum: Caravaggio und die Niederländer', in Klessmann 1988, pp. 9-12

De Bie 1661
C. de Bie, *Het gulden cabinet van de edel vrij schilder const, inhoudende den lof van de vermarste schilders, architecte, beldthouwers ende plaetsnijders van deze eeuw*, Antwerp 1661

Biesboer 2001
P. Biesboer, *Collections of paintings in Haarlem 1572-1745*, ed. C. Togneri (*Documents for the history of collecting; Netherlandish inventories, 1*), Los Angeles 2001

Bikker 2004
J. Bikker, 'Balthasar Coymans's Italian paintings and Annibale Carracci's Melancholy', in V. Manuth and A. Rüger (eds.), *Collected opinions. Essays on Netherlandish art in honour of Alfred Bader*, London 2004, pp. 27-33

Bikker 2004-2005
J. Bikker, 'Lucian's *Prometheus* as a source for Jordaens and Van Baburen', *Simiolus* 31 (2004-05), pp. 46-53

Bille 1961
C. Bille, *De tempel der kunst of het kabinet van den heer Bramcamp*, 2 vols., Amsterdam 1961

Blankert 1993
A. Blankert, 'Lastman kijkt naar Caravaggio en inspireert Rembrandt en Van Loo', *Oud Holland* 107 (1993), pp. 117-122

Blankert 2004
A. Blankert, *Selected writings. On Dutch painting*, Zwolle 2004

Bleyerveld 2000
Y. Bleyerveld, *Hoe bedriechlijck dat die vrouwen zijn: vrouwenlisten in de beeldende kunst in de Nederlanden circa 1350-1650*, Leiden 2000

Bodart 1966
D. Bodart, 'Intorno al Caravaggio: la Maddalena del 1606', *Palatino* 10 (1966), pp. 118-126

Bodart 1970
D. Bodart, *Louis Finson (Bruges avant 1580-Amsterdam 1617)*, Brussels 1970

Bok 1990
M.J. Bok, 'Kunstbezit in de Amsterdamse familie Van Ceulen: op zoek naar twee schilderijen van Rembrandt', *Jaarboek van het Centraal Bureau voor genealogie en het Iconografisch Bureau*, 44 (1990), pp. 149-166

Bok 1994
M.J. Bok, *Vraag en aanbod op de Nederlandse kunstmarkt, 1580-1700*, Utrecht 1994

Boomgaard 1995
J. Boomgaard, *De verloren zoon: Rembrandt en de Nederlandse kunstgeschiedenisschrijving*, Amsterdam 1995

Boonen 1991
J. Boonen, 'Verhalen van Israëls ballingschap en vrijheidsstrijd', in C. Tümpel (ed.), exhib. cat., *Het Oude Testament in de schilderkunst van de Gouden Eeuw*, Amsterdam (Joods Historisch Museum) & Zwolle 1991, pp. 106-121

Bottari 1822-1825
G. Bottari (ed.), *Raccolta di lettere sulla pittura, scultura ed architettura*, 8 vols., Milan 1822-1825, vol. 6, pp. 121-129 (ed. princ. Rome 1757-1773)

Braun 1966
H. Braun, *Gerard und Willem van Honthorst* (diss.), Göttingen 1966

Bredius 1893
A. Bredius, 'De portretten van Joris de Caullery', *Oud Holland* 11 (1893), pp. 127-128

Bredius 1915-1922
A. Bredius, *Künstler-Inventare. Urkunden zur Geschichte der Holländischen Kunst des XVIten, XVIIten und XVIIIten Jahrhunderts (Quellenstudien zur holländischen Kunstgeschichte)*, 8 vols., The Hague 1915-1922

Bredius 1918
A. Bredius, 'Iets over de schilders Louys, David en Pieter Finson', *Oud Holland* 36 (1918), pp. 197-204

Bredius and De Roever 1886
A. Bredius and N. de Roever, 'Pieter Lastman en Francois Venant', *Oud Holland* 4 (1886), pp. 1-13

Bredius/Gerson
A. Bredius, revised by H. Gerson, *Rembrandt: the complete edition of the paintings*, London 1969

Briels 1997
J. Briels, *Vlaamse schilders en de dageraad van Hollands Gouden Eeuw 1585-1630*, Antwerp 1997

Bruyn 1970
J. Bruyn, 'Rembrandt and the Italian Baroque', *Simiolus* 4 (1970), pp. 28-48

Bruyn 1983
J. Bruyn, 'On Rembrandt's use of studio-props and model drawings during the 1630s', in A.M. Logan (ed.), *Essays in northern European art presented to Egbert Haverkamp-Begemann on his sixtieth birthday*, Doornspijk 1983, pp. 52–60

Calvesi 1971
M. Calvesi, 'Caravaggio o la ricerca della salvazione', *Storia dell'Arte* 9/10 (1971), pp. 93-141

Cat. Berlin 1975
Katalog der Gemäldegalerie der staatlichen Museen Preussischer Kulturbesitz: Katalog der ausgestelten Gemälde des 13.-18. Jahrhunderts, Berlin 1975 (unpaginated)

Christiansen 1986
K. Christiansen, 'Caravaggio and "L'esempio davanti del naturale"', *The Art Bulletin* 68 (1986), no. 1, pp. 421-445

Christiansen 1999
K. Christiansen, 'Caravaggio's "Holy family" with the infant Saint John the Baptist', *Paragone* 593 (1999), pp. 3-11

Clark 1966
K. Clark, *Rembrandt and the Italian Renaissance*, London 1966

Contini 1992
R. Contini, *Il Cigoli*, Soncino 1992

Corpus
J. Bruyn *et al.*, *A corpus of Rembrandt paintings*, in progress, The Hague etc. 1982-

Cummings 1974
F. Cummings *et al.*, 'Detroit's "Conversion of the Magdalen"', *The Burlington Magazine* 116 (1974), pp. 563-593

Danesi Squarzina 2003
S. Danesi Squarzina, *La collezione Giustiniani: inventari*, 2 vols., Turin & Milan 2003

Dekiert 2003
M. Dekiert, *Musikanten in der Malerei der niederländischen Caravaggio-Nachfolge*, Münster 2003

Delahay and Schadee 1994
S. Delahay and N. Schadee, 'Verzamelaars en handelaars in Rotterdam', in N. Schadee (ed.), exhib. cat. *Rotterdamse meesters uit de Gouden Eeuw*, Rotterdam (Het Schielandshuis) & Zwolle 1994, pp. 31-41

Del Bravo 1983
C. del Bravo, 'Sul significato della luce nel Caravaggio e in Gianlorenzo Bernini', *Artibus et Historiae* 4, no. 7 (1983), pp. 69-77

Dudok van Heel 1975a
S.A.C. Dudok van Heel, 'Honderdvijftig advertenties van kunstverkopingen uit veertig jaargangen van de Amsterdamsche Courant 1672-1711', *Jaarboek Amstelodamum* 67 (1975), pp. 149-173

Dudok van Heel 1975b
S.A.C. Dudok van Heel, 'Waar woonde en werkte Pieter Lastman (1583-1633)?', *Maandblad Amstelodamum* 62 (1975), pp. 31-36

Dudok van Heel 1977
S.A.C. Dudok van Heel, 'Ruim honderd advertenties van kunstverkopingen uit de Amsterdamsche Courant 1712-1725', *Jaarboek Amstelodamum* 69 (1977), pp. 107-122

Dudok van Heel 1991a
S.A.C. Dudok van Heel, 'De familie van de schilder Pieter Lastman (1583-1633). Een vermaard leermeester van Rembrandt van Rijn', *Jaarboek van het Centraal Bureau voor Genealogie en het Iconografisch Bureau* 45 (1991), pp. 111-132

Dudok van Heel 1991b
S.A.C. Dudok van Heel, 'Pieter Lastman (1583-1633). Een schilder in de Sint Anthonisbreestraat', *Kroniek van het Rembrandthuis*, 1991, no. 2, pp. 2-15

Dudok van Heel 2004
S.A.C. Dudok van Heel, 'Rembrandt van Rijn – Eine ungewöhnliche Biographie eines grossen Malers', in exhib. cat. Vienna 2004, pp. 15-25

Duverger 2004
E. Duverger, *Documents concernant le commerce d'art de Francisco-Jacomo van den Berghe et Gillis van der Vennen de Gand avec la Hollande et la France pendant les premières décades du XVIIIe siècle*, Wetteren 2004

Ekkart 1998
R.E.O. Ekkart, *Isaac Claesz. Van Swanenburg 1537-1614. Leids schilder en burgemeester*, Zwolle 1998

Ellis 1900
F.S. Ellis (ed.), *The golden legend or lives of the saints. Compiled by Jacobus de Voragine, Archbishop of Genoa, 1275, Englished by William Caxton*, 7 vols., London 1900

Emmens 1979
J.A. Emmens, *Rembrandt en de regels van de kunst*, Amsterdam 1979

Exhib. cat. Amsterdam 1991
A. Tümpel and P. Schatborn (eds.), exhib. cat. *Pieter Lastman. Leermeester van Rembrandt – The man who taught Rembrandt*, Amsterdam (Het Rembrandthuis) & Zwolle 1991

Exhib. cat. Amsterdam 1999
B. van den Boogert (ed.), exhib. cat. *Rembrandts schatkamer*, Amsterdam (Museum Het Rembrandthuis) & Zwolle 1999

Exhib. cat. Bergamo 2000
J.-R. Armogathe *et al.*, exhib. cat. *La luce del vero, Caravaggio, La Tour, Rembrandt, Zurbarán*, Bergamo (Galleria d'Arte Moderna e Contemporanea) & Cinisello Balsamo 2000

Exhib. cat. Berlin, Amsterdam & London 1991
C. Brown, J. Kelch and P. van Thiel, exhib. cat. *Rembrandt: the master and his workshop*, 2 vols., Berlin (Altes Museum), Amsterdam (Rijksmuseum), London (National Gallery), New Haven & London 1991

Exhib. cat. Boston 2000
A. Chong (ed.), exhib. cat. *Rembrandt creates Rembrandt. Art and ambition in Leiden, 1629-1631*, Boston (Isabella Stewart Gardner Museum) & Zwolle 2000

Exhib. cat. Boston & Chicago 2003
C.S. Ackley *et al.*, exhib. cat. *Rembrandt's journey: painter, draftsman, etcher*, Boston (Museum of Fine Arts) & Chicago (The Art Institute) 2003

Exhib. cat. Braunschweig 1993
U. Berger *et al.*, exhib. cat. *Bilder vom alten Menschen in der niederländischen und deutschen Kunst 1550-1750*, Braunschweig (Herzog-Anton-Ulrich-Museum) 1993

Exhib. cat. Edinburgh & London 2001
J. Lloyd Williams (ed.), *Rembrandt's women*, Edinburgh (National Gallery of Scotland) & London (Royal Academy of Arts) 2001

Exhib. cat. Kassel & Amsterdam 2001
B. Schnackenburg and E. van de Wetering (eds.), *The mystery of the young Rembrandt*, Kassel (Staatliche Museen Kassel, Gemäldegalerie Alte Meister, Schloss Wilhelmshöhe) & Amsterdam (Museum het Rembrandthuis) 2001

Exhib. cat. Leiden 1976
R.E.O. Ekkart and M.L. Wurfbain, exhib. cat. *Geschildert tot Leyden anno 1626*, Leiden (Stedelijk Museum de Lakenhal) 1976

Exhib. cat. London 1982
C. Whitfield and J. Martineau (eds.), exhib. cat. *Painting in Naples 1606-1705. From Caravaggio to Giordano*, London (Royal Academy of Arts) 1982

Exhib. cat. London & The Hague 1999
C. White and Q. Buvelot (eds.), exhib. cat. *Rembrandt by himself*, London (National Gallery) & The Hague (Mauritshuis) 1999

Exhib. cat. Melbourne & Canberra 1997
A. Blankert *et al.*, exhib. cat. *Rembrandt: a genius and his impact*, Melbourne (National Gallery of Victoria) & Canberra (National Gallery of Australia) 1997

Exhib. cat. Naples & London 2004
N. Spinosa (ed.), exhib. cat. *Caravaggio. The final years*, Naples (Museo di Capodimonte) & London (National Gallery) 2004

Exhib. cat. New York 1995
H. von Sonnenburg, exhib. cat. *Rembrandt/not Rembrandt in the Metropolitan Museum of Art*, 2 vols., New York 1995

Exhib. cat. New York & Naples 1985
M. Gregori, *The age of Caravaggio*, New York (The Metropolitan Museum of Art) & Naples (Museo e Gallerie Nazionali di Capodimonte) 1985

Exhib. cat. Rome & Berlin 2001
S. Danesi Squarzina (ed.), exhib. cat. *Caravaggio e i Giustiniani: toccar con mano una collezione del Seicento*, Rome (Palazzo Giustiniani), Berlin (Altes Museum) & Milan 2001

Exhib. cat. Rome etc. 2004
P. Boccardo *et al.*, exhib. cat. *L'ultimo Caravaggio. Il martirio di Sant'Orsola restaurato: collezione Banca Intesa*, Rome (Galleria Borghese) Milan (Pinacoteca Ambrosiana) & Vicenza (Galleria di Palazzo Leoni Montanari) 2004

Exhib. cat. San Francisco etc. 1997
J.A. Spicer and L. Federle Orr (eds.), *Masters of light. Dutch painters in Utrecht during the Golden Age*, San Francisco (California Palace of the Legion of Honor), Baltimore (The Walters Art Gallery) & London (The National Gallery) 1997

Exhib. cat. Sydney & Melbourne 2003
J. Blunden (ed.), exhib. cat. *Darkness and light. Caravaggio & his world*, Sydney (Art Gallery of New South Wales) & Melbourne (National Gallery of Victoria) 2003

Exhib. cat. Utrecht & Braunschweig 1986
A. Blankert and L.J. Slatkes (eds.), exhib. cat. *Nieuw licht op de Gouden Eeuw. Hendrik ter Brugghen en tijdgenoten – Holländische Malerei in neuem Licht. Hendrik ter Brugghen und seine Zeitgenossen*, Utrecht (Centraal Museum) & Braunschweig (Herzog Anton Ulrich-Museum) 1986

Exhib. cat. Vienna 2004
K.A. Schröder and M. Bisanz-Prakken (eds.), *Rembrandt*, Vienna (Albertina) 2004

Exhib. cat. Washington & Los Angeles 2005
A.K. Wheelock *et al.*, exhib. cat. *Rembrandt's late religious portraits*, Washington (National Gallery of Art) & Los Angeles (J. Paul Getty Museum) 2005

Félibien 1973
André Felibien, *Conférences de l'Academie royale de peinture et de sculpture, pendant l'année 1667*, Geneva 1973 (ed. princ. Paris 1668)

Freise 1911
K. Freise, *Pieter Lastman. Sein Leben und seine Kunst*, Leipzig 1911

Friedländer 1955
W. Friedländer, *Caravaggio studies*, Princeton 1955

Gash 1997
J. Gash, 'The identity of Caravaggio's "Knight of Malta"', *The Burlington Magazine* 139 (1997), pp. 156-160

Van Gelder 1946
J.G. van Gelder, 'Honthorstiana', *Kunsthistorische Mededeelingen* 1 (1946), pp. 57-58

Van Gelder 1951
J.G. van Gelder, 'Rubens in Holland in de zeventiende eeuw', *Nederlands Kunsthistorisch Jaarboek* 3 (1951), pp. 103-150

Van Gelder 1974
J.G. van Gelder, 'Het kabinet van de heer Jaques Meyers', *Rotterdams Jaarboekje* 1974, pp. 167-183

Gilbert 1995
C. Gilbert, *Caravaggio and his two cardinals*, University Park 1995

Giltaij 1996
J. Giltaij, *Ruffo en Rembrandt: over een Siciliaanse verzamelaar in de zeventiende eeuw die drie schilderijen bij Rembrandt bestelde*, Rotterdam 1996

Golahny 2003
A. Golahny, *Rembrandt's reading. The artist's bookshelf of ancient poetry and history*, Amsterdam 2003

Gordenker 1995
E. Gordenker, '"En rafelkraagen, die hy schilderachtig vond": was Rembrandt een voddenraper?', in H.M.A. Breukink-Peeze *et al.* (eds.), *Kostuumverzamelingen in beweging: twaalf studies over kostuumverzamelingen in Nederland & inventarisatie van het kostuumbezit in Nederlandse openbare collecties*, Zwolle 1995, pp. 21-32

Gregori 1992
M. Gregori (ed.), *Michelangelo Merisi da Caravaggio, Come nascono i Capolavori* Milan 1992

Hall 1992
M.B. Hall, *Color and meaning. Practice and theory in Renaissance painting*, Cambridge 1992

Hartje 2004
N. Hartje, *Bartolomeo Manfredi (1582-1622). Ein Nachfolger Caravaggios und seine europäische Wirkung*, Weimar 2004

Haussherr 1976
R. Haussherr, *Rembrandts Jacobssegen: Überlegungen zur Deutung des Gemaldes in der Kasseler Galerie*, Kassel 1976

Hecht 1997
C. Hecht, *Katholische Bilder: Theologie im Zeitalter von Gegenreformation und Barock*, Berlin 1997

Hedquist 1994
V.L. Hedquist, 'Rembrandt and the Franciscan Order of Amsterdam', *Dutch Crossing: a Journal of Low Countries Studies* 18 (1994), no. 1, pp. 20-49

Held 1969
J. Held, *Rembrandt's 'Aristotle' and other Rembrandt studies*, Princeton 1969

Hermens 1998
E. Hermens (ed.), *Looking through paintings: the study of painting techniques and materials in support of art historical research (Leids Kunsthistorisch Jaarboek 11)*, Baarn & London 1998

Herrmann Fiore 1995
K. Herrmann Fiore, 'Caravaggio's "Taking of Christ", and Dürer's woodcut of 1509', *The Burlington Magazine* 137 (1995), pp. 24-27

Hibbard 1983
H. Hibbard, *Caravaggio*, London 1983

Hoet 1752
G. Hoet, *Catalogus of naamlyst van schilderyen, met derzelver pryzen*, 2 vols., The Hague 1752

Hofstede de Groot 1907-1928
C. Hofstede de Groot, *Beschreibendes und kritiches Verzeichnis der Werke der hervorrägendsten holländischen Maler des XVII. Jahrhunderts*, 10 vols., Esslingen & Paris 1907-1928

Hollstein
F.W.H. Hollstein, *Dutch & Flemish etchings, engravings and woodcuts, ca. 1450-1700*, in progress, Amsterdam 1949-

Van Hoogstraeten 1678
Samuel van Hoogstraeten, *Inleyding tot de hooge schoole der schilderkonst*, Rotterdam 1678

Houbraken 1718-1721
A. Houbraken, *De groote schouburgh der Nederlantsche konstschilders en schilderessen*, 3 vols., Amsterdam 1718-21

Huygens 1987
Constantijn Huygens, *Mijn jeugd*, trans. C.L. Heesakkers, Amsterdam 1987

Janssen 2005
A. Janssen, *Verbeelding van ouderdom in de prentkunst uit de Nederlanden, circa 1550-1650* (diss. Vrije Universiteit), Amsterdam 2005

Judson 1986
J.R. Judson, 'Utrecht, Rom, Leiden', in exhib. cat. Utrecht & Braunschweig 1986, pp. 53-62

Judson 2000
J.R. Judson, *Rubens. The Passion of Christ (Corpus Rubenianum Ludwig Burchard, 4)*, Turnhout 2000

Judson and Ekkart 1999
J.R. Judson and R.E.O. Ekkart, *Gerrit van Honthorst 1592-1656*, Doornspijk 1999

Junius 1641
F. Junius, *De schilder-konst der oude: begrepen in drie boecken*, Middelburg 1641

Keith 1998
L. Keith, 'Three paintings by Caravaggio', *National Gallery Technical Bulletin* 19 (1998), pp. 37-51

Kerler 1968
D.H. Kerler, *Die Patronate der Heiligen*, Hildesheim 1968

Kitson 1985
M. Kitson, *The complete paintings of Caravaggio*, Harmondsworth 1985

Klessmann 1988
R. Klessmann (ed.), *Hendrik ter Brugghen und die Nachfolger Caravaggios in Holland, Beiträge eines Symposiums aus Anlass der Ausstellung Holländische Malerei in Neuem Licht, Hendrik ter Brugghen und seine Zeitgenossen im Herzog Anton Ulrich-Museum, Braunschweig 23. bis 25. März 1987*, Braunschweig 1988

Kloek and Jansen 1993
W. Kloek and G. Jansen, *Rembrandt in nieuw licht: presentatie van zeven gerestaureerde schilderijen van Rembrandt* (RMA vouwblad 7), Amsterdam 1993

Langdon 1998
H. Langdon, *Caravaggio: a life*, London 1998

Lanzi 1782
L. Lanzi, *La Real Galleria di Firenze*, Florence 1782

Lenz 1985
C. Lenz, 'Rembrandts Auseinandersetzung mit Rubens *Die Blendung Simsons*', in F. Büttner and C. Lenz (eds.), *Intuition und Darstellung. Erich Hubala zum 24. März 1985*, Munich 1985, pp. 137-159

Logan 1979
A.-M.S. Logan, *The 'cabinet' of the brothers Gerard and Jan Reynst*, Amsterdam, Oxford & New York 1979

Lomazzo 1968
G.P. Lomazzo, *Trattato dell'arte de la pittura*, Hildesheim 1968 (facsimile reprint of ed. princ. Milan 1584)

Longhi 1999-2000
R. Longhi, *Studi caravaggeschi*, 2 vols., Florence 1999-2000

Lugt 1936
F. Lugt, 'Italiaansche kunstwerken in Nederlandsche verzamelingen van vroeger tijden', *Oud Holland* 53 (1936), pp. 97-135

Lugt
F. Lugt, *Répertoire des catalogues de ventes publiques intéressant l'art ou la curiosité*, vol. 1, The Hague 1938

Lunsingh Scheurleer 1969
T.H. Lunsingh Scheurleer, 'De woonvertrekken in Amalia's Huis in het Bosch', *Oud Holland* 84 (1969), pp. 29-66

Macioce 2003
S. Macioce, *Michelangelo Merisi da Caravaggio. Fonti e documenti 1532-1724*, Rome 2003

Mancini 1956-1957
G. Mancini, *Alcune considerazioni appartenenti alla pittura come di diletto di un gentilhuomo nobile e come introduttione a quello si deve dire*, 1619-21, in A. Marucchi and L. Salerno (eds.), *Considerazioni sulla pittura*, 2 vols., Rome 1956-1957, pp. 5-148

Van Mander 1604
K. van Mander, *Het schilder-boeck*, Haarlem 1604

Manuth 1990
V. Manuth, 'Die Augens des Sünders; Überlegungen zu Rembrandts *Blendung Simsons* von 1636 in Frankfurt', *Artibus et Historiae* 11, no. 21 (1990), pp. 169-198

Manuth 2005
V. Manuth, 'Rembrandt's apostles. Pillars of faith and witnesses of the Word', in exhib. cat. Washington & Los Angeles 2005, pp. 39-55

Manuth and De Winkel n.d.
V. Manuth and M. de Winkel, *Rembrandt's Minerva in her study of 1635. The splendor and wisdom of a goddess*, New York n.d.

Marini 1987
M. Marini, *Caravaggio Michelangelo Merisi da Caravaggio 'pictor preastantissimus'*, Rome 1987

Massing 1990
J.M. Massing, *Du texte à l'image: la Calomnie d'Apelle et son iconographie*, Strasbourg 1990

McMahon 1956
A. McMahon, *Treatise on painting (Codex Urbinas Latinus 1270), by Leonardo da Vinci*, 2 vols., Princeton 1956

Meijer 2000
B.W. Meijer, 'Italian paintings in 17th century Holland. Art market, art works and art collections', in F. Fehrenbach (ed.), *L'Europa e l'arte italiana, a cura di M. Seidel. Per I cento anni dalla fondazione del Kunsthistorisches Institut in Florenz* (Convegno internazionale Firenze, 22-27 settembre 1997), Venice 2000, pp. 376-417

Merke 1971
F. Merke, *Geschichte und Ikonographie des endemischen Kropfes und Kretinismus*, Bern 1971

Miedema 1973
H. Miedema, *Karel van Mander, Den grondt der edel vry schilder-const*, 2 vols., Utrecht 1973

Moir 1972
A. Moir, 'Drawings after Caravaggio', *Art Quarterly* 35 (1972), pp. 121-142

Moir 1976
A. Moir, *Caravaggio and his copyists*, New York 1976

Molhuysen and Blok 1911-1937
P.C. Molhuysen and P.J. Blok (eds.), *Nieuw Nederlandsch biografisch woordenboek*, 1911-1937 vol. 2, cols. 1469-1472

Müller Hofstede 1988
J. Müller Hofstede, 'Artificial light in Honthorst and Terbrugghen: form and iconography', in Klessmann 1988, pp. 13-43

Neumeister 2003
M. Neumeister, *Das Nachtstück mit Kunstlicht in der niederländischen Malerei und Graphik des 16. und 17. Jahrhunderts. Ikonographische und koloristische Aspekte*, Petersberg 2003

Nicolson 1956
B. Nicolson, 'The Rijksmuseum *Incredulity* and Terbrugghen's chronology', *The Burlington Magazine* 98 (1956), pp. 103-111

Nicolson 1979
B. Nicolson, *Caravaggism in Europe*, Oxford 1979

Noë 1954
H. Noë, *Carel van Mander en Italië. Beschouwingen en notities naar aanleiding van zijn 'Leven der dees-tijtsche doorluchtighe Italiaensche schilders'*, The Hague 1954

Nordenfalk 1982
C. Nordenfalk, *The Batavians' oath of allegiance: Rembrandt's only monumental painting*, Stockholm 1982

Pacelli 1994
V. Pacelli, *L'ultimo Caravaggio, dalla Maddalena a mezza figura ai due san Giovanni (1606-1610)*, Todi 1994

Pels 1681
A. Pels, *Gebruik, én misbruik des tooneels*, Amsterdam 1681

Perry Chapman 1990
H. Perry Chapman, *Rembrandt's self-portraits: a study in seventeenth-century identity*, Princeton 1990

Posèq 1990
A. Posèq, 'Caravaggio and the antique', *Artibus et Historiae* 11, no. 21 (1990), pp. 147-167

Prater 1992
A. Prater, *Licht und Farbe bei Caravaggio. Studien zur Ästhetik und Ikonologie des Helldunkels*, Stuttgart 1992

Prohaska 1980
W. Prohaska, 'Untersuchungen zur Rosenkranzmadonna Caravaggios', *Jahrbuch der Kunsthistorischen Sammlungen Wien* 76 (1980), pp. 111-132

Prohaska 2003
W. Prohaska, 'The spread of Caravaggio's influence. His influence in the North', in exhib. cat. Sydney & Melbourne 2003, pp. 59-65

205

Reznicek 1993
E.K.J. Reznicek, 'Drawings by Hendrick
Goltzius, thirty years later. Supplement to the
1961 *catalogue raisonné*', *Master Drawings* 31
(1993), pp. 215-278

Roethlisberger 1993
M.G. Roethlisberger, *Abraham Bloemaert and
his sons: paintings and prints*, Doornspijk 1993

De Roever 1885
N. de Roever, 'Drie Amsterdamsche schilders:
Pieter Isaaksz., Abraham Vinck, Cornelis van
der Voort', *Oud Holland* 3 (1885), pp. 171-208

Rzepínska 1986
M. Rzepínska, 'Tenebrism in Baroque paint-
ing and its ideological background', *Artibus et
Historiae* 7, no. 13 (1986), pp. 91-112

Von Sandrart 1675-1680
J. von Sandrart, *L'Academia Todesca della architec-
tura, scultura et pittura, oder teutsche Academie der
edlen Bau-, Bild- und Mahlerey Künste*, 3 vols.,
Nuremberg 1675-1680

Von Sandrart 1925
Joachim von Sandrart, *Academie der Bau-, Bild-
und Mahlerey-Künste von 1675*, ed. A.R. Peltzer,
Munich 1925

Saur
Saur, *Allgemeines Künstler-Lexikon*, in progress,
Munich & Leipzig 1983-

Savelsberg 1992
W.H. Savelsberg, *Die Darstellung des hl.
Franziskus von Assisi in der flämischen Malerei
und Graphik des späten 16. und des 17. Jahr-
hunderts*, Rome 1992

Scallen 2004
C.B. Scallen, *Rembrandt, reputation and the
practice of connoisseurship*, Amsterdam 2004

Scannelli 1657
F. Scannelli, *Il microcosmo della pittura*, Cesena
1657

Schama 1987
S. Schama, *The embarrassment of riches: an inter-
pretation of Dutch culture in the Golden Age*,
London 1987

Von Schneider 1933
A. von Schneider, *Caravaggio und die
Niederländer*, Marburg & Lahn 1933

Schwartz 2002
G. Schwartz, *The Night Watch* (Rijksmuseum
Dossier), Zwolle 2002

Scribner 1977
C. Scribner III, '*In alia effigie*: Caravaggio's
London Supper at Emmaus', *The Art Bulletin*
59, no. 3 (1977), pp. 375-382

Slatkes 1992
L.J. Slatkes, *Rembrandt: catalogo completo dei
dipinti*, Florence 1992

Sluijter 2005
E.J. Sluijter, 'Goltzius, painting and flesh; or,
why Goltzius began to paint in 1600', in
Weststeijn *et al.* 2005, pp. 158-177

Spike 2001
J.T. Spike, *Caravaggio*, New York & London
2001

Strauss and Van der Meulen 1979
W. Strauss and M. van der Meulen, *The
Rembrandt documents*, New York 1979

Sussino 1960
F. Sussino, *Le vite de' pittori messinesi*, ed.
V. Martinelli, Florence 1960 (ed. princ.
Messina 1724)

Summers 1981
D. Summers, *Michelangelo and the language of
art*, Princeton 1981

Taylor 1992
P. Taylor, 'The concept of *houding* in Dutch art
theory', *Journal of the Warburg and Courtauld
Institutes* 55 (1992), pp. 210-232

Taylor 1998
P. Taylor, 'The glow in late sixteenth and
seventeenth century Dutch painting', in
Hermens 1998, pp. 159-178

Thompson 1932-1933
D.V. Thompson, *Cennino Cennini, Il libro
dell'arte*, 2 vols., New Haven 1932-1933

Treffers 1991
B. Treffers, *Caravaggio, genie in opdracht.
Een kunstenaar en zijn opdrachtgevers in het Rome
van rond 1600*, Nijmegen 1991

Treffers 1996
B. Treffers, 'In agris itinerans: l'esempio della
Madonna di Loreto del Caravaggio', *Mede-
delingen van het Nederlands Instituut te Rome* 55
(1996), pp. 274-292

Tümpel 1969
C. Tümpel, 'Studien zur Ikonographie der
Historien Rembrandts. Deutung und Inter-
pretation der Bildinhalte', *Nederlands
Kunsthistorisch Jaarboek* 20 (1969), pp. 107-198

Tümpel 1986
C. Tümpel, *Rembrandt: Mythos und Methode*,
Königstein im Taunus 1986

Tümpel 1993
C. Tümpel, *Rembrandt: all paintings in colour*,
Antwerp 1993

Tzeutschler Lurie and Mahon 1977
A. Tzeutschler Lurie and D. Mahon,
'Caravaggio's Crucifixion of Saint Andrew
from Valladolid', *The Bulletin of The Cleveland
Museum of Art* 64 (1977), pp. 3-24

Valentiner 1908
W.R. Valentiner, *Rembrandt: des Meisters
Gemälde in 643 Abbildungen*, Stuttgart &
Leipzig 1908

Valentiner 1920/1921
W.R. Valentiner, 'Die Vier Evangelisten
Rembrandts', *Kunstchronik und Kunstmarkt* 56
(1920/1921), pp. 219-222

Vasari 1878-1885
G. Vasari, *Le vite de' più eccellenti pittori, scultori
ed architetti*, ed. G. Milanesi, 7 vols., Florence
1878-1885

Van der Veen 1997
J. van der Veen, 'Faces from life: "tronies" and
portraits in Rembrandt's painted oeuvre', in
exhib. cat. Melbourne & Canberra 1997,
pp. 69-75

Van der Veen 1992
J. van der Veen, 'Liefhebbers, handelaren
en kunstenaars. Het verzamelen van schilde-
rijen en papierkonst', in E. Bergvelt and
R. Kistemaker (eds.), exhib. cat. *De wereld
binnen handbereik. Nederlandse kunst- en rari-
teitenverzamelingen, 1585-1735*, Amsterdam
(Amsterdams Historisch Museum) & Zwolle
1992, pp. 117-134

Vermeylen 2003
F. Vermeylen, *Painting for the market.
Commercialization of Art in Antwerp's Golden
Age*, Turnhout 2003

Walsh 1995
J. Walsh, 'A Resurrection of 1612 by Pieter
Lastman', in *Shop talk. Studies in honor of
Seymour Slive presented on his seventy-fifth birth-
day*, Cambridge (Mass.) 1995, pp. 254-256

Westermann 2000
M. Westermann, 'Making a mark in
Rembrandt's Leiden', in A. Chong (ed.), ex-
hib. cat. *Rembrandt creates Rembrandt. Art and
ambition in Leiden, 1629-1631*, Boston (Isabella
Stewart Gardner Museum) & Zwolle 2000,
pp. 25-49

Weststeijn et al. 2005
T. Weststeijn, *et al.* (eds.), *The learned eye.
Regarding art, theory, and the artists's reputation.
Essays for Ernst van de Wetering*, Amsterdam
2005

Van de Wetering 1983
E. van de Wetering, 'Isaac Jouderville, a pupil
of Rembrandt', in A. Blankert *et al.*, *The impact
of a genius. Rembrandt, his pupils and followers in
the seventeenth century*, Amsterdam 1983,
pp. 59-69

Van de Wetering 1986
E. van de Wetering, *Studies in the workshop
practice of the early Rembrandt* (diss.), Amsterdam
1986

Van de Wetering 1997
E. van de Wetering, *Rembrandt, the painter at work*, Amsterdam 1997

Van de Wetering 1999
E. van de Wetering, 'The multiple functions of Rembrandt's self portraits', in exhib. cat. London & The Hague 1999, pp. 8-37

Van de Wetering 2001
E. van de Wetering, 'Rembrandt's beginnings - an essay', in exhib. cat. Kassel & Amsterdam 2001, pp. 22-57

Van de Wetering 2004
E. van de Wetering, 'Rembrandt und das Licht', in exhib. cat. Vienna 2004, pp. 27-39

Wheelock 2005
A.K. Wheelock, 'Rembrandt's apostles and evangelists', in exhib. cat. Washington & Los Angeles 2005, pp. 13-37

White 1984
C. White, *Rembrandt*, London 1984

De Winkel 1999
M. de Winkel, 'Costume in Rembrandt's self portraits', in exhib. cat. London & The Hague 1999, pp. 58-74

De Winkel 2001
M. de Winkel, 'Fashion or fancy? Some interpretations of the dress of Rembrandt's women re-evaluated', in exhib. cat. Edinburgh & London 2001, pp. 55-63

Photographic Acknowledgments

Amsterdam, Rijksmuseum *Cat. no. 2, 3, 4, 6, 12, 16, 18, 26, 29; fig. 2, 10, 11, 33, 35, 39, 41, 47, 51, 52, 55, 75, 84.*
Berlin, Jörg P. Anders *Cat. no. 23, 33; fig. 37, 53, 86.*
Boston, Isabella Stewart Gardner Museum/Bridgeman Art Library *fig. 74.*
Boston, Museum of Fine Arts *fig. 13, 83.*
Cleveland, The Cleveland Museum of Art, Leonard C. Hanna Jr. Fund, 1976.2 *Cat. no. 1.*
Copenhagen, SMK Foto *fig. 87.*
Detroit, The Detroit Institute of Arts *Cat. no. 30.*
Dresden, Herbert Boswank *fig. 54.*
Dresden, Staatliche Kunstsammlungen Dresden/Klut *fig. 24.*
Dresden, Staatliche Kunstsammlungen Dresden/E. Estel *Cat. no. 34.*
Dublin, National Gallery of Ireland *Cat. no. 17.*
Florence, Fondazione di Studi di Storia dell'Arte Roberto Longhi *Cat. no. 25.*
Florence, Photo Scala *fig. 64.*
Florence, Photo Scala/Fondo Edifici di Culto - Min. dell'Interno *fig. 96.*
Florence, Photo Scala - courtesy of the Ministero Beni e Att. Culturali *fig. 70.*
Florence, Photo Scala,/Fondo Edifici di Culto - Min. dell'Interno *fig. 69.*
Florence, Soprintendenza Speciale per il Polo Museale Fiorentino, Gabinetto Fotografico *Cat. no. 19, 21; fig. 8, 45, 50.*
Fort Worth, Kimbell Art Museum *fig. 22.*
Frankfurt am Main, Städelsches Kunstinstitut *fig. 63.*
Kansas City, Robert Newcombe & Edward C. Robison III *fig. 59.*
Kassel, Staatliche Museen *fig. 18.*
London, Alinari/Bridgeman Art Library *fig. 1.*
London, Bridgeman Art Library *fig. 5, 6, 25, 29, 36, 44, 58, 81.*
London, Giraudon/Bridgeman Art Library *fig. 14.*
London, The National Gallery *Cat. no. 28, 37, 38; fig. 16, 57, 68, 71, 72.*
London, The Royal Collection, Her Majesty Queen Elizabeth II *fig. 19.*
London, The Trustees of the Wallace Collection *fig. 48.*
Madrid, Museo Nacional del Prado *Cat. no. 32.*
Madrid, Museo Thyssen-Bornemisza *Cat. no. 15.*
Madrid, Patrimonio Nacional *fig. 21.*
Melbourne, National Gallery of Victoria *Cat. no. 7.*
Messina, Archive Magika *fig. 27.*
Milan, Bibliotheca Ambrosiana – Auth. No. INT44/05 *fig. 49.*

Naples, Banca Intesa Collection *Cat. no. 31.*
New York, The Metropolitan Museum of Art *Cat. no. 12; fig. 20, 23, 56.*
Nürnberg, Germanisches Nationalmuseum *Cat. no. 8.*
Oslo, The National Museum of Art, Architecture and Design *fig. 82.*
Oxford, Ashmolean Museum *fig. 12.*
Paris, Collection Frits Lugt, Institut Néerlandais *fig. 67.*
Paris, École nationale supérieure des beaux-arts *fig. 38.*
Paris, Institut de France – Musée Jacquemart-André *fig. 17.*
Paris, Photo RMN, Daniel Arnaudet *fig. 43.*
Paris, Photo RMN, Hervé Lewandowski *Cat. no. 36.*
Paris, Photo RMN, René-Gabriel Ojéda *fig. 3, 42.*
Postdam, Stiftung Preußische Schlösser und Gärten Berlin-Brandenburg, Klaus Bergmann *fig. 28.*
Raleigh, North Carolina Museum of Art *fig. 32, 88.*
Rome, Archivio Fotografico Soprintendenza Speciale per il Polo Museale Romano *Cat. no. 10, 27, 35; fig. 34, 46, 62.*
Rome, Galleria Doria Pamphilj *Cat. no. 13.*
Rotterdam, Museum Boijmans Van Beuningen *Cat. no. 24.*
San Francisco, Fine Arts Museums of San Francisco *Cat. no. 20.*
St. Petersburg, The State Hermitage Museum *Cat. no. 14, 22; fig. 7, 9, 73.*
Stockholm, Nationalmuseum Stockholm *fig. 26.*
Utrecht, Centraal Museum Utrecht *fig. 31.*
Washington, Board of Trustees, National Gallery of Art *fig. 40.*
Weilheim, Blauel/Gnamm-Artothek *fig. 4.*
Weilheim, Joachim Blauel – Artothek *Cat. no. 9, 11; fig. 60, 61.*
Wien, Albertina *fig. 85.*
Wien, Kunsthistorisches Museum *fig. 77.*

Every effort has been made to apprise all institutions and other concerned parties of the publication of photographic material. Any unintentional oversight may be communicated to the Rijksmuseum, Amsterdam (Exhibitions Department).

Rembrandt–Caravaggio
is a publication of the Rijksmuseum, Amsterdam and
Waanders Publishers, Zwolle.

Concept
Ronald de Leeuw

General Editor
Duncan Bull

Copy Editors
Michael Hoyle, Amsterdam
Toon Vugts, Leiden

Translation
Dutch – English: Michael Hoyle

Design
Victor Levie, Amsterdam

Printing
Waanders Printers, Zwolle

Photography
Department of Photography, Rijksmuseum, and
the persons and institutions listed in the Photographic
Acknowledgements (p. 207).

ISBN 90 400 9135 8 (hardback)
ISBN 90 400 9136 6 (paperback)
NUR 646

For more information on the activities of the Rijksmuseum
and Waanders Publishers, please visit www.rijksmuseum.nl
and www.waanders.nl

Cover
Front: Caravaggio, *Omnia vincit Amor* (Cat. no. 33)
Back: Rembrandt, *The rape of Ganymede* (Cat. no. 34)